PENGUIN

DIDEROT: SELEC...
ART AND LITERATURE

DENIS DIDEROT was born at Langres in eastern France in 1713, the son of a master cutler. He was originally destined for the Church but rebelled and persuaded his father to allow him to complete his education in Paris, where he graduated in 1732. For ten years Diderot was nominally a law student, but actually led a precarious bohemian but studious existence, eked out with tutoring, hack-writing and translating. His original writing began in 1746 with a number of scientific works setting out the materialist philosophy which he was to hold throughout his life. Along with his editorship of the *Encyclopédie* (1747–73), he wrote works on mathematics, medicine, the life sciences, economics, drama and painting, two plays and a novel, as well as his *Salons* (1759–81). His political writings were mainly composed around 1774 for Catherine II, at whose invitation he went to St Petersburg. Diderot's astonishingly wide range of interests, together with his growing predilection for the dialogue form, led to the production of his most famous works: *D'Alembert's Dream*, *The Paradox of the Actor*, *Jacques the Fatalist* and *Rameau's Nephew*. During the latter part of his life Diderot received a generous pension from Catherine II, in return for which he bequeathed her his library and manuscripts. He died in 1784.

GEOFFREY BREMNER read Modern Languages at Oxford. After a period as a schoolmaster he lectured at the universities of the West Indies and Khartoum. On his return to the United Kingdom, he wrote a doctoral thesis on Diderot at Reading University and then taught in the French department of the University College of Wales, Aberystwyth. He is now a freelance translator and lexicographer. The author of two books on Diderot, he has also written numerous articles and papers on eighteenth-century French literature and thought.

DENIS DIDEROT

SELECTED WRITINGS ON
ART AND LITERATURE

TRANSLATED WITH AN INTRODUCTION
AND NOTES BY
GEOFFREY BREMNER

To Mother

With much love,

Geoff

PENGUIN BOOKS

PENGUIN BOOKS

Published by the Penguin Group
Penguin Books Ltd, 27 Wrights Lane, London w8 5tz, England
Penguin Books USA Inc., 375 Hudson Street, New York, New York 10014, USA
Penguin Books Australia Ltd, Ringwood, Victoria, Australia
Penguin Books Canada Ltd, 10 Alcorn Avenue, Toronto, Ontario, Canada m4v 3b2
Penguin Books (NZ) Ltd, 182–190 Wairau Road, Auckland 10, New Zealand

Penguin Books Ltd, Registered Offices: Harmondsworth, Middlesex, England

This translation first published 1994
1 3 5 7 9 10 8 6 4 2

Typeset by Datix International Limited, Bungay, Suffolk
Set in 10/13 pt Monophoto Bembo
Printed in England by Clays Ltd, St Ives plc

CONTENTS

ILLUSTRATIONS

FOREWORD

In the dual function of editor and translator of this selection I have tried to reflect the variety of views and styles to be found in Diderot's writings on aesthetic matters. This has not presented any great problem as far as selection goes, except perhaps for the *Salons*, where some interesting material has had to be rejected. The difficulties arose in finding a style, or styles, which would adequately reflect the vagaries of Diderot's own. It is not just that some works, like the *Conversations on 'The Natural Son'*, seemed to require a more formal style than, say, *The Paradox of the Actor*, but that some of Diderot's writing can sound quite modern and racy whereas other passages, often only a page or two away, are irrevocably dated, both in subject-matter and expression. I have tried to vary the style of the translation in a way which reflects these contrasts without becoming too incongruously modern on the one hand or too quaintly eighteenth-century on the other. As for the further problem of the technical language in the *Salons*, I have tried to use a vocabulary which conveys Diderot's considerable expertise without creating difficulties for those with less.

For the bulk of the information given in the introductions and the notes I am indebted to the painstaking work of past researchers and editors. Finding out the facts is an unglamorous and often unrewarding occupation, but in the long run this kind of research is more valuable than those flashy interpretive studies which attract attention for a while and are then forgotten.

INTRODUCTION

Diderot's life (1713–1784), as opposed to his writing, is remarkable chiefly for the events at the beginning and end of his career. In 1749 he was imprisoned for a few months at Vincennes for the atheistic ideas expressed in his *Letter concerning the Blind for the Use of those who can See* and the licentious ones in *The Indiscreet Jewels*; and in his early sixties he left France for the first time to undertake the arduous journey to Russia at the invitation of Catherine II. Apart from that, after a comfortable provincial childhood and rather less comfortable studies in Paris, his whole life was devoted to writing. Or rather writing as the end product of a life full of the activities in which most educated people interested themselves in those days, except that Diderot pursued them more voraciously and energetically than most. He succeeded, in an age when patronage was still the best hope for survival for most writers and artists, in making an independent living from his profession.

If, towards the end of the eighteenth century, one had asked an averagely cultivated person who were the greatest French writers of the century, the answer would almost certainly have been Montesquieu, Voltaire, Rousseau and Buffon. Today we would endorse the first three but, with hindsight, and evidence unavailable to his contemporaries, substitute Diderot for Buffon. Diderot's popularity today is something to which he would have reacted with a mixture of astonishment and wry amusement. The man who fought with more energy than most for the spread of enlightened thinking is now honoured for works which did little to propagate that ideal and in some cases were not even published in his own lifetime. Of the two dialogues which are now considered to be his masterpieces, *Rameau's Nephew* came to light only after his death and *Jacques the Fatalist* was known only to a small circle of his contemporaries. It is not surprising that he made no effort to reach a wider public with

these two works: both of them seem to undermine his public mission, calling into question the possibility of successful communication and sometimes even the validity of the ideas he so determinedly advocates in the public arena.

But of course it is this very quality which makes these two dialogues so interesting to readers of the late twentieth century. The ideas of Diderot and the Encyclopedists, which would help to define the thinking of the Western world for two centuries, have now run their course. The notion that knowledge, instilled through education, would bring out the natural goodness in man; that the end of political and ecclesiastical tyranny would produce a democratic consensus; that the advance of science would generate not just prosperity, but happiness; that paintings and novels and plays could make better people of us: all this seems strangely naive and utopian now. The seventeen volumes of text and twelve volumes of illustrated plates of the *Encyclopédie*, which took up twenty years of Diderot's life and were intended to embody the essence of Enlightenment thinking, are now just a fascinating curiosity and a subject of scholarly research. His political writings, especially those written for the Empress Catherine II of Russia, are idiosyncratic and lack the political depth and lasting relevance of Montesquieu. The two plays with which he hoped to spearhead a reform of dramatic writing are dated, tedious and unactable. Of the great thinkers of eighteenth-century France, Montesquieu and Rousseau are still widely read for the content of what they wrote, Voltaire has bequeathed the *esprit voltairien*, but as far as Diderot's thought is concerned, there is no legacy. Yet, paradoxically, he is now seen by many as the most interesting and congenial of all the writers of that period.

Ironically – but understandably, given the works on which his present popularity rests – interest in him began to revive at the very moment when Enlightenment ideas were losing their power to inspire. Since the 1950s, more and more scholars have devoted their time to editing and interpreting his works, and the ones which have aroused the most discussion and achieved the most success with the general public are those which have least to do with Diderot the

philosophe and Encyclopedist. Part of the attraction, especially in academic circles, has been that Diderot has seemed more 'modern' than any of his contemporaries, but another factor is that, from the dialogues and 'unofficial' writings, together with what we know from his correspondence and the observations of his contemporaries, there emerges an engaging personality with whom we can feel in sympathy. However incomplete the evidence, we feel that there is a man here whom we would like to have known. He was probably a delightful, and sometimes embarrassing, friend, a stimulating, and exhausting, conversational partner, a devoted father and a less than perfect husband, and above all a man of immense vitality and energy.

It was this energy which drove him to spread and sometimes dissipate his talent in so many directions. Not that he was alone in having a wide range of interests: most cultivated people at that time were interested in politics and science as well as the arts, but Diderot acquired an expert knowledge of politics, the life sciences, mathematics and physics, literary theory, music and – as we shall see in his *Salons* – painting, which sets him apart from most of his contemporaries.

What also sets him apart is the extent to which his knowledge and talent were squandered, or at least inadequately exploited. Other writers may have been led by prudence, political or otherwise, to deny authorship of their works, as Voltaire denied authorship of *Candide*, but these books were still published. Of the works in this volume, only the *Conversations on 'The Natural Son'* and *In Praise of Richardson* were published in Diderot's lifetime. The *Isolated Thoughts on Painting* were never published, and the first stage (of five) of *The Paradox of the Actor* and all the *Salons* were available only in the *Correspondance littéraire*. These volumes were edited by Diderot's friend, Friedrich Melchior Grimm, and circulated in manuscript form between 1753 and 1790 to privileged foreign subscribers who were desirous of keeping abreast of the latest developments in the cultural capital of Europe. As Norman Bryson writes of the *Salons*,[1] they 'were conceived by their author, Denis Diderot, and

by Grimm, their impresario, as an act of unprecedented and magnificent waste'.

Through dogged research, a degree of serendipity and painstaking editing, Diderot's works, whether published or not in his lifetime, have long since been accessible to the general reader. Thanks to this research, our view of him is radically different from that of his contemporaries, for whom he was first and foremost the editor of the *Encyclopedia*. For those who have the time and interest to read all, or even the greater part of this extensive *oeuvre*, the first impression must be one of amazement at its sheer variety. In the eighteenth century, only Voltaire had anything like Diderot's breadth of interests – and the energy to write about them.

Great writers are usually defined as those who impose a dominant unity on their subject-matter, so that the antiquity of their ideas is absorbed into and 'saved' by an inspired vision. This cannot really be said of Diderot. Certainly there are dominant themes and recurrent patterns in his writings, and there is evidence that he frequently revised and polished his work, but the overall effect is not of a finished product, a carefully constructed unity, but instead of a mind at work. We get a privileged view both of a brilliant intellect grappling with a problem and of a man conversing with himself. He was not a master of form, not at ease with large-scale projects. His talent was best suited either to works where the general organization was decided for him, as with the articles in the *Encyclopedia* or the pictures in the *Salons*, or to those where, as it were, the work structured itself as it went along, as it does in the dialogues, including the two in this collection, the *Conversations on 'The Natural Son'* and *The Paradox of the Actor*. The other two works presented here are further illustrations: the *Isolated Thoughts on Painting* speak for themselves; *In Praise of Richardson*, though traditional enough as a literary form, is described by Diderot as 'lines which I have set down without coherence, plan or order, just as they came to me in the tumult of my heart'. Obviously this needs to be taken with a pinch of salt, but such is the initial impression as we read it.

The case has often been made for saying that nearly all Diderot's works, whether overtly in dialogue or not, involve some kind of exchange with an explicit or implicit antagonist. It is certainly true that most of his work was written in opposition to prevailing ideas and existing traditions, but to say this is only to class him with the other avant-garde, subversive writers of his time. His originality, and the appeal of his writings for us, lies in the presence of some visible or invisible opponent or questioner who leads Diderot beyond his ostensible subject-matter and along unforeseen paths, often throwing a fresh light on the subject, sometimes illuminating a new one and occasionally even threatening to redefine the terms of the discussion.

The presence of such an antagonist is probably the only common element in the works collected in this volume. The process is most obvious in the *Paradox*, where the Second Speaker's comments encourage the First to pursue the theme along lines which eventually take the discussion far beyond the original subject, the qualities required of a good actor, to an attack on one of the fashionable orthodoxies of the mid-eighteenth century, the virtues of sensibility. From this he develops a series of subversive reflections on the nature of effective action and on the conflicts between truth and credibility, and morality and power. The *Conversations on 'The Natural Son'* are much more complex. We would seem to be listening to a conversation between Diderot and his friend Dorval, who has attempted to set down in dramatic form some recent events involving his own family and friends. In fact Diderot has made Dorval, one of the characters in his own (fictitious) play, *The Natural Son*, into its author, and has given himself the role of lone spectator of the play's first, private performance. The discussion which follows the performance is thus enabled to cover not only the nature of drama and the reforms Diderot would like to see in it, but the artist's relationship with his material, the ill-defined boundaries between fiction and reality and the problematic role of the spectator.

The *Salons*, intended to inform absent enthusiasts about the works exhibited, are actually addressed to Grimm, the editor of the

Correspondance littéraire. It is as if Diderot is most at ease when he can formulate his critiques and reflections as a conversation – a one-sided one, it's true, but then one has the impression that many of Diderot's actual conversations were fairly one-sided once he got into his stride. In any case, Grimm is often forgotten in the *Salons* when Diderot buttonholes the painters themselves, telling them how much they could learn from another painter, or how much better they could have done it if they had organized their subject-matter along lines suggested by Diderot. Sometimes he appears to forget he is looking at a painting and speaks of some figure which has taken his fancy as though it were a real person, even, as in the case of Greuze's *Girl Weeping for her Dead Bird*, talking to the girl herself.

No doubt there is an element of artifice in all this: Diderot contemplating the weeping girl is probably not as carried away as he seems, any more than he is in the more purple passages of his piece on Richardson. The artifice is much more obvious when he 'forgets' that Vernet's landscapes are paintings and strolls through them with his friend the abbé. This is a device to allow him some aesthetic and philosophical reflections on the nature of art and reality. We know too that his views on the works in the *Salons* were often inspired by the writings of other contemporary critics. Nevertheless, throughout the *Salons*, and especially in those he wrote in the 1760s, when his enthusiasm was at its height, we get the *impression* of an immediate, highly personal reaction. Moreover, knowing that his comments are unlikely to be seen by the painters themselves, he is able to distribute praise and blame without mincing his words, and his strictures on bad paintings, or immoral painters like Boucher and Baudouin, are often more readable, and certainly more amusing, than the eulogies of his favourites, Greuze, Chardin and Vernet.

We must conclude, I think, that Diderot was both an enthusiast, who got easily carried away by his ideas and feelings, and a writer who deliberately cultivated a direct, immediate style, straight, as it were, from the heart. There is a contradiction here which lies at

the centre of the eighteenth-century attitude to art and self-expression. It has been discussed by Lionel Trilling in *Sincerity and Authenticity* and more recently by Michael Fried in *Absorption and Theatricality*. In Diderot's case, his preference for some kind of dialogue opens the way to a spontaneity which is clearly connected with the interest, obsession indeed, of the mid-century with sensibility.

In an age which was acutely conscious of the stifling effect of Church and State tradition on the natural fulfilment of human needs, it was inevitable that some way should be sought to identify and give expression to those needs. Sensibility seemed to provide the answer: sensibility as that quality in all human beings (but especially in the more cultivated: they were economical with their egalitarianism) which enabled them to make direct contact with their authentic selves and to give transparent expression to their feelings. It was connected with the tendency in political thought to discover the true nature of human beings by going back to a supposed state of nature and in aesthetic theory with the enthusiasm for what we would now call realism, but which, tellingly, was then called 'illusion'.

Anyone interested in artistic theory and practice was bound to be concerned with the contradiction between the appearance of reality and the artificial means employed to achieve the illusion. Diderot had clear ideas on how it should be done in both literature and art, but at times he is less concerned with the means than the final result, almost to the point, as with Chardin and Vernet, or Richardson for that matter, of claiming that the work of art has an equal or even a superior status to the real thing. One can reproduce a Chardin still life, he says, by simply taking the objects portrayed and setting them down on a table exactly as Chardin did. Vernet's landscapes and seascapes make him the equal of the Creator. Richardson's characters become friends and enemies, like real people.

But this is only part of Diderot's attitude. Helped no doubt by the Socratic approach, which led him always to consider the opposite point of view, he is concerned with both the difficulties and the artifice involved in achieving the illusion of reality. In the *Conversa-*

tions on 'The Natural Son', Dorval is persuaded, sometimes by the theatrical proprieties and sometimes by the originals of his characters, not to portray things as they actually took place. By contrast, he is taken to task by his servant, André, for not portraying things as they happened. In the *Salons* of the late 1760s Diderot begins to lay much more emphasis on the degree of contrivance necessary to produce an effective painting, and the work in which he finally comes to terms with the problem of illusion and artifice is *The Paradox of the Actor*.

In this dialogue he makes a direct attack on the cherished values associated with sensibility. He had already maintained in *D'Alembert's Dream* that sensibility is morally neutral, equally capable of generating good or evil. Now he takes on the partisans of sensibility on their favoured ground, the theatre. In the third quarter of the century sensibility became an obsession, and nowhere more so than in the theatre, where weeping, swooning and moaning with empathetic delight were regular features of a successful performance. For such transports to take place it was necessary to believe that the actors felt the emotions they were depicting, that they were imbued with the same degree of sensibility as their audience. This is the belief held by the Second Speaker in the dialogue, while the First Speaker sets out to explode it. He makes the scandalous claim that the essence of good acting consists in having no feeling, no sensibility. Only thus can the detachment be achieved which enables an actor, night after night, to reach the same perfection in performance. The argument is conducted convincingly (even if actors, then and now, remain unconvinced), but the logic of the dialogue carries Diderot, or rather the First Speaker, far beyond the realms of acting to the nature of effective action in general. How do politicians, preachers or prostitutes successfully influence their listeners or clients if not by acting a part, that is, by not being involved in what they are doing? And, to take the implications further, what credence can we give to politicians and preachers if their effectiveness lies not in sincerity but in artifice? And, one might add, where does this leave the values of the Enlightenment, at least where Diderot is concerned?

The answer is probably that it left them very much where they were, that Diderot continued to hold his enlightened beliefs but felt that they could not be effectively put into practice without being betrayed by the very action they called for. As Lester Crocker puts it in *Diderot's Chaotic Order*, 'there may be no way of translating ideals into action except by means that contradict them'.[2] It seems too that eighteenth-century people may have been more at ease with this contradiction than we have since become. They were able to combine their idealization of sincerity with a disenchanted awareness of the practicalities of everyday activity. In our own day, on the other hand, the United States, which founded itself on the ideals of the Enlightenment, was shaken to the core by the realities of Watergate. Richard Sennett, in *The Fall of Public Man*, explains the apparent double thinking of eighteenth-century society by the simultaneous existence in each person of a public and a private personality which enables people to hold certain values which are reserved for their private, or perhaps family life, and to subscribe to others in their public dealings. Certainly this dual personality was beginning to break up in Diderot's lifetime, slowly giving way to the monolithic personality with which we are more familiar, but it was still powerful enough to account for some of the contradictions we find in Diderot's own thinking and writing. What is also true is that he alone had the curiosity and the perception to examine these contradictions in his great dialogues.

If we now return to the complete reality of Diderot we are faced with an enormous range of ideas and feelings, each encased in an appropriate style. In the writings presented in this volume we have the dispassionate, subversive reflections which characterize some of the dialogue in the *Paradox* contrasting with the 'enthusiastic' outbursts of Dorval in the *Conversations*; the straightforward, detached, and sometimes minute description of paintings with the sickly sentimentality of some of the *sensible* passages on Greuze or Richardson; the 'high', sober style of the reflections on the nature of art and drama with the earthy comments on some of the more *risqué* paintings. It is sometimes difficult to imagine too that the same man

could have approved of the violence of Aeschylus's *Eumenides*, as he does in the *Conversations* and the *Paradox*, and also have spoken with such apparent enthusiasm of the soppy peasant operetta in the third *Conversation*.

With Diderot more than with most of the great writers of the period, and that includes Rousseau, one has to take the fine writing and the original ideas with a good proportion of what one can only call bad taste. There seems to be no governing mechanism which prevents Diderot sliding off into seemingly uncontrolled emotionalism when the mood takes him. This is the price we have to pay for the freedom and variety of his writing.

Looking more closely now at the content of Diderot's works, one of the features which distinguishes him is his attention to the technique of writing and painting. Just as, in the *Encyclopedia*, he insisted on recording every aspect of the technology of his time, so, in the *Conversations*, he dwells not only on the art of constructing a plot but on the structure of the stage itself, and in the *Salons* on the practicalities of painting, of which he had made a thorough study. As well as being a matter of personal inclination, this interest in the technical side of things is something which Diderot shared with many others who wanted to bring art, literature and the theatre closer to the lives of the public. The whole trend implied a reaction against the traditional academicism of the arts.

Before embarking upon a discussion of the actual reforms which Diderot advocated, it is important to see them in perspective. A feature which might be found surprising in someone who is anxious to bring things up to date is the obsession with the classical past. His writings on the drama are full of examples from Aeschylus and Euripides, and the *Salons* contain frequent references to classical art, despite the fact that little was known of such Greek painters as Apelles and Zeuxis. The explanation seems to be that, lacking our sense of historical relativism, the thinkers of the eighteenth century saw progress not as a process of constant change, but as an effort to get closer to an absolute standard of perfection which, in their view, had been most nearly achieved by the Ancients. Diderot would

certainly have been surprised and disappointed to know that the artistic developments begun in his own century had in fact taken us further and further away from the artistic ideals of classical times. There is a certain poignancy in the fact that Diderot's two attempts to write stage plays, *The Natural Son* and *The Father*, bore no resemblance whatever to anything to be found in classical drama, and contained nothing of the energy and violent passion which he so admired in it. At times, especially in the *Paradox*, he does seem aware of the gulf which separated his own time from the antique past, but he was clearly unable to see that the gulf was unbridgeable.

There are two dominant themes in Diderot's plan for the future of drama, themes which, for that matter, also shape his approach to art and the novel. The first is that drama should concern itself with the real preoccupations of its public, by which he meant in practice the bourgeoisie, the class to which he himself belonged; the second, that drama should be morally uplifting, that it should have a social function. Both of these elements were a reaction against the traditional drama of his day, which, in the case of tragedy, he felt was too lofty and pompous, too far removed from the reality of ordinary people's lives, and in the case of comedy and opera, too frivolous and corrupting. Diderot's reforms were conceived in opposition both to academicism and to decadence. The kind of drama he envisaged is fully discussed in the *Conversations* and to a certain extent in the *Paradox*.

Diderot's plan for drama embraces every type of theatre, from high tragedy to farce, but in practice the discussion in the *Conversations* centres on what he calls the serious genre, or domestic bourgeois tragedy. This is the truly innovative aspect of his proposed reforms. His first and most obvious requirements are that the characters should be recognizably drawn from real life and that they should speak in prose, whereas in traditional drama they were drawn from history or mythology and spoke in verse. It is worth noting here that, although Diderot was certainly not alone in advocating reform along these lines, classical tragedy, as written by Corneille and

Racine in the seventeenth century, continued to flourish until the end of the eighteenth century and beyond, its most famous practitioner being Voltaire.

An additional element, very dear to Diderot's heart, was that drama should concern itself less with character than with what he calls 'conditions', that the protagonists, in other words, should be defined by their social function rather than their innate qualities and defects. Social function implies both professional status, the lawyer, the doctor, and so on, and family relationships, the most important of which in his eyes, the father, Diderot embodied in one of his own plays. Whereas members of the audience could, as it were, escape identification with characters whose qualities or defects they did not recognize in themselves, they were obliged to see that the station in life being represented was their own, or, presumably, one which concerned them. The presence of 'conditions' thus brought the play closer to the public and also enabled the theatre to fulfil its own social function, which, in Diderot's view, was not just to teach people to be more moral, but more specifically to remind them of their social duties. Ideally, and unrealistically, he would have liked serious drama to be a ceremonial occasion, as he imagines it to have been in antiquity, when thousands of people would have gathered together as on a great public occasion, to be inspired anew with a sense of their civic duties.

That such drama should be written in prose is no cause for surprise, given that it was intended to reflect people's own experience of life, but Diderot pursued the concept of realism in expression much further than this. Reacting against the highflown versified language and the mandatory *tirades* of classical drama, with their function of drawing attention to performance rather than giving the illusion of reality, he reminds us that deep feeling is often expressed in real life not by words but by inarticulate sounds, gestures and even silence. And so another element enters into his preoccupations, that of mime. His ideal actor will be able to convey the emotions he is representing not just in words, but through facial expression and gesture, and sometimes without words at all. This approach is

evident in his two plays and even in the *Conversations*, where, at dramatic moments, the protagonists' roles are punctuated by exclamations, rows of dots and directions that they should walk up and down, hang their heads, and so on. He also suggests that there are times when the mime could be left to the actors themselves to decide, rather than being dictated by the author. One can imagine this being popular with audiences addicted to the expression of sensibility on the stage, but it is hardly in keeping with Diderot's other ambition for drama to become a large-scale public spectacle.

This is a problem which he attacks from a different angle in the *Paradox*, again without coming up with a practical solution. The distinction is already drawn in the *Conversations* between a performance given in private, in a drawing-room, and one which is subject to all the limitations and conventions of the stage, and here he seems to be dealing with the gulf already mentioned between the public and the private aspects of the social personality. A reading or a dramatic performance given in the presence of a few people in a drawing-room bears no resemblance to one given in a public place. An actor who succeeds in moving a small private audience with a performance full of sensibility and personally felt emotion will fail miserably if he attempts the same thing on stage. Naturalness belongs in the private world, but the stage demands artifice, exaggeration and careful rehearsal if the audience is to be reached. In the *Paradox* he draws the logical conclusion, that the passion by which we are moved in the theatre is not genuine passion at all but a carefully contrived simulation of it, created by an actor who is familiar with all the artifice involved in dramatic performance and theatrical convention. The effective stage actor must at all times be in control of himself, must never abandon himself to emotions which belong only in the private world of the 'salon', the drawing-room.

There is an irony, but also a logic, in the fact that this self-confessed victim of sensibility should attach so much importance to control, not just the self-control needed by the actor and the man of action but control of one's perception of the outside world. This is the

reason for two further reforms which Diderot was anxious to introduce into the theatrical practice of his day: the larger stage and the tableau. His ideal stage would allow for the simultaneous presence of a number of sets, which would enable the action to move from one place to another without the necessity for a break in the performance. In this way the audience would enjoy a panoramic view of the whole action of the play, and more importantly, they would have a more complete awareness of what was happening than the characters themselves, who might well be ignorant of what was going on in another section of the stage. The achievement of a greater degree of realism was perhaps less important in Diderot's mind than the fact that the audience would first of all be more moved by the spectacle of successive or even simultaneous scenes taking place before them in a complete, self-contained world, and would also enjoy a broader view of the whole, a greater feeling of control over their reaction to the events of the drama.

The tableau has a similar purpose. Diderot defines it in one passage as a scene which could successfully be transferred to the canvas and in another as a point when the action comes to a momentary halt and a number of characters are seen gathered together at some significant stage in the development of their relationships. As with the multiple sets on his stage, Diderot seems to be aiming at emotional scenes which deepen the audience's understanding of the dramatic situation and presumably enhance the moral impact of the play. He seems to allot a secondary role to the excitement of seeing a plot unfold, which he would probably class as mere entertainment. It is significant that he contrasts the tableau with the *coup de théâtre*, which he would like to see banished from the stage. The essence of the *coup de théâtre* is of course surprise, not only for the characters but for the audience, and this conflicts with their ability to survey the whole action in time and space.

Another feature of the tableau is that it would involve a radical change in acting method. The tradition, at least as described by Diderot, was for actors to stand facing the audience and declaim their lines. He wanted them to relate to each other rather than to

the audience, to simulate a self-contained world which could be contemplated by the spectator in the same way, perhaps, as he would view a genre painting by Greuze. Diderot's comparison of a tableau with a painting is indicative of the nature and the weakness of his ideas on drama. In theory and in practice he was more impressed by fine set pieces and beautiful sentiments than by interesting and exciting developments in the plot. His preference seems to have been for the static, in the interest no doubt of achieving the calm perception which favoured the moral impact of the play.

Diderot's views on drama are in fact quite closely paralleled in some of his comments on painting. This is less surprising in the eighteenth century than it would be today. Drama and painting were traditional art forms which, unlike the novel, had acquired their own status in the cultural and even the political world. Both were officially, though often not in practice, subject to the deliberations of *Académies*, and received official encouragement in an age when the arts were seen as an expression of the greatness of a nation. One of the best treatments of this question, which is too complex to be discussed here, can be found in Thomas Crow's *Painters and Public Life in Eighteenth-Century Paris*. Both drama and painting had their hierarchy of genres, with mythological and religious subjects at the top, followed by historical tragedy and history painting. Comedy and farce enjoyed a lower status in the dramatic hierarchy, just as genre painting, landscape and still life did in painting. In keeping with his brief from Grimm, Diderot of course deals with every aspect of painting in his *Salons*, and is often enthusiastic about examples from the top rungs of the hierarchy, but his natural preference is for three painters, Greuze, Chardin and Vernet, who operated at a lower level.

One can imagine some of Greuze's scenes, *The Ungrateful Son*, *The Son Punished* and especially *The Village Betrothal* (with the exception of the chickens in the foreground, perhaps), being of a kind which Diderot would like to see as a tableau on the stage. The figures represent 'conditions' and are caught at dramatic or significant moments in their lives from which it is easy to draw a moral

lesson. Greuze's characters, it is true, are a little too far down the social scale to be the subjects of domestic bourgeois tragedy, but they make up for this in their appeal to the sensibility. Indeed, the lives of the respectable peasant class were no doubt more moving, and more moral, because such people were felt to be closer to the natural, less subject to the formality and artificiality of urban bourgeois life. Such people could not of course appear on the stage, except as servants, since their speech would be regarded as shocking and ridiculous.

Diderot's enthusiasm for Greuze, and his essay on Richardson, which is roughly contemporary with *The Village Betrothal*, reveal him succumbing to the popular identification of sensibility with moral values, despite anything he says in his more reflective writings. Sensibility here is the force which breaks through, or perhaps bypasses, the artificiality of society and releases genuine feeling. It enables the values of the private world to come into their own in the public world. In this sense it is a political as well as a moral and aesthetic concept, opening up the possibility of a reform in social values, to which art and drama would make a valuable contribution. Art and literature thus become part of a democratic process in which the values of society are generated from within itself instead of being dictated by government and the Church. Whereas classical tragedy and history painting were intended, at least in the official view of things, and perhaps too in the public mind, to reinforce and celebrate the values of the State, domestic tragedy and genre painting of the type practised by Greuze were an alternative force, drawing their strength from the values of the urban middle class.

This is the sense in which Diderot's views on art and literature form part of the reformist thought of the eighteenth century, but we are rarely made conscious of this in reading the *Salons*, nor were such thoughts necessarily at the forefront of his mind as he wrote his critiques of the paintings which filled almost every inch of the walls of the exhibition room. All one can say is that his preference seemed to be for painters who worked in the lower reaches of the traditional hierarchy. What is most striking in his discussions of

Vernet's landscapes and Chardin's still lifes is his praise for their ability to represent things as they are, or more exactly, their ability to give an impression of reality, since the 'reality' of a fine painting is an enhanced version of anything we might see in nature. This approach sometimes comes over as rather naive when compared with the preoccupations of modern art criticism. Diderot clearly delights in describing the reality of Chardin's fruits, jugs and items of food, or Vernet's trees, clouds and people, and talks of Greuze's figures as if they were really there. His attitude is more understandable when we remember that, as in drama, he wants his artists to give us the direct experience of their subject-matter, not something mediated through the formalities and conventions of traditional art. Formal, academic art acts through the mind, which has to use its knowledge of the conventions to interpret what it sees. Diderot favours painters who speak directly to the senses and the heart. His enthusiasm often makes him a prey to his sensibility as he gets carried away by his emotional involvement in these genre paintings, but he is also well aware of the techniques necessary to achieve such effects.

He stresses the importance of accuracy in representation: hands and feet are a particular obsession with him, and he complains that history painters generally consider such details to be beneath their notice. He wants his artists to spend a lot of their time in the observation of nature, the effects of light at different times of day, the appearance of still water, rushing water, skies and clouds. He indulges in minute criticism of faces, complexions and clothes. Nothing must be present in a painting which might remind us that we are looking at an artificial construction. And because nothing must jar, he also stresses the importance of artifice in the arrangement of figures, the relationship of figures to landscape and buildings, the harmony of colours, the gradation of light, and – a frequent comment – the necessity for objects to appear separate from one another, so that we are aware of the air circulating between them: an artist must aim at three-dimensional effect, so that the observer can, as it were, enter the picture and become totally immersed in it,

experiencing it as a direct reality. At the same time, the harmonious relationship of forms and colours and the unity in the structure of the painting will make of it a self-contained world which, far from excluding the observer, will enhance the illusion and facilitate his involvement.

As one might expect from his views on drama, the moral effect of a painting is also one of Diderot's main concerns. While admitting to his own sensuality and not being averse to erotic art as such, he condemns artists like Boucher and Baudouin for their triviality. What he really wants is for the frivolity and decadence of much contemporary art to be replaced by healthy, vigorous values. He praises paintings for their strong, lively treatment of the subject-matter, as well as for their vigorous brush-strokes. In Greuze, as in drama, he approves of the emphasis on family life. He has high praise for Doyen's *St Denis Preaching*, being prepared to overlook its technical deficiencies in favour of its movement, energy and vigour. He likes Vernet's storms at sea, not only for the representation of the natural effects but also for the actions and sufferings of the victims. In this, though not in much else, he has a kind of Thatcherite attitude, with the energy and simplicity of ancient art acting as the equivalent of Victorian values.

The association of moral values and sensibility comes over even more strongly in *In Praise of Richardson*, which sometimes reads as if he regards Richardson's main purpose as being to improve his readers' morals. By his accurate portrayal of believable characters, the variety and distinctive nature of each of the characters themselves, the proliferation of realistic detail, he creates a world in which, and into which, the receptive reader cannot help but be absorbed, almost to the point of becoming a character in the action. Once established within the novelist's world, he learns to admire the good and unmask the evil in the characters surrounding him, finally becoming better able to practise virtue on his return to his own world. A bald summary like this conveys little of the flavour of Diderot's essay, of the extraordinary enthusiasm, at times quite moving, at others almost comic, which Richardson was able to generate in his contemporaries.

A point which is barely hinted at by Diderot, but which is likely to strike anyone who reads the *Salons* in conjunction with the piece on Richardson, is that Richardson's type of novel reveals many more parallels with the kind of painting favoured by Diderot than does the visual world of the drama. The novel is a far more suitable vehicle than drama to convey the wealth of detail necessary to a convincing evocation of everyday life. Nor is it subject to the conventions which stand in the way of realism on the stage. It is a pity that he did not commit himself to further reflections on a genre of which he was himself a practitioner, and which we now see as the great innovatory form of his period.

I have so far stressed the social element in Diderot's ideas on art and literature, but there is another area which certainly offers less attraction to modern aesthetic sensibilities but is essential to the understanding of Diderot and indeed the aesthetics of the latter half of the eighteenth century. This is what was once known, when Whiggish tendencies were dominant in aesthetic criticism, as 'pre-Romanticism'. Whatever we call it now, it is closely related to the sublime and the 'gothic', and is an area in which Diderot's sensibility can be seen at its most unrestrained. The first example of it in this selection is the opening passage of the second of the *Conversations on 'The Natural Son'*, where we find Dorval 'under the spell'. He seems to have moved into another dimension, as, only vaguely aware of Diderot's presence but inspired by the wildness of the natural scene around him, he launches into a monologue in which nature is praised as the source of poetic enthusiasm, itself the source of truth. Most of the elements are here of that 'natural' nature which was one of the great discoveries of the eighteenth century: wildness, solitude, mountains, forests, streams, all of them generating a state of mind which seems the very opposite of the rational study of the natural world which we also associate with the period.

It is this apparently uncontrolled release of sensibility which makes uneasy reading for the modern public. It can only be explained, and justified, by the fact that it did in fact represent a *release*, a liberation from the formality and artificiality which we

associate with the *ancien régime,* which had seemed to deny mankind a whole range of experiences, and, more importantly, had concealed a truth which alone could enable human beings to be fulfilled and happy. To use the word 'happy' in connection with Dorval's melancholy disposition, or Diderot's reaction to Hubert Robert's paintings of ruins, is admittedly a little incongruous. There seems to be a discrepancy between the more impersonal thinking of the period on political and social reform, which considered human happiness in general terms, and the more individualistic attitudes associated with the new sensibility. Yet both these elements exist side by side in Diderot, and Dorval. Dorval is anxious to do the right thing by his friends and family, and takes a responsible attitude towards his tenants: he promotes human happiness but it seems almost a condition of that impulse that he should himself be unhappy. He seems to belong to a kind of aristocracy of sensibility. He is one of a probably small number of beings who are privileged to feel deeply, to be inspired by nature and to feel the promptings of genius. The melancholy he experiences is thus a sign of superiority, the price he pays for his enhanced sensitivity. It is perhaps its reward as well, for there is no doubt that this power to suffer, to feel, and fear, the horrors of lonely places and dark forests, to become aware of the brevity of human existence in the spectacle of ruins, is also a pleasure, and one which will be savoured to the full by the Romantic poets of later years.

It is this aspect of sensibility which surfaces not only in Diderot's comments on Hubert Robert's paintings of ruins, but also in his enthusiasm for the wilder landscapes and seascapes of Vernet and Loutherbourg. It takes the form here not so much of an indulgence in unconstrained emotionalism as of a delight in phenomena which inspire fear and horror. It is of course the sublime, most famously discussed by Edmund Burke in his *Philosophical Enquiry into the Origin of our Ideas of the Sublime and the Beautiful,* a work known to Diderot. Some of Diderot's most illuminating observations on the subject come in the section on Vernet in the 1767 Salon. Here, among other things, he gives what amounts to a list of ingredients

for the sublime which includes darkness, indistinguishable shapes, the depths of forests, the infinite, tombs, spirits, anything mysterious, and the sound of muffled drums, bells and nocturnal birds. But the most important reaction we should experience is astonishment: objects and incidents which throw us off balance and defy rational judgement are the essence of the sublime. This is in direct contradiction to the scientific experimentalism of the eighteenth century where we find writers insisting time and again that we should precisely avoid astonishment in our reactions to natural phenomena.

The enthusiasm which Diderot and so many of his contemporaries felt for the sublime, without in any way rejecting the need for objectivity in the quest for knowledge, is symbolic of the development of a new attitude in European thinking, in which the world of scientific knowledge is seen as something of a different order from that of the arts and the emotions. This is an extreme simplification of a complex mutation in Western sensibility, but one which is worth mentioning here because we can see so many signs of it, as well as some of its complexity and its contradictions, in Diderot. This introduction has merely touched on a few aspects of his views on art and literature, but what I hope has become evident is something of the distinctive flavour of his thought which, because of his reluctance on the one hand to produce a lengthy coherent treatise and his willingness on the other to explore the contradictions in the ideas he deals with, conveys a better, albeit confused, picture of his age than the work of most of his contemporaries. His acute sensibility, his readily fired enthusiasm, his tendency to get carried away, which account for the best and the worst in his writing, form a sharp and at times barely credible contrast with his recognition of the need for rationality, controlled action and perception, and sound judgement. Both tendencies were present in the age, but nowhere do we see them coexisting so vividly as in Diderot.

CHRONOLOGY OF DIDEROT

1713 Birth of Diderot.

1732 Accepted as a Master of Arts of the University of Paris.

 Diderot's early years in Paris are difficult. His allowance is cut off in 1736 after his father gets reports of his way of life and he survives largely by translating. At some time during this period his friendship with Jean-Jacques Rousseau begins. In 1743 he secretly marries Antoinette Champion.

1746 *Pensées philosophiques* (*Thoughts on Philosophy*). Banned by the Parlement.

1747 Diderot and D'Alembert take on the joint editorship of the *Encyclopédie*.

1748 *Les Bijoux indiscrets* (*The Indiscreet Jewels*).

1749 *La Lettre sur les Aveugles* (*The Letter on the Blind*).

 These last two publications lead to Diderot's imprisonment at Vincennes. He is released later in the year.

1751 *Lettre sur les Sourds et Muets* (*Letter on the Deaf and Mute*); first volume of the *Encyclopédie*.

1753 *De l'Interprétation de la Nature* (*On the Interpretation of Nature*).

1757 *Le Fils naturel* (*The Natural Son*) and *Entretiens avec Dorval* (*Conversations with Dorval*, later known as *Conversations on 'The Natural Son'*). End of friendship with Rousseau. Volume VII of the *Encyclopédie* appears and is banned.

1758 *Le Père de famille* (*The Father*) and *Discours sur la poésie dramatique* (*Discourse on Dramatic Poetry*).

1761 *The Father* is performed. *Eloge de Richardson* (*In Praise of Richardson*). *Salon* of 1761.

1765 The last ten volumes of the *Encyclopédie* are printed.

1768 *Salon* of 1767 completed.

1769 *The Father* revived at the Comédie-Française. *Garrick, ou les acteurs anglais* (*Garrick, or English Actors*).

1771 *The Natural Son* performed unsuccessfully at the Comédie-Française. Completes a first draft of *Jacques le fataliste*.

1772 Begins working with Raynal on *L'Histoire des deux Indes* (*The History of the Two Indies*) and completes the first draft of the *Supplément au Voyage de Bougainville* (*Supplement to Bougainville's Account of his Voyage*).

1773 Departure for Russia, via Holland and Germany.

1774 Returns to Paris, again with a stop in Holland. Working on the *Réfutation d'Helvétius*, his political writings for Catherine II and the *Eléments de physiologie*.

1778 *Essai sur la vie de Sénèque* (*Essay on the Life of Seneca*).

1781 Diderot's bust (by Houdon) is placed in the Town Hall of Langres. *Jacques le fataliste* is completed.

1784 Death of Diderot. He is buried in the church of Saint Roch.

Introductory Note

CONVERSATIONS ON *THE NATURAL SON*

The *Conversations* appeared in 1757, the same year as the play they discuss, and that edition is the text on which this translation is based. The play had been written in 1756 at Massy, not far from Paris, where Diderot had gone to take a rest after the publication of the sixth volume of the *Encyclopedia*, at the country home of his publisher, Le Breton. The countryside may have inspired the setting of the walks with Dorval in the *Conversations*. Neither the play nor the *Conversations* had any success. Grandval, the actor whose advice was taken by the Duc d'Orléans, a theatre enthusiast, declared it unactable, and subsequent experts have agreed, but the failure of the *Conversations* is harder to explain. The reforms Diderot proposes were very much in the spirit of the age and a great deal of what he wrote is reflected in plays by Sedaine, Mercier, Nivelle de la Chaussée and Beaumarchais. The character of Dorval is an example of a new kind of hero emerging at that time: the solitary, romantic, introspective, melancholic figure, full of virtue but ill at ease with the world around him, a forerunner of Werther, and, it is claimed, a portrait of Rousseau. In some ways, too, the relationship between the two speakers adumbrates that between the two characters in *Rameau's Nephew*, the conflict between sensibility and rationality.

The reaction of the modern reader is likely to be an alternation between interest in the interplay between the characters and impatience, embarrassment even, at the paths along which Diderot's enthusiasms take him. More than most, this work shows how interesting Diderot can still be and at the same time how dated, but these dated elements too can give us an impression of the sensibility and preoccupations of the time.

The *Conversations* are often difficult to understand without at least a basic idea of the plot of *The Natural Son*, which runs as follows.

1

The play has four main characters: Dorval, who is the natural son, reserved, melancholy, difficult to get on with, acutely conscious of his illegitimacy and his social isolation, but, for reasons which become clear later on, quite rich; then Rosalie, who is his legitimate half-sister, though, again, this is not revealed until the end of the play; Clairville, Dorval's aristocratic and only friend, who is in love with Rosalie, and in whose house in Saint-Germain-en-Laye the action takes place; finally, Clairville's sister Constance, a young widow who has been sufficiently impressed with the nobility of Dorval's character to fall in love with him.

In the first act we learn that Dorval is, alas, in love with Rosalie. In despair, he plans to leave, not of course because Rosalie is his sister, since he does not yet know this, but because she is more or less engaged to his friend Clairville. We then learn that Clairville too is in despair, because Rosalie no longer seems to love him. It soon becomes clear, first to us, then to Dorval, that Rosalie's affections have turned towards Dorval himself. She writes him a letter, full of guilt and despair, and Dorval begins to write a reply. At this point he is called away to defend Clairville, who is duelling with two men who have had the effrontery to suggest that Dorval is in love with Rosalie. Dorval's intervention saves his life, but while Dorval is away, Constance (in love with Dorval) discovers the half-finished letter to Rosalie and thinks it is addressed to her. Neither she nor Clairville when he hears of it can understand Dorval's reluctance to declare himself.

This is where the play reaches its point of maximum complexity, and maximum gloom. Everyone except Dorval is under a false impression of some kind. Everyone including Dorval is unhappy. The rest of the play's action is spent resolving the situation, and the first development is one which seems to make it even worse. A servant of Rosalie's father (we still do not know that he is Dorval's father as well) arrives with the news that the ship on which he was sailing home with a fortune has been captured by the English (the play was written, and the action takes place, during the Seven Years War). So even if the marriage of Rosalie and Clairville had still

been a possibility, it is now out of the question, since Rosalie's family fortune had been intended to restore the shaky finances of Clairville.

A lesser man might have seen this as his chance to marry Rosalie himself. Dorval, by contrast, performs an enlightened act. Seeing the opportunity to extricate himself from his position of bad faith with the other characters, he decides to renounce his love for Rosalie and secretly to give her his fortune, pretending that the ship on which her father was sailing was actually insured. Dorval and Constance now combine to try to bring Clairville and Rosalie back together, a process which brings Dorval closer to Constance. Rosalie is duly persuaded by Dorval to renounce him for Clairville, and this in the nick of time, for now her father, Lysimond, freed from captivity, arrives to reveal that Dorval is his son and that he has not lost his fortune after all. Dorval's noble stratagem is unmasked: his money, which had come from Lysimond anyway, and his honour are restored. The play ends with a tableau of family happiness and unity as old Lysimond is surrounded by the grateful — and reassorted — couples: Rosalie and Clairville, Dorval and Constance.

CONVERSATIONS ON *THE NATURAL SON*

INTRODUCTION

I promised to say why I did not understand the final scene, and this is why. They had prevailed upon a friend of his, who was about his age, with his build, voice and hair, to take his place in the play.

This old man came into the room, as Lysimond had come in the first time, supported by Clairville and André, and dressed in the clothes which his friend had brought from the prison. But hardly had he appeared there than, this point in the action bringing back to the whole family a man whom they had just lost, and who had been so respected and cherished, not one of them could hold back his tears. Dorval was weeping; Constance and Clairville were weeping; Rosalie stifling her sobs and turning her face away. The old man who was representing Lysimond became upset and he too began to weep. The grief, as it passed from the masters to the servants, became universal, and the play could not be concluded.

When everyone had left, I came out of my corner and returned as I had come. As I went, I dried my eyes and said by way of consolation, for I was sad at heart: 'I must be foolish to get upset like this. All this is only a play. Dorval made the subject up. He wrote the words from his imagination, and today they were amusing themselves acting it out.'

Yet there were some features which troubled me. Dorval's story was known in the district. The performance had been so true to life that, forgetting at some points that I was an onlooker, and an unseen one, I had been about to come out of my place and add a real character to the action. And then, how could I reconcile what had just happened with my ideas? If this was a play like any other, why were they unable to play the last scene? What was the cause of

4

the deep sorrow which had overcome them at the sight of the old man who played Lysimond?

A few days later I went over to thank Dorval for the delightful, painful evening which I owed to his kindness . . .

'So you were satisfied with it . . .?'

I like to tell the truth. This man liked to hear it; and I answered that the acting had made such an impression on me that I found it impossible to make a judgement on the rest; and, not having heard the last scene, I did not know how it ended; but if he would let me have the work, I would tell him what I thought . . .

'What you think! Do I not know as much now as I want to know? A play is not so much made to be read as to be performed. You enjoyed this performance: that is all I need to know. But here it is; read it and then we will talk about it.'

I took Dorval's work, read it at my leisure, and we discussed it the following day and the two days after that.

Here is what we said. But what a difference there is between what Dorval said to me and what I write! . . . Perhaps the ideas are the same; but the genius of the man is gone . . . In vain do I seek within me the impression made upon me by the spectacle of nature and the presence of Dorval. It will not come back; I cannot see Dorval; I cannot hear him. I am alone, amid the dust of my books and the shadows of my study . . . and the lines I write are feeble, sad and cold.

DORVAL AND I

First Conversation

That day Dorval had been trying without success to conclude a dispute which for a long time had divided two families in the neighbourhood, and which threatened to ruin them both. He was depressed about it and I could see that the mood he was in was going to cast a shadow over our conversation. But I said to him: 'I have read what you have written; but either I am much mistaken or you have not taken care to conform scrupulously to your father's

intentions. He had enjoined you, so it seems to me, to represent things exactly as they took place; and I have noticed several which have a fictional character which is effective only in the theatre, where, as it were, the illusion and the appreciation of it are a matter of convention.

'In the first place, you have subjected yourself to the rule of the unities. But it is impossible to believe that so many events happened in one place; that they filled the space of only twenty-four hours, and that they proceeded in the same order in your life as they are linked in your work.'

DORVAL. You are right. But if the reality lasted a fortnight, do you think we should have allowed the same length of time for its representation? If the events were interspersed with others, that it was appropriate to reflect this confusion? And if they happened in different parts of the house, that I should have distributed them over the same area?

The rules of the three unities are difficult to keep to; but there is good sense in them.

In society, the passage of events is marked by small incidents which would give the ring of truth to a novel but would remove all interest from a dramatic work: our attention is dispersed amongst numberless different objects of interest; but in the theatre, where only particular moments of real life are represented, we must be totally absorbed in one thing.

I like a play to be simple rather than full of incidents. At the same time I am more concerned with linking these incidents together than multiplying them. I am less inclined to believe in two events that chance has made successive or simultaneous than in a large number, which, because they are close to everyday experience (the invariable rule of verisimilitude), would give me the impression of being drawn together by natural connections.

The art of plot-making consists in making connections between events in such a way that a sensible observer can always see a reason for them which satisfies him. The more unusual those events are, the stronger must be the reason for them. But one must not judge

them in relation to oneself. The person who acts and the person who observes are two very different beings.

I should be very unhappy if I had taken any liberties with those general principles of the unity of time and the unity of action; and I believe one cannot be too strict where the unity of place is concerned. Without this unity, the conduct of the play is almost always awkward and confused. Oh! if only we had theatres where the sets could change every time the scene of the action needs to change! . . .

I. And what great advantage would you find in that?

DORVAL. The spectator would have no difficulty in following the whole development of the play; the action would become more varied, more interesting and clearer. The set can only change when the stage is empty at the end of an act. Thus each time that two incidents demanded a different set, they would take place in two different acts. You would not see a meeting of senators follow a meeting of conspirators, unless the stage were so extensive that you could mark out distinct spaces. But in small theatres like our own, what is a reasonable man to think when he hears courtiers, who are so well aware that walls have ears, plotting against their sovereign in the very same place where he has just consulted them on that most important matter, the abdication of the Empire?[1] Since the people remain, he presumably has to suppose that the place goes away.

In fact this is what I think about these theatrical conventions. Anyone who does not understand the nature of poetry, and therefore has no understanding of the basis for the rules, will neither be able to depart from them nor obey them in the right way. He will either have too much respect for them or too much contempt, two opposing pitfalls, but equally dangerous ones. One of them reduces the observations and experience of past ages to nothing and takes the art back to its infancy; the other brings it to a halt where it stands, and prevents it from going forward.

It was in Rosalie's rooms that I was talking to her, when I destroyed in her heart the false inclination which I had inspired in her and aroused once again her passion for Clairville. I was walking

with Constance in that broad avenue, beneath the old chestnut trees which you can see, when I was finally convinced that she was the only woman in the world for me; for me! who had set out at that moment to explain to her that I was not the right husband for her. At the first sound of my father's arrival, we all went down and rushed to meet him; and the final scene took place in as many different spots as that honest old man stopped, from the front door to the drawing-room . . . If I have confined all the action to one place, it is because I could do so without disturbing the economy of the play and without depriving the events of the appearance of truth.

I. That is admirable. But when you arranged the places, the time and the order of events, you should not have invented some which do not belong to our customs or your character.

DORVAL. I did not think I had done so.

I. Are you going to persuade me then that you had the second scene of the first act with your valet? What? when you said to him: *Fetch my carriage and horses*, and he did not go? He did not obey you? He remonstrated with you and you listened calmly? Stern Dorval, this man who is not even communicative with his friend Clairville, had a familiar conversation with his valet Charles? That is neither true to life nor true.

DORVAL. That must be admitted. I actually told myself more or less what I have put into Charles's mouth. But Charles is a good servant and he is attached to me. If the occasion arose he would do for me everything that André did for my father. He was a witness to it all. I saw so little reason not to bring him into the play for a moment; and it pleased him so much! . . . Because they are our valets, do they cease to be men? . . . If they serve us, there is another whom we serve.

I. But if you were writing for the theatre?[2]

DORVAL. I should leave aside my moral scruples and I should take good care not to give importance on the stage to creatures who are of no account in society. The Davi[3] were the pivots of ancient comedy because they were in fact the initiators of all the domestic

strife. Should it be the customs of two thousand years ago, or our own, that we imitate? The valets in our comedies are always amusing, a certain proof that they are cold. If the poet leaves them in the antechamber where they belong, the action taking place between the main characters will be that much more absorbing and powerful. Molière, who was so good at exploiting them, kept them out of *Tartuffe* and *Le Misanthrope*. These plots involving valets and soubrettes which interrupt the main action are a sure way to destroy the interest. Dramatic action has no points of rest; and mingling two plots means halting the progress first of one and then of the other.

I. If I dared, I should plead for the soubrettes to be spared. I think young people, whose behaviour and speech is always under constraint, have only these women to speak freely with and reveal those intimate concerns which are repressed by custom, decorum, fear and prejudice.

DORVAL. Let them stay on the stage then until our education improves, and mothers and fathers become the confidants of their children . . . What else have you noticed?

I. Constance's declaration . . .

DORVAL. Well?

I. Women rarely make them . . .

DORVAL. True. But suppose a woman has the soul, the nobility and the character of Constance: that she has chosen a man of honour: and you will see that there is nothing to prevent her confessing her feelings. Constance worried me . . . a great deal . . . I felt sorry for her and respected her all the more.

I. That really is amazing! Your interests lay in another direction . . .

DORVAL. What is more, I was no fool.

I. People will find some passages in this declaration quite outspoken . . . The women will do their best to make this character look foolish.

DORVAL. Which women, I should like to know? Fallen women, who betray their shameful feelings every time they say: *I love you.* Constance is not like that; and society would be in a sorry state if there were no women like her.

9

I. But this tone is surely out of place in the theatre . . .

DORVAL. Leave the boards behind; come back into the drawing-room and admit that Constance's speech gave you no offence when you heard it there.

I. No.

DORVAL. Enough then. But I must tell you everything. When I had finished the play I showed it to all the characters so that each of them could add to their parts, or cut bits out, and portray themselves even more faithfully. But something happened which I was hardly expecting, but which is really quite natural. It was that, being more concerned with their present than their past, they softened an expression here and moderated a feeling there; elsewhere they built up to an incident. Rosalie wanted to seem less guilty in the eyes of Clairville; Clairville to show even greater passion for Rosalie; Constance to express a little more tenderness for a man who is now her husband; and the result was that the characters became less lifelike at some points. One of these is Constance's declaration. I see that the others will not escape your perceptive eye.

I found what Dorval said all the more gratifying because he is not in the habit of giving praise. By way of an answer, I picked out a minor point which I should otherwise have passed over.

I. And the tea party in the same scene? I said.

DORVAL. I know what you mean; it is not a custom of this country. I agree, but I have spent a long time travelling in Holland and I have taken this custom from them, and I have portrayed myself.

I. But on the stage!

DORVAL. It is not there but in the drawing-room that you must judge my work . . . But do not pass over any of the places where you think it offends against the practice of the stage . . . I shall be happy to examine whether the fault lies with me or with the practice.

While Dorval was speaking, I was looking for the pencil marks I

had made in the margin of his manuscript, wherever I had found something to object to.

I noticed one such mark near the beginning of the second scene of the second act, and I said: 'When you saw Rosalie, as you had promised your friend you would do, either she was aware that you intended to leave, or she knew nothing of it. If the first was the case, why did she not say anything about it to Justine? Is it natural for her not to have said a word about an event which must have preoccupied her entirely? She wept, but her tears were for herself. Her grief was that of a sensitive soul which is aware of feelings it can do nothing about and which it cannot condone. *She knew nothing of it*, you will tell me. *She seemed surprised; that is what I wrote, and you saw it.* That is true. But how could she not know what everyone in the house knew? . . .'

DORVAL. It was morning; I was anxious to leave a place where I was causing distress, and to carry out a most unexpected and painful duty, and I saw Rosalie at home as soon as it was light. The scene changed, but without losing anything of its credibility. Rosalie was living in seclusion; she could only hope to conceal her secret thoughts from the keen eye of Constance and the passion of Clairville by avoiding them both; she had only just come down from her rooms; she had not yet seen anyone when she came into the drawing-room.

I. But why was Clairville announced when you were talking to Rosalie? No one has ever been announced in his own home; and this has all the appearance of a specially contrived *coup de théâtre*.

DORVAL. That was how it was and how it had to be. If you see it as a *coup de théâtre*, very well; it happened of its own accord.

Clairville knew that I was with the woman he loved; it would not be natural for him to come in in the middle of a conversation which he himself wanted to take place. Yet he could not resist his impatience to know the result. He called me to him. Would you have acted differently?

Dorval stopped here for a moment; then he said: 'I should much

prefer tableaux on the stage, where there are so few, and where they would produce such a pleasing and reliable effect, to these *coups de théâtre* which are brought about in such an artificial way and are based on so many peculiar suppositions that, for one of these combinations of events which is felicitous and natural, there are a thousand which must displease a man of taste.'

I. But what do you see as the difference between a *coup de théâtre* and a tableau?

DORVAL. It would be quicker if I gave you examples rather than definitions. The second act of the play opens with a tableau and ends with a *coup de théâtre*.

I. I see. An unforeseen incident which takes place in the action and abruptly changes the situation of the characters is a *coup de théâtre*. An arrangement of these characters on stage, so natural and so true that, faithfully rendered by a painter, it would please me on a canvas, is a tableau.

DORVAL. More or less.

I. I would almost be prepared to bet that in the fourth scene of the second act every word is true. It shattered me in the drawing-room, and I immensely enjoyed reading it. What a fine tableau, for I think it is one, is made by Clairville leaning on his friend's breast as though this were the only refuge left to him . . .

DORVAL. You may well think of his troubles, but what about mine! How cruel that moment was for me!

I. I know, I know. I remember how you shed tears over him while he was giving vent to his grief and misery. Those are situations which are not easily forgotten.

DORVAL. You must admit that this tableau could not have taken place on the stage; that the two friends would never have dared to look each other in the face, turn their backs to the audience, come together, move apart and come together again; and that everything they did would have been very stilted, very stiff, very mannered and very cold.

I. I think so.

DORVAL. Can people possibly not realize that misfortune has the

effect of bringing men closer together; and that it is ridiculous, especially in moments of turmoil, when passions are carried to extremes, and the action is at its most violent, to stand in a circle, separated, at a certain distance from one another, and in a symmetrical pattern?

Dramatic action must still be very far from perfection, since one sees hardly any scenes on the stage from which one could make a tolerable composition for a painting. How can this be? Is truth less essential here than on the canvas? Could there be a rule that the closer an art form is to reality the further one must move away from it, and put less of real life into a living scene which involves actual human beings than into a painted scene where, so to speak, only their shadows are visible?

My own view is that if a dramatic work were well made and well performed, the stage would offer the spectator as many real tableaux as the action would contain moments suitable for a painting.

I. But what about the proprieties?

DORVAL. That word is all I ever hear. Barnwell's mistress comes into her lover's prison cell in a dishevelled state. The two lovers embrace and fall to the ground. Philoctetes once upon a time rolled on the ground at the entrance to his cave. He uttered inarticulate cries of grief.[4] Those cries did not make for harmonious verse, but they rent the hearts of the spectators. Do we have more subtlety and genius than the Athenians? ... Can there really be anything more passionate than the behaviour of a mother whose daughter is being sacrificed? Let her rush on to the stage like a woman possessed or deranged; let her fill her palace with her cries; let even her clothes reveal her disorder: all these things are appropriate to her despair. If the mother of Iphigeneia showed herself for one moment to be the queen of Argos or the wife of the Greek general, she would only seem to be the lowest of creatures. The true dignity which seizes my attention and overwhelms me is that of mother love in all its truth.

*

As I looked through the manuscript, I came across a little pencil mark which I had missed. It was at the point in the second scene of the second act, where Rosalie says of the person who has won her heart that *she thought to see in him the truth of all the ideals of perfection she had imagined.* This thought struck me as a little advanced for a child: and *the ideals of perfection* somewhat removed from her simple way of speaking. I made this observation to Dorval. By way of an answer he referred me to the manuscript. I examined it carefully and saw that these words had been added afterwards, in Rosalie's own hand; and I went on to talk of other things.

I. Do you not like *coups de théâtre*?

DORVAL. No.

I. But here is one, and it is very well brought about.

DORVAL. I know, and I mentioned it to you.

I. It is the basis of your whole plot.

DORVAL. I agree.

I. And it is a bad thing?

DORVAL. Most definitely.

I. Why did you use it, then?

DORVAL. Because it is not fiction but fact. It would have been much better for the play if things had come about differently.

I. Rosalie declares her love for you. She hears that she is loved in return. She neither hopes nor dares to see you again. She writes to you.

DORVAL. That is quite natural.

I. You answer her.

DORVAL. I had to.

I. Clairville has promised his sister[5] that you would not leave without seeing her. She loves you. She has told you so. You are aware of her feelings.

DORVAL. She has to try to discover mine.

I. Her brother goes to fetch her from a friend's house, where she has gone because of some unfortunate rumours which have been circulating about Rosalie's fortune and her father's return. Your departure was known about and caused surprise, and you were

accused of encouraging his sister's love and being in love with his mistress.[6]

DORVAL. All that is true.

I. But Clairville does not believe it. He defends you vigorously and gets involved in a fight. You are called to his aid just as you are answering Rosalie's letter. You leave your reply on the table.

DORVAL. You would have done the same, I think.

I. You rush to the aid of your friend. Constance arrives. She thinks she is expected, then sees she is abandoned. She finds this incomprehensible. She notices the letter that you were writing to Rosalie, reads it and thinks it is meant for her.

DORVAL. Anyone else would have made the same mistake.

I. No doubt; she has no inkling of your passion for Rosalie, nor of Rosalie's for you; the letter is in answer to a declaration of love and she has made one.

DORVAL. Add to that that Constance has discovered the secret of my birth from her brother, and that the letter is from a man who would think himself false to Clairville if he had designs on the person whom Clairville loves. So Constance believes, must believe, that she is loved; hence all the difficulties you saw me in.

I. How can you find fault with that? There is nothing false about it.

DORVAL. Nor anything which has the ring of truth. Do you not see that it takes centuries to bring so many circumstances together? Let artists preen themselves as much as they like on their talent for contriving such coincidences; I can see inventiveness there, but no real discernment. The simpler a play is in its development, the more beautiful it is. A poet who thought up that *coup de théâtre* and also the situation in the fifth act where, going over to Rosalie, I show her Clairville at the other end of the room, on a sofa, in an attitude of despair, would not be very sensible if he preferred the *coup de théâtre* to the tableau. One is almost like a children's game, the other is a stroke of genius. I speak without partiality. I invented neither of them. The *coup de théâtre* is a fact; the tableau, a happy circumstance created by chance which I was able to take advantage of.

I. But when you knew about Constance's misunderstanding, why

did you not warn Rosalie? It was a simple device, and it would have put everything right.

DORVAL. Oh, this time you are a long way from the theatre, and you are examining my play with a severity which no play known to me could stand up to. You would oblige me greatly if you could quote one which could reach the third act, if everyone did exactly as he ought. But this answer, which would be acceptable for an artist, is not acceptable to me. We are talking here of fact, not fiction. You are not asking an author to justify an incident; you are asking Dorval to give an account of his conduct.

I did not inform Rosalie of Constance's mistake and her own because it suited my plans. Determined as I was to behave honourably, I saw this contretemps which separated me from Rosalie as an event which removed me from danger. I did not want Rosalie to have a false impression of my character; but it was much more important to me not to be false to myself or my friend. It hurt me to deceive him and to deceive Constance, but it had to be.

I. I can see that. Who were you writing to, if it was not Constance?

DORVAL. Moreover, so little time passed between this incident and my father's arrival; and Rosalie was living in such isolation! There was no question of writing to her. It is very doubtful whether she would have accepted my letter, and there is no doubt that a letter which convinced her of my innocence without enlightening her about the wrongness of our feelings for each other would only have made things worse.

I. Yet you hear from Clairville's own lips all kinds of things which distress you. Constance gives him your letter. It is not enough to conceal your real inclination, you have to pretend to one which you do not have. Your marriage with Constance is arranged and you can do nothing to prevent it. This good news is announced to Rosalie and you cannot deny it. She is fading away before your eyes, and her lover, treated with unbelievable severity, falls into a state close to despair.

DORVAL. That is the truth, but what could I do about it all?

I. There is something odd about this state of despair. I was very much moved by it in the drawing-room. Imagine how surprised I was, when I read it, to discover gestures there, but no words.

DORVAL. Here is a story which I would take good care not to tell you if I attached any value to this work, and if I were very proud to have written it. When I reached this point in our story and in the play, and found only a powerful impression within me, but no words, I recalled some scenes from plays I had seen and, using them as a model, I made Clairville very eloquent in his despair. But when he cast a brief eye over his part, he said: *My dear friend, this is worthless. There is not a single word of truth in all this verbiage.* – I know. But look at it and see if you can do any better. – *I can do it easily. One simply needs to put oneself back into the situation and listen to oneself.* And that seems to be what he did. The following day he brought me the scene you have before you, just as it is, word for word. I read it over several times. I saw in it the voice of nature, and tomorrow, if you will, I will tell you a few thoughts it suggested to me about the passions and their expression, and about declamation and mime. This evening I will accompany you to the foot of the hill which marks the half-way point between our houses, and we will make that our meeting-place.

As we walked along, Dorval was observing the natural phenomena which follow the sunset, and he said: 'Do you see how the separate shadows fade as the general darkness increases ... Those broad bands of purple promise a fine day ... Now the whole area of sky opposite the sunset is beginning to turn a violet colour ... In the forest only a few birds can still be heard enlivening the twilight with their lingering notes ... The noise of running water, as it begins to be heard above the general noise, tells us that work is finished in many places, and that it is growing late.'

Meanwhile we reached the foot of the hill. We agreed on the spot where we would meet and went our separate ways.

Second Conversation

The next day, I went to the foot of the hill. It was a lonely, wild place. The view was of a few hamlets spread out over the plain; beyond, a range of irregular, jagged mountains which formed a part of the horizon. We were shaded by some oak trees, and the muted sound could be heard of an underground stream flowing nearby. It was that season when the earth is covered with the fruits it grants to the toil and sweat of men. Dorval had arrived first. I went up to him without him noticing me. He had abandoned himself to the spectacle of nature. His chest swelled out and he was breathing deeply. His eyes were fixed keenly on everything around him. I could see on his face the various impressions of what he saw, and I was beginning to share in his rapture when I cried out, almost involuntarily: 'He is under the spell.'

He heard me and replied in a troubled voice: 'It is true. Here it is that nature can be seen. This is the sacred abode of enthusiasm. If a man has been granted the gift of genius he quits the town and its people. He takes pleasure, as his heart inclines him, in mingling his tears with the crystal waters of a spring, in bearing flowers to a grave, in walking lightly across the tender grass of a meadow, in wandering slowly through fertile fields, in contemplating the work of men, in fleeing to the depths of the forests. He loves their secret horror. He wanders on. He seeks a cavern to inspire him. Who is it that mingles his voice with the torrent falling from the mountain-side? Who feels the sublime nature of a wilderness? Who listens to his heart in the silence of solitude? It is he. Our poet dwells on the banks of a lake. He casts his eyes over the waters and his genius takes flight. There he is gripped by that spirit, now tranquil, now violent, which lifts his soul or calms it as it will ... O nature, all that is good has its place in your breast! You are the fertile source of every truth! ... In this world, only virtue and truth are worthy to fill my thoughts ... Enthusiasm is born of some object in nature. If the mind has perceived it in striking and varied forms, it becomes absorbed, agitated, tormented. The imagination is stirred, passions

are roused. One is successively astonished, moved, indignant, angered. Without enthusiasm, either the true idea of things will not come, or, if it does by chance appear, it cannot be pursued . . . The poet can feel the moment when enthusiasm comes; it follows a period of meditation. He feels it first in a trembling which starts in his breast and spreads, voluptuously and rapidly, to the extremities of his body. Soon it is no longer a trembling but a strong, steady heat which sets him ablaze, makes him gasp, consumes him and lays him low; but which gives spirit and life to everything he touches. If this heat grew any stronger, phantoms would gather together before his eyes. His passion would almost develop into a fury. He would find relief only in pouring forth a torrent of ideas, all pushing, jostling and fighting to come out.'

Dorval was at that moment experiencing the state he was describing. I did not answer him. There followed a silence between us during which I could see that he was calming down. Soon he asked me, like a man emerging from a deep sleep: 'What did I say? What did I have to say to you? I cannot remember.'

I. A few ideas which the scene with Clairville in despair had suggested to you about the passions and their expression, and declamation and mime.

DORVAL. The first is that you should never make your characters say witty things; you should rather put them in situations which inspire wit in them . . .

Dorval realized, from the rapidity with which he had spoken these words, that his brain was still disturbed. He stopped, and to allow time for calm to return, or rather, to counter his confusion with a more violent, but fleeting emotion, he told me what follows.

DORVAL. A peasant woman from the village you see between those two mountains, with the roofs of its houses showing above the trees, sent her husband to see her parents, who lived in a neighbouring village. This unfortunate man was killed there by one of his brothers-in-law. The following day, I went to the house where the incident had taken place. I saw a spectacle and heard words which I

have never forgotten. The dead man was lying on a bed. His naked legs hung over its side. His dishevelled wife was on the floor beside him. She was holding her husband's feet, and she said as she broke down in tears, tears which drew more from everyone present: 'Alas! when I sent you here, I did not think that these feet were taking you to your death.' Do you imagine a woman from another class would have said anything more moving? No. The same situation would have inspired the same words. Her mind would have been absorbed in that moment; and what the artist must look for is what anyone would have said in the same circumstances; what nobody will hear without immediately recognizing it in themselves.

Great concerns, great passions. They are the source of great words, true words. Nearly all men speak well when they are dying.

What I like in the Clairville scene is that it contains strictly nothing but what passion inspires at its most extreme.

Mime, which we have so neglected, is used in this scene, and you have seen yourself how successfully!

We speak too much in our plays, and consequently our actors do not act enough. We have lost an art whose resources were well known to the Ancients. Then the mime would act every condition in society, kings, heroes, tyrants, the rich, the poor, townspeople, country people, selecting from each condition what is peculiar to it, from each action, what is most striking. The philosopher Timocrates, present one day at such a performance, from which his austere character had always kept him away, said: *Quali spectaculo me philosophiae verecundia privavit!* Timocrates had a false sense of shame, and it deprived that philosopher of a great pleasure.[7] The cynic Demetrius attributed its effect entirely to the musical instruments, the voices and the decorations, and a mime who was present replied: 'Watch me act alone: and then say what you like about my art.' The flutes fell silent. The mime performed, and the philosopher, quite carried away, cried: *Not only do I see you, I hear you. You speak to me with your hands.*

What effect could this art not produce if it were accompanied by speech? Why have we separated what nature joined together? Does

not gesture correspond to speech the whole time? I was never so much aware of it as when I was writing this play. I tried to remember what I had said, what the answer had been, and recalling only movements, I wrote in the names of the characters, and underneath, their movements. I said to Rosalie, in Act II, scene ii: *If it ever happened . . . that your heart, despite you . . . were overcome by an inclination . . . which your reason told you was wrong . . . I have known this cruel state! . . . How I would pity you!*

She answered: *Pity me then . . .* And pity her I did, but with a gesture of sympathy; and I do not think a man of feeling would have acted otherwise. But how many other circumstances are there, where we are forced to silence? If someone asked your advice and it involved him in risking his own life if he took it, or his honour if he did not, you would not act cruelly or ignobly. You would indicate your confusion with a gesture; and you would leave the man to make up his own mind.

What I also saw in this scene was that there are points where you must almost leave the actor to his own devices. It is up to him to arrange the scene on the page, to repeat certain words, to return to certain ideas, to remove some and to add others. In the *cantabile* the composer allows the singer to do as his taste and talent dictate: he confines himself to indicating the main intervals in a song. The poet should do the same, once he is familiar with his actor. What is it that affects us in the spectacle of a man fired by some great passion? Is it his words? Sometimes. But what is always moving are cries, inarticulate words, moments when speech breaks down, when a few monosyllables escape at intervals, a strange murmuring from the throat or from between the teeth. When the violence of an emotion stops the breath and brings disorder to the mind, the syllables of words come separately, a man jumps from one idea to another, he begins to say a number of things and does not finish any of them; and, apart from a few feelings which he conveys at the first onset of his passion and to which he constantly returns, the rest is nothing but a succession of weak, confused noises, sounds fading away, stifled tones which the actor understands better than the poet.

Voice, tone, gesture, action, these are the actor's province, and they are what we notice, especially in the spectacle of great passions. It is the actor who gives the words the energy they have. It is he who brings to our ears the power and truth of expression.

I. I have sometimes thought that the words of people who are truly in love should not be read but heard. For, I thought, it is not the phrase *I love you* which ever overcame the resistance of a prude, the devices of a flirt, or the virtue of a sensitive woman: it is the tremor in the voice which uttered it; the tears, the looks which accompanied it. This idea is really the same as your own.

DORVAL. It is the same. The twitterings which lie at the other extreme from these true voices of passion are what we call *tirades*. Nothing receives more applause, nor is in worse taste. In a dramatic performance, the spectator has no more importance than if he did not exist. Is there anything there which is addressed to him? Then the author has deserted his theme and the actor has stepped outside his role. They both come down off the stage. I see them both in the pit and as long as the tirade lasts, the action is halted as far as I am concerned, and the stage remains empty.

There is, in the structure of a dramatic composition, a unity in the speeches which corresponds to the unity of tone in declamation. They are two systems which vary, not just from comedy to tragedy, but from one comedy or tragedy to another. If it were otherwise there would be something wrong, either with the poem or with its performance. The characters would not have that affinity or conformity which must bind them, even when they are contrasted. There would be discordances in the delivery which would offend the ear. And in the play there would be a person who did not seem to be meant for the society into which he had been introduced. It is the actor's task to be aware of this unity of tone. That is his life's work. If he lacks this instinct, his performance will sometimes be weak and sometimes exaggerated, but rarely well judged: good in places but bad overall.

If an actor is obsessed with the desire for applause, he will overact. This defect in his performance will be reflected in that of

another actor. There will be no more unity in his delivery of the role, nor in the performance of the play. Soon I should see nothing else on the stage but a disordered gathering of people, each adopting the tone he fancies; I should be overcome by boredom; my hands would cover my ears and I would take flight.

I should like to talk to you about the expression appropriate to each emotion. But this expression alters in so many ways and it is such a delicate and elusive subject that there is none that I know of which better illustrates the poverty of all the languages which exist or have ever existed. You can have a clear idea of what it is you want to say: it is there in your head. But if you look for a way to express it, you find nothing. You can put together words like low or high, fast or slow, gentle or strong; but the net is too slack and everything escapes. Who could describe the proper way to deliver these two verses:

> *Les a-t-on vus souvent se parler, se chercher?*
> *Dans le fond des forêts allaient-ils se cacher?*[28]

[Have they often been seen talking, looking for each other? Did they go away and hide in the depths of the forests?]

It is a mixture of curiosity, disquiet, grief, love and shame which the worst painting could convey better than the best words.

I. It is another reason for writing mime.

DORVAL. Certainly, intonation and gesture each determine the other.

I. But intonation cannot be written down, whereas gesture is easy to write.

Dorval paused at this point. Then he said: 'Fortunately an actress who has limited judgement and indifferent perception, but a good deal of sensitivity, has no difficulty in understanding an emotional situation and can, without thinking about it, find the best way to convey a number of different feelings merging together to form the

kind of state which all the wisdom of philosophy could never analyse.

'Poets, actors, composers, painters, fine singers, great dancers, passionate lovers, the truly devout, all those who possess enthusiasm and passion, have powerful feelings, and few thoughts.

'They are not guided and enlightened by principles but by something else more immediate, intimate, obscure and certain. I cannot tell you how much I admire a great actor or a great actress. How vain I should be if I had that talent! Once, alone in the world, master of my fate, without preconceived ideas, I wanted to be an actor; and if the success of Quinault-Dufresne can be guaranteed, then I will be one tomorrow. Only mediocrity turns one away from the theatre, and in whatever station in society, only low morals bring dishonour. Beneath Racine and Corneille, I see Baron, Desmares, de Seine; beneath Molière and Regnard, Quinault the Elder and his sister.[9]

'It used to sadden me when I went to the theatre and compared the great value it has with the scant attention paid to recruiting actors. Then I would cry out: "Ah! my friends, if ever we go to Lampedusa[10] and, far from the mainland, amidst the waves of the sea, found a little community of happy people! they will be our preachers; and we shall be sure to choose them according to the importance of their ministry. All peoples have their sabbath days, and we shall have ours. On these solemn days, a great tragedy will be performed, to teach men to fear the passions; and a good comedy, to teach them to know and love their duty."

I. Dorval, I hope we shall not see ugly people in roles which call for beauty.

DORVAL. I think not. Goodness, are there not enough strange fictions which I am forced to accept in a dramatic work without the illusion being even further removed by those which conflict with my senses?

I. To tell you the truth, I have often regretted the disappearance of the masks of the Ancients; and I think I would have been more ready to accept the praises given to a fine mask than to a displeasing face.

DORVAL. And have you been any less offended by the contrast between the moral standard of the play and that of the person acting it?

I. There have been times when the spectator could not help laughing, and the actress blushing.

DORVAL. No, I know of no profession which should demand more refined behaviour and higher moral standards than the theatre.

I. But our stupid prejudices do not allow us to be very particular.

DORVAL. But we have drifted a long way from my play. Where were we?

I. The scene with André.

DORVAL. I ask your indulgence for this scene. I like it because it is totally honest and severe in its impartiality.

I. But it holds up the progress of the play and weakens our involvement.

DORVAL. I shall always enjoy reading it. May our enemies come to know it, admire it, and never read it without pain! How happy I should be, if the opportunity to depict a domestic misfortune were also the occasion to rebuff the insults of a jealous people, in such a way that my country could recognize itself in it, and the enemy nation would not even feel at liberty to take offence.[11]

I. It is a moving scene, but a long one.

DORVAL. It would have been more moving and longer, if I had listened to André. 'Sir,' he said, when he had read it, 'this is all very good, but there is a slight fault in it: it is not exactly as it happened. You say, for instance, that when we arrived in the enemy harbour and they separated me from my master, I called out several times *Master, Master*: that he fixed his eyes on me, let his arms fall to his side, turned round and, without speaking, followed the men surrounding him.

'That is not what happened. You should have said that, when I called *Master, my dear master*, he heard me, turned round and fixed his eyes on me; that his hands went to his pockets and, finding nothing there, for the greedy English had left him nothing, he sadly let his arms fall to his side; that he bowed his head to me in a cool

expression of sympathy, turned round and, without speaking, fol-
lowed the men surrounding him. That is how it was.

'In another place you take it upon yourself to leave out one of the
things which best shows the kindness of your father; that is very
bad. In the prison, when he felt that his bare arms were wet with
my tears, he said: "You are weeping, André! Forgive me, my
friend; it was I who brought you to this: I know. You have been
dragged into this misfortune by me . . ." And now you are weeping!
Was it not a good thing to put in?

'At another point, you have done something even worse. When
he said to me: "My child, take heart, you will escape from here: but
I can feel by my weakness that I shall have to die here", I
abandoned myself to my grief and made the cell echo with my
cries. Then your father said to me: "André, stop this complaining,
respect the will of heaven and the misfortune of those here with
you, who are suffering in silence." And where is all that?

'And what about the agent? You have made such a mess of that
bit that I cannot make head or tail of it. Your father told me, as you
have set it down, that this man had acted on his behalf, and that my
presence with him was certainly the first of his good offices. But
then he added: "Oh! my child, if God had only given me the
consolation of having you beside me at this cruel time, how much
would I have to thank him for!" I see nothing of that in what you
have written. Sir, is it forbidden to speak God's name on the stage,
that holy name which was so often on your father's lips? – I do not
think so, André. – Were you afraid that people might know that
your father was a Christian? – Not at all, André. Christian morality
is such a fine thing. But why do you ask this question? – We do say
amongst ourselves . . . – What? – That you are . . . a sort of . . .
freethinker: and from the bits you have cut out, I would think there
might be something in it. – André, that would oblige me to be all
the better a citizen and all the more decent a man. – Sir, you are a
good man; but don't go thinking you're as good as your father.
You may be one day. – André, is that all? – There is one more
thing I should like to say, but I dare not. – You may speak. – Since

you allow me, you pass rather quickly over the kind offices of the Englishman who came to our assistance. Sir, there are decent people everywhere . . . But you have changed a lot from what you were, if what they still say about you is true. — And what are they still saying? — That you were full of enthusiasm for those people. — André! — That you regarded their country as a haven of liberty, the home of virtue, invention and originality. — André! — Now it annoys you to hear that. Well then, let us say no more about it. You said that the agent, seeing your father naked, took off his own clothes and dressed him in them. That is very good. But you should not have forgotten that one of his servants did the same for me. Not to mention this, Sir, would reflect on me, and give me an appearance of ingratitude which I do not want at all.'

You see that André was not entirely of your opinion. He wanted the scene as it happened: you want it to be in keeping with the work; and I alone am in the wrong for displeasing you both.

I. *Who left him to die in the depths of a prison cell, lying on the clothes his valet had discarded*, is a hard thing to say.

DORVAL. It was an outburst of spite; it escaped from a melancholic who has practised virtue all his life, who has not yet known a moment of happiness, when he hears of the misfortunes of a good man.

I. Add to that that this good man is perhaps his father; and that these misfortunes wreck the hopes of his friend, cast his mistress into poverty, and add a new source of bitterness to his situation. All that will be true. But what of your enemies?

DORVAL. If they ever come to know of my work, the public will be their judge and mine. I will quote a hundred examples from Corneille, Racine, Voltaire and Crébillon, where character and circumstance bring about more extreme situations which have never outraged anybody. They will find no answer; and we shall see what they are anxious not to reveal, that it is not the love of good which motivates them, but hatred for the man who devours them.

I. But what sort of man is this André? I find he speaks too well for a servant; and I confess that there are passages in his story which would not be unworthy of yourself.

DORVAL. I have already told you; there is nothing like misfortune to make a man eloquent. André is a fellow who has had some education but who was, I think, a little dissolute in his youth. He was sent to the Indies, where my father, who was a good judge of men, took him on, put him in charge of his business affairs, and was glad to have done so. I think I see a little mark beside the monologue at the end of the act.

I. That is so.

DORVAL. What does it mean?

I. That it is very fine, but unbearably long.

DORVAL. Well then, let us shorten it. Let us see: what do you want to cut out?

I. I have no idea.

DORVAL. But it is long.

I. You can embarrass me as much as you like, but you will not remove this impression.

DORVAL. Perhaps not.

I. You would be doing me a great favour.

DORVAL. I would simply ask you how you liked it in the drawing-room.

I. Very well; but I would ask you in turn how it is that what seemed short when it was performed seems long when I read it.

DORVAL. It is because I did not write in the mime, and because you do not remember it. We still do not know how much influence mime can have on the composition of a dramatic work, and on its performance.

I. That may well be so.

DORVAL. And then, I wager you are still seeing me on the French stage, in the theatre.

I. Do you think, then, that your work would not succeed in the theatre?

DORVAL. It would be difficult. Either the dialogue would have to

be cut in certain places, or else the action and the set would have to be changed.

I. What do you mean by changing the set?

DORVAL. Taking away everything which clutters up a space which is already too confined; putting in scenery; being able to perform different set pieces from those we have seen for the last hundred years; in a word, transporting Clairville's drawing-room into the theatre, just as it is.

I. Is it important, then, to have a set?

DORVAL. Definitely. Remember that French theatre contains as many kinds of scenery as the opera, and would offer more pleasing ones, because the world of magic can amuse children, and only the real world can appeal to reason ... Without scenery, nothing will ever be imagined. Any man of genius will grow tired of it; indifferent authors will succeed by means of slavish imitation; more and more importance will be attached to trivial proprieties; and national taste will deteriorate ... have you seen the theatre in Lyon?[12] All I would ask for is a similar edifice in the capital, to bring forth a mass of new works, and perhaps give rise to some new genres.

I. I do not understand: I should be grateful if you would explain what you mean.

DORVAL. I shall be happy to.

If only I could convey everything that Dorval said to me, and the way in which he said it! He began on a sober note, then he gradually became more heated; his ideas tumbled out and he moved towards his conclusion so rapidly that I could scarcely follow him. This is what I have remembered.

'I should very much like', he began by saying, 'to persuade those cautious spirits who know of nothing beyond what is already there, that if things were otherwise they would be just as happy with them; and that since the power of reason is nothing to them compared with the power of time, they would approve of what they now find fault with, just as they have often found fault with

what they used to approve of . . . To be a good judge of the fine arts, one needs a combination of several rare qualities . . . Fine taste demands fine judgement, long experience, honesty, sensibility, an elevated mind, a somewhat melancholic temperament, finely tuned reactions . . .' A moment later, he went on:

DORVAL. All I would ask, to change the face of drama, is a very extensive stage which could display, when the subject of the play called for it, a large square with its adjacent buildings, such as the columned front of a palace, the entrance to a temple, various places set out in such a way that the spectator could see all the action, but with an area hidden from the actors.

Such was, or may once have been, the scene of Aeschylus's *Eumenides*. On one side there was a space in which the unleashed Furies sought Orestes, who had hidden from them while they were asleep. On the other side one saw the guilty man, wearing a headband, his arms round the feet of the statue of Minerva, imploring her aid. Here, Orestes is uttering his complaint to the goddess; there, the Furies are in action, running in all directions. At last one of them cries out: 'Here is a trace of blood left by the parricide . . . I smell it, I smell it . . .' She goes forward. Her pitiless sisters follow her: they move from the place where they were into Orestes' refuge. They surround him, uttering cries, trembling with rage, brandishing their torches. What a moment of terror and pity that must be when one hears the pleas and groans of the victim above the cries and dreadful movements of the merciless creatures who seek him out! Shall we ever perform anything to compare with that in our theatres? There, only one action can ever be displayed, whereas in reality there are nearly always several at a time which, performed simultaneously, each reinforcing the other, would produce a terrifying effect. Then we should tremble at the thought of going to the theatre, yet be unable to prevent ourselves. Then, instead of those shallow, passing emotions, that cool applause, those occasional tears which are enough to satisfy the author, he would overwhelm us and fill our minds with confusion and horror. Then we should see revived in our midst those wonders of ancient

tragedy, which it is so possible to create and which are so little believed in. To come into being they await a man of genius who is capable of combining mime with speech, of intermingling spoken scenes with silent ones, of getting the best out of the collision of two scenes and most of all of the build-up to that collision which, whether awful or comic, would always be made. After the Eumenides have rushed about on the stage they arrive in the sanctuary where the guilty man has taken refuge, and then the two scenes become one.

I. Two scenes alternately silent and spoken. That I understand. But would there not be some confusion?

DORVAL. A silent scene is a tableau, a stage-set in motion. When you are at the opera, does the pleasure of what you see interfere with the pleasure of what you hear?

I. No . . . but is that how we should interpret what we are told of these ancient plays, where music, speech and mime were sometimes combined and sometimes separate?

DORVAL. Sometimes. But this discussion would lead us astray: let us keep to our subject. Let us see what would be possible today; and let us take an ordinary example from domestic life.

A father has lost his son in a duel; it is night. A servant who has witnessed the fight comes to announce the death. He comes into the room where the unhappy father is asleep. He paces up and down. The sound of a man's footsteps awakens the father. He asks who it is. – It is me, Sir, the servant replies in a troubled voice. – Well, what is it? – Nothing. – What, nothing? – No, Sir. – This cannot be. You are trembling, you are turning your face away and avoiding my eyes. Now, what is it? I want to know. Speak! I command you. – I tell you, Sir, it is nothing, the servant again replies as his tears begin to fall. – You wretched fellow, the father cries, jumping up from the bed where he has been lying; you are deceiving me. There has been some great disaster . . . Is my wife dead? – No, Sir. – My daughter? – No, Sir. – Then it is my son? . . . The servant says nothing; the father hears his silence; he throws himself on the ground and fills the room with his grief and his cries. He does and

says all that despair might arouse in a father who loses his son, the only hope of his family.

This same man rushes to the mother, who is also asleep. She is awoken by the noise of the curtains being violently drawn aside. What is it? she asks. – Madam, the greatest of misfortunes. Now is the time to show your Christian virtue. You no longer have a son. – Oh God! this mother cries in her distress. And taking up a cross from her bedside, she clasps it in her arms, she presses her lips to it, her eyes dissolve in tears and these tears pour over her God nailed to a cross.

There is the tableau of the pious woman: soon we shall see that of the tender wife and the grieving mother. When religion dominates the natural reactions of a person, it needs a more violent shock to draw out their true voice.

Meanwhile the corpse of his son had been carried into the father's room. There a scene of despair took place, while in the mother's room there was a silent display of piety.

You see how mime and speech alternate between one place and another. That is what should be substituted for our *asides*. But now the moment is drawing near for the two scenes to come together. The mother, led by the servant, is approaching her husband's room ... I would ask you what happens to the spectator during this time? ... A mother's eyes are about to be presented with the sight of a husband, a father, lying across the dead body of his son! Now she has crossed the space between the two scenes. Pitiful cries have reached her ears. Now she sees. She falls back. Her strength abandons her and she falls lifeless into the arms of the man beside her. Very soon she will be overcome with weeping. *Tum verae voces.*

That is tragedy. But for this type of drama we need authors, actors, a theatre, and perhaps a public.

I. What! you would want in a tragedy to have a bed, a mother and a father asleep, a crucifix, a corpse, and two scenes alternately silent and spoken! And what about the proprieties?

DORVAL. Ah! cruel proprieties, how proper and how feeble you

make our plays! ... But (Dorval added with a coolness which surprised me) is what I suggest not possible any more, then?

I. I do not believe we could ever achieve that.

DORVAL. Well then, all is lost! Corneille, Racine, Voltaire and Crébillon have received the greatest applause to which men of genius could aspire; and tragedy has with us reached its highest degree of perfection.

While Dorval was speaking I had a strange thought: how, by turning a domestic incident into a play, he had established the rules for every type of drama, and yet was induced by his melancholy temperament to apply them only to tragedy.

After a moment's silence, he said: 'But there is one resort: we must hope that one day a man of genius will realize how impossible it is to come near to those who have preceded him along a much-travelled path, so that, out of despair, he will take another. That is the only eventuality which can free us from a number of prejudices that philosophy has failed to overcome. We no longer want ideas but a finished work.'

I. We have one.

DORVAL. What?

I. *Sylvie*, a prose tragedy in one act.[13]

DORVAL. I know it: it is *Le Jaloux*, a tragedy. It is the work of a man of thought and feeling.

I. It opens with a charming tableau: the inside of a room whose walls are completely bare. At the far end of the room, on a table, are a lamp, a water jug and a loaf of bread: that is the place and the food to which a jealous husband has condemned, for the rest of her days, an innocent woman whose virtue he has suspected.

Now imagine this woman at the table, in tears: Mademoiselle Gaussin.

DORVAL. And you can judge the effect of tableaux by the one you describe to me. There are other details in this play which I liked. It is enough to awaken the ideas of a genius: but it needs another kind of work to convert the public.

★

At this point Dorval cried out: 'You who possess all the fire of genius at an age when others are barely left with cold reason, why can I not be at your side, your Fury? I should spur you on unceasingly. You would create this work. I should remind you of the tears we shed over the scene of the prodigal son and his manservant,[14] and, when you disappeared from our midst, you would not leave us to bemoan the loss of a new genre of which you could have been the founder.'

I. And what will you call this genre?

DORVAL. Domestic bourgeois tragedy. The English have *The London Merchant* and *The Gamester*, prose tragedies.[15] Shakespeare's tragedies are half verse and half prose. The first poet to make us laugh with prose introduced prose into comedy. The first poet who can make us weep with prose will be the one to introduce prose into tragedy.

But in art, as in nature, everything is connected. If you can draw near to truth from one angle, you will draw near it from many others. Then it is that we shall see on the stage natural situations, which have been banished from our theatre by propriety, that enemy of genius and great effects. I shall never cease crying out to the French: Truth! Nature! the Ancients! Sophocles! Philoctetes![16] The poet showed him on the stage, lying at the entrance to his cave, covered in rags. He is rolling about, beset with grief, crying out and uttering inarticulate sounds. The scene was wild; the play lacked any kind of decoration. Natural clothes, natural speeches, and a simple, natural plot. Our taste would be very degraded if this spectacle did not affect us more than that of a richly dressed man, done up in his finery . . .

I. As if he had just come out of his dressing-room.

DORVAL. Walking with measured tread across the stage and assaulting our ears with what Horace calls

> . . . *ampullas, et sesquipedalia verba,*[17]

'clever sayings, bulging bottles, words a foot and a half long'.

We have spared no effort to corrupt the drama. We have

DORVAL. And have you been any less offended by the contrast between the moral standard of the play and that of the person acting it?

I. There have been times when the spectator could not help laughing, and the actress blushing.

DORVAL. No, I know of no profession which should demand more refined behaviour and higher moral standards than the theatre.

I. But our stupid prejudices do not allow us to be very particular.

DORVAL. But we have drifted a long way from my play. Where were we?

I. The scene with André.

DORVAL. I ask your indulgence for this scene. I like it because it is totally honest and severe in its impartiality.

I. But it holds up the progress of the play and weakens our involvement.

DORVAL. I shall always enjoy reading it. May our enemies come to know it, admire it, and never read it without pain! How happy I should be, if the opportunity to depict a domestic misfortune were also the occasion to rebuff the insults of a jealous people, in such a way that my country could recognize itself in it, and the enemy nation would not even feel at liberty to take offence.[11]

I. It is a moving scene, but a long one.

DORVAL. It would have been more moving and longer, if I had listened to André. 'Sir,' he said, when he had read it, 'this is all very good, but there is a slight fault in it: it is not exactly as it happened. You say, for instance, that when we arrived in the enemy harbour and they separated me from my master, I called out several times *Master, Master*: that he fixed his eyes on me, let his arms fall to his side, turned round and, without speaking, followed the men surrounding him.

'That is not what happened. You should have said that, when I called *Master, my dear master*, he heard me, turned round and fixed his eyes on me; that his hands went to his pockets and, finding nothing there, for the greedy English had left him nothing, he sadly let his arms fall to his side; that he bowed his head to me in a cool

expression of sympathy, turned round and, without speaking, fol-
lowed the men surrounding him. That is how it was.

'In another place you take it upon yourself to leave out one of the
things which best shows the kindness of your father; that is very
bad. In the prison, when he felt that his bare arms were wet with
my tears, he said: "You are weeping, André! Forgive me, my
friend; it was I who brought you to this: I know. You have been
dragged into this misfortune by me . . ." And now you are weeping!
Was it not a good thing to put in?

'At another point, you have done something even worse. When
he said to me: "My child, take heart, you will escape from here: but
I can feel by my weakness that I shall have to die here", I
abandoned myself to my grief and made the cell echo with my
cries. Then your father said to me: "André, stop this complaining,
respect the will of heaven and the misfortune of those here with
you, who are suffering in silence." And where is all that?

'And what about the agent? You have made such a mess of that
bit that I cannot make head or tail of it. Your father told me, as you
have set it down, that this man had acted on his behalf, and that my
presence with him was certainly the first of his good offices. But
then he added: "Oh! my child, if God had only given me the
consolation of having you beside me at this cruel time, how much
would I have to thank him for!" I see nothing of that in what you
have written. Sir, is it forbidden to speak God's name on the stage,
that holy name which was so often on your father's lips? – I do not
think so, André. – Were you afraid that people might know that
your father was a Christian? – Not at all, André. Christian morality
is such a fine thing. But why do you ask this question? – We do say
amongst ourselves . . . – What? – That you are . . . a sort of . . .
freethinker: and from the bits you have cut out, I would think there
might be something in it. – André, that would oblige me to be all
the better a citizen and all the more decent a man. – Sir, you are a
good man; but don't go thinking you're as good as your father.
You may be one day. – André, is that all? – There is one more
thing I should like to say, but I dare not. – You may speak. – Since

retained from the Ancients the emphatic versification which was so suitable for languages with strong measures and heavy stresses, for spacious theatres, for a declamation which was scored and accompanied by instruments; and we have abandoned their simplicity of plot and dialogue, and the truth of their tableaux.

I should not want to have back on the stage the great clogs and high buskins, the voluminous clothes, the masks, the speaking-trumpets, even though all these things were necessary components of a theatrical system. But were there not certain affectations in this system? and do you think it would be advisable to add further obstacles to genius, just when it was deprived of a great resource?

I. What resource?

DORVAL. The presence of a large audience.

Properly speaking, there are no longer any public spectacles. What comparison is there between our theatre audiences on the most popular days and those of Athens or Rome? The theatres of antiquity held as many as eighty thousand citizens. The theatre of Scaurus was decorated with three hundred and sixty columns and three thousand statues. When these theatres were built, they made use of every possible means to do justice to the instruments and the voices. *Uti enim organa in æneis laminis, aut corneis echeis ad chordarum sonitus claritatem perficiuntur: sic theatrorum, per harmonicen, ad augendam vocem, ratiocinationes ab antiquis sunt constitutæ.*[18]

At this point I interrupted Dorval and said to him: 'I shall have a little story to tell you about our theatres.' 'I shall ask you for it,' he replied; and he went on:

DORVAL. You can judge the power of a large gathering of spectators from what you know yourself about the influence that men exert on one another and the way in which emotions are communicated in popular risings. Forty or fifty thousand men do not restrain themselves out of a sense of propriety. And if some republican dignitary were to shed a tear, what effect do you think his grief would have on the other spectators? Is there anything more moving than the grief of a venerable man?

Anyone whose feelings are not intensified by the great number of those who share them has some secret vice; there is something unsociable in his character which I find displeasing.

But if a large gathering of men should add to the excitement of the spectators, what an effect it would have on the authors, and the actors! What a difference there is between an entertainment, given on a certain day, between certain times, in a small, gloomy place, for a few hundred people, and holding the attention of a whole nation on its feast days, occupying its most sumptuous buildings and seeing these buildings surrounded and filled with a multitude without number whom it depends on our talent either to entertain or to fill with tedium!

I. You attach a great deal of importance to purely local circumstances.

DORVAL. I attach the importance they would have for me; and I believe my feeling is right.

I. But to hear you speak, one would think these circumstances are what have sustained and perhaps even introduced poetry and energetic declamation into the theatre.

DORVAL. I do not insist on the truth of this supposition. I ask that it be examined. Is it not quite likely that the need to be heard by large audiences above the dull murmur they create, even when they are paying attention, led actors to raise their voices, to space out the syllables, to sustain their delivery, and to become aware of the value of versification? Horace says of dramatic verse:

Vincentem strepitus, et natum rebus agendis,[19]

'It is an appropriate vehicle for the plot, and can be heard above the noise.' But was it not necessary at the same time and for the same reason for this exaggeration to affect the progress, the gestures and all the other aspects of the action? From that came an art which was called declamation.

However it may be: whether poetry gave birth to theatrical declamation, or whether the need for this declamation introduced and maintained on the stage the poetry and its emphatic delivery, or

whether this system, having developed little by little, was able to last because its various elements complemented each other, there is no doubt that wherever dramatic action is larger than life, these effects all come into being and disappear at the same time. The actor leaves and takes up the exaggeration on the stage.

There is a kind of unity which one looks for without realizing it, and which one sticks to once it is found. This unity decides dress, tone, gesture, posture, everything from the throne placed in the temple to the trestles set up at the crossroads. Look how a quack behaves on the Place Dauphine; he is decked out in all sorts of colours, his fingers are covered with rings, his hat is hung round with big red feathers. He has brought a monkey or a bear with him, he stands as tall as he can, gesticulates in the wildest possible way: and all these things fit in with the place, the speaker and his audience. I have made something of a study of the dramatic art of the Ancients. I hope I shall be able to talk to you about it one day, give you an impartial explanation of its nature, its good and bad points, and show you how those who have attacked it had not examined it closely enough ... Now what was this adventure you were going to tell me, about our theatres?

I. This. I had a rather dissolute friend. He got into some serious trouble in the provinces. He had to avoid the possible consequences by taking refuge in the capital, and he came to stay with me. One day when the theatres were open, and I was looking for something which might amuse my prisoner, I suggested we should go. I forget which of the three it was.[20] It has no importance for my story. My friend agreed. I took him along. We reached the theatre, but at the sight of all the guards, the dark little wicket-gates which serve as entrances, and the hole protected by an iron grille through which the tickets are distributed, the young man thought he was at the gate of a prison and that an order had been obtained to shut him away. Being a brave man, he stopped there and then, put his hand on the hilt of his sword, and, turning indignantly towards me, he cried, in a tone of mingled rage and contempt: *Oh, my friend!* I realized what

he meant and reassured him; and you will readily admit that his error was not misplaced . . .

DORVAL. But what point did we reach in our examination? As you are the one who led me astray, you will no doubt undertake to put me back on the right path.

I. We have reached your scene with Constance in the fourth act . . . I can see only one pencil mark, but it goes from the first line to the last.

DORVAL. What did you not like?

I. First of all the tone; it seems to me beyond the capacity of a woman.

DORVAL. Of an ordinary woman, perhaps. But you will be meeting Constance, and then perhaps the scene will seem beneath her.

I. There are expressions and ideas which are more yours than hers.

DORVAL. That is inevitable. We take our expressions and ideas from the people with whom we talk and live. According to the opinion we have of them (and Constance has a high opinion of me), our character is more or less influenced by them. Mine must have affected hers, just as hers affected Rosalie's.

I. What about the length of it?

DORVAL. Ah! now you are back on the stage. It is a long time since that happened to you. You are seeing Constance and me up on the boards, standing very straight, looking at each other in profile and alternately reciting our questions and answers. But is that how it happened in the drawing-room? Sometimes we would be sitting, sometimes standing; occasionally we would walk up and down. Often we would stop, being in no hurry to see the end of a conversation which concerned us both equally. What did she not say to me? What did I not reply? If only you knew what she was like when her fierce spirit closed itself to reason and allowed sweet illusions and tranquillity to enter! *Dorval, your daughters will be honest and seemly, your sons will be noble and proud. All your children will be delightful* . . . I cannot convey to you how much magic there was in those words, spoken with a smile full of tenderness and dignity.

I. I can understand. I can hear those words from the lips of Mademoiselle Clairon, and I can see her before me.[21]

DORVAL. No, only women possess this secret art. We have only cold, dry reason.

'Is it not better', she said to me, 'to risk ingratitude than to miss the chance of doing good?

'Parents have a love for their children which is timid and unsure of itself and which spoils them. There is another kind of love, attentive and composed, which makes good people of them; that is the true love of a father.

'A distaste for everything which amuses ordinary people is the consequence of a genuine love of virtue.

'There is a tact in moral matters which extends to everything and which the wicked do not possess.

'The happiest man is he who has given happiness to the greatest number of others.

'"I wish I were dead" is a frequently expressed wish which proves, sometimes at least, that there are more precious things than life.

'An honest man is respected even by those who are not, even if he were on another planet.

'The passions destroy more prejudices than philosophy. And how could untruth resist them? Sometimes they even undermine the truth.'

Another thing she said, simple enough, it is true, was so close to my own situation that it frightened me. It was that 'there was no one, however good, who, when subject to a violent passion, did not deep in his heart desire the reputation of virtue and the benefits of vice'.

I remembered those ideas well, but not the way they were linked together, and so they were not included in the scene. Those that are there and what I have told you about them is enough, I think, to show you that Constance is not unaccustomed to thought. That was how she captivated me while her reason scattered like dust every argument which my ill-humour suggested.

I. I see there is something I have underlined in this scene, but I cannot remember why.

DORVAL. Read it out.

I. 'Nothing is more persuasive than the example of virtue, not even the example of vice.'

DORVAL. I know. The maxim did not ring true.

I. Exactly.

DORVAL. I do not practise virtue enough, but no one thinks more highly of it than I do. I see truth and virtue as two great statues raised upon the surface of the earth, motionless amidst the devastation and ruin of all that surrounds them. These tall figures are sometimes hidden in clouds. At such times men move about in darkness. These are the times of ignorance and crime, of fanaticism and conquests. But there comes a moment when the clouds open up; then men bow down as they see the truth and pay homage to virtue. All things pass, but virtue and truth remain.

I define virtue as a love of order in matters of morality. The love of order in general governs us from our earliest childhood; it was there in our hearts, Constance said to me, before any conscious thought; and in saying this she set me in opposition to myself; it is active within us without our being aware of it; it is the source of good behaviour and good judgement; it inclines us towards the good whenever it is not disturbed by the passions; it follows us even when we go astray; at such times it arranges things to give the best possible advantage to evil. If it could ever be stifled, there would be those who felt remorse for virtue, just as others feel remorse for vice. When I see a scoundrel who is capable of a heroic action, I am firmly convinced that good men are more truly good than evil men are really evil; that goodness is a more integral part of us than wickedness and that, in general, there is more goodness left in the heart of a wicked man than there is wickedness in the hearts of the good.

I. I feel moreover that one should not examine the moral standards of a woman as though they were the maxims of a philosopher.

DORVAL. Oh! if Constance could hear you! . . .

I. But are these moral standards not a little too elevated for the dramatic genre?

DORVAL. Horace said that a poet should seek his knowledge in the works of Socrates:

Rem tibi Socraticae poterunt ostendere chartae.[22]

Now, I think that in any kind of work the spirit of the age should be evident. If morals become more refined, if prejudice grows weaker, if there is a more general inclination towards good works, if a love for the public good becomes widespread, if the people show an interest in the work of the minister, then such things must be made evident, even in a comedy.

I. In spite of everything you say, I stick to my point. I think the scene is very fine and very long; I do not respect Constance any the less; I am delighted that there is a woman in the world like her, and that she is your wife . . .

(The pencil marks are beginning to thin out now, but here is another.)

Clairville has placed his fate in your hands; he comes to discover what you have decided. You have made the sacrifice of your love and decided upon that of your fortune. Clairville and Rosalie are once again rich because of your generosity. Conceal this fact from your friend if you like, but why amuse yourself tormenting him, pointing out obstacles which no longer exist? This does introduce a passage in praise of commerce, I know, and it is full of good sense and makes the work more instructive and useful; but it does prolong the scene, and I would leave it out.

> *. . . ambitiosa recidet*
> *Ornamenta . . .*[23]

DORVAL. I can see that you were born with a happy disposition. After a violent effort there comes a feeling of well-being which is impossible to resist, and which you would know if the practice of virtue were difficult for you. You have never felt the need to get your breath back . . . I was delighting in my triumph. I was causing

my friend to feel the most elevated sentiments; I saw him as more and more worthy of what I had just done for him. And this action does not seem natural to you! On the contrary, you should discern in these signs the difference between an imaginary event and a real one.

I. You may be right. But, tell me, would Rosalie not have added this passage in the first scene of the fourth act later on? 'My lover who was once so dear to me! Clairville whom I still hold in esteem, etc.'

DORVAL. You have guessed.

I. I have hardly anything but praise to give you now. I cannot tell you how happy I am with the third scene of the fifth act. I was saying to myself, before I read it: He intends to break Rosalie's ties with him. It is an absurd plan which did not succeed with Constance and will succeed no better with the other. What can he say which will not further increase her esteem and her love? But let us see. I read it, and I was convinced that no woman in Rosalie's place, if she was still possessed of the least vestiges of honour, would not have felt her affection turn from you to her lover; and I realized that there is nothing that cannot be worked upon the human heart with the help of truth, goodness and eloquence.

But how can it be that your play is not invented and yet the smallest incidents are prepared for?

DORVAL. Dramatic art only prepares incidents in order to link them together, and it only links them in plays because they are linked in reality. Art even imitates the subtle way in which nature hides from us the connections between its effects.

I. I should think that mime could sometimes prepare for things in a very natural and subtle way.

DORVAL. For sure, and there is an example in the play. While André was telling us of the misfortunes which had come upon his master, I repeatedly had the feeling that he was talking about my father, and I showed this uneasiness by movements which would have made an attentive observer suspect the same thing.

I. Dorval, I am concealing nothing from you. I noticed from time to time certain expressions which are not used in the theatre.

DORVAL. But which no one would dare to criticize if a well-known author had used them.

I. And those other expressions which are on everybody's lips and in the works of the best writers and which it would be impossible to change without destroying the sense; but you know that the language of drama becomes more refined as morals grow more corrupt, and that vice creates an idiom of its own which gradually takes hold and which must be recognized, because it is dangerous to use the expressions of which it has once taken possession.

DORVAL. What you say is very perceptive. We still need to know what the limits are of this kind of complacency we must have where vice is concerned. If the language of virtue grows poorer as that of vice extends, we shall soon be reduced to being unable to speak without saying something foolish. For my part, I think there are a multitude of occasions when a man would do honour to his own discernment and standards of behaviour by showing contempt for this licentiousness with which we seem to be overrun.

I have already noticed that in polite company, if anyone should think to react too squeamishly, people blush for him. If the French theatre follows this example, will it wait until its dictionary is as limited as that of the opera and the number of decent expressions is equal to the number of musical phrases?

I. That is all I had to say to you about the details of your play. As for its construction, I find one fault; perhaps it is inherent in the subject: you can judge for yourself. The centre of interest changes. From the first act to the end of the third it deals with the misfortunes of virtue; and in the rest of the play, virtue triumphant. You should have sustained this disorder, which would have been easy to do, and prolonged the trials and distresses of virtue.

For example, let everything remain the same from the beginning of the play until the fourth scene of the third act: that is the moment when Rosalie learns that you are to marry Constance, faints from grief, and says to Clairville in her anger: 'Leave me . . . I

43

hate you . . .'; then Clairville should become suspicious and you should become vexed with a troublesome friend who is breaking your heart without realizing it; and there the third act should end.

And now here is how I should organize the fourth act. I should leave the first scene more or less as it is, except that Justine would tell Rosalie that a messenger has come from her father, that he has seen Constance in secret and that she has every reason to believe that he has brought bad news. After this scene I should transfer the second scene from the third act, the one where Clairville throws himself at Rosalie's feet and tries to win her round. Then Constance comes in, bringing André with her, and he is questioned. Rosalie learns of the misfortunes which have befallen her father: you can see roughly how the rest proceeds. By inflaming the passions of Clairville and Rosalie, they would have created perhaps even greater problems for you than you had already had. From time to time you would have been tempted to confess everything. At the end you might even have done so.

DORVAL. I see what you mean; but that is not what happened to us. And what would my father have said? And are you really sure that the play would have gained from it? By bringing me to a dreadful plight, you would have made a very complicated play out of a quite simple incident. I should have become more theatrical . . .

I. And more ordinary, it is true. But the work would have been an undoubted success.

DORVAL. I think it would, and in very shallow taste. There was certainly less complication in my version; but I think there would have been less real truth and beauty if the disorder had been maintained than if things had proceeded in an atmosphere of calm. Remember that at such a time the sacrifices of virtue begin and then follow one after the other. Look at how the elevated speech and powerful scenes take the place of the emotion which arises out of circumstances. And yet, in the midst of this calm the fate of Constance, Clairville, Rosalie and myself remains uncertain. My intentions are known but there is little prospect of their succeeding.

Indeed, they do not succeed with Constance, and there is much less likelihood of my being more fortunate with Rosalie. What event of sufficient importance could have replaced these two scenes in the plan which you have just outlined to me? None.

I. I have one question left to put to you, on the genre of your play. It is not a tragedy, it is not a comedy. What is it then, and what name can be found for it?

DORVAL. Whatever you wish. But tomorrow, if you like, we can work together to find a suitable one.

I. And why not today?

DORVAL. I must leave you. I promised to see two local farmers and they may already have been at home for an hour waiting for me.

I. Another lawsuit to settle?

DORVAL. No, it is a rather different matter. One of these farmers has a daughter, the other has a son: these children are in love, but the girl is rich and the boy has nothing . . .

I. And you want to reconcile the parents and make the children happy. Goodbye, Dorval. Until tomorrow, at the same place.

Third Conversation

The next day the sky became overcast; a cloud bringing a storm and bearing thunder hung over the hill and covered it in darkness. From the distant point where I stood, the lightning seemed to flash and die away within this darkness. The tops of the oak trees were swaying backwards and forwards, the noise of the wind mingled with the murmuring of the waters, the thunder rumbled through the trees, and in my imagination, preoccupied with obscure associations, I saw, in the midst of this shadowy scene, Dorval, just as I had seen him the day before, carried away by his enthusiasm; and I seemed to hear his melodious voice above the winds and the thunder.

Meanwhile the storm died away, the air grew more pure and the sky more serene. I should have gone to find Dorval under the oak trees, but I thought the ground would be too soft and the grass too

wet. Though the rain had not lasted long it had been heavy. I went to his house. He was waiting for me, for he too had not thought that I should go to yesterday's meeting place. So it was in his garden, on the sandy banks of a broad canal, that he finished explaining his ideas to me. After a few generalities about the activities of life, and the way they are imitated in the theatre, he said:

DORVAL. In every moral object we distinguish a middle and two extremities. It would seem then, since all dramatic action is a moral object, that there should be an intermediate genre and two extreme genres. The latter we have; but man is not always in a state of grief or joy. There is therefore an intermediate point within the gap which separates the comic genre from the tragic.

Terence wrote a play on the following subject. A young man gets married. Hardly has he done so than he is called away on some business. He spends some time away. On his return he believes he sees definite proof of his wife's infidelity. In his despair he wants to send her back to her parents. Imagine the state of the father, the mother and the daughter. But there is a Davus, in himself an amusing character. What does the poet do with him? He keeps him off the stage for the first four acts and only brings him in to enliven the conclusion.[24]

I would ask what genre this play belongs to. The comic genre? There is nothing to laugh about. The tragic genre? Fear, pity and the other great passions are not aroused. Yet there is a centre of interest; and there will be one, without there being anything funny to laugh at or anything dangerous to tremble at, in any dramatic composition where the subject is important, where the poet adopts the tone we use for serious matters and where the action advances in the midst of confusion and difficulties. Now it seems that since these activities are the most common ones in our lives, the genre which deals with them must be the most valuable and the most practised. I shall call this genre the *serious genre*.

Once this genre is established there will be no station in society,

no important activity in life which cannot be related to some part of the dramatic system.

Should you wish to give this system its fullest possible range and include within it truth and fantasy, the imaginary world and the real world, then add the burlesque below the comic genre and the fantastic above the tragic.

I. I understand: The burlesque . . . the comic genre . . . the serious genre . . . the tragic genre . . . the fantastic.

DORVAL. A play never fits exactly into one category. There is no work in the tragic or comic genres without parts which would not be out of place in the serious genre; and there will equally well be some aspects of this genre which bear the stamp of the comic or the tragic.

The advantage of the serious genre is that, set as it is between the other two, there are possibilities for it whether it moves upward or downward. It is not the same for the comic or tragic genres. All the gradations of the comic are contained between this genre and the serious genre; and all those of the tragic between the serious genre and tragedy. The burlesque and the fantastic both go beyond nature and nothing can be taken from them which would not spoil the effect. Painters and poets are free to risk anything, but this freedom does not extend to mingling different types in the same character. To a man of taste it is as absurd to see Castor raised to the rank of a god as to see the *bourgeois gentilhomme* turned into a mamamouchi.[25]

The comic and tragic genres represent the true limits of dramatic composition. But, if it is impossible for the comic genre to call on the burlesque without debasing itself, and for the tragic genre to encroach upon the fantastic without losing the ring of truth, it follows that, being placed at the extremes, these genres are the most effective and the most difficult.

The serious genre is the one which a man of letters should try first if he feels he has a talent for drama. A young pupil who is destined to be a painter is first taught to draw the nude. Once he has become familiar with this basic aspect of the art he can choose a subject. He can take it from the ordinary ranks of society or from a

more elevated one, he can clothe the figures as he wishes, but one must always be aware of the nude beneath the drapery. If someone has made a lengthy study of man through practising the serious genre, let him put on the buskin or the clog, according to his talent, let him throw a royal cloak or a lawyer's gown over his character's shoulders, but the man must never disappear beneath the costume.

If the serious genre is the easiest of all, it is, on the other hand, the least subject to the contingencies of time and place. Take the nude to whatever place on earth you like: it will arouse interest if it is well drawn. If you excel in the serious genre, you will give pleasure at all times and amongst all peoples. Any small differences which it borrows from a neighbouring genre will be too insignificant to disguise it; they will be small pieces of drapery which cover only a few areas and leave the main expanses naked.

You can see that tragi-comedy cannot be a good genre, because it brings together two genres which are far apart and separated by a natural barrier. It does not progress by imperceptible gradations; instead you come up against contrasts at every step, and the unity is lost.

You can see that this type of drama, in which the most amusing aspects of the comic genre are juxtaposed with the most moving aspects of the serious genre, and in which you jump constantly from one genre to another, is certain to be found wanting in the eyes of a severe critic.

But if you really want to be convinced about the dangers of crossing the barrier which nature has set between the genres, then carry things to extremes. Bring together two very distant genres such as tragedy and burlesque. You will see, one after the other, a staid senator at the feet of a courtesan, playing the part of the lowest kind of debauchee, and a group of conspirators planning the downfall of the republic.[26]

Farce, parade[27] and parody are not genres but types of comedy or burlesque with a particular intention.

The poetics of the comic and tragic genres have been written a

hundred times. The serious genre has its own poetics, which would also be very extensive, but I will simply tell you the things that came into my mind as I worked at my play.

Since this genre lacks the lively colour of the extreme genres on either side of it, nothing must be neglected which can give body to it.

The subject must be an important one and the plot must be simple, domestic and close to real life.

I do not want any valets: decent people do not admit them to a knowledge of their affairs, and if all the scenes are between their masters, that will only make them more interesting. If a valet speaks on the stage as he does in company he will appear slovenly: if he talks in any other way, he will seem false.

If features borrowed from the comic genre are too evident, the play will arouse laughter and tears, and both unity of interest and unity of tone will be lost.

The serious genre permits monologues, from which I conclude that it leans more towards tragedy than comedy, a genre in which they are infrequent and short.

It would be dangerous to borrow features from the comic and tragic genres in the same work. Be well aware of the direction your subject and your characters are taking and follow it.

The moral element should be one of general interest and strongly emphasized.

No episodic characters, or, if the plot demands one, he must have unusual qualities which make him stand out.

Much attention must be paid to mime. Abandon the *coups de théâtre* with their momentary effects, and create tableaux. The more you see of a fine tableau, the more pleasure it gives.

Movement almost always detracts from dignity; therefore your main character should rarely be the activator of the plot in your play.

And above all bear in mind that there is no general principle: I know of none, among those which I have just mentioned, which cannot be successfully offended against by a man of genius.

I. You have anticipated my objection.

DORVAL. The comic genre concerns types and the tragic genre concerns individuals. Let me explain. The hero of a tragedy is such and such a man: he is either Regulus, or Brutus, or Cato, and no other. The main character in a comedy, on the other hand, must represent a large number of men. If one were to give him so distinctive an appearance that there was only one person in society who resembled him, comedy would revert to its infancy and degenerate into satire.

Terence seems to me to have made this mistake once. His *Heautontimorumenos* is a father who is distressed at the terrible straits to which he has brought his son by his own undue severity, and punishes himself by putting on ragged clothing, eating poor food, avoiding human society, dismissing his servants and condemning himself to cultivating the soil with his own hands. This father cannot be called natural. A large city would hardly provide one example in a hundred years of such a strange affliction.

I. Horace, who had an uncommonly fastidious taste, seems to have noticed this defect and criticized it with a very light touch.

DORVAL. I do not remember this passage.

I. It is in the first or second satire of the first book, where he sets out to show that, in order to avoid one excess, a fool will often fall into the opposite. Fufidius, he says, is afraid of being taken for a spendthrift. Do you know what he does? He lends money at five per cent a month and takes payment in advance. The deeper a man is in debt, the more demanding he is: he knows by heart the names of all the sons of good families who are beginning to go out in society and who have strict fathers. But if you were to think that this man spends in proportion to his income you would be quite wrong. He is his own worst enemy, and the father in the comedy who punishes himself because his son has run away is not torturing himself any worse:

. . . *non se pejus cruciaverit* . . .[28]

DORVAL. Yes, nothing is more typical of this author than to have given two meanings to this word *worse*, one of which applies to Terence and the other to Fufidius.

In the serious genre, people's characters will often be as general as in comedy, but they will always be less individual than in tragedy.

People sometimes say: *Something very amusing happened at court*, or *There was a great tragedy in town*. It follows that both comedy and tragedy belong to all levels of society, but with the difference that grief and tears are more often to be found in the homes of the people than pleasure and gaiety in the palaces of kings. It is not so much the subject-matter which makes a play comic, serious or tragic, as the tone, the passions, the characters and the interest. The effects of love, jealousy, gambling, dissoluteness, ambition, hatred or envy can arouse laughter, reflection or fear. A jealous man who goes out of his way to make certain of his dishonour is an object of ridicule; a man of honour who has suspicions of someone he loves is plunged into grief; a man of violent passions who is certain of his dishonour may be led into crime. A gambler will take his mistress's portrait to a usurer; another gambler will endanger or destroy his fortune, plunge his wife and children into poverty and himself fall into despair. What more can I say? The play we have been talking about has almost been written in all three genres.

I. Really?

DORVAL. Yes.

I. That seems very strange.

DORVAL. Clairville is a good man, but he is impetuous and thought-less. When all his wishes were fulfilled and he was sure of Rosalie's love he forgot about the troubles he had been through; he saw our story as nothing more than a commonplace incident. He made jokes about it and even went so far as to write a parody of the third act of the play. It was an excellent piece of work. He threw a thoroughly comic light on all my problems. I laughed about it, but secretly I was offended at the way Clairville had held up to ridicule what was one of the most important events in our lives, for after all there was one moment which could have cost him his fortune and the woman he loved, Rosalie her innocence and integrity, Constance her peace of mind, and myself my honour and perhaps my life. I took my revenge on Clairville by making a tragedy of the last three

acts of the play, and I can assure you that I made him weep longer
than he made me laugh.

I. And might one see these pieces?

DORVAL. No. This is not a refusal. But Clairville burnt his act, and
I only have the outline of mine.

I. And what about this outline?

DORVAL. You will have it, if you ask me for it. But think carefully.
You are a man of sensibility. You are fond of me, and this outline
may leave you with an impression which will be hard to forget.

I. Give me the outline of the tragedy, Dorval, give it to me.

Dorval took a few loose pages out of his pocket and gave them to
me with his head turned away, as if he was frightened to look at
them. This is what they contained:

Rosalie, having learnt in the third act of the marriage between
Dorval and Constance, and convinced that Dorval is a treacherous
friend, a man without honour, makes an extreme decision: to reveal
all. She sees Dorval and treats him with the utmost contempt.

ROSALIE. I am not a treacherous friend, not a man without honour.
I am Dorval. I am an unhappy man.

ROSALIE. A wretched man rather . . . Did he not lead me to believe
he loved me?

DORVAL. I did love you, and I love you still.

ROSALIE. He loved me! he loves me! And he is marrying Constance.
He gave his word to her brother and this union is being consum-
mated today! . . . Come now, you are depraved: be gone from here
and make way for innocence to dwell in this place from which you
have banished it. Peace and virtue will return here when you have
gone. Go! Shame and remorse, which never fail to seek out the
wicked, await you at that door.

DORVAL. I am crushed! I am dismissed! I am a villain! Virtue! this,
then, is your final reward!

ROSALIE. No doubt he was confident that I would say nothing . . .
No, no . . . everything will be known . . . Constance will take pity
on my inexperience, my youth . . . she will find in her heart the
means to excuse and forgive me . . . O Clairville! how much I must

love you, to expiate my unjust behaviour and repair the ills I have done you! . . . But the time is near for this evil man to be known.
DORVAL. Incautious young woman, stop, or you will be guilty of the only crime I shall ever have committed, if it is a crime to cast far away a burden one can no longer bear. One more word, and I shall think that virtue is nothing but an empty vision, life nothing but an unhappy gift of fate, happiness nowhere to be found, and peace, only in the grave; and my life will end.

Rosalie has gone: she no longer hears what he is saying. Dorval is despised by the only woman he loves or has ever loved; exposed to the hatred of Constance and the indignation of Clairville; about to lose the only two people who kept him in this world and to descend into the solitude of the universe . . . where will he go? . . . to whom will he go for help? . . . whom will he love? . . . who will love him? . . . Despair enters his soul: he is weary of life and desires death. That is the subject of a monologue which closes the third act. From the end of this act onwards he no longer speaks to his servants; he gives them orders with a wave of his hand, and they obey.

Rosalie carries out her plan at the beginning of the fourth act. Imagine the surprise of Constance and her brother! They dare not see Dorval, nor Dorval either of them. They all avoid each other. They all flee from each other's presence, and Dorval suddenly and quite naturally finds himself in that state of general abandonment which he feared. His destiny is fulfilling itself. Realizing it, he is now resolved to face the death which is drawing him on. Charles, his valet, is the only being in the world who remains to him. Charles discovers his master's fatal plan. He fills the whole house with his fears. He seeks out Clairville, Constance and Rosalie and tells them everything. They are dismayed, and immediately all their selfish concerns disappear. They try to approach Dorval, but it is too late. Dorval no longer loves or hates anyone, no longer speaks or sees or hears. His mind, as if it were stupefied, is incapable of feeling. He fights briefly against this state of darkness, but in short bursts, with neither strength nor effect. That is how he is at the beginning of the fifth act.

This act opens with Dorval alone, walking about on the stage, saying nothing. His intention to end his life is visible in his dress, his

movements and his silence. Clairville enters and pleads with him to live; he casts himself at his knees, embraces them and urges him with the most honest and tender arguments to accept Rosalie. It only serves to make him more cruel. This scene hastens Dorval's fate. Clairville extracts only a few monosyllables from him. During the remaining action Dorval is silent.

Constance arrives and joins her efforts to those of her brother. She says the most moving things she can think of about resignation to events, about the power of the supreme Being, a power which it is criminal to evade, about Clairville's offers, etc. ... As Constance speaks, she is holding one of Dorval's arms in her own, and his friend is holding him round the waist, as though he were frightened he might escape him. But Dorval, wrapped up in himself, is unaware of his friend holding him and hears nothing of what Constance is saying to him. All he does is occasionally to throw himself on them to weep. But his tears refuse to flow. Then he withdraws, sighing profoundly, making a few slow, terrible gestures. Across his lips there flickers a brief smile, more terrifying even than his sighs and gestures.

Now Rosalie comes. Constance and Clairville withdraw. This scene is one of shyness, naivety, tears, grief and repentance. Rosalie sees all the harm she has done. She is overwhelmed by it. Weighed down by the love she feels, the concern she has for Dorval, the respect she owes to Constance and the feelings she cannot deny Clairville, what touching things she says! At first Dorval appears neither to see nor to hear her. Rosalie cries out, takes his hands and makes him stand still: and a moment comes when Dorval's distraught eyes rest on her. His gaze is like that of a man emerging from a drugged sleep. This effort is too much for him. He slumps into a chair as though he had been knocked down. Rosalie leaves him, sobbing aloud, moaning, tearing her hair.

Dorval remains for a moment in this death-like state. Charles stands before him, saying nothing ... His eyes are half closed, his long hair hangs over the back of the chair; his mouth is half open, his breath comes quickly and his chest is heaving. This troubled state slowly passes and he emerges from it with a long, painful sigh, and a plaintive moan. He rests his head in his hands and his elbows on his knees. He gets up with difficulty and walks slowly up and down. He

comes across Charles, takes his arm, looks at him for a moment, takes out his purse and his watch and gives them to him together with a sealed, unaddressed paper and signs to him to leave. Charles throws himself at his feet, pressing his face to the ground. Dorval leaves him there and carries on walking about. As he does so his feet touch Charles lying on the floor, he turns away . . . Then Charles gets up suddenly, leaving the purse and the watch on the floor, and runs to get help.

Dorval follows him slowly . . . he leans aimlessly against the door . . . he notices a bolt . . . looks at it . . . closes it . . . draws his sword . . . leans the hilt on the floor . . . points the tip at his breast . . . leans his body sideways . . . lifts up his eyes . . . looks down again . . . stays still for a moment . . . utters a deep sigh and falls forward.

Charles arrives and finds the door bolted. He calls for help and people come and force the door open. They find Dorval bathed in his own blood, dead. Charles goes back, uttering cries of grief. The other servants stay round the body. Constance appears. Overcome by this spectacle, she cries out, rushing wildly about the stage without knowing what she is saying or doing, or where she is going. They take Dorval's body away. Meanwhile Constance, looking at the place where this bloody event occurred, sits motionless in a chair, her face covered with her hands.

Now Clairville and Rosalie come in. They find Constance in this state. They question her. She does not answer. She says nothing. They question her again. Her only answer is to uncover her face, turn her head away and point her hand towards the spot which is stained with Dorval's blood.

Now all that can be heard are cries, weeping, silence, and more cries.

Charles gives Constance the sealed packet: it contains the history of Dorval's life and his last wishes. But hardly has she read out the first few lines than Clairville storms out; Constance follows him. Justine and the servants carry away Rosalie, who feels unwell, and the play ends.

'Ah!' I cried, 'either I know nothing about it or that is tragedy. In truth, it is not virtue put to the test, but virtue brought to despair. Perhaps it would be dangerous to show a good man reduced to

these terrible straits, but one can none the less feel the power of the mime alone, and the mime combined with speech. They are the beauties which we are losing because we lack the stage, and the courage, because we slavishly imitate our predecessors, and, abandoning nature and truth ... But Dorval does not speak ... But then can there be any words more striking than his action and his silence? ... It may be that one could give him a few words to say at intervals, but one must not forget that those who talk a lot rarely kill themselves.'

I got up and went to find Dorval. He was wandering among the trees and seemed to be absorbed in his own thoughts. I thought it would be all right to keep his notes and he did not ask for them back.

'If you are convinced', he said, 'that this is tragedy, and that there is between tragedy and comedy an intermediate genre, then there are two branches of this genre which are still uncultivated and which are only waiting for the right men. Write comedies in the serious genre, write domestic tragedies, and have no doubt that applause and immortality await you. Be sure to avoid *coups de théâtre*; concentrate on tableaux: get close to real life and first of all have an area big enough to allow complete freedom for mime ... They say that there are no great tragic passions left to move us, and that it is impossible to portray elevated feelings in a new and striking way. That may be so of the kind of tragedy which has been written by the Greeks, the Romans, the French, the Italians, the English and every people on earth. But domestic tragedy will have a different kind of action, a different tone, and a sublimity all its own. I can feel that sublimity; it is in the words of a father who said to the son who supported him in his old age: "My son, our debts are settled. I gave life to you, and you have restored it to me." And in these of another father who said to his son: "Always speak the truth. Never make a promise which you do not intend to keep. I entreat you by these feet which I warmed in my hands, when you were in your cradle."'

I. But will this kind of tragedy engage our interest?

DORVAL. I ask the same question of you. It is closer to ourselves. It represents the misfortunes which are all around us. What! can you not imagine the effect upon you of a real background, authentic dress, speeches adapted to actions, simple actions, dangers which you cannot fail to have feared for your relations, your friends, yourself? A sudden change in fortune, the fear of public disgrace, the consequences of poverty, a passion which leads a man to ruin, from ruin to despair, from despair to violent death, these are not infrequent events; and do you think they would not move you as much as the fictitious death of a tyrant, or the sacrifice of a child on the altars of the gods of Athens or Rome? . . . But your mind is wandering . . . you are dreaming . . . you are not listening to me.

I. I cannot stop thinking about your sketch for a tragedy . . . I see you walking about on the stage . . . turning your feet away from your prostrate valet . . . closing the bolt on the door . . . drawing your sword . . . The thought of this mime makes me shudder. I do not believe one could bear such a spectacle. Perhaps all this kind of action should be narrated.

DORVAL. I do not think an unlikely event should be either narrated or shown to the audience, and in the case of events which are likely to have happened, it is easy to decide which should be portrayed and which should be banished from the stage. I will have to use tragedies which are already familiar to illustrate my ideas; I cannot take examples from a genre which does not yet exist amongst us.

When an action is simple, I think it is better to portray it than to narrate it. The spectacle of Mahomet with his dagger raised over the breast of Irene,[29] hovering between his ambition which urges him to plunge it in and the passion which stays his arm, is a striking tableau. My soul will be troubled by the compassion which always puts us in the place of the victim, and never of the villain. It will not be over Irene's breast but my own that I shall see the dagger poised in uncertainty . . . This action is too simple to be badly

represented ... But if the action grows more complex, if the incidents grow more numerous, there may easily be some which will remind me that I am in an auditorium, that all these characters are actors, and that this is not a real event which is taking place. The narrative, on the other hand, will transport me beyond the stage; I shall follow its every detail. My imagination will bring them to life just I have seen them in nature. There will be nothing that does not ring true. The poet says, for example:

> *Entre les deux partis, Calchas s'est avancé,*
> *L'oeil farouche, l'air sombre, et le poil hérissé,*
> *Terrible, et plein du dieu qui l'agitait sans doute . . .*[30]

[Between the two sides Calchas came forward, fearsome
of eye, sombre of mien, the hair bristling on his skin,
terrible, and full of the god who undoubtedly moved
him . . .]

or

> *. . . les ronces dégouttantes*
> *Portent de ses cheveux les dépouilles sanglantes.*[31]

[. . . the dripping briars bear the bloody remains of his
hair.]

Where is the actor who can portray Calchas as he is in these lines? Grandval[32] will step forward, noble and proud, between the two sides; he will have the sombre mien, and perhaps the fearsome look in his eye. I shall discern in his acting, his gestures, the presence within him of a demon tormenting him. But, however awesome he is, the hair on his head will not stand on end. Dramatic imitation does not go that far.

The same can be said of most of the other images which enliven this account; the air darkened by the flight of arrows, an army in a state of tumult, a young princess with a dagger plunged into her breast, the winds unleashed, the thunder resounding

in the upper air, the sky lit with flashes of lightning, the foaming and roaring of the sea. The poet has painted all these things; we can see them in our imagination; they cannot be imitated by art.

But there is something else: an overriding desire for order, of which I have already spoken, constrains us to put things in proportion. If we are presented with some circumstance which goes beyond ordinary nature, it magnifies everything else in our minds. The poet said nothing of Calchas's stature. But I can see him, and I make his stature fit his actions. This mental exaggeration moves out from here to embrace everything near him. The real spectacle would have been a small, feeble, mean thing, either a travesty or a failure; it becomes great, powerful and true, colossal even, in the telling. In the theatre it would have fallen well below nature; I imagine it as being somewhat above. In this way, in epic poetry, the figures of poetry grow a little greater than the figures of reality.

They are the principles; now apply them yourself to the action of my outline of a tragedy. Is the action not simple?

I. It is.

DORVAL. Is there any circumstance which could not be imitated on the stage?

I. None.

DORVAL. Will its effects be awesome?

I. Only too much so, perhaps. Who can tell whether we should go to the theatre to seek such powerful impressions? We want to be moved, touched, frightened; but only up to a point.

DORVAL. If we are to make a sensible judgement, we must be clear what we mean. What is the purpose of a dramatic composition?

I. It is, I believe, to inspire in men a love of virtue and a horror of vice . . .

DORVAL. So to say that they must only be moved up to a certain point amounts to claiming that they must not come away from a play too much taken with virtue or too much averse to vice. There

would be no poetic theory possible for so craven a people. What kind of taste would there be and what kind of art would come about if one were to resist its energy and set arbitrary limits upon its effects?

I. I have a few more questions to ask you about the nature of domestic bourgeois tragedy, as you call it; but I can already guess what you are going to reply. If I were to ask you why, in the example you have given of it, there are no alternate silent and spoken scenes, you would no doubt reply that not every subject admits of this kind of beauty.

DORVAL. That is true.

I. But what will the subject-matter be of this serious comedy, which you regard as a new category in drama? In human nature there are, at the most, only a dozen or so truly comic, boldly delineated characters.

DORVAL. I think so.

I. The minor differences which can be discerned in men's characters cannot be handled as successfully as the distinctive characters.

DORVAL. I think so. But do you know what follows from that? . . . That, properly speaking, it is not characters which should be placed on the stage, but conditions. Until now, character has been the main object and condition has been an accessory; now condition must be the main purpose and character an accessory. The whole plot used to arise out of character. The usual practice was to concentrate on the circumstances which emphasized it and to link these circumstances together. A man's condition, with its duties, its advantages, its difficulties, must provide the basis of a dramatic work. I believe this source is more productive, more extensive and more valuable than that of character. If there was the least bit of exaggeration in a character, a spectator could say to himself: that is not me. But he cannot avoid noticing that the station in life being portrayed before him is his own; he cannot be unaware of his own duties. He must necessarily apply what he hears to himself.

I. I believe several of these subjects have already been treated.

DORVAL. That is not the case. Make no mistake about it.

I. Do we not have financiers in our plays?

DORVAL. Certainly there are some. But we have yet to see the true financier.

I. One would be hard put to find a play without the father of a family in it.

DORVAL. Agreed, but we have yet to see the true father. In short, I am asking whether the duties of the various conditions, their advantages and their disadvantages, their dangers, have been put on the stage. Whether they form the basis of the plot and the moral import of our plays. And whether these duties, advantages, disadvantages and dangers do not daily reveal to us the spectacle of men in very difficult situations.

I. So you would want to see the characters of the man of letters, the philosopher, the trader, the judge, the lawyer, the politician, the citizen, the magistrate, the financier, the great noble, the intendant.

DORVAL. Add to that all the family relationships: father, husband, sister, brothers. The head of a family! What a subject, in an age such as ours where it seems no one has the least idea what it means to be a father!

Remember that new functions in life are created every day. Remember that there is perhaps nothing which we know less about, and nothing which should concern us more than these functions. We each of us have our station in society, but we have dealings with men of all stations.

The conditions! What a source they are of interesting facts, public and private activities, unfamiliar truths and novel situations! And are there not the same contrasts between people's conditions as there are between characters? and might the poet not make these comparisons?

But these subjects belong only to the serious genre. It is up to the genius of the man who takes them up to make them either comic or tragic.

The laughable and the vicious qualities of people undergo such changes that I think one could write a new *Misanthrope* every fifty years. And is it not the same for many other characters?

I. I rather like these ideas. I declare I am quite prepared to hear the first comedy in the serious genre, or the first bourgeois tragedy which is put on. I am happy for the scope of our pleasures to be broadened. I applaud the possibilities you are offering, but let us keep what we have. I confess I have a great affection for the fantastic genre. I hate to see it taken together with the burlesque genre and dismissed from the worlds of nature and drama. Quinault set beside Scarron and Dassouci: oh Dorval, Quinault of all people![33]

DORVAL. No one reads Quinault with more pleasure than I do. He is a writer full of elegance, with a moving, flowing and often elevated style. I hope one day to show you the extent of my knowledge and esteem for the talents of this unique man, and what good use might have been made of his tragedies, just as they stand. But what I disapprove of is the genre in which he writes. You are, as I see it, abandoning the world of the burlesque. And do you know the world of fantasy any better? What can you compare with the things it portrays, if no model exists in nature for them?

There is no aesthetic for the burlesque and the fantastic, and there cannot be one. If, on the operatic stage, one tries out some novel idea, it is just an absurdity which can only be sustained by a more or a less distant comparison with another absurdity of the past. The reputation and the talents of the author have some influence too. Molière lights candles all round the *bourgeois gentilhomme*'s head; it is a ridiculous extravagance, as everybody agrees, but they laugh. Another imagines men getting smaller the more stupid things they do; there is a sensible allegory in this invention, but he gets hissed. Angélique makes herself invisible to her lover by means of a ring which leaves her visible to everyone in the audience;[34] and this absurd device shocks no one. Put a dagger in the hand of a villain so that he strikes at his enemies and only injures himself: this is a common enough result of wickedness, but nothing is less certain than whether this miraculous dagger will be a success.

All I can see in these dramatic inventions are stories like those we tell to children to send them to sleep. Can people believe that, by

being embroidered upon, they will become convincing enough to interest sensible men? The heroine of Bluebeard is at the top of a tower; at its foot she hears the terrible voice of her captor; she will perish if her deliverer does not appear. Her sister is by her side; she is looking into the distance for this deliverer to come. Can anyone think that this situation is not just as beautiful as any in the operatic theatre, and that the question, *My sister, do you not see anyone coming?* is without the power to move? Why then does it not touch the emotions of a man of good sense, as it brings tears to the eyes of little children? It is because there is a Bluebeard ruining the effect.

I. And you think that there is no work in either the burlesque or the fantastic style which is without a few hairs from this beard?

DORVAL. I believe so. But I do not care for that expression of yours; it is burlesque, and the burlesque offends me wherever I find it.

I. I shall try to make up for this error by making a more weighty comment. Are not the gods of the operatic theatre the same as those of the epic? And why, pray, should Venus not be as becoming when she is lamenting the death of Adonis on the stage as when she is screaming because of the little scratch she has received from Diomedes' sword in the *Iliad*, or sighing when she sees the place on her lovely white hand where the bruised skin is beginning to darken? Is that not a charming scene in Homer's poem, where this goddess weeps on the bosom of her mother Dione?[35] Why should this tableau be any less pleasing in an operatic composition?

DORVAL. A cleverer man than I will tell you that the ornaments of the epic, which were suitable for the Greeks, the Romans, and the Italians of the fifteenth and sixteenth centuries, are unacceptable to the French; and that the gods of fable, the oracles, the invincible heroes and the fabulous adventures are a thing of the past.

And I would add that there is a big difference between portraying a thing for the benefit of my imagination and acting it out before

my eyes. You can make my imagination accept anything you like; all you have to do is to take hold of it. The same is not true of my senses. Remember the principles I set out just now on the things, including those which are true to life, which one can reasonably show to the audience and those which must be hidden from them. The same distinctions I was making apply even more rigorously to the fantastic genre. In short, if this system cannot possess the kind of truth appropriate to the epic, how could it engage our interest on the stage?

If elevated conditions are to be made moving, they must be put into powerful situations. Only by this means is it possible to draw from these cold, constrained characters the accent of nature, without which no great effects are possible. This accent becomes weaker the more elevated they are. Listen to Agamemnon:

> *Encor si je pouvais, libre dans mon malheur,*
> *Par des larmes, au moins, soulager ma douleur;*
> *Tristes destins des rois! esclaves que nous sommes,*
> *Et des rigueurs du sort, et des discours des hommes!*
> *Nous nous voyons sans cesse assiégés de témoins;*
> *Et les plus malheureux osent pleurer le moins.*[36]

[If only I could at least have the freedom in my misfortune to relieve my suffering with tears; sad destiny of kings! for we are slaves of the rigours of fate and the utterances of men! We see ourselves always surrounded by witnesses, and the most unfortunate are the ones who can least dare to weep.]

Should the gods be less mindful of their dignity than kings? If Agamemnon, whose daughter is to be sacrificed, fears for the dignity of his rank, what kind of circumstance will cause Jupiter to descend from his?

I. But ancient tragedy is full of gods; and it is Hercules who resolves the famous tragedy of *Philoctetes*, where, according to you, there is not a word to be altered.

DORVAL. Those who first put their minds to a consistent study of human nature first of all concentrated on distinguishing between the passions, on understanding and defining them. One man worked out the abstract concepts: he was a philosopher. Another gave the concept flesh and motion: he was a poet. A third fashioned this likeness in marble: he was a sculptor. A fourth made the sculptor prostrate himself at the foot of his creation: he was a priest. The pagan gods were made in the image of man. What are the gods of Homer, Aeschylus, Euripides and Sophocles? The vices of men, their virtues, the personifications of the great phenomena of nature, these are the true theogony, this is the perspective in which we should see Saturn, Jupiter, Mars, Apollo, Venus, the Fates, Love and the Furies.

When a pagan was torn with remorse he really thought that a fury was working within him: and how he must have been troubled at the sight of this phantom crossing the stage bearing a torch in its hand, its head alive with serpents, offering to its guilty victim's sight its hands stained with blood! But what of us who know the vanity of all these superstitions! What of us!

I. Well, all we have to do is substitute our devils for the Eumenides.

DORVAL. There is too little faith on our earth ... And then, our devils have such a gothic look ... in such bad taste ... Is it surprising that it should be Hercules who resolves Sophocles' *Philoctetes*? The whole plot of the play is based on his arrows; and this same Hercules had a statue in the temples before which the people prostrated themselves every day.

But do you know what the result was of the union of national superstition and poetry? It was that the poet could not provide his heroes with clear-cut characters. It would have meant duplicating his characters, representing the same passion in the form of a god and in the form of a man.

That is the reason why Homer's heroes are nearly all historical figures.

But when the Christian religion had banished the pagan gods from people's minds and forced the artist to seek other sources of

illusion, the poetic system changed; men took the place of the gods and were given more unified characters.

I. But is not strict unity of character something of an illusion?

DORVAL. Very probably.

I. So truth was abandoned?

DORVAL. Not in the least. Remember that in a play there is only one action, one event in life, a very short interval during which it is likely that a man will preserve the same character.

I. And in the epic, which encompasses a large area of life, a prodigious number of different events, situations of all kinds, how must men be presented there?

DORVAL. I think there is a lot to be said for representing men as they are. What they ought to be smacks too much of system and is too vague to serve as a basis for an imitative art. There is nothing so rare as a completely wicked man, unless it be a completely good man. When Thetis steeped her son in the Styx, he emerged like Thersites, as far as his heel was concerned. Thetis is the image of nature . . .[37]

At this point Dorval stopped; then he resumed.

DORVAL. There are no lasting forms of beauty save those which are founded on relationships with the phenomena of nature. If one imagined phenomena in a rapid process of change, with every painting representing just a fleeting moment, all imitation would be superfluous. Beauty has in the arts the same basis as truth in philosophy. And what is truth? The conformity of our judgements with phenomena. What is beauty in the imitative arts? The conformity of the image with the thing itself.

I am very much afraid that neither the poets, nor the composers, nor the set designers, nor the dancers have yet understood what the theatre really is. When the lyric genre is bad, it is the worst of all genres. When it is good, it is the best. But can it be good if it does not aim at the imitation of nature, and nature in its most powerful forms? What good is there in putting into poetry something that was not worth the trouble of inventing? or of putting into song

what was not worth reciting? The more you put into a subject, the more important it is that it should be a good one to start with. Does it not amount to prostituting philosophy, poetry, music, painting, dancing, if you occupy them with absurdities? Each of these arts on its own has the imitation of nature as its purpose; so why should their combined magic be expended on a fiction? And is not the illusion of reality already far enough removed? And what is there in common between metamorphoses and magic spells and the universal order of things which must always be the basis of poetic reason? In our own time men of genius have restored the philosophy of the intelligible world to the real world. Will there not now be one who renders the same service to lyric poetry and brings it down from the world of marvels to the earth on which we live?

Then it will no longer be said of a lyric poem that it gives offence, either in its subject, which goes beyond nature, or in its main characters, who are imaginary, or in its plot, which often observes neither the unity of time, nor the unity of place, nor the unity of action, and where all the imitative arts seem only to have been combined in order that each might weaken the effect of the others.

A wise man used once to be a philosopher, a poet and a composer. By becoming separate, these talents have degenerated: the field of philosophy has narrowed, poetry has run out of new ideas, song has lost its power and energy; and wisdom, deprived of these means of expression, has no longer exerted the same influence on the people. A great composer and a great poet would put everything right.

There then is an ambition to be achieved. Let him come forward, this genius who is destined to set true tragedy, true comedy on the operatic stage. Let him cry out, like the prophet of the Hebrew people in his moment of rapture: *Adducite mihi psaltem*, 'Bring me a minstrel', and he will bring him into being.[38]

The operatic genre of a neighbouring nation no doubt has its faults, but far fewer than one imagines. If the singer disciplined himself to imitate, in his cadences, only the inarticulate accents of

passion in emotional songs, only the main phenomena of nature in descriptive songs, and if poets were to realize that their ariettas should act as a conclusion to a scene, the reform would be well advanced.

I. And what would become of our ballets?

DORVAL. The dance? The dance still awaits a genius; it is everywhere bad, because people have barely realized that it is an imitative art. The dance is to mime as poetry is to prose, or rather as natural declamation is to song. It is rhythmical mime.

I should be glad if someone would tell me what meaning all these dances have, such as the minuet, the passe-pied, the rigadoon, the allemande, the saraband, which follow a set pattern. This man is performing movements of immense gracefulness; in every one of them I see ease, gentleness and nobility; but what is he imitating? This is not singing, it is just running through the scales.

A dance is a poem. This poem should therefore have a performance of its own. It is an imitation by means of movements, which demands the collaboration of the poet, the painter, the composer and the mime. It has its own subject-matter; this can be set out in acts and scenes. The scene has its recitative, either obbligato or improvised, and its arietta.

I. I confess I only half understand you and that I would not understand you at all if it were not for a pamphlet which appeared a few years ago. The author, unhappy with the ballet which concluded the *Devin du Village*,[39] proposed another, and I am very much mistaken or his ideas are very similar to your own.

DORVAL. That may be.

I. An example would clear the matter up.

DORVAL. An example? Yes, one could be imagined. I will think about it.

We did several turns around the paths in silence with Dorval thinking about his example of the dance and me going over some of his ideas in my mind. This is more or less the example

he gave me. 'It is a very ordinary one,' he said, 'but I can illustrate my ideas with it as easily as if it were closer to nature and more affecting':

Subject. – A peasant boy and girl are coming home from the fields in the evening. They meet in a little wood near their village and decide to rehearse a dance which they have to perform together the following Sunday, beneath the great elm tree.

ACT ONE

Scene I – Their first reaction is one of pleasant surprise. They show their surprise to each other by means of a *mime*.

They draw near and greet each other; the peasant boy suggests to the girl that they rehearse their steps: she replies that it is late and she is afraid of being scolded. He persuades her and she accepts; they lay the tools they are carrying on the ground: there is a recitative. The steps which they walk and the mime, which is without rhythm, are the recitative of the dance. They repeat their dance and memorize the movements and steps; they correct themselves and start again, they do it better and feel pleased with themselves; they go wrong and get annoyed: this is a recitative which might be interrupted by an arietta of pique. Here the orchestra must speak: it is for them to render the words and imitate the actions. The poet has laid down what the orchestra must say; the composer has written it; the painter has created the scenery: it is for the mime to form the steps and movements. From which you can easily understand that if the dance is not written like a poem, if the poet has botched the words, if he has failed to invent pleasing tableaux, if the dancer cannot act, if the orchestra cannot speak, all is lost.

Scene II – While they are busy practising, dreadful sounds are heard; our children are frightened; they stop and listen; the noise stops and they calm down; when they continue they are immediately interrupted and frightened by the same sounds: it is a *recitative* interspersed with a little *song*. It is followed by a mime of the peasant girl trying to run away while the peasant boy holds her

back. He explains, but she will not listen; this makes a lively *duet* between them.

This *duet* has been preceded by a short piece of recitative made up of the little movements of the faces, bodies and hands of these children as they point out to each other where the noise came from.

The peasant girl has been persuaded and they were getting on very well with their dance rehearsal when two older peasants, wearing terrifying and comic disguises, come slowly forward.

Scene III – These disguised peasants, accompanied by a subdued orchestral passage, perform every kind of action which might horrify the children. Their approach is a *recitative*; their words are a *duet*.

The children are terrified and trembling in every limb. Their terror increases as the spectres draw nearer and they do everything they can to get away. They are held back, then pursued, and the disguised peasants with the frightened children form a lively *quartet* which concludes with the children's escape.

Scene IV – Then the spectres take off their masks; they begin to laugh and mime the whole performance of rascals delighted with the trick they have played. They express their satisfaction in a *duet*, and leave the stage.

ACT TWO

Scene I – The peasant boy and girl had left their bags and crooks on the stage; they come back to get them, the boy first. First of all his nose appears; he takes a step forward, draws back, listens, looks around, comes forward a little further, goes back again, gradually gets bolder and walks in all directions; he is no longer afraid: this monologue is an *obbligato recitative*.

Scene II – The peasant girl appears, but stays in the background. Although the peasant boy encourages her she will not come any nearer. He throws himself at her feet and tries to kiss her hand. – 'What about the ghosts?' she says. – 'They have gone away, they

have gone away.' This is another *recitative*, but it is followed by a *duet* in which the peasant boy tells her of his desire in the most passionate way and the girl gradually lets herself be drawn back on to the stage to start again. This *duet* is interrupted by expressions of fear. There is no noise, but they think they hear it. They stop, listen, calm down and carry on with the *duet*.

But this time it is not a mistake; the frightening noises have started up again; the peasant girl has run to get her bag and crook and the boy has done the same.

They try to run away.

Scene III – But they are surrounded by a crowd of phantoms who cut off their flight in every direction. They move about amongst these phantoms, looking for a way out but not finding one. And you can imagine that this scene is a *chorus*.

Just when their consternation is at its height the phantoms take off their masks and reveal friendly faces to the peasant boy and girl. Their naive amazement makes a very pleasing tableau. Each of them picks up a mask; they examine them and compare them to their faces. The peasant girl has a hideous man's mask, the boy a hideous woman's mask. They put these masks on and look at each other, making faces: and this recitative is followed by an ensemble *chorus*. During this *chorus* the peasant boy and girl play all kinds of childish tricks on each other, and the play ends with the *chorus*.

I. I have heard a spectacle like that described as the most perfect thing imaginable.

DORVAL. You mean Nicolini's troupe?[40]

I. Exactly.

DORVAL. I have never seen it. Well then, do you still think the last century has left this one with nothing to do?

To create domestic and bourgeois tragedy.

To perfect the serious genre.

To substitute the conditions of men for their characters, perhaps in all genres.

To associate mime closely with dramatic action.

To alter the stage; and to substitute tableaux for *coups de théâtre*, a new source of invention for the poet and of study for the actor. For what use is it if the poet imagines tableaux and the actor remains faithful to his symmetrical positioning and his stilted acting style?

To introduce real tragedy into the operatic theatre.

Finally to subject the dance to the discipline of real poetic form, to be written down, and distinguished from any other imitative art.

I. What kind of tragedy would you want to establish on the operatic stage?

DORVAL. Ancient tragedy.

I. Why not domestic tragedy?

DORVAL. Because tragedy, and in general any work intended for the operatic theatre, must be metrical, and I do not think domestic tragedy can be versified.

I. But do you think this genre would provide the composer with all the resources which his art requires? Every art has its advantages; it would seem that the same applies to them as to the senses. All the senses are a form of touch, and all the arts are a form of imitation. But the touch of each sense, and the imitation of each art, is proper to itself.

DORVAL. There are, in music, two styles: one is simple, the other figurative. What will you say if I show you, still within the field of dramatic poetry, pieces in which the composer can choose to display all the energy of one or all the wealth of the other? When I say the *composer*, I mean someone who possesses all the genius of his art, which is not the same as someone who can only do a series of modulations and combine various notes.

I. Dorval, one such piece, please.

DORVAL. With pleasure. It is said that Lulli himself noticed the one I am going to quote, which might go to prove that this artist lacked only a different kind of poem, and felt that his genius was capable of the greatest things.

Clytemnestra, whose daughter has just been taken from her to be

sacrificed, sees the sacrificial knife raised over her breast, sees the blood flow from her and a priest consulting the gods in her palpitating heart. Distressed at these sights, she cries out:

> . . . O mère infortunée!
> De festons odieux ma fille couronnée,
> Tend la gorge aux couteaux par son père apprêtés.
> Calchas va dans son sang . . . Barbares! arrêtez;
> C'est le pur sang du dieu qui lance le tonnerre . . .
> J'entends gronder la foudre et sens trembler la terre.
> Un dieu vengeur, un dieu fait retentir ces coups.[41]

> [O unhappy mother! my daughter, her head festooned
> with hateful garlands, offers her breast to the knives
> prepared by her father. Calchas, in her blood . . . Barbar-
> ians, stay your hands. This is the pure blood of the god
> who casts the thunderbolt . . . I hear the roaring of the
> thunder and feel the trembling of the earth. A vengeful
> god is making these sounds ring out.]

Neither in Quinault, nor in any other poet, do I know of more lyrical verses nor a situation more suited to musical imitation. Clytemnestra's plight must draw from her heart the very cry of nature, and the composer will bring it to my ears in all its nuances.

If he composes this piece in the simple style, he will steep himself in the grief and despair of Clytemnestra and he will only begin his work when he feels himself borne down by the terrible sights which obsessed her. What a fine subject those first lines are for an obbligato recitative! How well the different phrases could be separated by a plaintive ritornello . . . *O God!* . . . *O unhappy mother!* . . . first break for a ritornello . . . *my daughter, her head festooned with hateful garlands* . . . second break . . . *Offers her breast to the knives prepared by her father* . . . third break . . . *By her father* . . . fourth break . . . *Calchas, in her blood* . . . fifth break . . . In how many

different ways this symphony can be treated! I feel I can hear it . . .
it portrays the lament . . . the grief . . . the fear . . . the horror . . .
the fury . . .

The aria begins with *Barbarians, stay your hands*. The composer
can declaim the *Barbarians, stay your hands* in as many ways as he
likes; he will be surprisingly unimaginative if he does not find these
words an inexhaustible source of melodies . . .

A lively rendering: *Barbarians; barbarians, stay, stay your hands . . .
this is the pure blood of the god who casts the thunderbolt . . . this is the
blood . . . this is the pure blood of the god who casts the thunderbolt . . .
stay your hands! I hear the roar of the thunder . . . I feel the trembling of
the earth . . . stay your hands . . . A god, a vengeful god is making these
sounds ring out . . . stay, barbarians . . . But nothing holds them back . . .
Ah! my daughter! . . . ah, unhappy mother! . . . I see her . . . I see her
blood flow . . . she is dying . . . ah, barbarians! O God!* . . . What a
wealth of feelings and images!

Let these verses be left to the talents of Mademoiselle Dumesnil;[42]
unless I am much mistaken, that is the kind of disorder she will
spread amongst them, those are the feelings which will unfold in
her heart, that is what her genius will inspire in her, and it is her
delivery that the musician must have in mind and set down. Let this
be tried, and we shall see nature inspiring the same ideas in the
actress and the composer.

But what if the composer adopts the figurative style? a differ-
ent delivery, different ideas, different tunes. He will give the
voice to do what the other reserved for the instrument; he will
make the thunder roll, he will send it down and make it break;
he will show me Clytemnestra frightening the murderers of her
daughter with the image of the god whose blood they are about
to shed; he will present this image to my imagination, already
shaken by the emotional force of the poetry and the situation,
with as much truth and power as he is capable of. The first
was entirely concerned with Clytemnestra's singing; this time
it will be a matter of what she is saying. I no longer hear
the mother of Iphigeneia, but the roaring of the thunder, the

trembling of the earth, the terrifying noises resounding in the air.

A third composer will try to unite the best of both styles. He will seize the cry of nature in its violent and inarticulate expression and make it the basis of his melody. Over this melody, played by the strings, he will make the thunder roll and cast down the thunderbolt. He may try to render the vengeful god, but he will certainly make the cries of a tearful mother stand out amongst the different aspects of this description.

But however powerful the genius of this artist, he will never achieve one of these objects without sacrificing something of the other. Everything he gives to the descriptive passages will be lost to the emotional impact. The whole will have more effect on the ear, and less on the heart. This composer will be more admired by artists, and less by men of discernment.

And do not imagine that it is those words which attach themselves to the lyrical style, *cast . . . roll . . . tremble . . .*, which make this piece so moving! It is the passion which informs it. And if the composer were to neglect the cry of passion and spend his time putting sounds together round these words, the poet would have set a cruel trap for him. Does faithful delivery depend on such ideas as *cast, roll, tremble*, or these, *barbarians . . . stay your hands . . . it is the blood . . . it is the pure blood of a god . . . of a vengeful god . . .*?

But here is another piece in which this composer will show just as much genius, if he has any, where there is no *cast*, no *victory*, no *thunder*, no *flight*, no *glory*, or any of these words which will give trouble to the poet as long as they remain the sole, feeble resource of the composer.

OBBLIGATO RECITATIVE

> *Un prêtre environné d'une foule cruelle . . .*
> *Portera sur ma fille . . . (sur ma fille!) une main*
> *criminelle . . .*

Déchirera son sein . . . et d'un oeil curieux . . .
Dans son coeur palpitant . . . consultera les dieux! . . .
Et moi qui l'amenai triomphante . . . adorée . . .
Je m'en retournerai . . . seule . . . et désespérée!
Je verrai les chemins encor tout parfumés
Des fleurs dont sous ses pas on les avait semés.

ARIA

> *Non, je ne l'aurai point amenée au supplice . . .*
> *Ou vous ferez aux Grecs un double sacrifice.*
> *Ni crainte, ni respect ne m'en peut détacher.*
> *De mes bras tout sanglants il faudra l'arracher.*
> *Aussi barbare époux qu'impitoyable père,*
> *Venez, si vous l'osez, la ravir à sa mère.*[43]

[A priest in the midst of a cruel mob will lay upon my daughter . . . (*upon my daughter!*) his criminal hand . . . will tear open her breast . . . and with his inquisitive gaze will . . . in her throbbing heart . . . consult the gods. And I who led her triumphant . . . adored . . . will walk back . . . alone . . . and in despair! I shall see the paths still scented with the flowers which had been strewn beneath her feet.]

[No, I shall not have led her to her death . . . Or else you will make a double sacrifice to the Greeks. Neither fear nor respect can separate me from her. She will have to be dragged from my bleeding arms. Come then, you who are as barbarous a husband as you are a pitiless father, come, if you dare, and take her from her mother.]

No, I shall not have led her to her death . . . No . . . neither fear, nor respect can separate me from her . . . No . . . barbarous husband . . . pitiless father . . . come and take her from her mother . . . come, if you

dare . . . Those are the main ideas in the mind of Clytemnestra, and which will be in the mind of the composer.

There are my ideas. I am all the more happy to tell them to you because, even if they are never of any real use, they cannot possibly be harmful, if it is true, as one of the first men of our nation claims, that nearly all the great literary genres are exhausted and that there are no great things left to be done, even for a genius.[44]

It is for others to decide whether this type of poetic scheme which you have drawn from me contains any worthwhile ideas or whether it is just a collection of wild fancies. I should be inclined to believe what Monsieur de Voltaire says, but only if he were to support his views with a few illuminating arguments. If ever I were to recognize an authority as infallible, it would be his.

I. If you like, we can tell him your ideas.

DORVAL. I agree to that. I may find pleasure in the praise of a clever, sincere man, and I cannot find his criticism hurtful, however bitter it is. I set out, long ago, to find happiness in something more solid, and more in my control, than literary fame. Dorval will die content if, when he is no more, he can deserve the words: *His father, who was a good man, was not a better man than he.*

I. But if you were almost completely indifferent to the success or failure of a work, what objection could you have to your own being published?

DORVAL. None. There are so many copies of it anyway. Constance never refused them to anyone. All the same, I should not like my work to be offered to the actors.

I. Why not?

DORVAL. It is uncertain whether it would be accepted, and even more uncertain whether it would be a success. A failed play is rarely read. And since I want to increase the usefulness of this one, I might risk destroying it altogether.

I. But look here . . . There is a great prince who is fully aware of the importance of drama and who is concerned with the development

of national taste. He could be approached . . . and might offer . . .

DORVAL. I think so; but let us reserve his protection for *The Father*.[45] He is not likely to refuse it, having shown so courageously what a good father he is himself . . .[46] This subject is tormenting me; I know I shall need to deliver myself sooner or later of this fancy, for a fancy it is, such as all men have when they lead solitary lives . . . What a fine subject the father is! . . . It is the universal vocation of all men . . . Our children are the source of our greatest pleasures and our greatest grief . . . With this subject my eyes will be firmly fixed on my own father . . . My father! . . . I shall complete the portrayal of good Lysimond . . . I shall learn in the process . . . If I have children, I shall not be unhappy to have made commitments towards them . . .

I. And what genre will *The Father* be in?

DORVAL. I have been thinking about it, and my feeling is that this subject is of a different kind from *The Natural Son*. *The Natural Son* has tragic tendencies; *The Father* will lean towards the comic.

I. Have you made enough progress with it to know that?

DORVAL. Yes . . . go back to Paris . . . Publish the seventh volume of the *Encyclopedia* . . .[47] Then come here and take a rest . . . and be sure that *The Father* will either not be done or that it will be finished before the end of your holiday . . . But I am told that you are leaving soon.

I. The day after tomorrow.

DORVAL. What, the day after tomorrow?

I. Yes.

DORVAL. That is a little sudden . . . but do as you wish . . . you must absolutely meet Constance, Clairville and Rosalie . . . Would you be prepared to come over this evening and beg a supper from Clairville?

Dorval could see that I consented and we set off straight away towards the house. What a welcome they gave to a man introduced by Dorval! I immediately became one of the family. The talk,

before and after supper, was of government, religion, politics, literature, philosophy; but however varied these subjects were, I was always able to recognize the personality which Dorval had given to each of his characters. He was marked by melancholy, Constance by reason, Rosalie by openness, Clairville by passion, and myself by good nature.

Introductory Note

IN PRAISE OF RICHARDSON

Reading Diderot's essay on Richardson, we might get the impression that the novels were a new and glorious discovery for him, if not for French readers in general. In fact Diderot was by no means the first person in France to react. The novels had long been familiar through the abbé Prévost's watered-down and much truncated translations: *Pamela* in 1742, *Clarissa Harlowe* in 1751 and *Sir Charles Grandison* in 1755. Impressions had been mixed, indicating the growing divide between traditional classical taste and the new sensibility. What was new as far as Diderot was concerned was that he had read Richardson in the original and realized how much had been lost in Prévost's translation.

He wrote the *Eloge de Richardson* in 1761, completing the first draft in twenty-four hours, according to Grimm. It was published in the *Journal étranger* in January 1762 (the text used here), acquiring an added celebratory status through the death of Richardson in 1761, and was published separately in August of the same year. It was translated into German in 1766, in time for *Sturm und Drang*.

Today, even though Richardson has benefited from a revival of interest in recent years, it is hard to imagine how Diderot could have been so overwhelmed by these novels, like an adolescent making a discovery that changes the world for him. Yet this is how it must have been for those who were rebelling against the formal, classical culture of the *ancien régime*. Here was a writer who spoke with the voice of the new, liberating sensibility, who equated sensibility and virtue and showed them in opposition to coldness and vice, and who at the same time portrayed in all its detail a believable contemporary world. This was the world which Diderot and his contemporaries were to find again, in that same year, in Greuze's *Village Betrothal* and Rousseau's *Julie, or The New Heloïse*. It is rare to find such uncritical idealism expressed by a writer of

Diderot's talent. He was later to temper his views, both on Richardson and Greuze, but as so often with Diderot, we have his volatile temperament to thank for this expression of what it must have been like to have made a discovery which seemed so exactly to answer the needs of the age.

IN PRAISE OF RICHARDSON

By 'novel' we have until now understood a tissue of fantastic and frivolous events which presented a threat to the taste and morals of its readers. I should like another name to be found for the works of Richardson, which raise the spirit, touch the heart, are permeated with a love for what is good, and are also called novels.

All that Montaigne, Charron, La Rochefoucauld and Nicole[1] expressed in maxims, Richardson has expressed in actions. But an intelligent man who reads the works of Richardson attentively will recreate most of these moralists' pronouncements; and yet with all these pronouncements he would not recreate a page from Richardson.

A maxim is an abstract, general rule of conduct whose application is left to ourselves. It does not of itself impress any perceptible image on our minds: but in the case of someone who acts, we see him, we put ourselves in his place or by his side, we enlist enthusiastically for or against him; we identify with his role if he is virtuous and we draw indignantly away from it if he is unjust or vicious. Who has not been made to shudder by a character such as Lovelace or Tomlinson?[2] Who has not been filled with horror at the moving, sincere tones, the air of candour and dignity, the profound skill with which this man acts out all the virtues? Who is there who has not thought within his heart that he would be forced to flee from the society of men or take refuge in the depths of the forests, if there were many men capable of such dissimulation?

O Richardson! whether we wish to or not, we play a part in your works, we intervene in the conversation, we give approval and blame, we feel admiration, irritation and indignation. How many times have I caught myself, as happens with children being taken to the theatre for the first time, shouting out: *Don't believe him, he's deceiving you . . . If you go there it'll be the end of you.* My

heart was in a state of permanent agitation. How good I was! How just I was! Wasn't I pleased with myself! When I had been reading you, I was like a man who had spent the day doing good.

In the space of a few hours I had been through a host of situations which the longest life can scarcely provide in its whole course. I had heard the genuine language of the passions; I had seen the secret springs of self-interest and self-love operating in a hundred different ways; I had become privy to a multitude of incidents and I felt I had gained in experience.

This author does not send blood flowing down the walls, he does not transport you to distant lands, he does not expose you to being eaten by savages, he does not confine himself within the secret haunts of debauchery, he never wanders off into the world of fantasy. The world we live in is his scene of action, his drama is anchored in truth, his people are as real as it is possible to be, his characters are taken from the world of society, his events belong to the customs of all civilized nations; the passions he portrays are those I feel within me; the same things arouse them, and I recognize their force in myself; the problems and afflictions of his people are of the same kind as those which constantly hang over me; he shows me the general course of life as I experience it. Without this art, my mind would easily take to the paths of fantasy, there would be only a fleeting illusion and a faint, passing impression.

What is virtue? It is, from whatever angle one considers it, a sacrifice of oneself. The sacrifice one makes of oneself in imagination is a preconceived inclination to do the same in reality.

Richardson sows in our hearts the seeds of virtues which at first remain still and inactive: their presence is hidden until the moment comes for them to stir and come to life. Then they develop and we feel ourselves driven towards what is good with an enthusiasm we did not know was in us. At the spectacle of injustice we feel a revulsion for which we can find no explanation. All this because we have been in contact with Richardson; we have been in conversation with this worthy man at a time when our unprejudiced hearts were open to the truth.

I still remember the first time I came across Richardson's work: I was in the country. How delightfully moved I was by them! With every moment I saw my time of happiness growing a page shorter. Soon I had the same feeling as is experienced by men who get on extremely well together and, having been together for a long time, are about to separate. When it was finished, I suddenly felt that I was left alone.

This author constantly reminds you of the important things in life. The more you read him, the more pleasure you take in him.

He it is who lights the depths of the cavern with his torch; he it is who teaches you to detect the cunning, dishonest motives concealed and hidden from our sight beneath other, honest motives, which are always the first to show themselves. He it is who spirits away the mighty phantom which guards the entrance to the cavern, and the hideous blackamoor which it masked stands revealed.

He it is who can make the passions speak, now with the violence they have when they can no longer contain themselves, now in those subtle, modest tones which they affect at other times.

He it is who causes men of every rank and condition, in all the various circumstances of life, to speak in a way we recognize. If he insinuates a secret thought into the depths of someone's heart, listen, and you will hear the jarring note which gives it away. For Richardson has seen that untruth can never perfectly resemble truth, because one is truth, and the other untruth.

If it matters to men to be convinced that, independently of any concerns beyond this life, the best thing we can do to be happy is to be virtuous, what benefit Richardson has brought to humankind! He has not demonstrated this truth; he has made us feel it; with every line he leads us to prefer the fate of virtue oppressed to that of vice triumphant. Who would wish to be Lovelace with all his advantages? Who would not rather be Clarissa, despite all her misfortunes?

I have often said, as I read him: I would happily give my life to be like this woman; I would rather be dead than be that man.

If I am able, despite the selfish motives which may disturb my

judgement, to apportion my contempt or my esteem according to just standards of impartiality, it is to Richardson that I owe it. My friends. read him again and again, and you will no longer exaggerate the importance of those little qualities which happen to be useful to you; you will not disparage great talents which thwart or humiliate you.

Mankind, come and learn from him how to come to terms with the evils of life; come, we shall weep together over the unfortunates in his stories, and we will say: 'If fate casts us down, at least honest folk will also weep over us.' If Richardson wants to gain our sympathy, it is for the unfortunate. In his work, as in the world, men are divided into two classes: those who enjoy and those who suffer. He always gains my sympathy for the latter; and, without my being aware of it, the gift of compassion is practised and strengthened.

He has left me with a feeling of melancholy, both pleasing and enduring. Sometimes people notice it and ask: 'What is the matter? there's something different about you; what has happened to you?' They question me about my health, my financial affairs, my family, my friends. O my friends! *Pamela*, *Clarissa* and *Grandison* are three great dramas! When important activities dragged me away from them, I felt an overwhelming reluctance; I abandoned my duties and took up Richardson's book again. Take care not to open one of these enchanting works if you have any duties to perform.

Who has read Richardson's works without wanting to know this man, to have him as a brother or a friend? Who has not wished all kinds of blessings on him?

O Richardson, Richardson, a man who has no equal in my eyes, you will at all times be the subject of my reading! If I am compelled by pressing needs, if my friend is afflicted by poverty, if my modest wealth does not suffice to give my children what is necessary for their education, I shall sell my books. But I shall keep you, I shall keep you on the same shelf as Moses, Homer, Euripides and Sophocles; and I shall read you all in turn.

The finer one's soul, the more delicate and pure one's taste, the

more one understands nature, the more one loves truth, the greater is one's esteem for the works of Richardson.

I have heard my author criticized for his details, said to be too long-drawn-out: how impatient I grew with these criticisms!

Woe betide the man of genius who oversteps the barriers that time and custom have prescribed for works of art, and tramples underfoot the forms hallowed by precedent! Long years will follow his death before he earns the justice he deserves.

And yet, let us be fair. For a people open to a thousand distractions, whose days have not enough hours for all the amusements with which they are wont to fill them, Richardson's books must seem long. It is for the same reason that this nation no longer has an opera, and that very soon only isolated scenes of comedy and tragedy will be performed in its other theatres.

My dear fellow countrymen, if Richardson's novels seem long to you, why not shorten them? Be consistent. You hardly ever go to see more than the last act of a tragedy. Skip to the last twenty pages of *Clarissa*.

Richardson's detail does not appeal, and cannot appeal, to a man who is frivolous and dissipated; but he was not writing for such men; it is for the quiet, solitary man, who has come to recognize the vanity of the noise and distractions of the world, and loves to dwell in the shadows of a retreat and to find value in emotions experienced in tranquillity.

You accuse Richardson of being long-drawn-out! You must have forgotten how much trouble, care and activity it takes to accomplish the smallest undertaking, to see a lawsuit through, to arrange a marriage, to bring about a reconciliation. Think what you will of these details, they will always be interesting to me if they are true to life, if they bring passions to light and reveal people's characters.

They are trivial, you say; it's something we see every day! You are wrong; it is something which takes place every day before your eyes but which you never see. Be careful what you say: you are criticizing the greatest poets when you criticize Richardson. You have seen the sun set and the stars come out a hundred times, you

have heard the countryside echo to the glorious song of the birds; but which of you has realized that it was the noise of the day which made the silence of the night more moving? Well then! as far as you are concerned, moral phenomena are the same as physical phenomena: outbursts of passion have often reached your ears, but you are a long way from understanding all that is concealed within their tones and their expression. There is not one which does not have its own expression, and these expressions appear one after another on a face, without that face ceasing to be itself; and the art of the great poet and the great painter lies in showing you some passing feature which had escaped you.

Painters, poets, people of discernment, good people, read Richardson, read him constantly.

Remember that the illusion depends for its effect on this multiplicity of little things: imagining them is difficult enough; it is even more difficult to convey them. There is sometimes as much sublimity in a gesture as in a word; and it is these factual details which prepare our minds for the powerful effects made by great events. When your impatient expectations have been held in check by these short-lived details which served as constraints, how impetuously they will surge forward when the poet decides to release them! Then, oppressed with grief or carried away with joy, you will be powerless to restrain the tears which are about to flow, and to say to yourself: *But this may not be true.* This thought has gradually been removed from your mind and it is so far away that it will not occur to you.

An idea that I have sometimes had when I am thinking about Richardson's works is that I have bought an old château, and, inspecting its various rooms one day, I see in a corner a cupboard which has not been opened for ages, and, breaking it open, I find, higgledy-piggledy, the letters of Clarissa and Pamela. When I had read some of them, how eagerly I should have arranged them in the order of their dates! What misery I should have suffered if there had been any gaps in them! Is it to be imagined that I would allow anyone rashly (I almost said sacrilegiously) to suppress one line of

them? If you have only read Richardson's works in your elegant French translation, and think you know them, you are wrong.[3]

You do not know Lovelace; you do not know Clementine; you do not know the unhappy Clarissa; you do not know Miss Howe, her dear, tender Miss Howe, because you have not seen her with her hair dishevelled, lying across her friend's coffin, wringing her hands, lifting her tear-stained eyes to heaven, filling the Harlowes' home with her shrill cries and casting imprecations upon the whole of this cruel family. You know nothing of the effect of these things, which your shallow taste would suppress, because you have not heard the mournful sound of the bells of the parish church, carried on the wind to the Harlowes' house, and awakening the remorse which lay dormant in these stony hearts; because you have not seen them start up at the sound of the hearse bearing the corpse of their victim. Then it was that the gloomy silence which hung over them was broken by the sobbing of the father and mother; then it was that the true sufferings of those wicked souls began, and the serpents stirred within their hearts and tore them apart. Happy were those who could find it in them to weep!

I have observed that, amongst people who read Richardson together or separately, the conversation was all the more interesting and lively.

I have heard, as a consequence of their reading, the most important questions concerning morality and taste being discussed and analysed.

I have heard the conduct of the characters being discussed in the way one would talk about real events; Pamela, Clarissa, Grandison being praised or blamed like living people whom one knew and took the greatest interest in.

Anyone who did not know of the reading which had inspired the conversation would have imagined, from the sincerity and warmth of the exchanges, that they were talking about a neighbour, a relative, a friend, a brother or a sister.

Shall I say it? . . . I have seen how the diversity of judgements gave rise to secret grudges, hidden contempt, in fact to the same

divisions between united friends as if they had been involved in some serious dispute. Then I likened Richardson's work to an even more sacred book, to a gospel brought down to earth to separate husband from wife, father from son, daughter from mother, brother from sister; and his work thus entered into the condition of the most perfect beings in nature. Created as they are by an all-powerful hand and an infinitely wise intelligence, there is not one of them that does not show some imperfection. A present good may in the future be the source of a great evil; an evil the source of a great good.

But what does that matter, provided that, thanks to this author, I have loved my fellow beings more, and loved my duty more; that I have had only pity for the wicked; that I have developed more sympathy for the unfortunate, more reverence for the good, more prudence in dealing with the things of the present, more indifference for the things of the future, more contempt for life and more love for virtue, the only good which we can ask from heaven, and the only one it can grant us, without punishing us for our ill-considered requests!

I know the Harlowes' house as I know my own; my father's home is no more familiar to me than Grandison's. I have formed a picture for myself of the characters the author has brought before us; their faces are there: I recognize them in the street, in public places, in houses; they inspire affection or aversion in me. One of the advantages of his work is that it covers such a wide field that some part of the picture is always before my eyes. Rarely have I found six people gathered together without being able to give them some of his names. He leads me to seek out honest folk and to avoid the wicked; he has taught me to recognize them by subtle, readily discernible clues. He guides me sometimes without my being aware of it.

The works of Richardson will, to a greater or lesser degree, please all men, at all times and in all places; but there will never be many readers who appreciate his full worth: that requires a very strict standard of judgement; and then, there is such a variety of

events, such a multiplicity of relationships, such complexity in the plot, so many events are always in the making, so many others are being justified, there are so many people with so many different characters! I have hardly skimmed through a few pages of *Clarissa* and I can already count fifteen or sixteen characters; it is not long before the number doubles. There are up to forty in *Grandison*, but it redoubles our amazement to discover that each one has his own ideas, his own facial expressions, his own tone of voice, and that these ideas, expressions and tones vary with circumstances, interests and passions, just as one can see one after another, on the same face, the different expressions of the passions. A man of discernment will not mistake a letter from Mrs Norton for a letter from one of Clarissa's aunts, the letter from an aunt for that from another aunt or from Mrs Howe, nor a note from Mrs Howe for a note from Mrs Harlowe, even though it may be that these characters have the same relationship and the same feelings towards the same matter. In this immortal book, as in nature in springtime, you cannot find two leaves which are exactly the same green. What an immense variety of different shades! If it is difficult for the reader to grasp them, how much more difficult it must have been for the author to create and describe them!

O Richardson! I will dare to say that the truest piece of history is full of lies, and that your novel is full of truths. History portrays a few individuals, you portray the human race; history ascribes to a few individuals what they have neither said nor done; everything you ascribe to man he has said and done; history covers only a portion of time, a point on the surface of the globe; you have embraced all times and all places. The human heart, which was, is, and always will be the same, is the model from which you copy. If one were to subject the best of historians to rigorous criticism, are there any who would sustain it as you can? Seen in this light, I make bold to say that history is a bad novel, and that the novel, in your hands, is good history. Painter of nature! you alone never lie.

I shall never tire of wondering at the amazing breadth of mind

you must have had to execute dramas with thirty or forty characters, all of them so exactly preserving the characteristics you gave them; the amazing knowledge of laws, customs, practices, manners, the human heart, life itself; the inexhaustible fund of moral strength, experience and observation that all this presupposes.

The interest and charm of this work conceal Richardson's art from those who are best fitted to see it. I have several times begun to read *Clarissa* in order to learn from it, and as many times I have forgotten about my plan twenty pages later; I have simply been struck, like any ordinary reader, by his genius in creating a young woman full of wisdom and prudence, yet who never does a single thing which is not wrong and does not lay her open to accusations, because she has inhuman parents and an abominable man as her lover; in giving that young prude this lively madcap of a friend, who never says or does anything which is not sensible, and that without its seeming implausible; in giving this friend a good man as a lover, but a good man with a stiff, absurd character who is vexed by his beloved, despite the fact that she is accepted and protected by a mother who supports her; in combining in the person of Lovelace the rarest qualities and the most odious vices, meanness and generosity, seriousness and frivolity, violence and calm, good sense and stupidity; in creating a rogue who invites hatred and love, admiration and contempt, who amazes you in whatever form he appears and who never for an instant remains the same. And this host of secondary characters! in what profusion! This man Belford with his companions, and Mrs Howe and her Hickman, and Mrs Norton, and the Harlowes, father, mother, brother, sisters, uncles and aunts, and all the creatures which people that place of debauchery! What clashes of interests and temperaments! the ways they all speak and act! How could a young woman, alone with so many enemies united against her, not have succumbed? And what a fall it was!

Does one not see, against an entirely different background, the same diversity of character, the same vigour in the events and conduct, in *Grandison*?

Pamela is a simpler work, with less breadth and complexity; but is there any less genius? Now these three works, one of which alone would have sufficed to make him immortal, were created by one man.

Since I have known them, they have been my touchstone. If anyone does not like them, my judgement on that person is made. I have never talked about them to any man I esteem without trembling lest his judgement might not be the same as mine, I have never met anyone who shared my enthusiasm without wanting to put my arms round him and hug him.

Richardson is no more. What a loss for letters and for humanity! I was as much affected by this loss as if it had been my own brother. I carried him in my heart though I had never seen him, and knew him only by his works.

I have never met one of his compatriots, or any of my friends who had travelled to England, without asking him: 'Have you seen the poet Richardson?' And after that: 'Have you seen the philosopher Hume?'

One day, a woman of unusual taste and sensibility, who was very much taken with the story of Grandison, which she had just read, said to a friend of hers who was leaving for London: 'Please pay a visit to Miss Emily and Mr Belford on my behalf, and especially Miss Howe, if she's still alive.' Another time, a woman I know, who had begun a correspondence in all innocence, was so alarmed by the fate of Clarissa that she broke it off when she started reading this book.[4]

Did not two women friends fall out, and resist all my efforts to bring them together, because one of them had a poor opinion of the story of Clarissa and the other worshipped it?

I wrote to this last, and here are some extracts from her reply:

Clarissa's piety irritates her! Well! does she expect a girl of eighteen, brought up by virtuous, Christian parents, shy, unhappy in this life, seeing little hope of her fate improving except in another life, to be without faith and religion? This sentiment is so great, so sweet, so

touching in her; her thoughts about religion are so healthy and pure; this sentiment gives such a moving quality to her character! No, no, you will never persuade me that a generous soul could think like this.

She laughs when she sees this child in desperation at her father's curse! She laughs, and she is a mother! I tell you this woman can never be my friend; I blush to think that she once was. And so the curse of a respected father, a curse which already seems to be fulfilled in several important respects, cannot be such a terrible thing for a child of this nature! And who knows whether God will not confirm for eternity the sentence passed by her father?

She finds it extraordinary that reading him should reduce me to tears! And what always amazes me, when I reach the last moments of this innocent girl, is that the flints, the walls, the cold, unfeeling paving stones I walk upon are not moved to join their laments with mine. At such times everything grows dark about me; my soul is filled with blackness, and it seems that nature has veiled itself in deep mourning.

In her opinion, Clarissa's wit consists in uttering fine phrases, and when she has managed to produce a few, then she is consoled. It is, I confess, a great affliction to feel and think like this; such an affliction that I would rather my daughter died forthwith in my arms than know she suffered it. My daughter! ... Yes, I have thought about it, and I stand by it.

Work now, wonderful man, work, use up your strength; expect the end of your career at an age when others are just beginning, so that like judgements can be passed on your masterpieces! Nature, take centuries to produce a man like Richardson; use up all your resources on him; be unkind to your other children, it will only be for a small number of souls like mine that you have brought him into being; and the tear which falls from my eyes will be the sole reward for his sleepless nights.

And as a postscript, she adds: 'You asked me for Clarissa's funeral and last testament and I am sending them; but I should never in my whole life forgive you if you showed them to that woman. No, I take that back: read these two pieces to her yourself and make sure

you tell me that her laughter escorted Clarissa to her last resting place, so that my aversion for her can be complete.'

One can see that there is in matters of taste, as in matters of religion, a kind of intolerance of which I disapprove, but which I can only avoid in myself by an effort of reason. I was with a friend when I was given Clarissa's funeral and testament, two passages which the French translator left out, for some unknown reason. This friend is one of the most tender-hearted men I know, and one of the keenest devotees of Richardson: very nearly as keen as me. He promptly grabbed the pages and went off into a corner to read them. I was watching him: first I saw tears flowing, he stopped reading and began to sob; suddenly he got up and walked up and down without knowing where he was going, crying out like a man distressed, and addressing the most bitter reproaches to the whole Harlowe family.[5]

I had planned to make a note of the finest passages in these three poems of Richardson; but how? There are so many!

I remember only that the hundred and twenty-eighth letter, which is from Mrs Hervey to her niece, is a masterpiece. Without any affection, without any apparent effort, with an appearance of truth one cannot imagine, she deprives Clarissa of any hope of reconciliation with her parents, supports the plans of her ravisher, delivers her up to his wickedness, persuades her to go to London and listen to marriage proposals, etc. She invents everything imaginable: she accuses the family in the very act of apologizing for them, she demonstrates the necessity for Clarissa to run away in the very act of blaming her. This is one of the passages, and there are many, where I have cried out: *Divine Richardson!* But to experience this delight you need to start at the beginning and read through to this point.

I have made a pencil mark in my copy next to the hundred and twenty-fourth letter, which is from Lovelace to his accomplice Leman, indicating what a charming piece it is: this is where you see all the folly, the gaiety, the cunning, the wit of this character. You do not know whether to love or hate this demon. Look how he wins over that poor servant! It's *good Leman, honest Leman.* See how

he describes the reward which awaits him! *The Blue Boar will also be yours . . . Landlord and Landlady at every word*, and then at the end: *Your loving friend Lovelace.*[6] Lovelace does not allow petty social considerations to get in his way when he wants to succeed: anyone who fits in with his plans is his friend.

Only a master of the art could have thought of associating Lovelace with this company of unprincipled debauchees, these base creatures who goad him with their taunts and embolden him to crime. If Belford alone stands up to his villainous friend, how much weaker he is! What genius it took to introduce and preserve such a balance between so many conflicting interests!

And is it to be believed that the author had no purpose in giving his hero this vivid imagination, this dread of marriage, this unbounded love of intrigue and freedom, this inordinate vanity, so many virtues and vices!

Poets, learn from Richardson to give confidants to the wicked characters, so as to lessen the horror of their crimes by sharing it out; and, for the opposite reason, not to give them to honest people, so that they have the full deserts of their honesty.

With what skill this Lovelace degenerates and then recovers himself! Look at letter one hundred and seventy-five. These are the sentiments of a cannibal; this is the cry of a savage beast. A postscript of four lines suddenly transforms him into a decent man, or very nearly.

Grandison and *Pamela* are also fine works, but I prefer *Clarissa* to both of them. Here, everything the author writes is a stroke of genius.

Yet one cannot see Pamela's old father arriving at his lordship's door, after walking through the night, or hear him talking to the servants of the house, without experiencing the most violent shock.

The whole episode with Clementine in *Grandison* is exceptionally fine.

And when is it that Clementine and Clarissa become two sublime creatures? It is when one has lost her honour and the other her reason.

I can never remember without a shudder the moment when Clementine comes into her mother's room, pale, with a wild look in her eye, a bandage round her arm, blood flowing down her arm and dripping from her fingers, and saying: *Mama, look, it is yours.* That rends one's heart.[7]

But why is Clementine so engaging in her madness? Because, now that she has lost control of the thoughts in her mind and the emotions in her heart, if there were anything to be ashamed of, it would be revealed. But she says nothing which is not a proof of candour and innocence; and her condition leaves us in no doubt of the truth of what she says.

I have been told that Richardson spent several years in society and scarcely spoke.

He has not had the reputation he deserved. What a terrible passion envy is! It is the cruellest of the Eumenides: it follows a man of distinction to the edge of the grave; there, it disappears; and eternal justice takes its place.

O Richardson! if you have not enjoyed in your lifetime all the renown you deserved, how great you will be amongst our descendants, when they see you from the distance from which we see Homer! Who is there then who will dare to subtract a line from your sublime work? You have had more admirers amongst us than in your own country, and I am glad of it. Centuries, hurry past and bring with you the honours which are due to Richardson! I call to witness those who listen to me: I have not waited upon the example of others to pay homage to you; from this day I bowed down before your statue; I venerated you, seeking within my heart words to express the extent of my admiration for you, and I found none. You who read these lines which I have set down without coherence, plan or order, just as they came to me in the tumult of my heart, if heaven has given you a more feeling heart than mine, strike them out. Richardson's genius has stifled any genius of mine. His ghosts haunt my imagination constantly; if I want to write, I hear the laments of Clementine; the shade of Clarissa appears before me; I see Grandison walking before my eyes; Lovelace comes to disturb

me, and the pen falls from my hand. And you, gentler spectres, Emily, Charlotte, Pamela, dear Miss Howe, as I talk with you, the years of toil and the harvest of laurels fall away, and I go forward to my last hour, abandoning every project which might also recommend me to future ages.

Introductory Note

THE PARADOX OF THE ACTOR

Of all Diderot's works, *The Paradox of the Actor* has the most complex history. It came to light in its complete form in 1830, among various works preserved in the Hermitage collection, but the dialogue we now know developed from an original sixteen pages published in one of the issues of the *Correspondance littéraire* for 1770 as *Observations on a brochure entitled 'Garrick or English Actors'*. This brochure, translated from the English by an actor, Antonio Sticoti, in 1769, had caught the attention of Grimm, the editor of the *Correspondance*, who asked Diderot to write a review of it. In it, Diderot expressed the original, not to say scandalous idea that the best actors had to be devoid of feeling, or sensibility. Obviously deciding that the idea needed further development, he produced a second version in 1773, when he was in Holland on his way to the court of Catherine II. Before the final text was completed (if indeed it was intended to be final), there were to be three more versions, the last of them shortly before Diderot's death in 1784. Since 1830 other copies have come to light, but the Hermitage text, with a few corrections, is regarded as the best, and is the one used here.

As I have suggested in the general introduction, this dialogue is not just about actors. A comparison of the sixteen pages in the *Correspondance littéraire* with the version presented here shows that Diderot was fascinated by the wider implications of his theory. Moreover, knowing what advantages he draws from the dialogue form in his other works, it would be surprising if he had confined himself to simply defending his point about acting in this one. He seems first of all to have wanted to explode the myth of sensibility, natural feeling, as a kind of universal panacea for the ills of society, a myth to which he himself may have been in danger of subscribing when he wrote the *Conversations on 'The Natural Son'* and *In Praise*

of Richardson. More interestingly, he is at pains to stress that the stage is a different world, different in kind from that of everyday life. Many of his additions to the original version are made in order to emphasize the gulf that exists between the two, and the idea was already in his mind when, in the *Conversations*, he pointed out the difference between a *salon* performance and one made on the stage of a theatre.

The full development of the dialogue implies a demotion of sensibility to the status of an unreliable quality, morally indifferent (as he stresses in *D'Alembert's Dream*, contemporary with the first draft of the *Paradox*), and one which acts as an impediment to effective action. Action, persuasion, making things happen, is, like acting, best achieved in a state of moral and emotional detachment. It is in fact a form of acting, just as effective painting, as he increasingly emphasizes in the *Salons*, is a matter of technique, of assessing the best way to create an illusion. The moral and social implications of this are as subversive as anything in *Rameau's Nephew*.

THE PARADOX OF THE ACTOR

FIRST SPEAKER. Let's say no more about it.

SECOND SPEAKER. Why?

FIRST. It was written by your friend.

SECOND. What does that matter?

FIRST. A lot. What's the use of putting you in a position where you're forced to scorn either his talent or my judgement, and forfeit some of the good opinion you have of him or me?

SECOND. That won't happen. And even if it did it wouldn't affect my friendship for either of them, which is based on more important qualities.

FIRST. Possibly.

SECOND. I'm sure of it. Do you know who you remind me of now? An author I know who went down on his knees and begged a woman he was fond of not to go to the first performance of one of his plays.

FIRST. Your author was a modest and prudent man.

SECOND. He was afraid that the affection she had for him might depend on her opinion of his literary merits.

FIRST. That could well be.

SECOND. And that a failure in the public eye might have a bad effect on her view of him.

FIRST. So that by being less esteemed he might be less loved. And that seems ridiculous to you?

SECOND. That's how it was seen. A box was taken and his play was a great success: and you can't imagine all the hugs and praises and adoration he got.

FIRST. He'd have got a lot more if the play had been booed.

SECOND. I don't doubt it.

FIRST. And I stick to my opinion.

SECOND. Stick to it then, but remember I'm not a woman and that you must be kind enough to explain yourself.

FIRST. Must I absolutely?

SECOND. Absolutely.

FIRST. I should find it easier not to say anything than to disguise my thoughts.

SECOND. I believe you.

FIRST. I shan't mince my words.

SECOND. My friend would have asked for exactly that.

FIRST. Well then, since you must be told, the style of his book is tortured, obscure, twisted and turgid and the ideas are commonplace. When he's finished reading it, a great actor will be no better and a bad actor will be none the worse. It's nature's job to hand out the personal qualities: figure, face, voice, judgement, wit. The perfecting of these gifts comes through study of the great examples, knowledge of the human heart, moving in society, hard work, experience and familiarity with the stage. An imitative actor can reach the point where he can play any part acceptably, where there's nothing either to praise or blame in his performance.

SECOND. Or where everything can be criticized.

FIRST. If you like. The natural actor is often dreadful and sometimes excellent. Whatever the genre, beware of a consistently ordinary performance. However harshly you treat a beginner, it's easy to see if he's marked out for success. Booing only stifles the ones without talent. Indeed how could nature without art provide a training for a great actor, since nothing happens on the stage exactly as it does in reality, and plays are all written according to a particular set of rules? And how could a part be played in the same way by two different actors, since even with the most clear, precise and positive writer the words are never, can never be, anything but signs approximating to a thought, a feeling, or an idea, signs whose value is completed by movement, gesture, tone, the eyes and the particular situation. When you've heard these words:

. . . What is your hand doing there? –
 I am feeling your dress, the material is so soft.[1]

what do you know? Nothing. Think carefully about what follows and consider how frequent and easy it is for two speakers to use the same expressions and to have thought and said completely different things. The example I'm about to give you is quite remarkable; it's actually from your friend's book. Ask a French actor what he thinks of it and he'll agree that it's all true. Put the same question to an English actor and he'll swear, *by God*, that there's not a sentence to be changed and it's the true gospel of the stage. Yet as there's hardly anything in common between the English way of writing comedy and tragedy and the way it's done in France; as, in the opinion of Garrick himself, someone who can do a perfect performance of a scene from Shakespeare doesn't have the first idea of how to deliver a scene from Racine; and as he would be entangled in the melodious lines of this latter as if so many serpents were gripping his head, his feet, his hands, his legs and his arms in their coils, there would be no freedom left in his performance. It follows clearly that the French actor and the English actor, who fully agree on the truth of your author's principles, don't understand each other, and that there is in the technical language of the theatre such looseness, such vagueness, that sensible men with diametrically opposed views can both think they're seeing the light of truth in it. So you should be more than ever attached to your maxim: *Don't explain yourselves if you want to remain in agreement.*

SECOND. You think that in every work, and especially in this one, there are two distinct meanings contained in the same signs, one in London and the other in Paris?

FIRST. And that these signs offer up these two meanings so clearly that even your friend was caught out, since, when he set the names of English actors side by side with the names of French actors, applied the same rules to them and gave them the same criticism and the same praise, he no doubt imagined that what he said of the one was equally true of the other.

SECOND. But to judge by that, no other author would have contradicted himself so completely.

FIRST. I'm afraid it must be said that he's using the same words to

propound one thing at the Carrefour de Bussy and another in Drury Lane;[2] but then I may be wrong. But the important point, on which our opinions are totally opposed, your author and I, is what the chief qualities of a great actor are. I want him to have a lot of judgement, for me there needs to be a cool, calm spectator inside this man, so I demand sagacity and no feeling, the power to imitate anything, or, what amounts to the same thing, an equal aptitude for all characters and parts.

SECOND. No feeling!

FIRST. None. I haven't organized my arguments properly yet, and if I may, I'll set them out as they come to me, in the same disorder as they appear in your friend's book.

If the actor actually felt what he was doing, would it honestly be possible for him to play a part twice running with the same warmth and the same success? He would be full of warmth for the first performance and exhausted and cold as stone at the third. Whereas if he's a close imitator and thoughtful disciple of nature, the first time he appears on stage as Augustus, Cinna, Orosmane, Agamemnon, or Mahomet, being a strict copyist of his own acting or the part he has studied, and a constant observer of our sensations, his performance, far from falling off, will benefit from the new ideas he's gathered. He'll intensify or modify what he does, and you will be more and more satisfied. If he's himself when he acts, how will he stop being himself? If he wants to stop being himself, how will he know where the right point is to fix his performance?

What confirms me in my opinion is the unevenness of actors who play from the heart. Don't expect any kind of consistency from them; their performance is alternately strong and weak, hot and cold, dull and brilliant. The bit they do brilliantly today will be the one they muff tomorrow; and conversely, they'll do brilliantly in the one they muffed the day before. Whereas the actor who acts from the head, from studying human nature, from constantly imitating some ideal model, using his imagination and his memory, will always be the same, unchanged from one performance to the next, always with the same degree of perfection: everything has

been measured, thought out, learnt and organized in his head; there's no monotony, nothing out of place in his delivery. The warmth of his performance has its development, its leaps forward, its moments of calm, its beginning, its mean and its extreme. It's always the same accents, the same poses, the same movements: if there is any difference between one performance and the next it's usually to the advantage of the later one. He won't vary from day to day: he's a mirror, always ready to picture things and to picture them with the same accuracy, the same power and the same truth. Like the poet, he's ceaselessly delving into the inexhaustible wealth of nature, whereas he would soon have come to the end of his own potential.

Who can act with more perfection than Mademoiselle Clairon?[3] Yet if you follow her and study her you'll be convinced that by the sixth performance she'll know by heart every detail of her performance, just as she will every word of her part. Doubtless she has created a model for herself and tried to adapt her acting to it, doubtless this model she has created is the most elevated, the greatest and the most perfect she could think of; but this model which she has taken from history or which her imagination has created like a great phantom, it's not her: if this model were comparable to her, how weak and shallow her acting would be! Once hard work has brought her as close to this idea as she can get, the work is done; sticking to it is simply a matter of practice and memory. If you could be there when she was working on her part, how many times you would say: *You're there!* . . . and how many times she would reply: *You're wrong!* . . . It's like Le Quesnoy[4] when his friend took him by the arm and cried: *Stop! the best is the enemy of the good: you'll spoil everything* . . . 'You're seeing what I've done,' replied the breathless artist to the amazed connoisseur, 'but you don't see what I've got in my head and what I'm after.'

I don't doubt that Mademoiselle Clairon goes through the same torments as Le Quesnoy in the experimental stage; but when the struggle is over, when she's once on a level with her phantom, she's in control of herself, she can rehearse her part without any feeling.

Just as sometimes happens in our dreams, her head touches the clouds, her hands seek out the bounds of the horizon; she is the soul within a great lay figure enveloping her; her experiments have clothed her in it. Languidly stretched out on a *chaise-longue*, arms folded, eyes closed, motionless, she can follow her dream from memory and so hear and see herself, judge herself and the impression she'll create. In that moment she is two people: little Clairon and great Agrippina.

SECOND. To listen to you, there's nothing so much like an actor when he's on stage or working on his part than those children who pretend to be ghosts in cemeteries at night by lifting a big white sheet over their heads with a pole and then making a mournful voice come out from under this catafalque to frighten passers-by.

FIRST. You're right. It's not the same with Dumesnil[5] as with Clairon. She mounts the boards without any idea of what she's going to say; half the time she doesn't know what she's saying, but every now and then there's a great moment. And why should actors be any different from poets, painters, orators and composers? The decisive touches don't come in the fury of the initial inspiration but in cool, quiet moments, completely unexpected moments. You can't tell where these touches come from; they're all to do with inspiration. It's when they're suspended between nature and the outline of their work that these men of genius cast a careful eye from one to the other; the strokes of inspired beauty, the fortuitous touches which they distribute through their works and whose sudden appearance surprises even them, are effective and successful in an altogether more assured way than what they threw off in a flight of fancy. It needs a cool head to temper the frenzy of enthusiasm.

A violent man who's beside himself can never impose his will upon us: this is an advantage confined to the man who's in control of himself. The great dramatic poets in particular are keen observers of what's going on around them in the physical and moral world.

SECOND. Which are one and the same.[6]

FIRST. They seize on everything that strikes them and collect it

together. It's from these collections, formed inside them without their realizing it, that so many rare features pass into their works. The hot-blooded, violent, emotional men are on the stage, but they don't enjoy the performance. They are used by the man of genius to copy from. Great poets, great actors, and perhaps all the great imitators of nature, whatever they are, gifted as they are with a fine imagination, a delicate touch and sure judgement, are the least emotional of beings. They have an equal capacity for too many things; they are too busy watching, identifying and imitating to be deeply affected within themselves. I see them forever with a pad on their knees and a pencil in their hand.

We are the ones who feel; they observe, study and portray. Shall I say it? Why not? Sensibility is hardly ever the quality of a great genius. He will love justice; but he will exercise this virtue without experiencing its sweetness. He does everything through his head, not his heart. At the least unexpected thing, the man of feeling loses his head: he will never be a great king, a great minister, a great general, a great advocate or a great doctor. Fill the auditorium with these tearful people, but don't put any of them on the stage. Take women: they're certainly ahead of us, far ahead, where feeling is concerned; how do we compare with them in moments of passion? But as much as we lag behind them in action, they are behind us in imitation. Sensibility always implies a weakness in the system. The tear which escapes a man, a real man, moves us more than all the tears of a woman. In the great comedy, the comedy of the world, the one to which I always return, all the hot-blooded people are on the stage; all the men of genius are in the pit. The first are called madmen, the second, who are busy copying their follies, are called wise men. It's the wise man's eye which seizes on the ridiculous side of so many different people, portrays them, and makes you laugh not only at the troublesome characters of whom you've been the victim, but at yourself. He it was who was observing you and creating his comic version of the troublemaker and the things you suffered at his hands.

Even if these truths were proved, the great actors would never

admit them: it's their secret. Indifferent actors and novices are the type to reject them, and it could be said of a few others that they believe they're feeling, just as it's said of superstitious people that they believe they're believing, and that there's no hope for the second without faith, nor for the first without sensibility.

What? people will say, these accents, so plaintive, so full of grief, torn by a mother from the depths of her heart, and which move my own heart so violently, are they not produced by real emotion, are they not inspired by despair? Not at all; and the proof is that they're spoken in a certain rhythm; that they're part of a system of declamation; that if they go up or down by the twentieth part of a quarter tone they'll ring false; that they're subject to a law of unity; that, as in the harmonic system, they're built up to and balanced against each other; that they only satisfy all the necessary conditions by virtue of long study; that they all contribute to the solution of a given problem; that, in order to be correctly spoken, they've been rehearsed a hundred times, and that in spite of these frequent rehearsals, actors can still get it wrong. Because before saying:

Zaïre, vous pleurez!

[Zaïre, you are weeping!]

or

Vous y serez, ma fille,

[You will be there, my daughter,][7]

the actor has spent a long time listening to himself; and he's listening to himself at the very moment when he moves you, and all his talent consists not in feeling, as you suppose, but in giving such a scrupulous rendering of the outward signs of the feeling that you're taken in. His cries of pain are marked out in his ear. His gestures of despair are memorized and have been prepared in a mirror. He knows the precise moment when he'll take out his handkerchief and the tears will flow: expect them at that word, that

syllable, no sooner and no later. That tremor in the voice, those halting words, those stifled or lingering sounds, that trembling in the limbs, that shaking of the knees, those swoons, those furies: pure imitation, a lesson learnt in advance, a show of pathos, a sublime piece of clowning which will stay in the actor's memory long after he's worked on it, which he was fully aware of while he was performing it, which, luckily for the poet, the audience and himself, leaves his mind in complete control, and, like the other exercises, only saps the strength of his body. When the sandal or the buskin is laid aside, his voice is extinguished, he feels acute tiredness, he goes off to change his clothes or lie down; but there is no trace of mental disturbance, no grief, no melancholy, no feeling of depression. You are the one who takes all these impressions away with you. The actor is weary, and you are sad, because he has exerted himself without feeling anything, and you have had the feeling without the exertion. If it were otherwise, the actor's lot would be a most unhappy one. But he is not the character: he plays it, and he plays it so well that you think he is. The illusion is yours alone; he is well aware that it's not him.

The idea of different types of sensibility all working together to obtain the greatest possible effect, getting in tune with each other, softening the tone here, strengthening it there, blending into each other to form a unified whole, all that makes me laugh. So I insist on this: 'Extremes of feeling make for indifferent actors; an average amount of feeling gives you the great mass of bad actors; a complete absence of feeling is what is needed for a great actor.' An actor's tears pour down from his mind; those of a man of feeling well up from his heart, and it's the heart which creates so much trouble in the mind of the man of feeling; it's the mind which occasionally causes a fleeting disturbance in the heart of the actor: he weeps like an unbelieving priest delivering a sermon on the Passion, like a seducer at the feet of a woman he doesn't love but wishes to deceive, like a beggar in the street or at the door of a church who insults you when he despairs of touching your heart, or like a prostitute, feeling nothing, but swooning in your arms.

Have you ever thought about the difference between the tears produced by a tragic event and the tears produced by a moving story? You hear something beautiful being recounted: gradually your mind is troubled, your heart is moved, and the tears flow. On the other hand, at the sight of a tragic incident the object, the feeling and the effect come together; in a moment your heart is moved, you utter a cry, you lose your head and the tears flow; they come suddenly, whereas the others are brought on. That's the advantage of a natural, genuine *coup de théâtre* in an effectively delivered scene, it suddenly brings about what the scene had led you to expect. But the illusion is much more difficult to produce: one false, badly managed incident can destroy the effect. The sounds of the voice are much easier to imitate than movements, but movements have a more violent impact. There's the basis of a law to which I don't think there's any exception: that an incident should be resolved by an action, not a narrative, unless you want it to fall flat.

Well, haven't you any objections to make? I know what you'll say: you're telling a story to a small gathering of people, your heart is moved, your voice falters, you weep. You say you've felt this and felt it very deeply. I agree, but did you prepare the scene? No. Were you speaking in verse? No. And yet you carried your audience away, you amazed them, you touched their hearts, you produced quite an effect. All that is true. But take your intimate tone of voice, your simple way of speaking, your homely demeanour, your natural gestures across into the theatre and you'll soon see how weak and feeble you'll be. You can shed as many tears as you like, you'll still look ridiculous and get laughed at. It won't be a tragedy you're performing but a tragic parody. Do you imagine that scenes from Corneille, Racine, Voltaire, Shakespeare even, can be delivered in your conversational tones and your armchair voice? No more than your armchair story can be delivered with the strong emphasis and loud tones of the theatre.

SECOND. Perhaps because Racine and Corneille, great men though they were, never wrote anything worthwhile.

FIRST. What blasphemy! Who would dare to put such a thing forward? Who would dare to applaud it? Even Corneille's more familiar remarks cannot be said in a familiar tone.

But an experience you must have had a hundred times is that, at the end of your narrative, in the midst of the emotion and confusion you've spread amongst your little salon audience, someone new arrives whose curiosity you have to satisfy. You can't do it any more, your emotions are exhausted, you have no feeling, passion or tears left. Why doesn't the actor have the same feeling of collapse? Because there's a big difference between his involvement in a story told to please and the involvement you have in a misfortune which happened to your neighbour. Are you Cinna? Have you ever been Cleopatra, Merope, Agrippina? What are these people to you? And the Cleopatra, the Merope, the Agrippina, the Cinna of the stage, are they even historical figures? No. They're figments of the poetic imagination; I'm going too far: they're spectres created in the particular manner of various poets. Let these monstrous creatures stay on the stage with their gesturing, their strutting and their shouting; they'd cut a sorry figure in history: they'd draw shouts of laughter in a literary circle or any other social gathering.

People would whisper to each other: Is he going round the bend? Where did they get that Don Quixote from? Where did they dig up these stories? Where is the planet where they talk like that?
SECOND. But why don't they put you off in the theatre?
FIRST. Because it's a convention. It's a recipe from old Aeschylus; it's a system that goes back three thousand years.
SECOND. And will this system last much longer?
FIRST. I don't know. All I know is we're moving away from it as we get nearer our own period and our own country.

Do you know of a situation more like that of Agamemnon in the first scene of *Iphigénie* than the situation of Henri IV when, overcome by fears which were only too well founded, he said to those close to him: 'They'll kill me, nothing is more certain; they'll kill me . . .' Suppose this excellent man, this great and unhappy monarch, tortured in the night by this dread premonition, gets up and

goes and knocks at the door of Sully, his minister and friend; do you imagine any poet could be so absurd as to make Henri say:

> *Oui, c'est Henri, c'est ton roi qui t'éveille,*
> *Viens, reconnais la voix qui frappe ton oreille . . .*

[Yes, it is Henri, it is your king who awakens you; come, acknowledge the voice which strikes your ear . . .]

and make Sully reply:

> *C'est vous-même, seigneur! Quel important besoin*
> *Vous a fait devancer l'aurore de si loin?*
> *A peine un faible jour vous éclaire et me guide.*
> *Vos yeux seuls et les miens sont ouverts!*[8]

[It is you, my lord! What pressing need has caused you so far to anticipate the dawn? A feeble light scarcely illuminates you and guides me. Only your eyes and mine are open!]

SECOND. That was perhaps how Agamemnon really spoke.

FIRST. No more than Henri did. It's the language of Homer, of Racine, of poetry; and this pompous language can only be used by unknown people, and spoken by poetic voices in a poetic tone.

Just think for a moment about what on the stage is called *truth*. Does it mean showing things as they are in nature? Not at all. Truth in this sense would simply be the ordinary. What then is the truth of the stage? It's the conformity of the actions, the speeches, the face, the voice, the movement, the gesture, with an ideal model imagined by the poet and often exaggerated by the actor. That's the wonder of it. This model doesn't just influence the tone; it even alters the way a man walks, the way he looks. Which is why the actor in the street and the actor on the stage are two people so different that it's hard to recognize them. The first time I saw

Mademoiselle Clairon at home I couldn't help saying: 'Oh! I thought you were taller by a head.'

An unhappy woman, a really unhappy woman, will weep and not move you: worse still, if she has a slight disfigurement it will make you laugh, or a way of speaking peculiar to her will grate on your ear and offend you, or a movement she's in the habit of making will show up her grief as something low and sluttish, for extreme emotions nearly always give rise to grimaces which an undiscerning artist will copy slavishly, but which the great artist will avoid. We require that a man in his worst moments of suffering should preserve his manliness, the dignity of his kind. What is the result of this heroic effort? To distract from the grief and temper its effects. We require this woman to fall to the ground gently and gracefully, we require this hero to die like the gladiator of old, in the centre of the arena, amid the applause of the circus, with grace and nobility, in an elegant and picturesque attitude. Who will fulfil our expectations? Will it be the athlete who is overcome by grief and at the mercy of his feelings? Or a well-schooled athlete who's in control of himself and observes the rules of gymnastics as he breathes his last? The gladiator of old, like the great actor, and the great actor, like the gladiator of old, do not die as one dies in one's bed, but are obliged to perform another kind of death to please us, and a sensitive spectator would be aware that the naked truth, a performance totally unadorned, would be pitiful and out of keeping with the poetry elsewhere in the work.

Not that pure nature doesn't have its sublime moments; but I think that if anyone can be relied on to grasp and preserve that sublimity, it's someone who, having first felt those moments through his imagination or his genius, can then render them in cold blood.

All the same I wouldn't deny that a sort of emotional facility can be acquired or simulated, but if you want my opinion, I think it's almost as dangerous as natural sensibility. It will slowly lead an actor to be mannered and monotonous. It conflicts with the diversity which the great actor should cultivate; he's often obliged to free

himself from it, and such self-denial is only possible to an iron will. What's more, it would be better, both for the ease and success of his preparation, for the universality of his talent and for the perfection of his performance, if he didn't need to achieve that unimaginable separation of self from self which is so extremely difficult that it limits each actor to a single role, condemns companies to be very large, or else every play to be badly performed. Either that or you must upset the order of things, and write plays for actors, whereas in fact the actors should be made for the plays.

SECOND. But if a crowd of men were brought out into the street by some catastrophe and were suddenly to unleash, each in his own way, their natural sensibility, quite independently of each other, they will create a wonderful spectacle, a thousand precious models for sculpture, painting, music and poetry.

FIRST. That's true. But would this spectacle stand comparison with one which arose out of a deliberate agreement, out of the harmony which the artist will introduce when he transports it from the street-corner to the stage or the canvas? If that's what you think, then what, I would ask, is this much-vaunted magic of art, if it only serves to spoil what raw nature and a chance combination had managed better? Do you deny that nature can be improved upon? Have you never praised a woman by saying that she was like a *Virgin* by Raphael? At the sight of a beautiful landscape, have you never exclaimed that it was picturesque?[9] In any case, you're talking to me about something real, and I'm talking to you about an imitation; you're talking to me about a fleeting moment in nature, and I'm talking to you about a work of art, planned, followed through, with its own development and duration. Take each one of these actors, alter the scene in the street as you would on the stage, and show me your characters successively, alone, two by two, three by three; leave them to make their own movements; let them be absolute masters of their actions, and you'll see the extraordinary chaos which will result. To avoid this problem, would you make them rehearse together? Then goodbye to their natural sensibility, and good riddance.

It's the same with a play as with a well-ordered society, where everyone sacrifices some of his original rights for the good of the whole. Who will best appreciate the extent of this sacrifice? Will it be the enthusiast, the fanatic? Indeed not. In society, it will be the just man; in the theatre, the actor who has a cool head. Your street scene is to the dramatic scene as a horde of savages is to a gathering of civilized men.

This is the place to talk to you about the perfidious influence which an indifferent partner can have on an excellent actor. The latter will have prepared his part on a grand scale, but he'll be forced to desert his ideal model to come down to the level of the poor chap he's on the stage with. Then he abandons study and good judgement: a thing which happens automatically if you're walking or sitting by the fireside: the person who speaks softly lowers the voice of the person he's talking to. Or if you prefer another comparison, it's like in whist, when you lose part of your skill if you can't rely on your partner. And here's another thing: La Clairon will tell you, if you like, that Le Kain,[10] out of spite, made her play badly or indifferently whenever he wanted to, and that to get her own back she sometimes made the audience hiss him. What then of two actors who give each other mutual support? They are two characters whose models, other things being equal, observe the equality or distance which fits the situation in which the poet has placed them; otherwise one of them would either be too strong or too weak. And to make up for this mismatch, the strong one will rarely be able to raise the weak one up to his level, but by giving thought to it he can descend to his level of weakness. And do you know what the purpose is of all these rehearsals? It's to achieve a balance between the different talents of the actors so as to arrive at an even quality in the general performance; and when one of them resists this balance out of pride, it's always at the expense of the perfection of the whole, and to the detriment of your enjoyment; for it's very rare that the excellence of a single actor can compensate for the mediocrity of the others which it brings out. I've sometimes seen the personality of a great actor punished when the audience

stupidly declared that he was overacting, instead of realizing that he had a weak partner.

Now you're a poet: you have a play to put on, and I leave you to choose between actors who have keen judgement and cool heads, or actors of sensibility. But before you decide, allow me to ask you a question. At what age is one a great actor? Is it when one is full of passion, when the blood is pulsing through one's veins, when the slightest shock upsets one's emotions, when the mind catches fire at the smallest spark? I think not. The man whom nature has marked out as an actor will only excel in his art when he has long experience behind him, when the tumult of the passions has died down, when his head is calm and his mind is in control of itself. The best-quality wine is bitter and rough when it's fermenting; only when it's been a long while in the cask does it become full-bodied. Cicero, Seneca and Plutarch represent for me the three ages of the creative writer: Cicero is often nothing but a straw fire which delights my eyes; Seneca a burning vine which hurts them; whereas if I stir the ashes of old Plutarch, I uncover the great coals of a steady fire which gently warm me.

Baron, when he was past sixty, played the Earl of Essex, Xipharès and Britannicus, and played them well. La Gaussin was a delight in *L'Oracle* and *La Pupille* at fifty.[11]

SECOND. She didn't exactly have the face for the part.

FIRST. That's true, and that's perhaps one of the insurmountable obstacles to the excellence of a performance. One needs to have spent long years treading the boards, and the role sometimes demands a person in their first youth. If there has been an actress of seventeen capable of playing Monime, Dido, Pulchérie and Hermione, it's a miracle we shan't see again. But an old actor is only ridiculous when his powers have finally deserted him, or when the superiority of his acting doesn't make up for the contrast between his age and his role. It's the same in the theatre as in society, where you only criticize a woman for her affairs when she no longer has enough talents or other qualities to cover up her bad behaviour.

In our own day Clairon and Molé[12] started off by acting almost

like automata, and then they showed themselves to be true actors. How did that come about? Did their feelings and sensibility and emotions come to them as they grew older?

Only a short while ago, after ten years away from the stage, Clairon decided to come back; if she acted poorly, was it because she had lost her feelings, her sensibility and her emotions? Not in the least; she'd lost her memory of the roles. The future will tell.

SECOND. What, do you think she'll come back to us?

FIRST. Either that or she'll die of boredom, for what do you think can replace the applause of the public or a great love? If this actor or that actress were, as they're supposed to be, emotionally involved in their parts, tell me if one of them would think to cast a glance at the boxes, another to direct a smile towards the wings, nearly all of them to speak to the people in the pit, and if they'd go to the greenroom and interrupt the crazy laughter of another to tell him it's time to come and run himself through with a dagger?

But I've an urge to sketch out a scene for you of an actor and his wife who couldn't stand each other, a scene of tender and passionate love, a scene played on the stage before the public, just as I'm going to give it to you, or perhaps a little better, a scene where two actors have never seemed more involved in their parts, a scene which drew the continuous applause of the pit and the boxes, a scene which was interrupted over and over by our clapping and shouting. It's the third scene of the fourth act of Molière's *Dépit amoureux*, their triumph.

The actor ERASTE, *lover of Lucile;* LUCILE, *lover of Eraste and wife of the actor.*

ACTOR

No, no, do not think, my dear, that I return once more to speak to you of my love.

Actress. You'd better not.

It is finished.

I should hope so.
I desire to cure myself and I know well how much of your heart my own possessed.
More than you deserved.
Such lasting anger to repay the mere shadow of an offence
You offend me? I'd never do you that honour.
has made me only too aware of your indifference and I must prove to you that the shafts of scorn
of the deepest kind
are felt most cruelly by noble spirits.
Yes, noble spirits.
I will own that my eyes observed in yours charms which they never found in any others,
Not for want of trying
and the delight I felt in my bonds would have made me reject the offer of a sceptre
You got it cheaper than that.
I lived entirely for you,
That's not true; you were lying.
and I will even confess that perhaps after all that, and despite this affront, I shall yet find it hard to break with you.
That would be a pity.
It is possible that, despite this attempted cure, my heart will still bleed from this wound,
Don't worry, it's full of gangrene.
and that, freed from a burden which was all my happiness, I shall have to resolve never to love again.
You'll find plenty of people to help you there.
But it matters not in the end; and since your hatred so often dismisses a heart which love returns to you, this is the last time I shall ever importune you with my rejected desires.

ACTRESS

You may relieve my own desires entirely, Sir, and spare me this last importunity.
Actor. My dear, you'll be sorry for this impudence.

ACTOR

Well then, Madam, your wishes will be satisfied. I am breaking with you, and I am breaking for ever. Since this is what you wish, let me die if I ever desire to speak to you again.

ACTRESS

So much the better, you do me a service.

ACTOR

No, no, have no fear
Actress. I'm not afraid of you.
that I should break my promise. If my heart were so weak as never to be able to wipe out the memory of you, believe me, you will never have the benefit
Misfortune, you mean.
of seeing me return.

ACTRESS

It would be in vain.
Actor. My sweet, you're nothing but a whore, and I'll teach you to mind your tongue.

ACTOR

I should pierce my breast a thousand times
Actress. I wish you would.
if ever I were to perform such a base act
Why not this one, after so many others?
as to see you again, after this vile treatment.

ACTRESS

So be it; let us say no more.

And so on. After this dual scene, of lovers and of a married couple, when Eraste was taking his lover Lucile back into the wings he squeezed her arm so violently that he tore the flesh of his dear wife, and answered her cries with the most insulting and bitter words.

SECOND. If I'd heard these simultaneous scenes, I don't think I'd ever have set foot in the theatre again.

FIRST. If you claim that this actor and actress felt what they were saying, I would ask you whether it was in the lovers' scene or in the married couple's scene, or both? But listen to the following scene between the same actress and another actor, her lover.

While the lover is speaking, the actress says of her husband: 'He's a swine, he called me . . .; I couldn't bring myself to repeat it.'

While she's replying, her lover replies to her: 'Aren't you used to it by now?' . . . And so on from couplet to couplet.

'Are we dining tonight? – I'd love to, but how can I get away? – That's your problem. – What if he finds out? – He'll still have been had, and we shall have enjoyed a pleasant evening. – Who shall we invite? – We must have the Chevalier, he belongs with us. – That Chevalier, you know if it were left to me, I could be jealous of him. – And if it were left to me, you could be right.'

So it was that these beings of such sensibility seemed to you to be entirely involved in the lofty scene you were hearing, when in fact they were simply concerned with the abject scene you weren't hearing; and you exclaimed: 'It must be confessed that this woman is a delightful actress; no one can listen as she does and she performs with an intelligence, a grace, a concern, a subtlety and a sensibility quite out of the ordinary . . .' As for me, I found your comments hilarious.

And all the time this actress is deceiving her husband with another actor, this actor with the Chevalier, and the Chevalier with a third, whom the Chevalier catches in her arms. He plans a signal act of revenge. He finds a seat on the lowest steps of the balconies. (This was before the Comte de Lauraguais had freed the stage of spectators.)[13] From there he resolved to disconcert this faithless woman by his presence and his scornful gaze, to upset her and expose her to the jeers of the pit. The play begins; the traitress appears; she sees the Chevalier; and, without departing from her role, she says to him with a smile: 'Go on with you; fancy sulking like that and getting upset over nothing.' The Chevalier smiles in

his turn. She goes on: 'Let's put an end to this sad little quarrel: bring up your carriage . . .' And do you know the scene where this was interpolated? One of the most moving of La Chaussée's,[14] where this actress was sobbing and bringing hot tears to our eyes. This astounds you, but it's the absolute truth.

SECOND. It's enough to turn me off the theatre.

FIRST. Why should it? If these people weren't capable of such feats then one ought not to go and see them. What I'm about to tell you now I've seen myself.

Garrick pushes his head out between the two halves of a double door and, in the space of five or six seconds, his expression goes successively from wild joy to moderate joy, from this joy to tranquillity, from tranquillity to surprise, from surprise to astonishment, from astonishment to sadness, from sadness to despondency, from despondency to fear, from fear to horror, from horror to despair, and then returns from this last level to the point from which it came. Was he capable of experiencing all these sensations and, with the cooperation of his face, performing this scale, as you might call it? I don't think so for a moment, and nor do you. If you asked this famous man, who alone made it just as worthwhile to make the journey to England as all the remains of ancient Rome made it worth the journey to Italy; if you asked him, I say, for the Little Baker's Boy scene, he would play it for you; if you asked him straight afterwards for the Hamlet scene, he would play it for you, just as ready to cry over the little pies he'd dropped as to watch the dagger as it moved through the air.[15] Can one laugh, can one weep, as the fancy takes one? One can put on the right face with more or less accuracy according to whether one is or is not Garrick.

I sometimes do performances myself, effectively enough even to impress the sharpest minds amongst men of the world. When I grieve over the feigned death of my sister in the Norman lawyer scene, when, in the scene with the first steward of the naval ship, I confess to fathering a child on a captain's wife, I look exactly as though I'm feeling grief and shame; but am I afflicted? am I ashamed? No more in my little act than in a social gathering, where

I played these two roles before I put them into a work for the theatre.[16] What is a great actor, then? A great tragic or comic performer to whom the poet has dictated his part.

Sedaine had *Le Philosophe sans le savoir* put on.[17] I was more concerned than he was that the play should succeed; envy of other people's talent is a vice which is foreign to me, I've got enough others without that: I call on all my literary friends to witness whether, when they've sometimes been so good as to consult me about their works, I haven't done everything in my power to respond worthily to this distinguished mark of their esteem. *Le Philosophe sans le savoir* had a shaky reception at its first and second performances and I was distressed; at the third it went brilliantly and I was carried away with joy. The following morning I jumped into a cab and dashed off to find Sedaine; it was winter and bitterly cold; I went everywhere I could hope to find him. I discovered he was down in the Faubourg Saint-Antoine and I arranged to be taken there. I went up to him; I threw my arms round his neck; my voice failed me, my tears ran down my cheeks. There's the ordinary man of sensibility for you. Sedaine, motionless and cool, looked at me and said: *Oh, Monsieur Diderot, how beautiful you are!* There's the observer and the man of genius.

I was telling this story one day at the table of a man destined by his superior talents to occupy the most important office of state, Monsieur Necker;[18] there were quite a number of men of letters there, including Marmontel,[19] whom I like and who is fond of me. He said to me, with a touch of irony: 'So when Voltaire gets upset at simply hearing about some moving event and Sedaine remains cool at the sight of a friend bursting into tears, it's Voltaire who's the ordinary man and Sedaine the man of genius!' This remark disconcerted me and reduced me to silence, because the man of sensibility, like me, completely overcome by the argument against him, loses his head and only recovers when he gets to the bottom of the stairs. Another man, cool and in control of himself, would have replied to Marmontel: 'Your comment would have come better from other lips than yours, because you have no more feeling than

Sedaine and you also produce some very fine things, and, being in the same business, you could have left it to your neighbour to appreciate his merits impartially. But without wishing to prefer Sedaine to Voltaire, or Voltaire to Sedaine, could you tell me what might have come from the mind of the author of *Le Philosophe sans le savoir*, *Le Déserteur* and *Paris sauvé* if, instead of spending thirty-five years of his life wasting plaster and cutting stone, he had used all this time, like Voltaire, you and me, in reading and meditating on Homer, Virgil, Tasso, Cicero, Demosthenes and Tacitus? We will never be able to see as he does, and he would have learnt to speak like us. I regard him as one of the great-grandchildren of Shakespeare, this Shakespeare whom I shall not compare to the Apollo of Belvedere, nor to the gladiator, nor to Antinous, nor to the Hercules of Glyco, but rather to the St Christopher of Notre-Dame, a shapeless colossus, crudely sculpted, but through whose legs we could all pass without our heads touching his private parts.'

But here's another example I'll give you of a character being made dull and stupid by his sensibility at one moment and at the next becoming sublime, when his sensibility was stifled and self-control took over:

A literary man, whose name I will not reveal, had fallen into extreme poverty. He had a brother, a wealthy prebendary. I asked this poor man why his brother did not help him. 'Because', he answered, 'I have done him a number of wrongs.' I obtained his permission to go and see the prebendary. I went. I was announced and went in. I said to the prebendary that I was going to talk about his brother. He seized me roughly by the hand, made me sit down and remarked that a man of good sense should know the person whose cause he has undertaken to plead. Then, addressing me forcefully: 'Do you know my brother?' 'I think so.' 'You think so? So you know . . .?' And the prebendary began to recite, with amazing speed and energy, a series of acts each more horrible and repulsive than the last. My head was in a whirl, I was overwhelmed; I no longer had the spirit to defend such an abominable monster as was being described to me. Fortunately the prebendary, who was

somewhat prolix in his philippic, allowed me time to recover. Gradually the man of sensibility withdrew and made way for the man of eloquence, for I make bold to say that I was eloquent on this occasion. 'Sir,' I said coolly to the prebendary, 'your brother has done worse than this, and I compliment you on concealing the most glaring of his crimes.' 'I am concealing nothing.' 'You could have added to everything you have told me that one night, when you were leaving home to go to matins, he took you by the throat, and, drawing out a knife which he had hidden under his coat, he was about to sink it into your breast.' 'He is perfectly capable of such a thing, but if I didn't accuse him of it, it's because it isn't true ...' And I, standing up suddenly, and fixing a firm and severe eye upon the prebendary, thundered, with all the energy and vigour which indignation inspires: 'And even if it were true, should you not still give bread to your brother?' The prebendary, crushed, cast down, overwhelmed, remained silent, walked away, came back to me and gave me an annual pension for his brother.

Do you write a poem on the death of your friend or your beloved at the very moment when you have lost them? No. Woe betide the man who makes use of his talent then! It's when the heavy grief has passed, when the sharpest feelings are dulled, when you are removed from the disaster and the mind is calm that you recall your lost happiness: then you are able to appreciate the loss you have suffered, then the memory joins together with the imagination, one to retrace, the other to enlarge upon the sweetness of past times. You must be in control and speak well. The poet says he is weeping, but he does not weep when he is looking for a forceful epithet which won't come; he says he is weeping, but he does not weep when he is trying to produce an elegant verse: or if the tears do flow, the pen will fall from his hand, he will abandon himself to his feelings and stop writing.

But violent pleasure is like deep sorrow: it's silent. A tender, sensitive friend sees a friend who had been lost to him through a long absence; this friend reappears unexpectedly and immediately the other's mind becomes confused: he runs towards him, embraces

him, tries to speak, but he cannot: he stammers out broken words, doesn't know what he's saying, understands nothing of what is said to him; if he were to realize that his excitement is not shared, how he would suffer! You can judge from the truth of this description how false these theatrical conversations are when two friends are so witty and self-possessed. What I could say to you of those insipid and eloquent disputes about who is to die, or who is not to die, if this matter, on which I could talk for ever, didn't distract us from our subject! This will suffice for people of superior, genuine taste; whatever else I said would not teach the others anything. But who can remedy these absurdities which are so common in the theatre? The actor; but what actor?

For one case where it's not, there are a thousand where sensibility is as harmful in society as it is on the stage. Here are two lovers: they both have a declaration to make. Which one will have more success? Not I. I remember how I always trembled when I approached the one I loved; my heart was thumping, my thoughts were confused, my words were mixed up, I made a mess of everything I said, I answered *no* when I should have said *yes*, I made endless clumsy and awkward remarks, I looked ridiculous from my head to my feet: I knew it and only looked more ridiculous. At the same time, before my eyes, a cheerful, agreeable, relaxed rival, self-possessed, enjoying what he was doing, missing no opportunity for flattery, and clever flattery at that, managed to be amusing and pleasing, and successful; he asked for a hand which was abandoned to him, he took it sometimes without asking, he kissed it, he kissed it again, and I, away in a corner, turning my eyes from a sight which angered me, stifling my sighs, clenching my fists so that the joints of my fingers cracked, overcome with sadness, bathed in cold sweat, could neither show nor hide my vexation. It's been said that love, which takes away the presence of mind of those who possess it, gives it to those who lack it; which is to say, in other words, that it makes some people sensitive and stupid, and others cool and enterprising.

The man of sensibility obeys natural impulses and expresses

nothing but the cry from his heart; as soon as he begins to control or constrain this cry, he's no longer himself, but an actor playing a part.

The great actor observes the phenomena around him; the man of sensibility is his model, which he reflects upon, and, thanks to this reflection, decides what is best to add or take away. And now, after the arguments, some facts.

At the first performance of *Inès de Castro,* at the point where the children appear, the pit started laughing; Duclos, who was playing Inès, said to them: 'Laugh then, you stupid people, at the finest thing in the play.' The pit understood and calmed down; the actress resumed her performance and the tears flowed, both hers and the public's.[20] How is it possible to go backwards and forwards between one deep feeling and another deep feeling, from grief to indignation and from indignation back to grief? I can't imagine; but what I can very well imagine is that Duclos's indignation was real and her grief was put on.

Quinault-Dufresne was playing the part of Sévère in *Polyeucte.* He was sent by the Emperor Decius to persecute the Christians. He confided his secret views about this maligned sect to his friend. Common sense demanded that this confidence, which could cost him the favour of the prince, his dignity, his fortune, his freedom and perhaps his life, should be made in a low voice. The pit shouted: 'Speak up!' He replied to them: 'And you, gentlemen, quieten down!' If he had really been Sévère, would he have become Quinault again so quickly? No, I tell you, no. Only a man who is in complete control of himself as he no doubt was, the actor in a million, the man of the stage *par excellence,* can take his mask off and put it on again like that.

Le Kain as Ninias descends into his father's tomb and kills his mother; he emerges with his hands covered in blood. He's filled with horror, his limbs are trembling, he has a wild look in his eyes, his hair seems to be standing on end. You can feel a tingling on your own head, you're seized with terror, you're as distraught as he is.[21] Yet Le Kain–Ninias can kick a diamond earring which an

actress had lost into the wings. Is this actor feeling? Impossible. Are you going to say he's a bad actor? I don't think so for a moment. What is Le Kain–Ninias, then? He's a cold man who feels nothing, but who can give a superb impression of feeling. He may well cry: 'Where am I?' I shall answer: 'Where are you? You know very well where you are: you're on the stage, and you're kicking an earring into the wings.'

Take an actor who's fallen for an actress; it happens that they're together in a scene involving jealousy. If it's an ordinary actor, the scene will gain by it; if it's a true actor, it will lose, because the great actor becomes himself instead of the ideal, sublime model of a jealous man he's created for himself. A proof of the fact that the actor and the actress both descend to ordinary life is that, if they stayed up on their stilts, they would roar with laughter at each other; that high-flown, tragic jealousy would often strike them as a blown-up version of their own.

SECOND. Yet there will be truths of nature there.

FIRST. Just as there are in a statue by a sculptor who's given a faithful rendering of a poor model. You admire the truths, but you find the whole thing mean and contemptible.

I'd go further: a sure way to give a weak, pitiful performance is to have to play one's own character. If you're a hypocrite, a miser or a misanthropist, you'll play the part well; but you won't produce what the poet created, because he created the Hypocrite, the Miser and the Misanthropist.

SECOND. What difference do you see between a hypocrite and the Hypocrite?[22]

FIRST. Commissioner Billard is a hypocrite, the abbé Grizel is a hypocrite, but they're not the Hypocrite. The financier Toinard was a miser, but he was not the Miser.[23]

The Miser and the Hypocrite were modelled on all the Toinards and Grizels in the world; they possess their most general and striking features, but they're not the portrait of any one of them; so no one recognizes himself in them.

Comedies of fantasy and even comedies of character are exagger-

ated. The wit you find in society is a light froth which evaporates on the stage; wit in the theatre is a sharp sword which would inflict wounds in society. We don't have the same consideration for imaginary creatures as we ought to have for real ones.

Satire is about a hypocrite, and comedy is about the Hypocrite. Satire attacks the vicious, comedy attacks vice. If there had only been one or two *précieuses ridicules*, one might have made a satire out of it, but not a comedy.[24]

Go and see Lagrenée,[25] ask him for *Painting*, and he'll think he's given you what you want when he's put a woman on the canvas sitting in front of an easel with her thumb through a palette and a brush in her hand. Ask him for *Philosophy*, and he'll think he's done it by painting a woman, informally dressed, with her hair down, looking pensive, leaning on her elbow at a desk at night, by the light of a lamp, and reading or meditating. Ask him for *Poetry*, and he'll paint the same woman, wind a wreath of laurels round her head and put a scroll in her hand. *Music*, the same woman again with a lyre instead of a scroll. Ask him for *Beauty*, or even ask a more accomplished painter for the same figure, and unless I'm much mistaken, this one too will be convinced that all you want from his skill is the face of a pretty woman. Your actor and this painter are both committing the same error, and I'd say to them: 'Your picture, your performance, are just portraits of individuals which come nowhere near the general idea which the poet has sketched out, nowhere near the ideal model of which I'd hoped for a copy. Your neighbour is beautiful, very beautiful, I agree, but this is not beauty. There's as much distance between your work and your model as there is between your model and the ideal.'

SECOND. But isn't this ideal model a figment of the imagination?

FIRST. No.

SECOND. But if it's ideal, it doesn't exist: now there's nothing in the mind which was not first in our senses.

FIRST. True. But let's consider an art in its origins: sculpture, for instance. It copied the first model that presented itself. It then saw that there were less imperfect models, and it preferred these. It

corrected their obvious defects, then the less obvious defects until, by continual efforts, it arrived at a face which was not present in nature.

SECOND. How so?

FIRST. Because it's impossible for a machine as complicated as an animal body to develop in a regular way. Go to the Tuileries or the Champs-Elysées on a fine holiday; look at all the women thronging the avenues and you won't find one with one side of her mouth exactly the same as the other. Titian's Danaë is a portrait; Love, at the foot of her couch, is ideal. In a Raphael, which went from Monsieur de Thiers's gallery to Catherine II's,[26] the St Joseph is an ordinary figure; the Virgin is a real, beautiful woman; the infant Jesus is idealized. But if you want to know more about these theoretical principles of art, I'll let you have my *Salons*.

SECOND. I've heard them very highly spoken of by a man of fine taste and discerning judgement.

FIRST. Monsieur Suard.[27]

SECOND. And by a woman who possesses everything that the purity of an angelic soul can add to the distinction of her taste.

FIRST. Madame Necker.

SECOND. But let's get back to our subject.

FIRST. All right, though I prefer praising virtue to discussing these somewhat otiose questions.

SECOND. Quinault-Dufresne, a conceited character, played that part brilliantly in *Le Glorieux*.[28]

FIRST. True, but how do you know he was playing the role of himself? or why shouldn't nature have created a conceited man very close to the limit between real beauty and ideal beauty, the limit where the different schools operate?

SECOND. I don't understand you.

FIRST. I make myself clearer in my *Salons*, where I suggest you read the piece on beauty in general.[29] Meanwhile, tell me, is Quinault-Dufresne Orosmane? No. Yet who has ever replaced him or will replace him in this part? Was he the man in *Le Préjugé à la mode*?[30] No. But wasn't he exactly right in this part?

SECOND. If you're to be believed, the great actor is everything and nothing.

FIRST. And perhaps it's because he's nothing that he's everything to perfection, since his particular form never stands in the way of the alien forms he has to assume.

Of all those who have exercised the fine and valuable profession of actor, or lay preacher, one of the most respectable men, one of the men who more than any others had the face, the voice and the bearing for it, the brother of the *Diable boiteux*, *Gil Blas*, the *Bachelier de Salamanque*, Montmesnil . . .

SECOND. The son of Le Sage, father of all that amusing family . . .[31]

FIRST. . . . was equally successful as Ariste in *La Pupille*, Tartuffe in the comedy of that name, Mascarille in *Les Fourberies de Scapin*, the lawyer or Monsieur Guillaume in the farce *Patelin*.

SECOND. I saw him.

FIRST. And to your considerable amazement, he wore the mask of all those different faces. Not naturally, because nature only gave him his own; so his art gave him the others.

Is there such a thing as an artificial sensibility? But whether it's assumed or innate, sensibility is not a feature of every role. What then is the quality, acquired or natural, which goes to make up the great actor in *L'Avare*, *Le Joueur*, *Le Flatteur*, *Le Grondeur*, *Le Médecin malgré lui*, who is the least feeling and most immoral character ever created in literature, *Le Bourgeois Gentilhomme*, *Le Malade imaginaire* and *Le Cocu imaginaire*; or in *Néron*, *Mithridate*, *Atrée*, *Phocas*, *Sertorius* and so many other tragic or comic characters, where the quality of feeling is diametrically opposed to the spirit of the part? It's the ease with which they can understand and copy any kind of nature. Believe me, we mustn't look for many causes when one is enough to explain every phenomenon.

There are times when the poet has had a more powerful feeling than the actor, and others, more frequent perhaps, when the actor has had a more powerful conception than the poet; and nothing is more true than that exclamation of Voltaire, when he heard Clairon in one of his plays: *Did I write that?* Does Clairon know more about

it than Voltaire? At that moment in the delivery at least, her ideal model was far beyond the ideal model the poet had imagined when he was writing, but that ideal model was not her. Where did her talent lie, then? In imagining a great phantom and copying it brilliantly. She was imitating the movement, the actions, the gestures, the whole expression of a being far above herself. She had found what Aeschines, reciting an oration by Demosthenes, could never render, the roaring of the beast. He used to say to his followers: 'If that has such an effect on you, how would it have been *si audivissetis bestiam mugientem?*'[32] The poet had created the terrible animal, Clairon made it roar.

It would be a singular abuse of words if we were to define sensibility as that easy ability to render any kind of nature, even savage kinds. Sensibility, in the only sense which has so far been given to this word, is, it seems to me, that disposition which goes with a weakness in the physical make-up and results from a sensitive diaphragm, a lively imagination and delicate nerves, and produces a tendency to sympathize, to thrill, to wonder, to take fright, to get upset, to weep, to faint away, to succour, to flee, to cry out, to lose one's head, to exaggerate, to scorn, to disdain, to have no clear idea of what is true, good and beautiful, to be unjust, to lose one's wits. If you increase the numbers of people of sensibility you'll increase in the same proportion good and bad actions of every kind, exaggerated praise and blame.

Poets, if you are writing for a delicate, dreamy, sensitive people, confine yourselves to the melodious, tender and touching elegies of Racine, for they would run away from the butcheries of Shakespeare: these feeble souls are unable to bear violent shocks. Make sure you don't offer them strong images. Show them, if you will,

> Le fils tout dégouttant du meurtre de son père,
> Et sa tête à la main demandant son salaire . . .[33]

[The son, his hands dripping with blood from the murder of his father, holding his head as he demands his reward . . .]

but don't go any further. If you dared to say to them with Homer: 'Where are you going, wretched creature? Do you not know that it is to me that heaven sends the children of fathers in misfortune; you will not receive the last embraces of your mother; already I see you stretched out on the ground, already I see the birds of prey, gathered round your corpse, tearing the eyes out of your head as they flap their wings with delight', all our women would turn their eyes away and cry: 'Oh! how dreadful! . . .' It would be even worse if this speech, delivered by a great actor, were fortified with the declamation that suited it.

SECOND. I'm tempted to interrupt you to ask you what you think of the vase presented to Gabrielle de Vergy, in which she sees the bloody heart of her lover.[34]

FIRST. My answer is that you must be consistent, and that, if you object to this spectacle, you must not allow Oedipus to appear with his eyes gouged out, and you must banish from the stage the scene where Philoctetes is in agony from his wound and expresses his suffering with inarticulate cries. The Ancients, I think, had a different idea of tragedy from ourselves, and these Ancients were the Greeks, the Athenians, a people of such sensitivity, who left us models in every genre which the other nations have not yet equalled. Aeschylus, Sophocles, Euripides didn't burn the midnight oil for years on end just to produce these little passing impressions which vanish while you're enjoying your supper. They wanted to make people feel deep sorrow for the unfortunate; they wanted not just to amuse their fellow citizens but to make them better people. Were they right or wrong in this? To achieve this effect they made the Eumenides rush across the stage in pursuit of the parricide, led on by the fumes of blood as it reached their nostrils. They had too much judgement to applaud these complicated plots, these conjuring tricks with daggers, which are fit only for children. In my view, a tragedy is simply a fine page from history divided into a certain number of points where the action is suspended. The sheriff is awaited. He comes. He questions the head of the village. He wants him to abandon his faith. He refuses. The sheriff condemns him to

death. He sends him to prison. The daughter comes and asks for her father to be released. The sheriff grants her wish on one repulsive condition. The village head is executed. The villagers pursue the sheriff. He takes flight. The lover of the head's daughter strikes him dead with his dagger; and the hateful fanatic dies amid the imprecations of the people. That is all a poet needs to create a great work. Let the daughter go to her mother's grave to learn what her duty is to the man who gave her life. Let her be unsure whether she should make the sacrifice of honour which is demanded of her. Let her, in this time of indecision, keep her lover away and refuse to listen to his protestations of love. Let her obtain permission to see her father in prison. Let her father want her to marry her lover and let her refuse. Let her prostitute herself. Let her father be put to death when she does prostitute herself. Let the audience be unaware of her prostitution until the moment when her lover, seeing her grief-stricken when he tells her of her father's death, learns of the sacrifice she has made to save him. Then let the sheriff come on, pursued by the people, and be slaughtered by the lover. These are some of the details possible in a subject of this sort.

SECOND. Some!

FIRST. Yes, some. Couldn't the young lovers encourage the head of the village to run away? Couldn't the villagers suggest he kills the sheriff and his minions? Won't there be a priest to speak in favour of tolerance? Will the lover remain idle in this time of affliction? Can we not suppose there to be some relationships between these characters? Is there no advantage to be taken of these relationships? Can't the sheriff have been the lover of the village head's daughter? Does he not return bent on vengeance, both towards the father, who can have expelled him from the village, and towards the daughter, who can have rejected his advances? There's no end to the important incidents one can develop from the simplest subject if one takes the time to think about it! How much colour one can put into them if one can be eloquent! No one can be a dramatic poet without eloquence. And do you imagine I shall want for spectacle? That cross-examination of the village head by the sheriff will be

carried out with all the trappings. Leave me free to arrange the setting, and now let's end this digression.

I call you to witness, English Roscius, famous Garrick, you who, by the unanimous consent of all the nations there are, are acknowledged to be the finest of all actors, pay homage to the truth! Did you not say to me that, although you felt strongly, your acting would be weak if, whatever the passion or character you had to play, you were not able to rise up in your thoughts to the level of the Homeric phantom with which you were trying to identify? When I objected that it could not be yourself that you were modelling your performance on, confess what your answer was: did you not admit that that was the last thing you did, and that the reason you made such an amazing impression on stage was that you were always exhibiting a creature of the imagination which was not you?

SECOND. The soul of a great actor has been formed from that subtle element with which our philosopher[35] filled space, and which is neither hot nor cold, nor heavy, nor light, takes no fixed form, and, equally capable of taking any, persists in none of them.

FIRST. A great actor is neither a pianoforte, nor a harp, nor a harpsichord, nor a violin, nor a cello; he has no harmony of his own, but he can assume the harmony and the tone which fit his part, and he can lend his talent to all of them. I have a high opinion of the talent of a great actor: such men are rare, as rare and perhaps greater than poets.

Anyone in society who wants to please everyone, and has the unfortunate talent to be able to, is nothing, possesses nothing which is proper to him or distinguishes him, nothing which might bring delight to some and tedium to others. He talks all the time, and always talks well; he is a professional sycophant, a great courtier, and a great actor.

SECOND. A great courtier, accustomed, since first he drew breath, to the role of a fabulous puppet, takes on all manner of forms in obedience to the strings in the hands of his master.

FIRST. A great actor is another fabulous puppet whose strings are

held by the poet, and he tells him with each line what form he must take.

SECOND. So a courtier and an actor who can only take one form, however beautiful and interesting it is, are only a pair of bad puppets?

FIRST. It's not my purpose to run down a profession which I love and esteem; I'm speaking of actors here. I should be very sorry if my observations, badly understood, were to diminish in any way men who possess a rare talent and a real value, these scourges of stupidity and vice, these most eloquent preachers of honesty and the virtues, these sticks which the man of genius uses to chastise the wicked and the foolish. But cast your eyes around you, and you'll see that people who are constantly good-humoured have neither great faults nor great virtues; that usually those who are profession-ally amusing are frivolous people, lacking any firm principles; and that those who, like certain people who frequent polite society, are without character, excel in playing all characters.

Does an actor not have a father, a mother, a wife, children, brothers, sisters, acquaintances, friends, a mistress? If he were gifted with that exquisite sensibility which is regarded as the chief quality of his calling, given that he's harassed as we are, and affected by a succession of troubles which sometimes dry up our emotions and sometimes tear them apart, how many days would he have left over for our amusement? Very few. It would be no use the gentleman of the chamber asserting his authority, the actor would often find himself forced to reply: 'Sir, I cannot laugh today', or 'I have other concerns than those of Agamemnon to weep over.' Yet it's not noticeable that the sorrows of life, which are just as frequent for them as for us, and far more likely to interfere with the free exercise of their activity, suspend it very often.

In society, when they are not clowning about, I find them polite, abrasive and cool, pompous, dissipated, spendthrift, self-interested, more affected by our foibles than touched by our misfortunes, relatively unmoved at the spectacle of an unfortunate event, or the account of a moving incident, solitary, unsettled, dependent on the

great; few morals, no friends, hardly any of those sweet and sacred bonds which acquaint us with the pains and pleasures of another who shares our own. I have often seen an actor laughing off-stage, but I don't recall ever having seen one weeping. This sensibility which they claim as their own, and which we attribute to them, what do they do with it then? Do they leave it on the boards when they step down and pick it up again when they go back?

What leads them to step into the clog or the buskin? A lack of education, poverty and debauchery. The theatre is a last resort, never a choice. No one ever became an actor out of love for virtue, the desire to be of use in society and to serve his country or his family, or any of the honourable motives which might induce an upright spirit and a warm heart to take up such a fine vocation.

I myself, when I was young, was torn between the university and the stage. In the winter, in the worst possible weather, I used to walk along the deserted avenues of the Luxembourg Gardens, reciting aloud from Molière and Corneille. What did I want from it? Applause? Perhaps. To be on familiar terms with the women of the theatre, whom I found immensely desirable and knew to be of easy virtue? Definitely. I don't know what I wouldn't have done to please Gaussin, who was just starting then and was the personification of beauty, or Dangeville, who was so charming on the stage.[36]

It's been said that actors have no character because playing them all makes them lose the one that nature gave them, and that they become false, just as doctors, surgeons and butchers grow hard. I think people have taken the cause for the effect, and that they're only fitted to play all characters because they haven't got one of their own.

SECOND. You don't become cruel because you're an executioner; you become an executioner because you're cruel.

FIRST. However much I study these people I don't see anything which marks them out from their fellow beings except a vanity which might be called insolence, a jealousy which brings discord and hatred into any association with them. Of all societies of men, there's probably none in which the common interest of all, and that

of the public, is more regularly and openly sacrificed to petty, miserable pretensions. Envy is even worse with them than it is with authors; that's saying a lot, but it's true. A poet is more ready to forgive another for the success of his play than an actress will forgive another the applause which brings her to the notice of some rich or distinguished debauchee. You see them as great on the stage because, you say, they have great souls; I see them as mean and petty in their social lives because they haven't: they may have the words and the tone of voice of Camille and the elder Horace, but they have the morals of Frosine and Sganarelle. Well then, if I'm to judge what's in their hearts, do I go by the words they've learnt and render superbly well, or the kind of things they do and the style of their lives?

SECOND. But there were once Molière and the Quinaults and Montmesnil, and now there are Brizard and Caillot, who is as welcome amongst the great as amongst ordinary folk, to whom you would happily entrust your secrets and your purse and with whom you would think the honour of your wife and the innocence of your daughter much more secure than with certain nobles from the court or certain respectable ministers of the Church . . .

FIRST. Your praise is perfectly justified: what I find disturbing is that one doesn't hear of more actors who have deserved it or do deserve it. What's disturbing is that amongst all these people who possess, by virtue of their profession, a quality which is the precious and fertile source of so many others, an actor who's a gentleman and an actress who's a respectable woman are such rare phenomena.

Let us conclude from all this that it's wrong to say that they're specially privileged in this respect, and that the sensibility which would govern their behaviour in society as it would on the stage, if they were gifted with it, is neither the basis of their character nor the reason for their success; that it's no more proper to them than it is to any other social condition, and that if one sees so few great actors it's because parents don't put their children on the stage, because it's not something you study for from your youth. A company of actors is not, as it should be, an association made up,

like any other community, of citizens drawn from all the families of good society, and attracted to the stage, as to the service of the king, to the law or to the Church, by choice or inclination, and with the consent of their natural guardians, and this is because our people are not prepared to attach the importance, honours and rewards it deserves to the function of addressing men who gather together to be instructed, entertained and corrected.

SECOND. The abject condition of modern actors is, it seems to me, an unhappy legacy from the actors of ancient times.

FIRST. I think it is.

SECOND. If the theatre were to come into being today, when we have a more accurate conception of things, then perhaps ... But you're not listening to me. What are you thinking about?

FIRST. I'm following up my first idea and thinking about the influence the theatre would have on good taste and moral standards, if actors were respectable people and their profession was an honourable one. Where is the poet who would dare to suggest to men of good family that they should repeat trivial or coarse speeches in public; or to more or less respectable women like our own that they should brazenly utter before a large audience words which they would blush to hear spoken in the privacy of their homes? Before long our dramatists would attain a purity, a delicacy, an elegance from which they are further removed than they imagine. Now, don't you think the spirit of our nation would feel the effects of it?

SECOND. One might perhaps object that the plays, ancient or modern, which your honourable actors would exclude from their repertoire are precisely those which we perform in private.

FIRST. And what does it matter if our citizens descend to the condition of the lowest buffoons? Would that make it less valuable, less desirable, that our actors should rise to the condition of the most respectable citizens?

SECOND. The transformation is not an easy one to make.

FIRST. When I put *Le Père de famille* on the stage the magistrate encouraged me to continue with this type of play.

SECOND. Why didn't you?

FIRST. Because, not having the success I'd hoped for, and not imagining that I could do much better, I tired of a career for which I didn't think I had enough talent.

SECOND. And why was this play given such a lukewarm reception at the beginning, when it now fills the theatre before half-past four and the actors advertise it every time they need a thousand *écus?*

FIRST. It was said by some that our manners were too artificial to accept such a simple genre, too corrupt to take to such a respectable genre.

SECOND. There could be some truth in that.

FIRST. But experience has shown that that was not the case, because we have not grown any better. And the true and the honest have so much influence over us that, if a poet's work possesses these two qualities and the author has some talent, its success will be all the more certain. It's at times when everything is false that people love what is true, it's when everything is corrupt that the theatre is at its most refined. A citizen who goes to the Comédie leaves all his vices at the door and picks them up again as he goes out. Once inside, he is just, impartial, a good father, a good friend, a lover of virtue; and I've often seen, sitting next to me, rogues who get deeply indignant at actions they would certainly have committed if they'd been in the same position as that in which the poet placed the character they detested. If I didn't succeed in the first place, it was because the genre was unfamiliar to the audience and the actors; because there was an established prejudice, which still exists, against what is called *comédie larmoyante*;[37] because I had a mass of enemies at court, in the town, amongst the magistrates, amongst the clergy and amongst the men of letters.

SECOND. And how did you incur so much hatred?

FIRST. Well, I really don't know, because I've never written a satire against the great or the small, and I've never got across anyone's path to fortune and honours. It's true I was one of those they call '*philosophes*', who were regarded at the time as dangerous citizens, and on whom the ministry let loose two or three rascally underlings who had neither virtue, nor understanding, nor, what is worse, talent.[38] But let's forget about that.

SECOND. Not to mention the fact that these *philosophes* made the work of poets and literary men in general more difficult. There was no question any more of making your name by throwing off a neat madrigal or a couple of dirty rhymes.

FIRST. That may well be. A young debauchee, instead of attending regularly at the studio of the painter, the sculptor or the artist who has taken him under his wing, has wasted the best years of his life and finds himself at twenty without resources or talent. What can he expect to become? A soldier or an actor. So there he is, signed up with a troupe of actors. He roams around until he has the chance of a start in the capital. A miserable creature has been wallowing in the mire of debauchery; tiring of this most abject of conditions, that of a sordid courtesan, she learns a few parts by heart and goes one fine morning and sees La Clairon, as the slave of antiquity went to the aedile or the praetor. Our actress takes her by the hand, makes her do a pirouette, touches her with her wand and says: 'Now go and make the Parisians laugh or cry.'

They're excommunicated. This public that can't do without them despises them. They're slaves, always at the beck and call of another slave. Do you imagine the marks of such constant degradation can remain without effect, and that, beneath the weight of such humiliation, the soul can still be strong enough to measure up to Corneille?

This tyranny that's exercised over them, they then exercise over the authors, and I don't know which ranks the lowest, the insolent actor or the author who has to put up with him.

SECOND. People do want to have their plays performed.

FIRST. At any price. They're all tired of their jobs. Once you've handed over your money at the door, they'll lose interest in you and your applause. Once they had enough in subscriptions from the boxes they were very near to deciding that either the author should waive his fee or his play wouldn't be accepted.

SECOND. But this idea would have meant nothing less than the extinction of drama.

FIRST. What do they care?

SECOND. I don't imagine you've much more left to say.

FIRST. You're wrong. I must now take you by the hand to see Clairon, that incomparable magician.

SECOND. She at least was proud of her profession.

FIRST. As all those will be who have excelled in it. The theatre is only despised by those actors who've been chased out of it by the hissing. I must show you Clairon when she's really carried away by anger. If she should happen to preserve her posture, her emphasis, her theatrical playing with all its trimmings, all its pompousness, wouldn't you be holding your sides, would you be able to contain your laughter? What are you going to tell me now? Do you not categorically declare that true feeling and acted feeling are two very different things? You were laughing at what you would have admired on the stage? And why, pray? Because Clairon's real anger looks like simulated anger, and you're able to distinguish clearly between the mask of this passion and her as a person. The images of passions on the stage are not the true images, they're only exaggerated portraits, great caricatures subject to conventional rules. Well then, search your mind, ask yourself which artist will be better able to confine himself within these given rules? Which actor will better understand this prescribed puffing up, the man who is dominated by his own character, or the man born without character, or the man who divests himself of it to assume another which is greater, nobler, more violent and more elevated? One is oneself by nature; one is another by imitation; the heart you imagine for yourself is not the heart you have. What then is true talent? Being familiar with the outward signs of the nature one has assumed, directing one's performance at the sensations of those who hear and see us and deceiving them by the imitation of these signs, an imitation which enlarges everything in their minds and becomes the standard for their judgement; because it's impossible to appreciate what goes on inside us in any other way. And what does it matter anyway whether they feel what they're doing or not, as long as we don't know about it?

The man who has the best understanding and gives the most perfect rendering of these outward signs according to the ideal model is the greatest actor.

SECOND. The man who leaves the least to the imagination of the actor is the greatest of poets.

FIRST. I was about to say that. When you've become so used to the theatre that you carry this theatrical exaggeration into your social life, bringing Brutus, Cinna, Mithridates, Cornelia, Merope, Pompey along with you, do you know what you're doing? To a character which may be great or small, having the exact dimensions which nature gave it, you're coupling the outward signs of an exaggerated, monstrous character which is not your own; and that's why it's ridiculous.

SECOND. What a cruel commentary you're making, either innocently or maliciously, on actors and authors!

FIRST. How is that?

SECOND. It is, I imagine, permissible for anyone to have a great and strong character; it is, I imagine, permissible to have the bearing, the speech and the actions which go with that character, and I think that the image of true greatness can never be ridiculous.

FIRST. What conclusion is to be drawn from that?

SECOND. Ah! traitor! you dare not say it, and I shall have to incur universal indignation in your place. That true tragedy is still to be discovered, and that for all their faults, the Ancients were probably nearer to it than we are.

FIRST. It's true that I'm enchanted to hear Philoctetes say with such simplicity and force to Neoptolemus, when the latter gives him back the arrows of Hercules which he had stolen from him at the instigation of Ulysses: 'See what you have done: without realizing it, you were condemning an unfortunate man to die of pain and hunger. Your theft is the crime of another, your repentance is your own. No, never would you have thought to commit such an unworthy act if you had been alone. Think then, my child, how important it is at your age only to mix with decent people. This

was what you had to gain by keeping company with a scoundrel. And why did you go with a man of this kind? Would your father have chosen such a man for a companion and friend? That noble father who never allowed himself to go near any but the most distinguished members of the army, what would he say, if he saw you with someone like Ulysses? . . .' Is there anything in this speech which you would not say to my son, or I to yours?[39]

SECOND. No.

FIRST. Yet that's a fine speech.

SECOND. Undoubtedly.

FIRST. And if this speech were delivered on stage, would its tone be any different from what you would use in private?

SECOND. I don't think so.

FIRST. And would this tone seem ridiculous in private?

SECOND. Not at all.

FIRST. The more forceful the action, the simpler the words, the more I admire them. I'm very much afraid that for a hundred years we've mistaken the posturings of Madrid for the heroism of Rome, and confused the tones of the tragic muse with the language of the epic muse.

SECOND. Our alexandrine verses are too high-sounding and noble for dialogue.

FIRST. And our ten-syllable verses are too light and empty. However, what I should like you to do, before you go to a performance of any of Corneille's Roman plays, is to read Cicero's letters to Atticus. I find our dramatists so high-flown! How distasteful their declamation is, when I remember the simplicity and power of Regulus's speech dissuading the Senate and people of Rome from exchanging prisoners! This is how he expresses himself in an ode, a poem which has more fire, energy and extravagance in it than a tragic monologue; he says: 'I have seen our colours hanging in the temples of Carthage. I have seen the Roman soldier stripped of weapons which were not stained by one drop of blood. I have seen liberty in oblivion and citizens with their arms tied behind their backs. I have seen city gates wide open

and harvests covering the fields which we had laid waste. And do you think that, when their freedom is bought, they will return any braver? You are only adding waste to humiliation. Virtue, once it has taken flight from a dishonoured spirit, will never return. Expect nothing from a man who might have died, but has allowed himself to be bound as a prisoner. O Carthage, what greatness you enjoy, and what pride in our disgrace! . . .'[40]

Such was his speech and his conduct. He rejected the embraces of his wife and children, thinking himself unworthy of them, like a slave. He kept his fierce gaze directed to the ground and disdained the tears of his friends until he had brought the senators round to an opinion which he alone was able to give, and he could then be permitted to return into exile.

SECOND. That is simple and very fine; but it's only in the moment which follows that we see Regulus's true heroism.

FIRST. You're right.

SECOND. He was well aware of the tortures which a ferocious enemy had in store for him. Yet he resumed his serene appearance, separating himself from his dear ones who were trying to delay his return with the same ease with which he freed himself from the throng of his clients to go and find relaxation from the stress of his business affairs in his fields in Venafrum or the countryside of Tarento.

FIRST. Very good. Now put your hand on your heart and tell me if there are many passages in our own poets where the tone is suitable for such lofty, easily assumed virtue, and tell me how our tender jeremiads or most of our Cornelian bombast would sound on those lips.

What a lot of things there are that I can say to no one but you! I should be stoned in the streets if I were known to be guilty of this blasphemy, and I've no ambitions to be honoured by any kind of martyrdom.

If the day comes when a man of genius dares to give his characters the simple tones of antique heroism, the actor's art will be much more difficult, because declamation will no longer be a kind of singing.

Moreover, when I declared that sensibility was the characteristic mark of a good soul and a mediocre genius, I made a rather unusual confession, because if nature ever fashioned a sensitive soul, it was mine.

The man of sensibility is too much a prey to his diaphragm to be a great king, a great politician, a great magistrate, a just man, a profound observer and therefore a sublime imitator of nature, unless he is capable of forgetting himself, of abstracting himself from himself and using a powerful imagination to create, and a retentive memory to keep his attention fixed on the phantoms which serve as his models; but in such cases it's no longer he himself who acts, it's the mind of another controlling him.

I ought to stop here; but you'll find it easier to forgive me for saying something out of place than for not saying it at all. It's an experience that you've no doubt had yourself sometimes when a young beginner has invited you to a small gathering at home to give your views on her talents, and you've acknowledged her spirit, sensibility, depth of feeling, you've showered her with praise and left her, as you made your departure, with the highest hopes of success. And what happens? She takes the stage and gets hissed, and you admit to yourself that she deserves it. How does that come about? Has she lost her spirit, her sensibility, her depth of feeling between the morning and the evening? No, but in her drawing-room you were on a level with her; you listened without regard to the conventions, she was face to face with you, there was no standard of comparison between you and her; you were pleased with her voice, her gestures, her expression, her bearing; everything was in proportion with the listeners and the space they occupied; there was no need for exaggeration. On the boards everything changes: here a different character was called for, because everything had grown bigger.

In a private theatre, in a drawing-room where the spectator is almost on the same level as the actor, a true dramatic character would have struck you as enormous, gigantic, and as you left the performance you would have confided in your friend: 'She won't

succeed, she overacts'; and her success on the stage would have amazed you. Once again, whether he does it well or badly, the actor neither says nor does anything in private exactly as he does on the stage; it's another world.

But an incident which clinches the matter was told me by a man who's completely trustworthy, with a sharp and original mind, the abbé Galiani, and this was later confirmed by another trustworthy man, with an equally sharp and original mind, the Marquis de Caraccioli, the ambassador of Naples in Paris; they told me that in Naples, the home town of both of them, there's a dramatist whose main concern does not lie in writing his play.

SECOND. Your play, *Le Père de famille*, had a remarkable success there.

FIRST. They gave four performances in succession before the king, against all court etiquette, which requires as many different plays as there are performance days, and the audience was carried away by it. But the main concern of the Neapolitan poet is to find in the society world people of the right age, appearance, voice and character to play his parts. No one dares refuse him, because it's to entertain the sovereign. He rehearses his actors for six months, together and individually. And when do you think the company begins to play, to act together, to approach the perfection he demands? It's when the actors are exhausted by the tedium of these repeated rehearsals, what we would call blasé. From that moment on, the progress is amazing, everyone identifies with his character; and it's after this laborious exercise that performances begin and go on for another six months in succession, and the sovereign and his subjects enjoy the greatest pleasure that can be had from the theatrical illusion. And this illusion, as powerful, as perfect at the last performance as at the first, do you think it can be the effect of sensibility?

Moreover, the question I'm going into was once taken up between a poor writer, Rémond de Sainte-Albine, and a great actor, Riccoboni. The writer pleaded the cause of sensibility, the actor

argues for mine. It's a story I didn't know about and have only just discovered.[41]

I have spoken, you have heard me, and now I'm asking you what you think.

SECOND. I think that this little man, who's so arrogant, dogmatic, humourless and hard-hearted, in whom anyone would detect a strong tendency towards disdain if he had even a quarter of the conceit with which nature has generously endowed him, would have been a little more reserved in his judgement if you, for your part, had been obliging enough to set out your arguments, and he had been patient enough to listen to them; but the trouble is that he knows everything, and by reason of being a universal man, thinks he's excused from listening.

FIRST. On the other hand, the public gives him as good as it gets. Do you know Madame Riccoboni?

SECOND. Who doesn't know the author of so many delightful works, full of genius, honesty, delicacy and grace?

FIRST. Would you say she was a woman of sensibility?

SECOND. She's proved it not only in her writings, but also in her conduct. Something happened in her life which looked like bringing her to her grave. After twenty years her tears are still flowing and the source of those tears is not yet dry.

FIRST. Well, this woman, one of the most warm-hearted that nature has ever created, was one of the worst actresses that ever appeared on the stage. No one speaks better of the art, no one performs worse.

SECOND. I would add that she admits it, and that she's never once said the hissing was unfair.

FIRST. And why, with this exquisite sensibility, the chief quality of an actor, according to you, was La Riccoboni so bad?

SECOND. Presumably because the others let her down so badly that she couldn't make up for it.

FIRST. But she's quite good-looking; she's clever; she carries herself well; there's nothing displeasing about her voice. She possessed all the accomplishments that come from education. She didn't offend

in any way in company. One is not unhappy to see her, one hears her with the greatest pleasure.

SECOND. I don't understand it. All I know is that the public has never come round to her, and that for twenty years she's been the victim of her vocation.

FIRST. And of her sensibility, which she's never been able to rise above; and it's because she's persistently remained herself that the public has persistently disdained her.

SECOND. And you, don't you know Caillot?[42]

FIRST. Very well.

SECOND. Have you ever discussed this with him?

FIRST. No.

SECOND. If I were you, I should be interested to know his opinion.

FIRST. I know what it is.

SECOND. What is it?

FIRST. The same as yours and your friend's.

SECOND. That's a terrible weight of authority against you.

FIRST. I agree.

SECOND. And how did you discover Caillot's opinion?

FIRST. From a woman of wit and discernment, Princess Galitzin. Caillot had been playing Le Déserteur,[43] he was still on stage, where he had experienced, and she had shared with him, all the agonies of an unhappy man about to lose his beloved and his life. Caillot went over to her box with that smiling face you know so well, and addressed her in the most cheerful, pleasant and courteous way. The princess, amazed at this, said: 'What! you're not dead! And I was only the spectator of your anguish, yet I still haven't got over it.' 'No, Madame, I am not dead. It would be a sad thing for me if I were to die so often.' 'So you don't feel anything?' 'Forgive me . . .' And off they launched into a discussion which ended up for them as this one will end for us: I'll stick by my opinion and you by yours. The princess didn't recall Caillot's arguments, but she did notice that this great imitator of nature, at the very moment of his death agony, when they were about to drag him off to his execution, seeing that the chair

147

where he would have to put the unconscious Louise was in the wrong place, adjusted it, all the time chanting in a dying voice: 'But Louise does not come and my hour draws near ...' But you're not paying attention; what are you thinking about?

SECOND. I'm thinking of suggesting a compromise: reserving the natural sensibility of the actor for those rare moments when he loses control, when he's no longer aware of the spectator, when he's forgotten that he's on a stage, forgotten himself, when he's in Argos, or Mycenae, when he's the actual character he's playing; he weeps.

FIRST. Rhythmically?

SECOND. Rhythmically. He cries out.

FIRST. In exactly the right tone?

SECOND. In exactly the right tone. Becomes angry, indignant, desperate, offers the true image to my eyes and carries the true accents to my ears and my heart of the passion which torments him, to the point when I don't know myself, when it's not Brizard or Le Kain any more, but Agamemnon I see and Nero I hear ... and so on, and to leave the rest of the performance to art ... I think that then perhaps it's the same for nature as for the slave who learns to move freely under the weight of his chains: he's so used to it that he forgets the weight and the constraint.

FIRST. An actor of sensibility will perhaps have during his performance one or two of these moments of alienation, and the finer they are, the more sharply they'll clash with the rest. But tell me, doesn't the spectacle cease to be a pleasure then? Doesn't it become a torture for you?

SECOND. Oh no!

FIRST. And isn't this fictional emotion preferable to the real, familiar spectacle of a family in tears round the deathbed of a beloved father or an adored mother?

SECOND. Oh no!

FIRST. Then neither you nor the actor had forgotten yourselves so completely ...

SECOND. You've already got me into a difficult position and I

don't doubt you can make it even more difficult; but I think I could shake you if you allowed me someone to back me up. It's half-past four; *Dido* is on; let's go and see Mademoiselle Raucourt; she'll answer you better than me.[44]

FIRST. I'd like that, but I don't expect it to happen. Do you think she'll do what neither Le Couvreur, nor Duclos, nor de Seine, nor Balincourt, nor Clairon, nor Dumesnil could do? I make bold to say that if our young débutante is still far from perfection, it's because she's still too much of a novice not to feel, and I predict that if she continues to feel, to remain herself and to prefer her limited natural instinct to the boundless study of art, she'll never rise to the level of the actresses I've mentioned. She'll have great moments, but she won't be great. She'll have the same fate as Gaussin and several others, who've remained mannered, weak and monotonous all their lives simply because they've never been able to emerge from the narrow limits in which their natural sensibility confined them. Do you still intend to set Mademoiselle Raucourt against me?

SECOND. Definitely.

FIRST. On the way there I'll tell you of an incident which bears on what we've been talking about. I knew Pigalle;[45] I could call on him when I liked. I went round one morning and knocked on his door; the artist opened it, holding his chisel, and, stopping me at the door of his studio: 'Before I let you in,' he said, 'swear that you won't be frightened of a beautiful woman completely naked . . .' I smiled . . . and went in. He was working at that time on his monument for the Maréchal de Saxe and a very lovely courtesan was serving as his model for the figure of France. But how do you think she struck me amongst the enormous figures surrounding her? Feeble, puny, mean, a sort of frog; she was crushed; and I should have taken this frog for a lovely woman, as the artist had said, if I hadn't waited until the end of the sitting and seen her down at ground level, with her back turned to these gigantic figures which reduced her to nothing. I'll leave it to you to apply this strange phenomenon to Gaussin,

Riccoboni and all those who haven't been able to grow bigger on the stage.

If the impossible happened and an actress had been endowed with the kind of sensibility which art can simulate when it's carried to its limits, the theatre offers so many different characters for imitation, and a single leading role brings so many contrasting situations, that this rare fount of tears, unable as she was to play two different parts, would scarcely excel in more than a few moments of the same part; she would be the most uneven actress, the most limited and the most inept that it's possible to imagine. If she did try to reach the heights, her overriding sensibility would soon bring her down to mediocrity again. She would be less like a powerful racehorse galloping along than a feeble old nag taking the bit between its teeth. Her brief moment of energy, fleeting, abrupt, without progress, preparation or unity, would look to you like an attack of madness.

Because sensibility is in fact associated with suffering and weakness, tell me if a gentle, weak and sensitive creature is the right person to render the coolness of Léontine, the jealous rage of Hermione, the fury of Camille, the motherly love of Merope, the madness and remorse of Phèdre, the despotic pride of Agrippine, the violence of Clytemnestra? Abandon this actress with her everlasting tears to the elegiac roles and leave her there.

You see, having sensibility is one thing, and feeling is another. One is a matter for the heart and the other a matter for the judgement. You can feel deeply and you can't convey it; you can convey something sitting alone, in private, by the fireside, reading a part aloud for a few listeners, but you can't convey anything worthwhile in the theatre, because in the theatre, with what's called sensibility, heart, feeling, you can carry off one or two big speeches and muff the rest. To embrace the whole range of a great part, to balance the areas of light and shade, the gentle and quiet moments, to succeed equally well in the calm passages and the exciting ones, to achieve variety in the details and harmony and unity in the whole and work out a sustained plan of

delivery which can even take in the poet's flights of fancy, all this needs a cool head, profound judgement, sophisticated taste, laborious preparation, long experience and an unusually retentive memory. That rule, *qualis ab incepto processerit et sibi constet*,[46] which is an inflexible rule for the poet, applies in the smallest detail for the actor. Anyone who comes out of the wings without having the part at his finger tips and his role memorized will play the part of a beginner all his life, unless he has the courage, self-confidence and spirit to rely on his presence of mind and experience, and then you'll applaud his acting in the same way as a connoisseur of painting smiles at a risqué sketch, where everything is suggested and nothing is made clear. It's one of those miracles that we've seen sometimes at the fair or with Nicolet. Perhaps these crazy people do well to remain what they are, actors in embryo. If they worked harder it would not give them what they lack and it wouldn't take away what they have. Take them for what they're worth, but don't set them beside a finished picture.

SECOND. I've only one more question to ask you.

FIRST. Ask it.

SECOND. Have you ever seen a play absolutely perfectly performed?

FIRST. My goodness, I don't remember ... Wait though ... Yes, occasionally an indifferent play, performed by indifferent actors ...

Our two speakers went to the theatre, but not finding a seat, they went on to the Tuileries. They walked for a while in silence. They seemed to have forgotten they were together, and each one talked to himself as if he were alone, one aloud, the other so softly that he couldn't be heard, with only an occasional word escaping at intervals, but distinctly enough for one to guess that he didn't consider himself beaten.

The ideas of the man of the paradox are the only ones I can vouch for, and here they are, incoherent as they must appear when

you remove from a soliloquy the intervening passages which link it together. He was saying:

Put an actor of sensibility in his place and see how he manages. What does this man do? He puts his foot up on the balustrade, ties his garter, and replies to the courtier he despises by looking back over his shoulder; in this way an incident which would have put anyone else off his stroke is quickly adapted to the circumstances and becomes a stroke of genius.

(I think he was talking about Baron in the tragedy *Le Comte d'Essex*.) He added with a smile:

Oh yes, he'll think that that actress feels what she's doing, leaning on her confidant's breast, almost dying, when, looking towards the third row of boxes, she sees an old lawyer breaking down in tears, and his affliction gives such a comic look to his face that she says: 'Just look at that marvellous face up there . . .' murmuring these words in her throat as if they were the effect of an inarticulate lament . . . Oh, you'll never convince me, never! If I remember rightly, this was Gaussin, in *Zaïre*.[47]

And there's a third, that man who died so tragically; I knew him and I knew his father, who often invited me round to say a word into his ear-trumpet.

(There's no doubt that this is that wise man, Montmesnil.)[48]

He was the personification of candour and honesty. What was there in common between his natural character and that of Tartuffe, which he played superbly? Nothing. Where did he pick up that crick in the neck, that peculiar rolling of the eyes, those sugary tones and all the other subtleties of the hypocrite's role? Be careful how you answer. I've got you here. – From a profound imitation of nature. – From a profound imitation of nature? So the outward signs which are most indicative of sensibility are not to be found in nature as much as the outward signs of hypocrisy are; so they couldn't be studied there, and a very talented

actor will find more difficulty in grasping and imitating one set than the other! And if I were to maintain that of all qualities of character sensibility is the easiest to mimic, since there's perhaps not a single man who's so cruel and inhuman that the germ of it is not present in his heart, that he's never felt it; something you couldn't say about all the other passions, such as avarice or distrust? Couldn't an outstanding performer . . .? – I understand: there will always be, between someone who mimics sensibility and someone who feels it, the difference between the imitation and the thing itself. – And so much the better, so much the better, I say. In the first case, the actor won't have to separate himself from himself, he'll reach up to the ideal model in one flying leap. – One flying leap! – You're quibbling about a form of words. I mean that, never being brought down to the level of the little model inside him, he'll be as great, as amazing, as perfect an imitator of sensibility as of avarice, hypocrisy, duplicity and any other characteristic which is not his own, any other passion which he doesn't feel. What the naturally sensitive person will show me will be weak; the other's imitation will be powerful; and if it did happen that their imitations were equally powerful, a point which I won't grant you, not in a million years, one of them, in complete control of himself and playing entirely from observation and judgement, would be what daily experience shows, that is, more uniform in his performance than the one who plays half from nature and half from observation, half from a model and half from himself. With however much skill these two imitations are merged together, a discerning spectator will recognize them even more easily than a consummate artist will distinguish in a statue the line separating either two different styles, or the front of a statue done from one model and the back from another. – What if an experienced actor stops acting from his head and forgets himself; what if his heart is troubled; what if he's overcome by his sensibility and abandons himself to it. He'll intoxicate us. – Perhaps. – We'll be carried away with wonder. – It's not impossible, but only on condition that he doesn't depart

from his style of delivery and that the unity isn't destroyed, for otherwise you'll declare that he's gone mad ... Yes, on that supposition you'll get a fine moment, I grant you; but do you prefer a fine moment to a fine performance? If that's your choice it's not mine.

At that the man of the paradox fell silent. He was striding along without looking where he was going; he would have bumped into everybody who came towards him if they had not avoided colliding with him. Then, stopping suddenly, and seizing his antagonist firmly by the arm, he said, with calm conviction:

My friend, there are three models, natural man, the poet's man, the actor's man. The natural man is not as great as the poet's man, and the poet's man is not as great as the actor's man, the most exaggerated of all. This last climbs on to the shoulders of the poet's man and shuts himself inside a huge wicker manne-quin[49] and becomes the soul within it. He moves this dummy in a terrifying way, terrifying even for the poet who no longer recognizes himself, and he frightens us, as you so rightly said, as children frighten each other by lifting their little short jackets over their heads, dancing about and imitating as best they can the hoarse, lugubrious voice of the phantom they pretend to be. But haven't you ever chanced to see engravings of children's games? Haven't you seen one of a little scallywag coming towards you covered from head to foot in the frightful-looking mask of an old man? Beneath this mask he's laughing at his little playmates who are fleeing in terror. This scallywag is the true symbol of the actor; his playmates are the symbols of the audience. If the actor is only gifted with a mediocre degree of sensibility, and that is all he has, would you not think him a mediocre man? Be careful now, this is another trap I'm setting you. – And if he's gifted with extreme sensibility, what will happen then? – What will happen? Either he won't act at all, or his performance will be ridiculous. Yes, ridiculous, and you'll see the proof of that in me, whenever you like. If I have a rather moving story to tell, a

kind of disorder invades my heart and my head; my speech is muddled; my voice is distorted; my ideas melt away; my words will not come out; I stammer, and I'm conscious of it; tears flow down my cheeks and I fall silent. − But it comes off. − In private; in the theatre I'd be booed. − Why? − Because people don't come to see tears but to hear the words which make them flow, because this truth of nature clashes with the truth of convention. Let me explain: I mean that neither dramatic convention, nor the action, nor the poet's words, could accommodate themselves to my stifled, broken, tearful delivery. You see, it's not permissible even to imitate nature, not even beautiful nature, truth, too closely: there are limits within which one must confine oneself. − And these limits, who set them? − Common sense, which requires that one talent should not get in the way of another talent. Sometimes the actor must make sacrifices to the poet. − But if the poet's work lent itself to this style? − Well then, you would have a totally different kind of tragedy from yours. − And what's the matter with that? − I don't really know what you'd gain, but I know very well what you'd lose.

At this point the man of the paradox came up close to his antagonist for the second or third time and said:

This remark is in bad taste, but it's amusing, and was made by an actress whose talent is acknowledged by everyone. It's the counterpart of Gaussin's situation and what she said. She too is in the arms of Pillot playing Pollux; she's dying, at least I think she is, and she mutters quietly to him: *Oh! Pillot, you do stink!*

This was said by Arnould playing Télaïre.[50] And when that happened, was Arnould really Télaïre? No, she was Arnould, Arnould all the time. You'll never persuade me to praise the intermediate levels of a quality which would ruin everything if it were pushed to the extreme and the actor were dominated by it. But supposing the poet had written the scene to be spoken in the theatre as I would recount it in private: who would play this scene? No one, no one at all, not even the most controlled actor; for once

when he pulled it off he would fail a thousand times. Success in these matters is such a precarious thing! . . . Does this last argument strike you as rather weak? Well, so be it; but I would still conclude from it that we should punch a few holes in our inflated language, lower our stilts by a few notches, and leave things more or less where they are. For one poet of genius who achieved this wonderful truth of nature, we should be enveloped in a cloud of insipid, uninspired imitators. It's not permissible, unless you wish to be insipid, slovenly and distasteful, to fall an inch away from the simplicity of nature. Don't you think so?

SECOND. I don't think anything. I didn't hear what you were saying.

FIRST. What! haven't we been going on with our discussion?

SECOND. No.

FIRST. And what the devil were you doing, then?

SECOND. I was daydreaming.

FIRST. And what was your daydream?

SECOND. It was about an English actor, called Macklin, I think (I was at the theatre that day), who needed to apologize to the pit for having the audacity to play some role in Shakespeare's *Macbeth* after Garrick had done it. He said, among other things, that the impressions which dominated the actor and subjected him to the genius and inspiration of the poet were very harmful to him. I can't remember what his arguments were, but they were very subtle and they were understood and applauded. In any case, if you're interested you'll find them in a letter in the *St James Chronicle*, under the name of Quintilian.[51]

FIRST. But have I been talking to myself for a long time, then?

SECOND. That's possible; as long as I've been daydreaming to myself. Did you know that male actors used in the past to play women's roles?

FIRST. I did.

SECOND. Aulus Gellius relates in his *Attic Nights* that a certain Paulus, wearing the mourning garb of Electra, instead of appearing on the stage with the urn of Orestes, came on embracing the urn

containing the ashes of his own son whom he'd just lost, so that it wasn't just an empty representation, a little show of grief, and the theatre echoed with cries and real lamentations.

FIRST. And you think that Paulus at that moment spoke on the stage as he would have spoken in his home? No, no. This miraculous effect, which I don't question, had nothing to do with Euripides' verse, nor with the actor's delivery, but with the sight of a father bathing with his tears the urn of his own son. This Paulus was perhaps only an indifferent actor; just like that Aesopus of whom Plutarch relates that 'playing one day to a full house the role of Atreus considering how he might take revenge on his brother Thyestes, one of his servants appeared suddenly and was about to run across in front of him, and Aesopus, beside himself with violent emotion and the ardent desire to give a vivid rendering of Atreus's passion, hit him so hard on the head with the sceptre he was holding, that he killed him on the spot ...' He was a madman whom the tribune should have sent straight to the Tarpeian rock.[52]

SECOND. As presumably he did.

FIRST. I doubt it. The Romans attached so much importance to the life of an actor and so little to the life of a slave!

But they say that an orator performs much better when he gets worked up, when he's angry. I deny that. It's when he imitates anger. Actors impress the public not when they're furious but when they act fury well. In courts, meetings, all the places where one wants to dominate people's minds, one feigns first anger, then fear, then pity, so as to arouse these different feelings in others. What passion itself couldn't do can be achieved by a good imitation of passion.

Don't they say in society that a man's a great actor? They don't mean by that that he feels, but rather that he excels in pretending, when in fact he feels nothing: a much more difficult role than the actor's, because he has to find the words as well, and has two tasks, the poet's and the actor's. The poet on the stage can be cleverer than the actor in society, but is it to be believed that the actor is more

profound, more skilled in feigning joy, sadness, sensibility, admiration, hatred or tenderness than an old courtier?

But it's getting late. Let's go and have supper.

Introductory Note

THE SALONS

Public exhibitions of painting and sculpture were instituted in 1667 by the Académie Royale de Peinture et de Sculpture to show works by members of the Academy. Although these exhibitions were always held in the Louvre, it was only in 1725 that they moved to the Salon Carré and acquired the name 'Salons', and only in 1748 that they became the regular biennial events with which Diderot was familiar. We can get an excellent idea of what the Salons were like from the drawings of Gabriel-Jacques de Saint-Aubin: paintings covering almost every inch of the walls from floor to ceiling, sculptures on tables in the centre; minor works were also hung on the staircases. Entry was free and the exhibitions were often so crowded that it was almost impossible to get a good look at some of the exhibits, especially when, like Greuze's *Village Betrothal*, they caught the public imagination. A printed catalogue, the *livret*, was on sale at each exhibition, and from these we know exactly what was shown. The responsibility of hanging the pictures went to the *tapissier*, a post occupied during much of Diderot's association with the Salons by Chardin.

Only members and *agréés* (see below) of the Academy could exhibit, and for most aspiring painters the Academy was the goal. After a rigorous training (see Chardin's description, reported by Diderot in his introduction to the 1765 Salon), they would enter for the Grand Prix or Prix de Rome, which enabled the successful candidate to spend about three years in Rome at the Académie de France, whose director, always a distinguished painter, would regularly keep the authorities in Paris informed of his progress. There were two more hurdles to be negotiated before an artist could be a full member of the Academy: he had to become an *agréé* by submitting a work of an approved standard, and then submit his *morceau de réception*, which, if approved, gave him full membership.

Membership was granted for a particular category of painting, the most coveted being that of history painter. Greuze failed to achieve this status and was accepted as a genre painter. Chardin entered as a 'painter of fruit and animals' and Vernet as a landscape and marine painter. In the earlier part of the century Watteau had had a category specially created for him as a painter of *fêtes galantes*.

For Diderot's commentaries on the Salons we owe a great debt to Friedrich Melchior Grimm who, as editor of the *Correspondance littéraire*, invited him to write without any constraints for the benefit of the foreign notables who were its subscribers. This he did from 1759 until 1781. The selection offered here gives little idea of the amount of writing involved, still less of the time Diderot spent making himself an expert: he regularly questioned practising artists about their work, visiting their studios, going to the Salons with them and studying the subject on his own. In the Salons he would make copious notes on the works exhibited before writing them up later, sometimes quite a long time after the exhibition had taken place.

Because the *Correspondance littéraire* never appeared in a definitive edition, and because the Salons for each exhibition were published in successive editions, it has taken a long time for an accepted text to be established. It is now generally agreed that the only complete collection, in St Petersburg, is the most reliable and this, with the use of some discretion, is the one used here.

The selection made here is not intended to give an impression of French art in the mid-century, but to provide some idea of the variety of Diderot's own style and opinions. Most of the extracts are from the mid-sixties, when he was at his best, condemning the immorality and triviality of Boucher and Baudouin, uplifted by the morality of Greuze's dramatic genre scenes, carried away by the beauty of Vernet's landscapes, drawn into a meticulous analysis of the religious paintings of Doyen and Vien, stunned by the realism and technical brilliance of Chardin's still lifes and inspired to dreamy meditations on the poetry of ruins by Hubert Robert. Of the Salon of 1765 he said, in a letter to Sophie Volland, 'This is definitely the

best thing I've done since I began writing.' We might now dispute this judgement, but he certainly invested most of himself in the *Salons*.

Diderot's commentaries on the paintings are supposedly addressed to Grimm, hence the mention from time to time of 'my friend', but this is frequently forgotten. As with most of his best works, he seems to have flourished in a situation where he did not need to think too specifically about a public, still less a patron. His genius resisted any kind of constraint, and he often remarks in the *Salons* that artists do their best work when they are not working within the constraints of a commission. He may not have been right about this, but it is an appropriate view in a period when it was becoming possible to envisage a time when artists and writers might be able to exist without depending on patronage.

THE SALONS

DIDEROT'S INTRODUCTION TO
THE SALON OF 1765

To my friend Monsieur Grimm.
Non fumum ex fulgore, sed ex fumo dare lucem
Cogitat[1]

If I have any considered ideas about painting and sculpture, it is to you, my friend, that I owe them. I should have been one of the idle crowd at the Salon, like them casting a heedless, superficial glance at the achievements of our artists, with one word consigning a valuable piece to the flames, with another praising an indifferent work to the skies, approving, disdaining, and never examining the reasons for my enthusiasm or my disdain. The task you suggested to me is what fixed my eyes upon the canvas and led me to walk round the marble. I have given the impressions time to reach and penetrate me. I have opened my heart to their effects and allowed them to work their way into me. I have taken note of the verdict of an old man and the idea of a child, the judgement of a man of letters, the witticism of a man of the world and the sayings of ordinary people; and if I happen to hurt the artist's feelings, it is often with the weapon he has sharpened himself. I have questioned them and I have learned to recognize fine draughtsmanship and truth to nature; I have understood the magic of light and shade; I have become familiar with colour; I have acquired a feeling for flesh tints. Alone again, I have reflected on what I have seen and heard, and these technical terms, *unity*, *variety*, *contrast*, *symmetry*, *disposition*, *composition*, *characteristics*, *expression*, so often on my lips, so vague in my mind, have acquired definition and stability.

O my friend, these arts whose purpose it is to imitate nature, whether through speech, as in eloquence and poetry, or through

sounds, as in music, or through colours and the brush, as in painting, or the pencil, as in drawing, or the chisel and clay, as in sculpture, or the graver, stone and metal, as in engraving, or the drill, as in the engraving of precious stones, or the stylus, the caulking chisel and the graver, as in metal-chasing, these arts are long, laborious and difficult!

Remember what Chardin told us at the Salon: 'Gentlemen, gentlemen, be lenient. Look through all the paintings here and find the worst, and know that two thousand poor devils have bitten their brushes to pieces in despair of ever doing as badly. You call Parrocel a dauber, and so he is, if you compare him with Vernet, but he's a rare talent compared with the multitude of those who've abandoned the career they entered with him.[2] Le Moyne used to say that it took thirty years' practice to be able to turn one's original sketch into a painting, and Le Moyne was no fool.[3] If you'll listen to what I say, perhaps you'll learn to be indulgent.'

Chardin seemed to doubt whether there was any longer and more laborious form of training than a painter's, not excepting even those of doctor, lawyer or professor at the Sorbonne.

'At the age of seven or eight,' he said, 'they put a pencil in our hands. We start copying eyes, mouths, noses, ears, then feet and hands. Our backs have long been bent over our portfolios before they set us in front of *Hercules* or the *Torso*, and you've never witnessed the tears we've shed over the *Satyr*, the *Gladiator*, the *Venus de Medici* or *Antinous*. You can be sure that these masterpieces of Greek art would never again arouse the jealousy of the masters if they had been delivered up to the anger of the pupils. After we've wasted our days and spent our lamp-lit nights before motionless, lifeless things, we're presented with living things, and all of a sudden the toil of all the preceding years seems to be reduced to nothing; no such demands were made of us even when we first took up a pencil. You have to teach your eye to look at nature; and how many there are who have never seen it and never will see it! It's the torment of our lives. They've kept us sitting in front of a model for five or six years before they deliver us up to our genius,

if we have any. Talent doesn't declare itself on the instant; it takes more than a first attempt before you have the courage to admit your incapacity. How many efforts we make, some successful, some not. Precious years have gone by before we reach the final day of disenchantment, weariness and fatigue. The pupil is nineteen or twenty when the palette falls from his hand and he's left without a profession, without resources, and without morals, for to be both young and respectable, if one is constantly gazing upon nature unadorned, is an impossibility. What is to be done? What can he do? Either he must resort to one of those inferior positions which are open to the destitute, or he must die of hunger. They take the first choice, and except for a score or so who come here every two years to exhibit themselves to the masses, the others, obscure and perhaps less unhappy, wear the plastron on their chests in a fencing school, or the musket over their shoulders in a regiment, or a theatrical costume on the boards. What I'm telling you here is the story of Belcourt, Le Kain and Brisart, all of them bad actors out of despair at being bad painters.'

Chardin told us, if you remember, that one of his colleagues, whose son was a drummer in a regiment, replied to those who asked about him that he'd abandoned painting for music. Then, becoming serious again, he added: 'Not all the fathers of these talentless, bewildered children are as good-humoured about it. What you see here is the result of the toil of the small number who have struggled with some degree of success. Anyone who has not been aware of the difficulty of art will never do anything worthwhile; someone like my son, who became aware of it too early, will do nothing at all; and believe me, most of the highest posts in society would be empty if admission depended on an examination as rigorous as the one we have to undergo.'

'But Monsieur Chardin,' I said, 'you mustn't take it out on us, if

Mediocribus esse Poetis
Non Di, non homines, non concessere columnae;[4]

and this man who incites the gods, men and the columns to anger

against indifferent imitators of nature was not unaware of the difficulty of the art.'

'Well,' he answered, 'one would do better to believe that he's warning the young student of the risks he runs than to make him the apologist of the gods, men and the columns. It's as if he said to him: My friend, be careful, you don't know your judge; he knows nothing, but he's still cruel ... Farewell, gentlemen, be kind, be kind.'

I am very much afraid that Chardin was asking alms from statues. Taste is deaf to prayer. I would almost say of the critic what Malherbe said of death; all is subject to its law,

> *Et la garde qui veille aux barrières du Louvre*
> *N'en défend pas nos rois.*[5]

I will describe the paintings for you, and my description will be such that with a little imagination and discernment they can be reconstructed in space and the objects can be placed more or less as we saw them on the canvas; and so that people can judge what reliance they can place on my censure or my praise, I will finish the Salon with a few reflections on painting, sculpture, engraving and architecture. You will read me as though I were an ancient author who is allowed a dull page for the sake of a good line.

I seem to hear you from where I sit, crying out sorrowfully: All is lost: my friend is arranging, ordering, worrying about details. You only borrow abbé Morellet's crutches when your genius fails you ...[6]

It is true my head is weary. The burden I have carried for twenty years has bowed me so low that I despair of standing upright again.[7] However that may be, remember my epigraph, *Non fumum ex fulgore, sed ex fumo dare lucem.* Let me give off smoke for a moment, and then we will see.

Before I get down to work, my friend, I must warn you not simply to assume that the pictures I pass over are bad. You can take as dreadful and worthless the works of people like Boizot, Nonnotte, Francisque, Antoine Le Bel, Amand, Parrocel, Adam, Descamp,

Deshays the younger and a few others. You can make an exception for one indifferent piece by Amand, the *Argus and Mercury* he painted in Rome; and for Deshays the younger, one or two heads which his rogue of a brother sketched for him so that he could get into the Academy.

When I pick out the faults of a composition, you can assume that if it is bad, it will stay bad, even if the fault is corrected; and when it is good, that it would be perfect, if the fault were corrected.

This year we have lost two great painters and two skilful sculptors: Carle Van Loo and Deshays the elder, Bouchardon and Slodtz. On the other hand, death has delivered us from the worst kind of connoisseur, the comte de Caylus.[8]

We have not been as blessed with great pictures this year as two years ago, but on the other hand we have had more small compositions, and the consolation is that some of our artists have revealed talents which can rise to anything. And who knows what Lagrenée will do? Either I am very wrong or the French school, the only surviving one, is still a long way from decline. Gather together, if you can, all the works of the painters and sculptors of Europe, and you will not make a Salon like ours out of them. Paris is the only city in the world where you can enjoy such a spectacle every two years.

BAUDOUIN

Salon of 1765

A good fellow, good-looking, good-natured, clever, and a bit debauched; but what do I care? My wife is over forty-five, and he won't get near my daughter, he or his compositions.

There were quite a number of little paintings by Baudouin, and all the girls, having cast a distracted eye over a few pictures, finished up at the place where *The Peasant Girl Being Scolded by her Mother* and *The Cherry Picker* were to be found; this was the bay for which they

had reserved their full attention. There is an age when one prefers reading licentious works to good ones, and when one would rather stop at a bawdy picture than a good picture. There are even old men who are punished for their debauchery by the vapid tastes it's left them with; a few of these old men were also lingering, with their sticks in their hands, their backs bent and their glasses on their noses, by Baudouin's scandalous little pieces.

The Confessional

A priest sits in a confessional. He's surrounded by a troop of little girls who've come to admit to the sins they've committed or would like to commit; so much for the confessor's left ear. His right ear will be listening to the stupidities of the old women, the old men and the snotty-nosed kids who are standing at the side. Chance, or the rain, has brought a couple of young sparks into the church. They promptly charge into the midst of the young penitents. There's an outcry; the priest leaps out of his box and speaks severely to our two hot-heads. This is the instant depicted in the picture. One of the two young men, eye-glass in hand, ironic and disdainful of demeanour, head turned back towards the confessor, is about to give him a piece of his mind. His companion, foreseeing that things may get serious, tries to draw him away. Most of the girls have hypocritically lowered their gaze. The old men and women are angry; the kids are grinning from where they stand behind their parents. All very amusing; but thanks to the piety of our archbishop, who is not given to seeing the funny side of things, the piece has been removed.

The Rejection[1]

In a small private room, a boudoir, nonchalantly stretched out on a *chaise-longue* we see a young gallant, disinclined to return to the fray; standing beside him, a girl in a shift, looking rather put out, seems to be saying, as she puts some more rouge on: Was that all you could manage?

The Cherry Picker[2]

In a tree we see a tall gardener's boy picking cherries; at the foot of the tree a young peasant girl ready to collect them in her apron. Another peasant girl is sitting on the ground looking at the boy: between her and the tree a donkey, loaded with baskets, is grazing. The gardener's boy has thrown his handful of cherries into the girl's apron, he just has two left in his hand, joined by the same stalk and hanging over his middle finger. A poor joke and a crude, trivial idea. But I'll say what I think about all that at the end.

A Girl Being Scolded by her Mother

The scene is a cellar. The girl and her sweetheart were just at the point . . . at the point . . . to say no more is to say enough, when the mother arrived exactly . . . exactly . . . it's already clear enough. The mother is very angry, she stands there with her arms akimbo. Her daughter, standing in front of a bale of recently crushed hay, is weeping; she has not had time to straighten her bodice and fichu, as one can easily see. Beside her, half-way up the cellar stairs, you can see the back of a big lad as he makes off; from the position of his arms and hands one is left in no doubt as to which part of his clothing he is pulling on. But our lovers were well organized: on a barrel at the bottom of the stairs are a loaf, some fruit, a napkin and a bottle of wine.

It's very naughty, but it's all right to go this far. I look, I smile, and pass on.

A Girl Recognizing her Child amongst the Foundlings at Notre-Dame, or Blood will Tell

The church. Between two pillars, the foundlings' bench. Around the bench, a crowd of people, joy, noise, surprise. In the crowd, behind the grey sister,[3] a tall girl holding a baby in her arms and kissing it.

A fine subject wasted. I would say that this crowd of people spoils the effect and reduces a moving event to a barely comprehens-

ble incident; that the scene lacks silence and peace, and needed only a small group of spectators. The draughtsman Cochin's answer is that the more crowded the scene is, the more evident are the ties of blood. Cochin argues like a literary man, and I'm arguing like a painter. If you want to bring out the ties of blood in all their force and preserve the calm and solitude and silence of the scene, this is how you should go about it, and how Greuze would have done it. I imagine a father and mother going off to Notre-Dame with their family, consisting of an elder sister, another sister and a little boy. They arrive at the foundlings' bench, the father and mother with the little boy on one side, the older girl and her younger sister on the other. The older girl recognizes her child; instantly carried away by the mother love which makes her forget the presence of her father, a violent man from whom the guilty secret had been kept, she cries out and stretches her arms towards this child; her younger sister tugs at her clothes, but it is no good, she hears nothing. While the younger girl whispers: *My sister, you're mad, you can't do this; father* . . . the mother's face goes white and the father looks fearsome and threatening: he casts furious glances at his wife, and the little boy, to whom all this is a complete mystery, yawns his head off. The grey sister is amazed; the few spectators, men and women in middle age, for there must not be any others, show joy and pity in the case of the women and surprise in the case of the men; and that's my composition, which is better than Baudouin's. But one must get the right expression for this older daughter, and that's not easy. I've said that there must only be middle-aged spectators round the bench, because reason and experience suggest that the others, young men and women, would not stop. So Cochin doesn't know what he's talking about. If he wants to defend his colleague against the light of his conscience and his own good taste, then let him.

Greuze has made himself the painter-advocate of good behaviour, Baudouin the painter-advocate of bad behaviour; Greuze the painter of the family and decent people, Baudouin the painter of the madhouse and debauchees. But luckily he has neither draughtsman-

ship, nor genius, nor a sense of colour, and we do have genius, draughtsmanship and a sense of colour and we shall be the winners. Baudouin once told me the subject of a painting: he wanted to show a scene with a midwife and a girl who has just secretly given birth and is forced by poverty to leave her child with the Foundling Hospital. Then why, I replied, don't you set it in a garret, with an honest woman doing the same thing for the same reason? That will be more beautiful, touching and decent. A garret brings out one's talents better than a midwife's hovel. If it doesn't compromise your art, isn't it better to display virtue than vice? Your composition will only inspire pity to no purpose; mine will inspire it with profit. – Oh! that's too serious; I can find as many girl models as I like. – Well then, do you want a cheerful subject? – Yes, and a bit *risqué* if you can, because I don't make any bones about it, I like *risqué* subjects, and the public isn't exactly against them. – Since you must have smut, smut you shall have, and your models will still be in the rue Fromenteau.[4] – Tell me, tell me quickly . . . – While he was rubbing his hands with glee, Imagine, I said, a hackney cab going towards Saint-Denis between eleven o'clock and midday. In the middle of that street, one of the cab's main braces snaps, and the carriage promptly keels over. The door falls open and out come a monk and three girls. The monk starts to run off. The cab-driver's poodle jumps down from beside his master, sets off after the monk, reaches him and sinks his teeth into his long coat. While the monk is struggling to get rid of the dog, the coachman, who doesn't want to lose his fare, gets down from his seat and goes after the monk. Meanwhile one of the girls was pressing her hand on a bump that one of her companions had received on her forehead, and the other one, who found it all highly amusing, was standing there with her clothes undone and her hands on her sides roaring with laughter; the shopkeepers were in their doorways, laughing too, and the urchins who had gathered round were shouting at the monk: *He's shat in the bed! He's shat in the bed!* – That's first-class, said Baudouin. – And it even has a moral slant; at least vice is punished. And who knows, this monk friend of mine, to whom it happened, might take

a turn round the Salon and blush when he recognizes himself. And isn't it quite something to make a monk blush?

Salon of 1767

Always the same little pictures, little ideas, frivolous compositions fit for a little madam's boudoir or the little house of a little fop; just right for minor abbés, small-time lawyers, major financiers and other people with no morals and trivial tastes.

The Bride's First Night[5]

Come into this room and look at the scene. To the right, chimney-piece and looking-glass. On the mantelpiece, candlesticks with several branches and lighted candles. In front of the fireplace, a lady's maid damping down the fire. Behind her, another lady's maid with an extinguisher in her hand is about to snuff out the candles in the sconces attached to the panelling. Beside the chimneypiece, as we move to the left, a third lady's maid, standing, and holding her mistress up with her arms, persuading her to get into the nuptial bed. This bed, half open, fills the background. The young bride has been persuaded: she already has one knee on the bed and she is in her nightclothes. She is weeping. Her husband, in a dressing-gown, is at her feet, pleading with her. You see only his back. At the head of the bed is a fourth maid who has lifted the bedcover; right over to the left, on a pedestal table, another branched candlestick; in the foreground, on the same side, a night-table with some clothes on it.

Monsieur Baudouin, have the goodness to tell me in what part of the world this scene took place. It certainly wasn't in France. Never has a well-born, well-brought-up young woman been seen half-naked, with one knee on the bed, being appealed to by her husband at the same time as she was being pulled about by her maids. An innocent woman will spend ages getting ready, she'll be trembling, reluctant to drag herself away from the arms of her father and mother; her eyes will be lowered, she won't dare to look up at her maids. She'll be shedding a tear. When she's finished getting ready

to go to the nuptial bed, her knees will give way beneath her. Her women have gone; she'll be alone when she's abandoned to the desire and impatience of her young spouse. This moment is wrong. Even if it were true, it would be a bad choice. What interest can there be in this husband, this wife, these chambermaids, this whole scene? Our late friend Greuze[6] would certainly have chosen the preceding moment, the moment when a father and a mother send their daughter to her husband. What tenderness! what decency! what delicacy! what variety he would have put into the actions and expressions of the brothers, sisters, parents, friends male and female! what a moving scene he would have made of it! It's a poor man who, in such circumstances, can only imagine a flock of chambermaids!

Even if the artist had not given them such low, mean, dishonest faces, the impropriety of the role of these maids would have been totally unacceptable. The harassed little face of the bride, the urgent and unappealing activity of the young husband seen from behind, those disreputable creatures round the bed, all of this reminds me of a brothel. All I see here is a courtesan who has had a bad experience with some debauchee and is frightened the same thing might happen again, while a few of her unhappy companions are assuring her it won't. All that's missing is an old madame.

Nothing is better proof than the example of Baudouin that morals are essential to good taste. This painter either chooses the wrong subject or the wrong moment; he's not even capable of being erotic. Does he imagine that the moment when everyone has gone, when the young bride is alone with her husband, would not have provided a more interesting scene than his?

Artists, if you are anxious for your works to survive, I advise you to stick to decent subjects. Anything that preaches depravity to men is doomed to destruction; and the more perfect the work, the more certain the destruction. Hardly any survive of those infamous and beautiful prints which Giulio Romano modelled on the obscenities of Aretino.[7] Probity, virtue, honesty, scruples, small-minded, superstitious scruples will eventually see the end of dishonest works.

Indeed, who is there amongst us, being in possession of a masterpiece of painting or sculpture capable of inciting to debauchery, who does not conceal it from the eyes of his wife, his daughter or his son? Who is there who does not think that this masterpiece should not get into the hands of another owner who might be less concerned to hide it away? Who is there who does not declare within himself that the talent might have been better employed, that such a work need not have been created and that one might do well to destroy it? How can a picture or a statue, however perfect, make up for the corruption of an innocent heart? And if these thoughts, which are not altogether absurd, should occur, not necessarily to a bigot, but to a decent man; and to a decent man, not necessarily a religious one, but a freethinker, an atheist, who is aged and about to meet his end, what becomes of the fine painting, the fine statue, that group of a satyr enjoying a goat, that little Priapus taken from the ruins of Herculaneum; those two pieces which are the most precious that have come to us from antiquity, in the judgement of the baron de Gleichen and abbé Galiani, who are connoisseurs?[8] And so, in one instant, a thing that cost sleepless nights to the most rare of talents is smashed to pieces! Yet which of us would dare to blame the honest, barbaric hand which committed this almost sacrilegious act? Not I, although I'm well aware of the objections that could be made: how little influence works of fine art have on moral standards in general; how independent they are even of the will and example of the sovereign, or of passing motives such as ambition, danger, patriotic spirit; I know that anyone who suppresses a bad book or destroys an erotic statue is like a fool who is afraid to piss in a river in case a man might drown in it: but let us leave aside the effect of these works on the morals of the nation; let us confine ourselves to individual morals. I cannot pretend that a bad book or an indecent print that chance might put into my daughter's hands would not be enough to put ideas into her head and ruin her. Those who fill our parks with the images of prostitution do not know what they are doing! Yet all the disgusting things which are constantly being scrawled on the statue of the *Vénus aux belles fesses*[9]

in the groves of Versailles; all the dissolute activities revealed in these graffiti, all the insults which debauchery delivers to its own idols, insults which are the sign of depraved minds, an inexplicable mixture of corruption and barbarity, all these are sufficient evidence of the pernicious effects of these kinds of work. Could not the busts of those who have deserved well of their country, whether bearing arms, in the courts of justice, in the counsels of the sovereign, or in the pursuit of letters or the fine arts, provide a better lesson? Why then do we not meet with the statues of Turenne and Catinat?[10] Because all the good things which are done in a nation are attributed to one man; because this man, jealous of every kind of glory, will not suffer another to be honoured. Because he alone is important.

If only Baudouin's poor choice of pictures were redeemed by draughtsmanship, interpretation, or a wonderful style; but no, every aspect of his art is mediocre. In this piece, the overall effect of the bride is nice, the head is well drawn; but the husband, seen from behind, looks like a sack with apparently nothing inside it; he's completely wrapped up in his dressing-gown, and the colour is dull. There's no effect of night; it's a night scene painted in daylight. At night the shadows are strong and therefore the lights are brilliant, but here all is grey. The lady's maid lifting the bedcover is quite nicely posed.

Salon of 1769

Friend Baudouin, you look too much at your father-in-law, and I've already told you this father-in-law is a most dangerous model;[11] I've said it to you again, but you pay no attention to my advice. There's such a thing as a chance encounter, you'll say; yes, but not all the time, and not always face to face. If I were you, I would rather be a poor little original artist than a great copyist; that's my idea and it may not be yours: master in my own cottage rather than slave in a palace.

This *Honest Model* is more your own, it's more accurate, but the

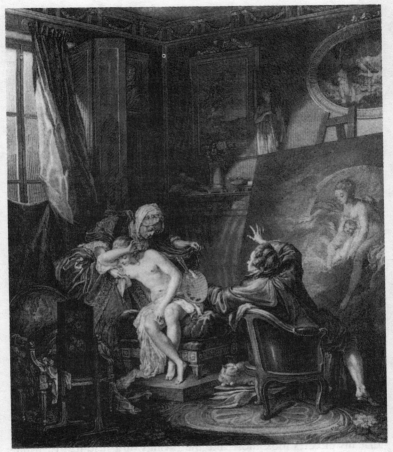

BAUDOUIN The Honest Model (Le Modèle honnête) (*engraving by
Moreau le jeune, Bibliothèque Nationale*)

colour's weak.[12] The material covering the girl shows up the light
well, but why didn't you spread it out more tastefully? You try for
expression for all you're worth and don't achieve it. You're affected
and mannered, and that's all. Just because you stretch out it doesn't
make you tall. And then the subject, in the way you've treated it, is

obscure: that woman isn't a mother, she's a vile creature operating some shady deal. One can't make head or tail of all this activity in a scene which should be moving and calm. A completely naked girl sitting for the artist with her head cradled in one hand, two tears coming from her lowered eyes, her other arm on her mother's shoulders, her mean clothes scattered around her, the honest, ragged mother hiding her face in her apron, the painter pausing in his work and looking tenderly at these two figures, that would have said everything. Take my advice and leave this sort of subject to Greuze.

BOUCHER

Salon of 1765

I don't know what to say about this man. His taste, colour, composition, characters, expression and draughtsmanship have deteriorated at exactly the same rate as his morals have become depraved. What would you expect this artist to put on his canvas? What is in his imagination? And what can there be in the imagination of a man who spends his life with prostitutes of the lowest kind? The grace of his shepherdesses is the grace of Favart in *Rose et Colas*; that of his goddesses comes from Deschamps.[1] I defy you to find in any stretch of countryside a single blade of grass which looks like those in his landscapes. Add to that a jumble of objects piled one on top of another, so out of place and ill-assorted that his pictures look more like the ravings of a madman than the work of a reasonable being. He was the man of whom the poet wrote:

> . . . *velut aegri somnia, vanae*
> Fingentur species: ut nec pes, nec caput . . .[2]

I make bold to say that this man really has no idea what grace is; that he has never known truth; that the notions of delicacy, honesty, innocence and simplicity have become almost foreign to him; that

he has never for an instant seen what nature is, or at least the kind of nature which could appeal to my mind or yours, or what it is to a well-bred child or a woman of sensitivity; that he is devoid of taste: of all the examples I could give of this, let one suffice: out of the host of male and female figures he has painted, I defy you to find four which would be suitable for a bas-relief, let alone a statue. There are too many pretty faces, trivial faces, too much mannerism and affectation for serious art. Even if he shows them to me naked, I can still see the rouge, the patches, the pompoms and all the fashionable trimmings. Do you imagine that anything resembling this honest, charming image of Petrarch's ever passed through his head:

E'l riso, e'l canto, e'l parlar dolce, humano?[3]

As for those delicate and subtle relationships which draw objects on to the canvas and bind them together with invisible threads, I swear to God he doesn't know a thing about them. All his compositions are an unbearable racket for the eye. He's the worst enemy to silence that I know. He does the prettiest little puppets you can imagine; he'll end up as an illuminator. Now then, my friend, at the very moment when Boucher ceases to be an artist he gets appointed first painter to the king.[4] And don't imagine that he is to his painting what Crébillon the younger is to literature; the morals are about the same, but the writer's talent is altogether different from the painter's. The only advantage the latter has over the former is his inexhaustible productivity, his unbelievable facility, especially in the decoration of his pastoral scenes. When he does children he groups them together beautifully, but they're only fit to romp about in the clouds. In all of this enormous family you won't find one who could turn his hand to the activities of real life, doing his lessons, reading, writing, stripping hemp; these are imaginary, story-book creatures, bastards fathered by Bacchus or Silenus. These children would do quite well for the sculpture round an antique vase; they're plump, podgy and chubby-cheeked. If this artist can work in marble, then we shall see. In a word, take all this man's

paintings and there'll scarcely be one to which you can't say, as Fontenelle did to the sonata, Sonata, what are you saying to me? Painting, what are you saying to me? Wasn't there a time when he was obsessed with painting virgins? And what were these virgins? Jolly little featherbrains. And his angels? Licentious little satyrs. And then his landscapes are so dull in colour and so uniform in tone that standing two feet away you'd take his canvas for a stretch of grass or a bed of parsley cut out in a square. Yet he's no fool, he's a good painter misdirected, as they say a man's talent is misdirected. He cares not for the meaning of art, but for empty display.

Jupiter Transformed into Diana to Surprise Callisto[5]

An oval painting about two feet high by one and a half feet wide.

In the centre we see Jupiter transformed. He is in profile, leaning across Callisto's knees. With one hand he is trying gently to remove her garment, this is the right hand; with his left he is stroking her chin: that's two hands put to good use! Callisto is painted in full face; she is feebly pushing away the hand which is unclothing her. Above this figure the painter has spread around some drapery and a quiver. The background is occupied by trees. On the left a group of children playing in the air; above this group the eagle of Jupiter.

But do mythological characters have different hands and feet from us? Ah! Lagrenée, what am I to think of this when I see you right beside it[6] and I'm struck by your firm colouring, the beauty of your flesh tints and the truths of nature which shine through every part of your composition? Feet, hands, arms, shoulders, a bosom, a neck, if you want any like those you've sometimes kissed, then Lagrenée will supply you; but not Boucher. Once they're fifty, my friend, there's scarcely a painter who still calls on a model, they do it from memory, and that's what Boucher does. They're all his old figures served up again and again. Hasn't he already shown us this Callisto and this

Jupiter a hundred times, as well as that tigerskin he's covered with?

Angelica and Medoro[7]
A painting of the same size and shape as the preceding one.

The two principal figures are placed to the right of the viewer. Angelica lies nonchalantly on the ground and is seen from behind, except for a small portion of her face which you can just see and which makes her look out of humour. On the same side, but further back, Medoro, standing, full face, leaning over, with his hand stretched out towards a tree on which he seems to be writing those two verses by Quinault, the two which Lulli has set so beautifully to music and which allow Roland to give expression to all the goodness of his soul and me to weep when the others are laughing:

> Angélique engage son coeur,
> Médor en est vainqueur.[8]

There are some Cupids busy putting garlands round the tree. Medoro is half covered in a tigerskin, and his left hand holds a hunter's spear. And imagine what the drapery is beneath Angelica: a cushion, a cushion, my friend! which fits in about as well as Nicaise's carpet in La Fontaine;[9] a quiver and arrows; on the ground a fat Cupid stretched out on his back and two others playing in the air round the tree to which Medoro is confiding his love; and then on the left some landscape and trees.

The painter has been pleased to call this Angelica and Medoro, but it could be anything. I defy anyone to show me anything which defines the scene and indicates who the characters are. Good God, he only had to follow the lead of the poet. How much more beautiful, grand, picturesque and well chosen is the scene of his adventure! It's a rustic cavern, a solitary place, the abode of darkness and silence. This is the place, far from any intruders, where one can make a lover happy, not in full daylight, in the open country, on a

cushion. It's on the mossy surface of a rock that Medoro carves their two names.

There's no sense in this. It's a little boudoir piece. And no feet, no hands, no truth, no colour, and the same old parsley on the trees. Look at Medoro, or rather don't look at him, especially his legs; it's as though they were done by a little boy with no taste and no learning. His Angelica is a little tripe-seller. Oh what a wicked thing to say! Agreed, but he can paint. His drawing is rounded, soft and his flesh is flabby. This man only takes up his brush to show me tits and bums. I'm quite happy to see them, but I don't want people to show them to me.

CASANOVA

Salon of 1765

He's a great painter, this Casanova. He has imagination and inspiration. Out of his brain he brings horses neighing, leaping, biting, rearing up and fighting, men killing each other in a hundred different ways, skulls cracked open, chests pierced through, shouts, threats, fire, smoke, dead men, dying men, all the confusion and all the horrors of hand-to-hand fighting. He can also arrange quieter compositions, and is just as able to show a soldier on the march or resting as one in battle, and he commands some of the most important aspects of technique.

An Army on the March

This is one of the finest and most picturesque creations I know! What a fine spectacle! What a fine poetic flight! How can I transport you to the foot of these rocks which reach up to the sky? How can I show you this bridge made of huge beams held up by joists and stretching from the top of those rocks towards that old castle? How can I give you a true impression of this old castle with its ancient crumbling towers and that other vaulted bridge which unites and separates them? How can I bring down the torrent from

the mountains, force the water through this bridge, and spread it all round the elevated site on which the massive stone structure is built? How can I trace the progress of this army as it leaves the narrow track driven through the summit of the rocks and brings them laboriously, tortuously from the top of those rocks down to the bridge which links them to the castle? How can I make you afraid for these soldiers and these heavy, lumbering baggage trains moving across this shaking wooden structure from the mountains to the castle? How shall I open up deep, dark precipices between these rotting wooden beams? How shall I make all these people go through the doors of one of the towers, how lead them from these doors to gather under the stone vault and then scatter them across the plain? Once scattered across the plain, you'll want me to depict some of them watering their horses, others quenching their thirst, some stretched idly on the banks of this broad, calm lake, others under a tent they have fashioned from a great length of cloth fixed here to a tree trunk and there to a piece of rock, drinking, talking, sitting down, standing up, lying on their backs, lying on their stomachs, men, women, children, horses, baggage. But perhaps, even as I despair of recreating in your imagination so many animate and inanimate objects, they're there and I've done it; if that's the case, God be praised! but my task is not over. Let's give Casanova's muse, and mine, a break, and give their work a cooler look.

On the right of the picture as you look at it, imagine a mass of great rocks of various heights; from the top of the lowest of these rocks a wooden bridge stretches down to the foot of a tower; this tower is linked with and separated from another tower by a stone arch, and this piece of ancient military architecture is built on a hillock; streams coming down from the mountains flow under the wooden bridge, under the stone arch, and go round behind the hillock to form a broad lake on the left-hand side of it. Imagine a tree at the foot of the hillock, which you should cover with moss and greenery; put a thatched cottage against the tower on the right; make little trees and parasitic plants grow out from between the

crumbling stones of each tower; scatter them over the tops of the mountains on the left. On the far side of the lake formed on the right by the streams, imagine a few distant ruins and you'll have an idea of the site. Now for the progress of the army.

It files down from the mountain tops on the right along a steep track; it moves under the wooden bridge which goes from the lowest of these mountains to the foot of one of the towers of the castle; it goes round the hillock on which the castle is built and reaches the stone arch which links the two towers; it goes under this arch and from there it spreads out to the left and right around the hillock, along the shores of the lake and finally settles at the bottom of the high mountains from whose summit it set out. If he looks up, each soldier can measure with a feeling of horror the height from which he has descended. Let us go on to the details.

At the top of the rocks are some soldiers in full view; as they come down the steep track they disappear; you see them again when they come out on the wooden bridge. This bridge bears a baggage cart; a large part of the army has already encircled the hillock, gone under the stone arch and is resting. Imagine, all round the hillock from which the castle rises, everything that goes on when an army stops to rest, and you'll have Casanova's painting. It's impossible to give an account of all these incidents, they are so infinitely varied; in any case, what I've sketched in the first lines will suffice.

But oh! if only the execution of this painting were up to the conception! If only Vernet had painted the sky and the water, Loutherbourg the castle and the rocks, and some other great master the figures! if only all these objects on different planes had been lit and coloured according to their distance! then you would only need to have seen this picture once in your life; but unfortunately it lacks all the perfection which those different hands would have given it. It's a fine poem, well thought out, well constructed and badly written.

This painting is gloomy, dull and lifeless. The whole canvas

offers only the various irregularities of a big, burnt crust of bread, so the whole effect of those great rocks, that great mass of stone rising up in the centre of the canvas, that wonderful wooden bridge and that priceless stone arch is destroyed and lost. There is no skill in the use of colour tones, no shading off in the perspective, no air between the objects, the eye is prevented from moving freely. The objects in the foreground have none of the strong colouring which their position demands. My friend, if the scene is taking place close to the spectator, the figure placed nearest to him will be at least eight or ten times as big as the one eighteen or twenty yards from it; so either there must be more strong colour in the foreground or all truth and effect are lost. If on the other hand the spectator is further away from the scene, the shading off of the objects will be relatively less obvious and will call for softer tones, because there will be a greater volume of air between the eye and the scene. Objects close to the eye are seen separately, further away they close up and merge together. Those are the elementary rules that Casanova seems to have forgotten. But how, you'll say, has he forgotten now what he remembers so well at other times? Shall I tell you how I see it? In other pictures the composition is up to him, he's the inventor; in this one, I suspect he's only the compiler; he'll have opened his portfolio of prints, skilfully combined three or four pieces by landscape artists and made an admirable sketch; but when he came to paint this sketch, style, skill, talent and technique deserted him. If he'd seen the scene in reality or in his head, he would have seen it with all its planes, its sky, its water, its light and its true colours, and that's what he would have executed. Nothing is so common or so difficult to recognize as plagiarism in painting; perhaps one day I'll say something to you about it. Style gives it away in literature, colour in painting. However that may be, how much beauty has been lost in the drabness of this piece, but despite that, its poetry, variety, richness and detail make it Casanova's finest work.

It is eleven feet long and seven feet high.

A Battle

A painting four feet long by three feet high.

This is a battle between Europeans. In the foreground you see a dead or wounded soldier; nearby, a cavalryman whose horse is receiving a bayonet thrust, while the cavalryman is firing his pistol at another who is raising his sword over him. Over towards the left, a fallen horse with its rider thrown down. In the background, hand-to-hand fighting. On the right, in the foreground, broken rocks and trees. The sky is lit up by fires and darkened with smoke. There you have the calmest imaginable description of a very violent action.

Another Battle

Same dimensions as the preceding one.

This is an action between Turks and Europeans. In the foreground a Turkish ensign whose horse has been felled by a blow to the left leg; the rider seems to be using one hand to cover his head with his colours and the other to defend himself with his sword. Meanwhile a European has seized the colours and is threatening his enemy's head with his sword. On the right, in the background, soldiers variously attacking and being attacked; amongst these soldiers one notices one who, sword in hand, looks on, motionless. In the background, on the left, the dead, the dying, the wounded, and other soldiers almost at rest.

This last battle is made up of colours taken straight off the palette and put on to the canvas, but there's no form, no effect, no draughtsmanship. Why is that? It's because the figures are a little too big, and Casanova doesn't know how to express them. The bigger a work is, the harder it is to transfer from the sketch.

The earlier composition, where the figures are smaller, is the better one; but all the same there's life, movement and action in both of them: they strike well and defend themselves well, they

attack and kill well; it's how I imagine the horrors of hand-to-hand fighting.

Casanova does not draw in an affected way; his figures are short. Despite the bold style of his compositions, I find him monotonous and sterile; there's always a big horse in the middle of his canvases, with or without a rider. I know it's hard to imagine a greater, nobler, finer form of movement than that of a beautiful horse rearing up on its hind legs, kicking out violently with its two front legs, turning its head, shaking its mane and waving its tail as it plunges forward in a whirl of dust; but just because something is beautiful, does it have to turn up at every opportunity? Other painters prefer a perspective where the pyramid goes from top to bottom; his goes from the surface of the canvas to the background; another monotonous feature. There's always a point in the centre of the canvas which projects well forward, and from this point, the summit of the pyramid, a series of objects on planes which grow successively broader into the background, where the broadest of all these planes forms the base of the pyramid. This arrangement is so peculiar to him that I would recognize it from one end of the gallery to the other.

A Spaniard on Horseback

A painting ten inches wide by fourteen inches high.

The Spaniard is mounted on a horse and occupies almost the whole of the canvas. The figure, the horse and the movement are as natural as it's possible to be. On the right-hand side you see a band of soldiers marching away from you; on the left, some very smooth mountains.

A lovely little picture, done in very strong, warm colours, and very lifelike. Good, bold brushwork, a positive effect, but without harsh contrasts. Buy this little picture and be sure you'll never grow tired of it, unless you were born with fickle tastes. You leave the most delightful woman for no other reason than that she has pleased you for too long, you grow weary of the sweetest pleasures without

really knowing why. Why should a picture have some advantage over the reality? For life is after all a very pleasant reality. Custom makes it less flattering to possess things and more cruel to be denied them. How strangely things are ordered! Have you ever been able to fathom it?

CHARDIN

Salon of 1763

Now here's a painter, here's a colourist for you.

There are several pictures by Chardin in the Salon; they nearly all of them represent fruit and the accompaniments of a meal. This is nature itself; the objects come out of the canvas with a truth that deceives the eye.

The one you see as you go up the staircase deserves special attention. The artist has set on a table an old china vase, two biscuits, a jar filled with olives, a basket of fruit, two glasses half full of wine and a bitter orange next to a pie.[1]

When I look at other men's pictures I seem to need new eyes; when I look at Chardin's, I need only to keep the ones nature gave me and use them properly.

If I wanted my son to be a painter, this is the picture I should buy. 'Copy this,' I should tell him, 'copy it again.' But perhaps nature itself is not more difficult to copy.

For this china vase is china; and these olives are really separated from the eye by the water they are floating in; these biscuits are there to be picked up and eaten, this orange to be cut open and squeezed, this glass of wine to be drunk, these fruits to be peeled, this pie to be sliced with a knife.

This man really understands the harmony of colours and highlights. Ah Chardin! what you mix on your palette is not white, red and black: it's the very substance of things, what you take on the tip of your brush and fix on to the canvas are the very air and light themselves.

After my child had copied this piece and copied it again, I would set him to do *The Skate* by the same master.[2] The object itself is repellent, but it's the very flesh of the creature, its skin and its blood; the sight of the real thing would not affect you any differently. Monsieur Pierre,[3] take a good look at this piece when you go to the Academy, and learn, if you can, the secret of using your talent to compensate for the offensive nature of certain things.

You can't fathom this magic. It's a series of thick layers of colour placed one on top of another with the effect coming through from underneath. Another time you might say it was like smoke breathed on to the canvas; at another, a light foam cast on to it. Rubens, Berghem, Greuze or Loutherbourg would explain this technique better than I can; all of them can create the effect for your eye. Go up close to the picture and everything blurs, flattens out and disappears; move further away, and it all takes shape and comes alive again.

I've been told that when Greuze was going up to the Salon and saw the piece by Chardin which I've just described, he looked at it and then moved on, giving a great sigh. That piece of praise is briefer and worth more than mine.

Who will be able to pay for Chardin's pictures when this rare man is no more? And I must also tell you that this artist is a man of good sense who talks wonderfully about his art.

Oh my friend, you can forget about Apelles' curtain and the grapes of Zeuxis.[4] It's easy to deceive an impatient artist, and animals are bad judges of painting. Haven't we seen the birds in the royal menagerie smashing their heads against the worst possible perspectives? But you and I are the ones that Chardin can deceive whenever he likes.

Salon of 1765

Chardin, you come most opportunely to refresh my eyes, grievously afflicted by your colleague, Challe.[5] Here you are once more, great magician, with your mute creations. How eloquently they speak to

the artist! How much they can tell him of the imitation of nature, the science of colour and harmony! How freely the air moves around these objects! The light of the sun is no better at making up for the disparities in the objects it illuminates. Here is a man who is scarcely concerned that some colours go together and others do not.

If it is true, as the philosophers say, that our sensations are the only reality, that there is perhaps nothing in either the emptiness of space or in the very solidity of bodies of what we actually experience, let these philosophers tell me what difference there is for them, standing four feet away from these pictures, between the Creator and you.

There is such truth in Chardin, such truth and harmony, that although we see on his canvas only inanimate nature, vases, jugs, bottles, bread, wine, water, grapes, fruit, pies, he can hold his own and even draw your attention away from two of the finest Vernets, beside which he has not hesitated to place himself. It is, my friend, the same as in the universe, where the presence of a man, a horse, an animal, does not ruin the effect of a fragment of rock, a tree, a stream. The stream, the tree, the fragment of rock are doubtless of less interest than the man, the woman, the horse; but there is just as much truth in them.

I must tell you, my friend, of an idea which has just come to me, and which might not come again at another time: this type of painting they call *genre* should be for old men or for people who are born old. It requires only study and patience, no inspiration, not much genius, hardly any poetry, plenty of technique and truth, and that is all. Now you know that the time when we apply ourselves to what is called, as custom rather than experience would have it, the quest for truth, philosophy, is precisely the time when we are going grey at the temples and would look silly trying to write a love letter. You might think about this resemblance between philosophers and genre painters. And, my friend, talking of grey hair, I looked at my head this morning and saw it was all silvery, and I exclaimed like Sophocles when Socrates asked him how his love life

was going: *A domino agresti et furioso profugi*; I am escaping from that wild and furious master.

I'm all the more pleased to spend time talking to you because I shall say but a single word to you about Chardin, and this is it: pick his site, arrange the objects on this site as I show you, and be sure that you will have seen his paintings.

He has painted *The Attributes of the Sciences*, *The Attributes of the Arts*, those of *Music*, some *Refreshments*, *Fruit* and *Animals*.

The Attributes of the Sciences

On a table covered with a reddish cloth, you see, going I think from right to left, some books standing upright, a microscope, a small bell, a globe half-hidden by a green taffeta curtain, a thermometer, a concave mirror on its stand, an eyeglass with its case, some rolled-up maps, part of a telescope.

It is nature itself, accurate in every shape and colour; the objects stand apart from one another, come forward, move back, as if they were real; nothing could be more harmonious and free of confusion, despite their number and the small space which contains them.

The Attributes of the Arts[6]

Here we have some books lying flat, an antique vase, drawings, hammers, chisels, rulers, compasses, a marble statue, brushes, palettes, and other objects of a similar kind. They are placed on a sort of balustrade. The statue is the one on the fountain in the rue de Grenelle, Bouchardon's masterpiece.

The same truth, the same colour, the same harmony.

The Attributes of Music[7]

On a table covered with a reddish cloth the painter has spread a host of different objects arranged in the most natural and picturesque way. There is an upright music stand and in front of it a candlestick with two branches; behind them a trumpet and a hunting-horn with the hollow part of the horn visible over the top of the music stand; there are oboes, a mandora, sheets of music lying about, the

neck of a violin with its bow, and some books standing upright. If a dangerous creature, a snake, were painted with such realism, it would give you a fright.

These pictures are three feet ten inches wide by three feet ten inches high.

Refreshments

Imagine a square structure made of greyish stone, a sort of window with its lintel and its cornice. In as noble and elegant a manner as you can, stretch a garland of vine leaves along the cornice and make it fall from each end. Place inside the window a glass full of wine, a bottle, a partly used loaf, some carafes cooling in a china bucket, an earthenware pitcher, radishes, fresh eggs, a salt cellar, two cups filled with steaming coffee, and there you'll have Chardin's picture. That broad, smooth stone structure decorated with a garland of vines is very beautiful indeed; it could serve as the model for the front of a temple to Bacchus.

Companion piece to the preceding picture

The same stone structure, and around it a garland of big white muscat grapes; inside, peaches, plums, carafes of lemonade in a tin bucket painted green, a peeled lemon cut through the middle, a basket full of simnel cakes, a masulipatan[8] handkerchief hanging over the edge, a carafe of barley water and a glass half-filled with it. What a profusion of objects! What a variety of shapes and colours! And yet what harmony! What a restful effect! The softness of the handkerchief is amazing.

Third painting of Refreshments, to be placed between the first two[9]

If it's true that a connoisseur absolutely must have one Chardin, let him get hold of this one. The artist is beginning to grow old; he's sometimes done as well as this, never better. Hang up a freshwater bird by one claw. On a sideboard underneath imagine some biscuits, some whole, some broken, a bottle, corked and filled with olives, a painted china bowl with a lid, a lemon, a napkin, unfolded and

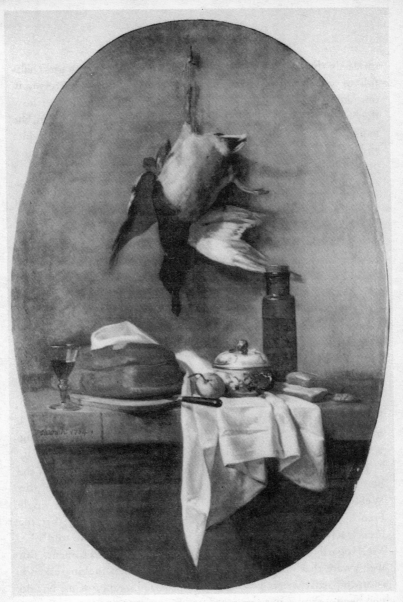

CHARDIN Third painting of Refreshments (Troisième
tableau de rafraîchissements à placer entre les deux premiers)
Museum of Fine Arts, Springfield, Massachusetts

carelessly thrown down, a pie on a wooden billet, with a glass half-full of wine. This is where you see that there are scarcely any ungrateful objects in nature and that everything depends on how they are represented. The biscuits are yellow, the bottle is green, the napkin white, the wine red, and the yellow, the green, the white and the red set against each other delight the eye with the most perfect harmony; and don't think that this harmony is the result of a weak, soft, artificial technique: not in the least, the brush-strokes are everywhere full of vigour. It's true that these objects don't change before the artist's eyes. They're the same one day as he'll find them the next. It's not the same with animate nature; only stone has the quality of constancy.

A Basket of Grapes[10]

That's all there is to the picture. Just spread around the basket a few odd grapes, a macaroon, a pear and two or three small apples. You'll agree that odd grapes, a macaroon and a scattering of apples are not the best example of form or colour; but have a look at Chardin's painting.

A Basket of Plums[11]

Place on a stone bench a wicker basket full of plums with a miserable piece of string for a handle, and scatter round it some walnuts, two or three cherries and a few bunches of grapes.

This man is the best colourist in the Salon and perhaps one of the best colourists there is. I will never forgive that impertinent man Webb for writing a treatise on art without mentioning a single French painter.[12] Nor can I forgive Hogarth for saying that the French school didn't even have a mediocre colourist. You told a lie, Mr Hogarth, either from ignorance or lack of discernment. I'm well aware that your nation has this peculiarity of looking askance at an impartial writer who dares to speak favourably of us; but do you need to kowtow to your fellow citizens at the expense of truth? Paint, and paint better if you can; learn to draw and stop writing. We and the English have two very different approaches: ours is to

overestimate what the English do; theirs is to run down what we do. Hogarth was still alive two years ago, he had stayed in France,[13] and Chardin has been a colourist for thirty years.

Chardin has a distinctive technique. It's made up of separate brush-strokes, so that close up you can't tell what it is, but as you move away, the object slowly takes shape and finally becomes a reality; sometimes, too, it's equally pleasing whether seen close up or from a distance. This man stands above Greuze by the whole distance between the earth and the sky, but only on this point. He has no style; no, I'm wrong, he has one of his own; but since he has a style of his own, there should be some circumstances where he goes wrong, but there aren't. Now, my friend, try and explain that. Do you know of any literary style which is suitable for anything? Chardin's kind of painting is the easiest of all, but there's no living painter, not even Vernet, who is as perfect in his own field.

Salon of 1767

Two paintings representing various Musical Instruments[14]

Let's start by revealing this man's secret. Such indiscretion will be of no consequence. He brings his picture into the presence of nature, and rejects it if it doesn't stand comparison.

These two pictures are very well composed. The instruments are tastefully arranged. There's a kind of inspired disorder in the way they're thrown together. The artistic effects are delightfully contrived. There is everywhere the greatest truth in the form and colour. This is where you can learn how to combine boldness and harmony. I prefer the one with the kettle-drums; either because the objects in it are in larger masses, or because their arrangement is more lively. The other one would pass for a masterpiece, without its companion piece.

I'm sure that, when time has extinguished the rather harsh, crude brilliance of the fresh colours, those who felt that Chardin had done better things will change their minds. Let them go and look at his works again when time has painted them. I would say the same of

Vernet, and of those who prefer his early paintings to those which have just come from his palette.

Chardin and Vernet see their paintings at twelve years' distance from the time they have painted them; and those who criticize them are as little justified as those young artists who go to Rome and slavishly copy paintings done a hundred and fifty years ago. Not realizing what changes time has made to the colour, they don't realize either that they're not seeing the Carracci's paintings now as they would have seen them on the Carracci's easels. But who can teach them to appreciate the effects of time? Who can save them from the temptation of doing more old paintings tomorrow, paintings from the last century? Common sense and experience.

I'm well aware that Chardin's models, the inanimate objects he imitates, do not change place, colour or shape, and that, given the same degree of perfection, a portrait by La Tour has more merit than a genre piece by Chardin. But the beating of time's wings will leave nothing behind to justify the former's reputation. The precious dust will be gone from the canvas, half of it scattered in the empty air, half clinging to the long feathers of old Saturn. La Tour will be spoken of, but Chardin will be seen.

It's said of this man that he has a technique all his own, and that he uses his thumb as much as his brush. I don't know about that. What is certain is that I've never known anyone who's seen him at work. However that may be, his compositions appeal equally to the ignorant and the connoisseurs. There's an incredible boldness in the colour, a general impression of harmony, an effect of liveliness and truth, beautiful masses, a magic to make you despair, and a piquant variety in the arrangement of objects. Whether you move away or draw up close, the illusion is the same, no confusion, no symmetry either, no bright spots of light; the eye is always refreshed because there is calm and repose. You stop in front of a Chardin as though by instinct, as a traveller weary of his journeying sits down, almost without thinking about it, in the spot which offers him greenness, silence, water, shade and coolness.

Salon of 1769

I ought simply to point out Chardin's pieces and refer you to what I've said of this artist in the previous Salons; but I like repeating myself when I'm giving praise: I give way to my natural inclination. The good generally affects me much more than evil. My first reaction to evil is to hit the roof; but that's a passing emotion. Admiration for what is good is a lasting thing with me. Chardin is not a history painter, but he is a great man. He's everyone's master when it comes to harmony, that rarest of qualities which everybody talks about and very few know. Stand for a long time in front of a fine Teniers or a fine Chardin; make sure the effect is firmly fixed in your mind; then refer everything you see to this model and have no doubt that you'll have discovered the secret of being seldom satisfied.

The Attributes of the Arts and the rewards which are given to them
Everyone is familiar with nature, but Chardin sees it properly and makes every effort to render it as he sees it; his piece on the *Attributes of the Arts* is proof of it. How well observed the perspective is! How well the objects are reflected in one another! How positive the masses are! You can't say where the magic lies because it's everywhere. You look for the shades and the lights, and there must be some, but they don't stand out at any particular point; the objects are isolated from one another without any contrivance.

Take the smallest painting by this artist, a peach, a grape, a pear, a walnut, a cup, a saucer, a rabbit, a partridge, and there you'll discover this great, profound colourist. Looking at his *Attributes of the Arts*, the eye, delighted, is left satisfied and tranquil. When you've spent a long time looking at this piece, the others seem cold, pieced together, flat, crude and out of tune. Chardin is between nature and art; he consigns the other imitations to the third rank. With him, you are never reminded of the palette. There is a harmony there beyond which nothing is felt to be wanting; it winds its way imperceptibly through his composition, fully present within every part of the whole canvas; it is, as the theologians say of

the spirit, discernible everywhere and hidden at every point. But as we must be fair, that is to say sincere with ourselves, the Mercury, symbol of sculpture, struck me as rather poorly drawn, just a little too bright, too strong for the rest of the picture; it doesn't create as complete an illusion as it might. This is because he shouldn't have taken a new sculpture as his model; a more dusty plaster would have given a duller light and the highlights would have been more successful; it's because it's so long since he's drawn an academic piece that he's lost the knack, and in addition the figure is not cleanly drawn. Chardin is an old magician whom age has not robbed of his wand. This painting of the *Attributes of the Arts* is a repeat of the one he executed for the Empress of Russia and is an improvement on it. Chardin frequently copies his own work, a fact which inclines me to think that these works take a lot out of him.

A Woman Returning from Market[15]

This cook coming home from the market is another repeat of a piece painted forty years ago.[16] This picture is a lovely little thing. If there is any fault in Chardin, then because he sticks to his particular style, you'll find it everywhere; for the same reason, he never loses what he does to perfection. He's equally harmonious here; there's the same congruity in the reflections, the same rightness in the effects, a rare achievement; because it's easy to get an effect when you take liberties, when you create a mass of shades without bothering about what produces them. But to combine vigour with principle, to be the slave of nature and the master of one's art, to possess genius and reason, that's the devil of a job. It's a pity that Chardin applies the same manner to everything, and that when he moves from one object to the next it sometimes becomes heavy and ponderous. It goes wonderfully well with the opaque, matt, solid nature of inanimate objects, but it clashes with the life and delicacy of living things. Look at it here, in a chafing dish, some loaves and other accessories, and see if it works as well with

the face and arms of that servant girl, who in any case strikes me as rather massive in her proportions and mannered in her posture.

Chardin is such a rigorous imitator of nature, such a severe judge of himself, that I once saw a painting of his called *Game* which he never finished, because some little rabbits he was working from had begun to rot, and he despaired of ever finding any others with which he could achieve the harmony he had in mind. All those that were brought to him were either too brown or too light.

DESHAYS

Salon of 1765

This painter is no more. He more than anyone had fire, imagination and inspiration; he more than anyone could create a scene of tragedy and fill it with incidents to make you tremble, and bring out the odiousness of his characters by a natural and carefully orchestrated contrast with gentle, innocent natures; he more than anyone was a genuine poet. A born libertine, he died a victim of his dissolute ways. His last works are poor, and proof of the state of his health when he was working on them.

The Conversion of St Paul[1]

If ever there was a great subject for a painting, it is the conversion of St Paul. I would say to a painter: Do you feel you have a mind which can conceive a great scene and arrange it in a striking way? Can you bring down the fire from heaven and overturn men and horses in panic? Do you have in your imagination the different faces of terror? If you have ever been master of the magic of chiaroscuro, take up your brush and show me Saul's adventure on the road to Damascus.

In Deshays' painting we see Saul, struck down, in the foreground; his feet are turned away from us, his head is lower than the rest of his body; he is supporting himself on one hand, which is touching

the ground, his other arm seems to be lifted up to protect his head, and his eyes are fixed on the place where the danger threatens.

This figure is beautiful, well drawn, boldly conceived, it's Deshays still, but the rest is not. One imagines that the effect of the light would be one of the main features of such a composition, and the painter hasn't thought of it. He has made a good job of arranging the frightened soldiers on the left, and you see another group round the fallen horse, but these groups are lifeless and indifferently done, without appeal or interest. What draws the viewer's eye is the enormous crupper of Saul's horse. If you calculate the height of this huge animal using that of the soldier holding him as a yardstick, he's bigger than the one on the Place Vendôme.[2] The overall colour is dirty and heavy, and it's really no more than a scrap of a composition.

St Jerome Writing on Death[3]

On the right an angel winging his way along, sounding a trumpet and passing on. To the left, the saint sitting on a rock, watching and listening to the angel as he trumpets and passes by. Around him, on the ground, a death's head and a few old books.

Deshays was very ill when he did this picture; no spark left, no genius. He has aimed at the old, grubby, smoky effect of the paintings of a hundred and fifty years ago in his Saul and his St Jerome. That aside, the St Jerome is well painted and well drawn, but the composition is heavy and stiff. The angel is lively and his head is very fine, granted, but his wings are dishevelled, ragged and the wrong way round, one in one colour and the other in another, like one of Milton's angels roughed up by the Devil. And what is that angel there for? What is that saint saying as he watches and listens to him? He's painted a figment of the man's imagination. What a wretched, feeble idea! I'd be happy for the angel to blow his trumpet and pass on, but instead of making him actually exist and making the saint look at him, he should have shown me his face, his arms, his attitude, his whole being exhibiting the terror which a man must feel when all the sufferings of the last hours of man are present in his mind, when he sees them and is filled with dismay;

and that is what Deshays would have done in the past, because the St Jerome I want was there in his head.

Two Sketches,
one representing the Comte de Comminges at La Trappe, the other, Artemisia at the tomb of Mausolus

Oh yes, here the whole genius of the man is restored to us. These two sketches are outstanding. The first is full of truth, interest and emotion. The superior of La Trappe is standing; at his feet, Adelaide lies dying on the ashes; the count is prostrate, kissing her hands; on the right, near the abbot, groups of monks stand amazed; around the count, more amazed monks; towards the background on the left, two amazed monks look on. Add to all that a tomb somewhere; look at the characters and movements of those monks and then you'll say: That's exactly as it should be . . . The Marquise de Tencin has written the romance of it; Deshays the history.[4]

Artemisia at the Tomb of Mausolus

Ludentis speciem dabit, et torquebitur . . .[5]

The whole of this composition is very gloomy, very lugubrious, very sepulchral. It fills one with admiration, grief, terror, and respect. It is the depth of night; a ray of light would add to the horror and even to the darkness without destroying the effect, the silence. In the hands of a genius, light can be used to give the impression of its opposite. Whether the light is bright, soft, graduated or generously distributed, each object, whether it shares it equally or in proportion to its exposure and its distance from the source, either spreads a feeling of joy or enhances it, or else is reduced to a simple technique which shows off the artist's skill without either weakening or improving the impression made. Concentrated in one place, on the face of a dying man, it intensifies the horror, emphasizing the surrounding darkness. Here a sparse, feeble light comes from the left, just touching the surface of the first objects it meets; the right-hand side of the picture can be discerned

only by the light of a coal fire, on which some perfumes are burning, and a sepulchre lamp hanging from the top of a monument. All kinds of artificial light, whether from fires, lamps, torches, spectres, sorcerers, sepulchres, graveyards, caverns, temples, tombs, secret activities, factions, conspiracies, crimes, executions, burials or murders, bring an atmosphere of gloom with them; they waver uncertainly, and by this continual wavering they suggest the inconstancy of the gentler passions and intensify the effect of harmful passions.

Mausolus's tomb occupies the right of the picture. At the foot of the tomb, at the front, a woman is burning perfumes in a brazier. Behind this woman, further back, you can see a few guards. From the top of the tomb, over on the right, hangs a large drapery. In the far distance, raised up a little, the painter has placed a weeping woman; above her head and above the mausoleum he has hung a lamp. This light falling from above puts all the objects leaning away from it into a half-light.

Artemisia, in front of the monument, is kneeling on a cushion; her upper body is bent forward. With both hands she is embracing the urn containing the cherished ashes; her sorrowful head is inclined towards this urn. At her feet is a funerary vessel, and behind her, in the background, stands a column which forms part of the monument.

Two companions in grief have followed her to the tomb. They are behind her; one is standing, and between her and Artemisia is the other, crouching down. Both bear the unmistakable marks of despair, the latter especially, with her head raised towards the sky. Imagine this tearful face illuminated by the light from the lamp at the top of the monument. On the ground beside these women is a cushion, and behind them, guards and soldiers.

But to feel the full effect, all the lugubrious character of this composition, you must look at the way the figures are draped, and all the heedless, voluminous disorder of it; this is almost impossible to describe. I have never understood more clearly how much this aspect of the art, which is usually considered unimportant, involved taste, poetry and even genius.

The way Artemisia is dressed is unimaginable; this great expanse

of drapery piled up on her head, falling forward in broad folds and spreading out at the side of her averted face, both revealing and accentuating that part of her head which is on view, is done in the grand manner and has a wonderful effect. How great, touching, sad and noble this woman looks! How beautiful she is! What graces she possesses, for her whole person can be discerned beneath her drapery! What distinction this picturesque drapery gives to her head and arms! How well posed she is! How tenderly she embraces all that remains of one who was dear to her!

A fine, truly fine composition, a fine poem. Affliction, sadness and grief leap out from every part of this picture to reach the soul. Whenever I think of this sketch and then of the sepulchral scenes in our theatres, our Artemisias of the wings and their confidantes, all powdered, curled and hooped, holding their big white handker-chiefs, I solemnly swear that I shall never go to see these insipid exhibitions of grief, and I shall keep my word.

Deshays composed this sketch during the last moments of his life; the chill of death was about to numb his hands and make his fingers helpless to grasp the pencil, but the eternal, divine spark still had its power. Archimedes wanted the sphere inscribed on the cylinder to be engraved on his tomb. This sketch should be engraved on the tomb of Deshays. But incidentally, my friend, did you know that Monsieur le Chevalier de Saint-Pierre[6] has kindly offered to finish the sketch of the Comte de Comminges? When Apelles died, there was not one who dared to finish the Venus he had begun. As you see, we have artists who are more aware of their own powers. It is a fine and lovely thing, this awareness we have of our own merit! Quite seriously, Pierre has done an honourable thing: he suggested to the minister that he should paint the Invalides chapel based on Van Loo's sketches. I had forgotten about that offer, which is not in the least vain.

I have seen Deshays come into the world and leave it. I have seen all the great compositions he has produced, his *St André* worship-ping his cross, the martyrdom of the same, his insolent and sublime *St Victor* defying the proconsul and overturning the idols; Deshays

realized that a fanatical soldier, a man whose profession led him to risk his life for others, must behave in a particular way when the glory of his God was at stake. I have seen his *St Benedict* dying at the altar; his *Temptation of St Joseph*, in which he was bold enough to show Joseph as a man and not a brute beast; his *Marriage of the Virgin*, looking beautiful in a temple, despite the fact that the costume called for it to be celebrated in a private room. Deshays had a vast, bold imagination. He was a creator of marvellous effects and now we find him sick and dying, but we still find him as he was in his *St Jerome*, contemplating his end, his *Saul* struck down on the road to Damascus, and his *Achilles* struggling against the waters of the Simois and the Scamander, all works which are vigorous in conception and execution. He is grand, free and noble in his manner. He understood the distribution of planes, he could make his figures look picturesque and arrange them effectively. His draughtsmanship was firm, sensitive, boldly expressed and slightly angular. He would unhesitatingly sacrifice the details to the whole. One finds in his works great shaded areas, uncluttered expanses which soothe the eye and cast brightness around them. His colour, neither over-subtle nor precious, is solid, vigorous and appropriate to the type of painting. All the same, his male figures have been criticized for their yellowish tones and their almost pure red colours, and his female figures for the rather artificial brightness of their complexions. In his *Joseph* it was very clear that he was no stranger to elegance and sensuality, but there remains in this elegance and sensuality something austere and noble. The drawings that he has left confirm our high regard for his talent; their tastefulness, the soft, substantial pencil strokes make up for the faulty handling and the exaggerated shapes. It is said that he has drawn studies of heads with so much artistry and feeling that they hold their own in portfolios that contain works left by the great masters. High hopes had been placed in Deshays and he has been much regretted. Van Loo had a better technique, but he could not compare with Deshays where imagination and genius are concerned. It was his father, a poor painter in his home town of Rouen, who first put a pencil in

his hand. He studied successively under Colin de Vermont, Restout, Boucher and Van Loo; with Boucher he ran the risk of losing all the benefit he had gained from his lessons with the others, the wisdom and the grandeur in design, the understanding of light and shade, the impressive effects to be gained from great masses of colour. He wasted his early years seeking after pleasure, yet he won the Academy prize and went to Rome.[7] The silence and gloom of this sprawling city did not appeal to him and he grew bored with it. Unable to return to Paris to find the dissipated life his fiery temperament required, he set about studying the great masterpieces and his genius began to awake. He returned to Paris and married the eldest daughter of Boucher. Marriage did not change his evil ways: he died at thirty-five, a victim of his irresponsible way of life. When I compare the little time we devote to work with the amazing progress we make, I think that a man of average ability, but with a strong, robust constitution, who took up his books at five in the morning and didn't leave them until nine in the evening, working on them as a coppersmith works on metal, would, at the age of forty-five, know everything there is to know.

DOYEN

Salon of 1767

Multaque in rebus acerbis
Acrius advertunt animos ad religionem[1]

Le Miracle des Ardents[2]

A painting twenty-two feet high by twelve feet wide, for the Chapelle des Ardents at Saint Roch.

Here are the facts. In the year 1129, in the reign of Louis VI, a plague from heaven visited the people of Paris. It consumed the vital organs, and one died the cruellest of deaths.

This scourge suddenly ended upon the intercession of St Genevieve.

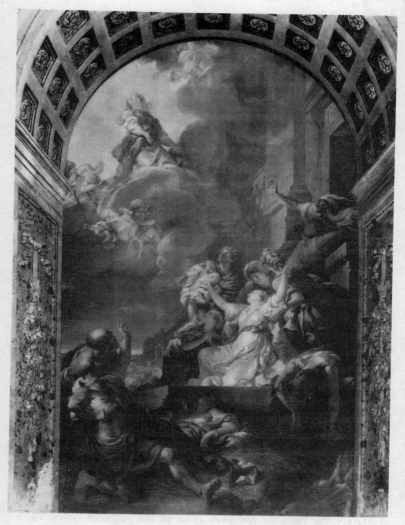

DOYEN Le Miracle des Ardents *Church of Saint Roch, Paris*

There are no circumstances where men are more susceptible to the sophism *post hoc, ergo propter hoc*[3] than those in which long

periods of calamity and the futility of human remedies force them to have recourse to heaven.

In Doyen's painting, right at the top of the canvas, on the left, you see the saint on her knees, borne up by clouds. Her eyes are turned towards a light shining in the sky above her head, while she gestures with her arm towards the earth. She is pleading. She is interceding. I would tell you what she is saying to God, but there would be no point here.

Beneath the glory whose light shines on the face of the saint, among the red-tinted clouds, the artist has placed two groups of angels and cherubim, some of whom seem to be fighting for the honour of carrying the crook of the shepherdess of Nanterre. This is a trivial, jolly idea, which clashes with the seriousness of the subject.

Towards the right-hand side, near to her, are another little group of cherubim and some more reddish clouds, joined to the first ones. These clouds grow darker and thicker as they descend to cover the top of a building which occupies the right-hand side of the scene, stretching into the background and facing the left-hand side. It's a hospital, an important part of the scene, of which it's difficult to form a clear idea, even when you're looking at it. It presents to the observer standing outside the picture the lateral face of a vertical section passing through the pier of the door of this building, not touching the door but dividing the parvis in front of it and the flight of steps going down into the street. The result is that the divided parvis and steps together form a solid perpendicular mass above a piece of ground which runs right across the foreground of the picture.

Thus an observer who planned to leave his place and go into the hospital would first of all go up on to this piece of ground. Coming up against the precipitous vertical face of this masonry he would turn left, discover the flight of steps, go up the steps, cross the parvis and go into the hospital through the door, which is on a level with the parvis.

It can be seen that another observer starting from the back of the picture would take the opposite route, and that we would begin to

see him only when his own height was greater than that of the flight of steps, which steadily diminishes.[4]

The first incident to strike one is a man in a frenzy hurling himself through the door of the hospital. His head, bound with a piece of rag, and his bare arms are raised towards the protecting saint. Two powerful men, seen from behind, are holding him back and supporting him.

To the right, on the parvis, in the foreground, is a large corpse of which only the back is visible. He is quite naked. His long, colourless arms, his head and hair are hanging down towards the foot of the structure.

Beneath, where the ground is lowest, at the corner of the building, is a ditch from which emerge the feet of a corpse and the two ends of a stretcher.

In the middle of the parvis, in front of the hospital door, a mother is kneeling, her arms and gaze turned towards heaven and the saint. Her mouth half-open, she tearfully pleads for her child to be saved. She has three of her women around her. One, seen from behind, is holding her up by the arms and at the same time her eyes and her prayers combine with the sorrowful cries of her mistress. The second, further back and seen full face, is doing the same. The third is kneeling at the very edge of the parvis and, arms raised, hands clasped, is also imploring the saint.

Behind her stands the husband of this grief-stricken mother, holding his son in his arms. The child is racked with pain and the father is looking up to heaven, *exspectando si forte sit spes*.[5] The mother has seized one of her child's hands. Thus the composition presents, here in the centre of the picture, on the solid mass of the parvis, some way above the ground which forms the nearest and lowest part of the painting, a group of six figures; the tearful mother supported by two of her women, her child whose hand she is holding, her husband in whose arms the child is suffering, and a third gentlewoman kneeling at the feet of her mistress and master.

Behind this group, a little to the left, in the background, at the foot of the building where the flight of steps comes down and loses

some of its height, are the imploring faces of a crowd of townspeople.

On the extreme left of the picture, on the ground at the bottom of the steps, a powerful man is supporting a naked victim. The sick man has one knee on the ground, the other leg stretched out and his body thrown back; his face, racked with pain, is turned towards the sky; he is crying out as his right hand tears at his side. The man who is helping this writhing victim is seen from behind, with his head in profile. His clothes are undone at the neck and his head and shoulders are bare. His eyes and his left hand point imploringly to heaven.[6]

Still on the stretch of ground, at the foot of the same block of stone and a little further back than the preceding group, is a dead woman, her feet lying beside the writhing man, her face turned to the sky; all the upper part of her body is naked, her left arm, with a heavy rosary round it, is stretched out on the ground; her head, with its dishevelled hair, is touching the block of stone. Scattered round about her are a hemp bolster, some straw, a few draperies and a kitchen utensil. Further back we see her child in profile, leaning forward and staring at his mother's face. He is horror-stricken; his hair is standing up on his head as he tries to see if his mother is still alive, or if he is now motherless.

On the other side of this woman the ground falls away, breaking up as it slopes towards the lower right-hand corner of the stone platform, to the ditch, the dark hole whence protrude the two ends of the stretcher and the two legs of the body which has been thrown into it.

Such is Doyen's composition: let us go over it again. There are enough good and bad things in it to merit a thorough and rigorous examination.

I forgot to say that in the extreme background there is the centre of a town with some distinctive buildings.

At first sight this is a great, impressive creation which demands that you stop and look at it. It could inspire both fear and pity. In fact it inspires only fear, and that is the fault of the artist who has not succeeded in conveying the moving incidents he had in mind.

It is difficult to get a clear idea of this hospital, this structure, this block of stone. One cannot explain why the place is so indeterminate, unless there is an error of perspective, a peculiarity caused by the difficulty of fitting disparate events into a single scene. In public disasters you see beggars near palaces, but you never see the inhabitants of palaces near where the beggars live.

Out of something like a hundred people, some of them very intelligent, there were not four who could make head or tail of this building. This fault could have been avoided through the advice of a good architect, or by a composition which was better thought out, with more cohesion and unity. That door does not look like a door. Despite the inscription over it, your first impression is that it's a window through which the sick man is throwing himself.

And then, once again, why does the scene take place at the entrance to a hospital? Is this a place for a woman of importance, for such she seems to be, judging by her appearance, her luxurious dress, her retinue and the distinction of her husband. I know what you were doing, Monsieur Doyen. You thought up various scenes of terror, and then a place where they could all happen. You needed a block of stone with a vertical drop for the corpse you wanted to show me with its head, arms and hair hanging down. You needed a ditch for the legs of your other corpse to stick out of. I'm quite happy about the hospital and the platform and the ditch. But when you then exhibit, at the entrance to this hospital, on the parvis, not far from the ditch, in the midst of the meanest riff-raff, amongst the beggars, the governor of the town, richly dressed, hung round with decorations, and his wife in the finest white satin, then I can't help but say: Monsieur Doyen, the proprieties, the proprieties!

Your St Genevieve is well posed, well drawn, well coloured, well draped, and hangs nicely in the air; she doesn't weigh down those clouds supporting her. But for me, and many others, she is a little mannered. With her twisted attitude, her arms reaching to one side and her head bent to the other, she seems to be looking back at God and saying over her shoulder: 'Come along then. Get on with it, we know you can do it. There's nothing special about this job.'

Certainly there's not the slightest trace of involvement or compassion on her face, and you could use it if you liked for a pretty little Assumption in the style of Boucher.

That garland of cherubims' heads behind her and under her feet forms a scattering of shiny circles which I find offensive, and then those angels are rather like puffed-up transparent cupids. As long as convention has it that these imaginary beings are made of flesh and blood they will have to be made of flesh and blood. You made the same mistake in your earlier painting of Diomedes and Venus. The goddess looked like a huge bladder which only needed to be leant on to explode with a loud report. Get rid of this mannerism, and remember that, although the ambrosia which intoxicated the pagan gods was a very light drink, and the beatific vision upon which those happy folk fed with such delight was very airy nourishment, there do still exist chubby, fleshy, fat, solid and plump creatures, and that Ganymede's buttocks and the Virgin Mary's breasts have to be just as nice to get hold of as those of any catamite, or any trollop, in this wicked world.

Apart from that, the thick cloud round the tops of your buildings is very filmy, and all that upper part of your composition is shaded off with great skill. I couldn't honestly say the same of the clouds which bear up your saint. The children enveloped in these clouds are as light and insubstantial as soap bubbles, and the heavy clouds are like balloons stuffed with wool flying through the air.

Of the two angels immediately below the saint there is one who is looking at the child suffering in its father's arms, and looking with an interest which is most natural and very cleverly conceived. Only a man of talent could think of that. And the angel and the child are two scamps of the same age. That the angel should be interested is right, because it's an angel. But in any other circumstances, don't forget that a child can sleep through a tempest. At the height of a fire in a country house I have seen the children of the house rolling about in heaps of corn. A palace on fire is of less consequence to a child of four than a house of cards collapsing.

The action and the expression of that pale man consumed with

fever who is throwing himself out of the window, or, since you insist, the door of the hospital, could not be bettered. There's something wild about the look in the eyes of that sick man; he's smiling in a terrifying way. There is on his face a mixture of hope, pain and joy which I find disturbing.

This sick man, then, and the two figures round him, make a fine group, drawn with rigour and power. The sick man's head is in the finest traditions of draughtsmanship, and beautifully expressed. The arms are drawn like those of the Carracci, and the whole figure in the style of the early Italian masters. The brushwork is strong and inventive. This is the true colouring of the sick, which I've never seen, but no matter. They say it's an imitation of Mignard.[7] What do I care? *Quisque suos patimur manes*, as that madman Rameau says.[8]

As for the two men who are holding him back, unless I'm very much mistaken their proportions are such that if you painted the rest of them their feet would come down below the platform you've put them on. Apart from that, they're doing what they're doing very well. They are sensibly clothed and well coloured, but, I say it again, they seem to be stopping a sick man from throwing himself out of a window rather than coming out of a door. That's the fault of the peculiar structure.

I'm sorry to have to say it, Monsieur Doyen, but the most interesting part of your composition, that tearful mother, the women surrounding her and that father holding his child, all that is a failure.

First of all, those three women and their mistress form a confused jumble of heads, arms, legs and bodies, a chaos you can't find your way through and couldn't look at for long. The head of the mother pleading for her son, with its stylish, neatly arranged hair, is not pleasant to look at. The colouring lacks substance. There's no bone beneath that skin. She lacks action, movement and expression. She's not suffering enough, in spite of that tear you're making her shed. Her arms are like coloured glass. Her legs are not clearly enough indicated. The satin drapery she's wearing makes a huge glowing stain. You may well have softened its colouring afterwards; it still has an incongruous effect. Its brightness still deadens the flesh tints.

That tall gentlewoman I can see from behind, holding her up, is turned and twisted in the most disagreeable way. The arm with which she's holding her mistress is stiff. You can't see what she's standing on. And that's the most enormous, the most monstrous woman's behind you can ever have seen. But the drapery is well positioned on this awful figure, and suggests the body well. The stiff arm is well coloured and fleshed out, but one might have doubts about whether it belongs to her or the green figure next to her. This one, helping the first in her duties, is well positioned and very beautiful, both in character and expression. But she should be given back to Domenichino.[9] The one kneeling is a disgrace. Worse, she's an ugly version of her mistress, and I'd be prepared to bet they were done from the same model. And then there's no substance in the colouring of the head. And what's that little patch of light on her hip? Can't you see that it ruins the effect and that it should either have been extinguished or enlarged? The child looks good in his wraps. He's suffering well and screaming well. But he is making rather a face. I don't expect the father's face to be more expressive than it is, but dignity is another matter. It's been said that he looks less like the husband of that woman than one of her servants. That's the general opinion. For my part, I find he has the plainness, the rustic simplicity, the homely ordinariness of the people of his time. I like his curly hair, and I feel happy about him. Quite apart from that, he has character, and his colouring is as strong as it could be, too strong perhaps, like the child's. This group comes too far forward and dislodges the mother from her plane, so that you wonder whether she can actually see the saint she's addressing; and the mother and the woman projected forward like that make the figures below look colossal.

Everyone's agreed about your sick man tearing at his side. He's a figure from the School of Carraccio, both in colour, drawing and expression. His face and his action make you shudder, but it's a fine head. The pain is terrible, but there's nothing ugly about it. He's suffering, suffering excessively, but without grimacing. The man supporting him is very fine, except that the top of his head, the

nape of his neck and his shoulder are a little yellowish. You wanted to give him a warm colouring and he's turned out like a brick. And I'm afraid this group doesn't come far enough into the foreground, or else the others are not set back as far as they should be.

Now that dead woman stretched out on the straw with her rosary round her arm, the more I look at her, the more beautiful I find her! What a beautiful, noble, moving figure this is! What simplicity, what fine drapery, what a fine portrayal of death, what a noble character! Although she's leaning back and her face is foreshortened, how well she retains these characteristics, as well as her beauty, and how well she retains them in the most unfavourable pose. If this figure were done by you, and was the only worthwhile thing in the whole of your painting, you would be no ordinary artist. The consistency and colour are good, but her strong green drapery does have the effect of forcing her head against the wall. She's supposed to be borrowed from Poussin's *Plague*.[10] Again, what do I care? The straw scattered round her, the draperies, the hemp cushion are all generously and skilfully done. I don't know what they mean by the heavy style, which they call German. *Faciunt ne nimis intelligendo, ut nihil intelligant.*[11]

It would be impossible to show more expression and to convey uncertainty and terror any better; it's impossible to paint with more vigour or to achieve anything better than that child in half-tone leaning over her. That hair standing on end is beautiful. He's well drawn, well painted.

When I said to Cochin that the ground could not have been more effectively done if Loutherbourg or some other professional landscape artist had done it, he replied that that was true, but it was a pity. Cochin, my friend, you may be right, but I don't know what you mean.

They're a fine and very poetic idea, those two big feet sticking out of the cave or ditch. And they are beautiful, well drawn, well coloured and exactly right. But the upper part of the cave is empty, and if anyone wanted to make me think that it was brimming over with bodies, he would have had to tell me. It's not the same with

these two feet as it is with the two arms which Rembrandt has coming out of Lazarus's tomb. The circumstances are different. Rembrandt achieves sublimity by only showing me two arms. You would have done so by showing me more than two feet. I can't imagine a place is full when I see it empty.

Another excellent and very poetic idea is that man whose head, long bare arms and hair are hanging down over the platform. I know some faint-hearted viewers turned their eyes away in horror. But what does that matter to me, since I'm not faint-hearted, and since I enjoyed the sight of crows in Homer gathered round a corpse, tearing the eyes out of its head and flapping their wings with delight? Where should I expect to find scenes of horror and terrifying images if not in a battle, a famine, a plague or an epidemic? If you had consulted these people with their shallow, refined taste, who are afraid of powerful sensations, you would have painted out your man desperately trying to get out of the hospital or the sick man tearing at his side at the foot of the platform, in which case I should have burnt the rest of your composition; but I make an exception for the woman with the rosary, whoever she belongs to.

But, my friend, if we were to abandon the painter Doyen for a moment and talk about something else, I don't think it would do any harm, would it? While I was writing the passage from Diomedes' speech which I've just quoted,[12] I was seeking the reason for the various judgements which have been made about it. It conjures up corpses, eyes torn out and crows flapping their wings with delight. There's nothing repulsive about a corpse. Painters exhibit them in their compositions without offending the eye. Poets use the word endlessly. As long as the flesh is not decaying, the putrefying parts are not coming away, the body is not teeming with maggots and preserves its shape, then in either of the two arts good taste will not be offended. The same cannot be said of the eyes being torn out. I close my own so as not to see those eyes being tugged out by the beak of a crow, those bloodstained, purulent shreds of flesh, half of them still joined to the socket in the corpse's

head, half hanging from the beak of the rapacious bird. That cruel bird flapping its wings with delight has a horrible beauty about it. What then should be the total effect of such a picture? It would vary, depending on the point at which the imagination is held. But at what point is it best for the imagination to come to rest in this case? On the corpse? No, it's a familiar image. On the eyes being torn out of the corpse's head? No, because there's a more unusual image, the bird flapping its wings with delight. So this image must be offered last, and thus offered last it cancels out the repellent aspect of the preceding image. So there is a big difference between these images arranged in the following order: *I see the crows flapping their wings around your corpse and tearing the eyes out of your head,* or in the poet's order: *I see the crows gathered round your corpse and tearing the eyes from your head as they flap their wings with joy.* Look closely, my friend, and you'll come to see that it's this last image which absorbs your attention and conceals the horror of the rest. There is then an art, inspired by good taste, which lies in the manner in which images are distributed in language and their effects compensated for, an art of fixing the mind's eye at the point where it's wanted. It's the art of Timanthe veiling the head of Agamemnon.[13] It's the art of Teniers allowing you to see only the head of a man crouching behind a hedge. It's Homer's in the passage just quoted. It does not consist only in the order of ideas. Choice of expression has much to do with it, whether the expressions are powerful or weak, literal or figurative, slow or rapid. There above all the magic of spoken verse comes into play when it holds up or hastens the delivery of the words.

[*Diderot reverts briefly to some further comments on the figures in the painting before going on to discuss its structure.*]

But what I admire more than anything else in Doyen's composition is that, through all the turmoil it portrays, everything is directed towards one single object. Each figure has an activity and a move-ment appropriate to it, but they all have a common link with the saint, a link of which there are even traces in the dead bodies. That beautiful woman who has just expired at the foot of the platform

was invoking the saint as she died. That terrifying corpse hanging down from the platform had his arms raised to heaven as he fell dead, as one can clearly see.

Despite that, I'm bound to say that Doyen's work has a tortured look about it, that there's a lack of naturalness and ease about the distribution of the figures, and everywhere you have the feeling of a man racking his brains for an answer. Let me explain.

There is in the whole of this composition a path, a line going through the upper parts of the masses and groups, crossing different planes, sometimes penetrating the depths of the picture, sometimes advancing into the foreground. If this line, which I shall call the connecting line,[14] bends one way and then another, twists and writhes, if its convolutions are small, repetitious, straight or angular, the composition will be ambiguous and obscure and the eye, following an irregular path, lost in the maze, will have difficulty in discerning the connections. If on the other hand it does not curve enough, if it goes for some distance without encountering any obstacle, the composition will lack body and shape. If it comes to a halt, there will be an empty space, a hole, in the composition. If you become aware of this fault and fill up the empty space or hole, you will simply be putting one fault right by making another.

Doyen's *Miracle des Ardents* certainly errs in this respect. The connecting line goes in and out, bends this way and that and is full of twists and turns. It is difficult to follow its course. Sometimes it's not clear where it's going, or it stops dead, or one needs a very accommodating eye to see which path it's following.

A well-ordered composition will only ever have one true, single connecting line, and this line guides both the observer and anyone who is trying to describe it.

Another fault, perhaps the most serious of all, is that one would have liked to see a better knowledge of perspective, the planes should be more distinct and there should be more depth. There's not enough air or freedom to move, it doesn't recede or advance enough. The sick man rushing out of the hospital and the mother kneeling in supplication and the three woman assisting her and the

husband holding the child, all these form a chaotic picture, a dense mass of figures. If, in the background behind the father, you imagine a vertical plane parallel to the canvas and in the foreground another plane parallel to it, you will have a box only six feet deep in which all Doyen's scenes will be taking place, and where his patients, even more cramped than they are in our hospitals, will die of suffocation.

What puts the finishing touch to the confusion and disharmony and wearies the eye is the fact that there are too many yellowish tones too close together; the clouds are yellowish; the men's complexions yellowish; the draperies either yellow or red tinged with yellow; the principal figure's cloak is a lovely bright yellow; the ornaments are gold; there are some sashes bordering on yellow; the big serving-woman with the huge behind is yellow. If you make everything partake of the same tone, you either avoid clashes of colour or you descend into monotony. You really are unlucky if you have both faults at the same time.

If the criticism is true, and Doyen would be hard put to prove otherwise, that he borrowed the distribution and the general appearance of his work from a composition by Rubens, where the disposition is said to be the same, I'm not surprised about these defects in its gradation and planes. They are almost inseparable from this kind of plagiarism. The engraving will certainly give you the positions of the masses and the distribution of the groups, and it will even give you the position of the lights and shades and a rough idea of how the objects are separated, but all this will be very difficult to transfer to the canvas. That is the inventor's secret. He conceived the general idea of his work according to a technique which is his alone, and will never be truly yours. It's difficult to execute a painting from a given description, however detailed; it's perhaps even more so from an engraving. Hence the failure to understand the chiaroscuro effect. There's nothing in it which moves away or comes forward, joins together or separates, advances or recedes, draws close or shrinks away; no harmony, no clarity, no impact, no magic. For this reason too, figures which are pushed too far forward will be too big, and others pushed too far back will be too

small; or more generally, because they are all piled one on top of the other, there will be no breadth, no air, no space, no depth, just a jumble of objects cut out and unnaturally stuck together; twenty different scenes taking place as it were between two boards, two panels with only the width of the canvas and the frame to separate them. In addition, the lack of gradation and perspective takes the foreground figures into the background and brings the background ones into the foreground; and a further disaster is that they seem to be hounded from the left-hand side towards the right and from the right-hand side towards the left, or held by force within the confines of the canvas, so that if this constraint were removed you'd be afraid that they'd all scatter into the surrounding air.

Despite everything I have criticized in Doyen's painting, it is beautiful, very beautiful. There is warmth in it, and imagination and inspiration. There's draughtsmanship, expression and movement, and much, much colour, and it makes a great impact. The artist shows he's a man, and not the man one was expecting. It's undoubtedly the best of his works. You can exhibit this painting anywhere in the world, and compare it with any master you like, ancient or modern, and he will not entirely lose by the comparison.

I believe I have already noted the point somewhere in my writings, where I set out to prove that a nation could have only one great period and that in that period a great man could be born at only one moment, that every fine composition, every true talent for painting, sculpture, architecture, eloquence or poetry presupposed a certain balance between reason and enthusiasm, judgement and inspiration, a rare, momentary balance without which compositions are either extravagant or cold. Doyen has one pitfall to fear: that, excited by the success of the *Miracle des Ardents*, a success due more to its poetry than its technique (because, to put it bluntly, in terms of painting this is nothing but a magnificent first draft), he might overstep the mark, his success might go to his head and he might overreach himself. He's on the borderline; one false step will lead to chaos and disorder. You'll tell me that you'd much rather have

extravagance than dullness, and so would I. But there is a middle way between the two which is more to the taste of us both.

I have seen the artist. You would never believe it, but he puts on a wonderful show of modesty. He does all he can to repress the feelings of pride swelling up within him. He enjoys hearing himself praised, but he has the strength to moderate his reaction. He sincerely regrets the time he has wasted with aristocrats and women, those two squanderers of talent. What he likes to hear praised most is his style, which you won't find in any modern studio. In fact his style and his brush are entirely his own. He's only prepared to acknowledge a debt to Raphael, Guido Reni, Titian, Domenichino, Le Sueur, Poussin, rich men whom we can permit him to question, consult and call to his aid, but not rob. Let him learn from one of them how to draw, from another how to colour, and from Poussin how to arrange his scenes, set out his planes, link his events, to understand the magic of light and shade, the effect of harmony, appropriateness and expression. Then we shall all be happy.

The public appears to have considered Doyen's painting to be the best piece in the Salon, and I'm not surprised. Anything powerfully expressed, a madman twisting his arms and foaming at the mouth, with a wild look in his eye, will always get a better reaction than a beautiful naked woman sleeping peacefully, offering her shoulders and hips to view. The great mass of people are not capable of appreciating the ways in which such a figure can captivate you, of understanding its gentleness, its naturalness, its grace and sensuousness.

[*Diderot gives a brief summary of his views on Doyen's painting, praising its power and energy and criticizing its detail and technique. A brief comparison follows with Vien's* St Denis Preaching. *Both paintings went to the church of Saint Roch in Paris, where they still are*.]

Give Vien Doyen's inspiration, which he lacks, and give Doyen Vien's technique, which he lacks, and you'll have two great artists. But perhaps that's impossible. At least, such a combination has never been seen; and the finest of all painters is only a runner-up where individual aspects of painting are concerned.

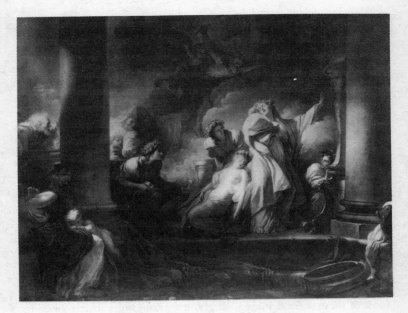

FRAGONARD Coresus and Callirhoe *Louvre*

Go and see Doyen's painting on a summer evening; and look at it from a distance. Go and see Vien's in the morning at the same time of year, and look at it close up or from a distance, as you like. Stay there until nightfall and you'll see how every part of it shades off in exactly the same way as the natural light, and how the whole scene fades just as the natural scene does, when the sun which illuminated it has disappeared. Twilight descends on his work, as it does on the natural scene.

FRAGONARD

Salon of 1765

The High Priest Coresus Sacrificing Himself to Save Callirhoe[1]
My friend, it's not possible for me to talk to you about this picture;

as you know, it had gone from the Salon when I went there in response to the great sensation it made.[2] So it's for you to tell me about it; we'll talk about it together. This will be a much better idea because we shall perhaps discover why, after the artist received his first tribute of praise and the first expressions of enthusiasm, the public seems to have cooled off. Any composition whose success is not sustained lacks true merit. But to fill up this Fragonard article, I want to tell you about a rather strange vision which tormented me the night after I had spent the morning looking at pictures and the evening reading some of Plato's *Dialogues*.

Plato's Cave[3]

I seemed to be imprisoned in the place they call the cave of this philosopher. It was a long, dark cavern. I was sitting there amid a multitude of men, women and children. We all had our hands and feet chained and our heads so firmly fixed between wooden splints that we were unable to turn them. But what amazed me was that most of them were drinking, laughing and singing without seeming to be bothered by their chains and, to look at them, you would have thought it was their natural state; it even seemed that they disapproved of those who made any effort to recover the freedom of their hands, feet and heads, hurled insults at them, moved away from them as if they had some contagious disease and, when any disaster occurred in the cavern, made a point of blaming them for it. Accoutred as I've described, we all had our backs to the entrance to this dwelling, and were able only to look at the far end, which was covered with an immense cloth.

Behind us there were kings, ministers, priests, doctors, apostles, prophets, theologians, politicians, tricksters, charlatans, illusionists and the whole band of dealers in hopes and fears. Each one had a supply of little transparent coloured figures appropriate to his function, and all these figures were so well made, so well painted, so numerous and varied, that there were enough to cast performances of all the comic, tragic and burlesque scenes that life has to offer.

These charlatans, as I saw later, standing between us and the

entrance to the cavern, had a great hanging lamp behind them. By its light they displayed their little figures, whose shadows, carried over our heads and growing bigger as they went, were projected on to the cloth stretched over the back of the cavern to create scenes which were so natural and lifelike that we thought they were real; and now we would be howling with laughter, now weeping bitterly, a thing which will strike you as all the more strange because behind the cloth there were other inferior tricksters in the pay of the first, who gave these shadows the accents, words and voices appropriate to their roles.

In spite of the illusion created by this spectacle, there were some of us in the crowd who were suspicious of it, shook our chains from time to time and were most anxious to free ourselves of our splints and turn our heads; but immediately one or other of the charlatans behind us would shout in a loud and terrible voice: 'Don't turn your heads! Woe betide anyone who shakes his chain! Stay in the splints . . .' I'll tell you another time what happened to the ones who took no notice of the voice's warning, what dangers they risked and what persecution they had to undergo; that will be for when we talk philosophy. Today we're talking painting and I prefer to describe some of those I saw on the great screen; I swear they were better than the best in the Salon. On this screen everything seemed confused at first: they were weeping, laughing, playing, drinking, singing, biting their knuckles, tearing each other's hair out, caressing each other, whipping each other; just as one of them was drowning, another was being hanged and a third raised up on a pedestal; but eventually everything fell into place and became clear and intelligible. This is what I saw happening at various points which I'll run together to cut it short.

First of all there was a young man with his long priestly vestments in disarray, a thyrsus in his hand and ivy over his brow, pouring floods of wine from a great antique vase into broad, deep goblets which he put to the lips of some wild-eyed, dishevelled women.[4] He drank with them, and they with him, and when they were drunk they got up and started running through the streets uttering

cries of mingled joy and rage. At these cries the people shut themselves in their houses, afraid of finding themselves in their path; they were capable of tearing apart anyone foolhardy enough to stand in their way, and I sometimes saw them doing it. Well, my friend, what do you say to that?

GRIMM. I say that those are two quite good pictures, more or less in the same style.

DIDEROT. Here's a third of a different kind. The young priest who was leading these furies had the most handsome of faces; I noticed him, and in my dream it seemed that, intoxicated with something more dangerous than wine, his face, his gestures and his words all addressed themselves in the most tender and passionate way to a girl whose knees he was embracing to no effect and who refused to listen to him.

GRIMM. Even though it only has two figures, this one wouldn't be any easier to do.

DIDEROT. Especially if you wanted to give them the powerful expressions and remarkable characters they had on the screen in the cavern.

While this priest was vainly pleading with the unyielding girl, I suddenly heard, somewhere among the houses, the sounds of shouting, laughing and screaming, and there emerged fathers, mothers, wives, daughters and children. The fathers were rushing after their daughters who had lost all sense of decorum, the mothers after their sons who did not know them, children of both sexes were all mingled together and rolling about on the ground. It was a scene of excessive joy, unbridled licence and unimaginable intoxication and fury. Oh! if only I were a painter! I can still picture all those faces.

GRIMM. I know something about our artists and I swear there's not one who could do a sketch for that picture.

DIDEROT. In the midst of this tumult, a few old men who had survived the epidemic, their eyes bathed in tears, prostrate in a temple, were beating their foreheads on the ground and most beseechingly embracing the altars of the god, and I heard quite distinctly the god, or perhaps the lower-ranking trickster behind the screen, saying: 'She must die, or someone else must die in her place'.

GRIMM. But, my friend, do you realize that at the rate your imagination's going, a single one of your imaginings would fill a whole gallery?

DIDEROT. Wait, wait, we haven't got to the end yet. I was terribly impatient to discover what the outcome would be of this fateful oracle, when the temple once again opened before me. Its floor was covered with a red carpet edged with a broad gold fringe; this rich carpet and its fringe hung down over a long platform which occupied the whole length of the façade. To the right, near this platform, was one of those large sacrificial vessels intended to receive the victims' blood. On either side of that part of the temple which was visible to me, two great columns of white, transparent marble seemed to rise up towards the vault. To the right, at the foot of the nearer column, a black marble urn had been placed, partly covered with the clothing appropriate to these bloody ceremonies. On the other side of the same column was a large candelabrum of the most noble proportions, so tall that it almost reached the capital of the column. In the space between the two columns on the other side was a great altar or triangular tripod on which the sacred fire was burning. I could see the reddish glow of its burning coals, and the smoke from the incense concealed part of the inner column. Such is the theatre of one of the most terrible and moving performances enacted on the screen in that cavern during my vision.

GRIMM. But tell me, my friend, have you told anyone about your dream?

DIDEROT. No. Why do you ask?

GRIMM. Because the temple you've just described is precisely the site of Fragonard's painting.

DIDEROT. That may well be. I'd heard so much about this picture in the days before, that if I'd had to dream up a temple, I'd have dreamt his. Anyway, as my gaze wandered over the temple and all the preparations, foreshadowing some event which filled me with uneasiness, I saw a young acolyte coming in alone, dressed in white; he looked sad. He went and crouched at the foot of the candelabrum, resting his arms on the jutting base of the inner column. He was

followed by a priest. This priest had his arms crossed over his chest and his head bowed and seemed to be absorbed in grief and the most profound reflection; he was moving slowly forward. I waited for him to lift his head; as he did so he raised his eyes to heaven and uttered a most harrowing exclamation, which brought a cry from me when I saw who this priest was. He was the same one that I had seen a few moments before so urgently and unsuccessfully trying to persuade the inflexible young woman; he too was clothed in white; he was still handsome, but grief had altered his face profoundly. His brow was crowned with ivy and he held the sacred knife in his hand. He went and stood some distance from the young acolyte who had preceded him. A second acolyte came in, clothed in white, and stood behind him.

Next I saw a girl come in; she was similarly clothed in white, with a circlet of roses on her head. Her face had a deathly pallor, her knees were trembling and giving way beneath her; she barely had the strength to reach the feet of the one who adored her, for she it was who had so proudly disdained his vows and tender words. Although all this took place in silence, one had only to look at each of them and remember the words of the oracle to realize that she was the victim and he was to be the one to sacrifice her. When she drew near the high priest who was her unhappy lover – oh! a hundred times more unhappy than she – her strength deserted her completely and she fell back on the bed or the very place where she was to receive the mortal blow. Her face was turned to heaven, her eyes were closed, her arms, from which the life seemed already to have gone, hung down at her sides, the back of her head almost touched the vestments of the high priest, her immolator and lover; the rest of her body lay flat, except that the acolyte who had stopped behind the high priest was raising it a little.

While the unhappy fate of men and the cruelty of the gods, or their ministers, for the gods are nothing, occupied my thoughts and I was wiping away a few tears which had fallen from my eyes, a third acolyte had come in, clothed in white like the others and with roses circling his brow. How handsome this young acolyte was! I

don't know whether it was his modesty, his youth, his gentleness or his nobility which held my attention, but he seemed to be more impressive than even the high priest. He had crouched some way away from the unconscious victim and his pitying gaze was fixed upon her. A fourth acolyte, also in white, came and stood beside the one who was holding the victim; he placed one knee on the ground and on the other set a large bowl which he held by its rim as though to offer it up for the blood which was about to flow. This bowl, the position of the acolyte and his actions were an all too clear indication of his cruel task. Meanwhile many other people had come to the temple. Men, innately compassionate, seek out cruel spectacles in order to exercise this quality.

I could make out in the background, near the inner column on the left-hand side, two aged priests, standing, and noteworthy for their unusual headdresses, the severity of their appearance and the gravity of their bearing.

Almost outside the temple, and against the front column on the same side, was a solitary woman; a little further on, and further outside, another woman, her back against a stone post, with a young, naked child on her knees. The beauty of this child, and even more perhaps the unusual effect of the light which illuminated him and his mother, imprinted them on my memory. Beyond these women, but inside the temple, two more spectators. In front of these spectators, exactly in between the two columns, opposite the altar and its blazing fire, an old man whose appearance and grey hair caught my eye. I suspect the space further back was full of people, but from where I was in my dream and in the cavern, I couldn't see anything more.

GRIMM. That's because there was nothing more to see, and they are all the people that were in Fragonard's picture, and they were placed in your dream exactly as they are on the canvas.

DIDEROT. If that's the case, what a fine picture Fragonard has painted! But listen to the rest. The sky shone with the purest brilliance; the sun seemed to be sending the whole volume of its light into the temple and lovingly concentrating it on the victim,

when the vaults darkened with thick shadows which, extending over our heads and mingling with the air and the light, aroused a sudden feeling of terror. Through these shadows I saw an infernal spirit hovering above us, I saw it: from his head protruded wild eyes, he held a dagger in one hand and in the other he was brandishing a burning torch; he was shouting aloud. It was Despair, and he was bearing Love, valiant Love on his back. At that moment the high priest drew the sacred knife, he raised his arm, I thought he was about to strike the victim with it, plunge it into the breast of the woman who had scorned him and whom heaven had delivered up to him; but no, he struck himself with it. A universal cry rent the air. I saw death and its outward signs invest the cheeks and brow of that tender and courageous unfortunate; his knees gave way, his head fell back, one of his arms hung down, the hand with which he had seized the knife still held it plunged into his heart. All eyes were fixed, or feared to be fixed, on him; everywhere were the signs of affliction and consternation. The acolyte at the foot of the candelabrum was gaping wide-eyed with terror; the one supporting the victim's head was looking round in terror; the one holding the fateful bowl was raising his eyes in terror; the face and outstretched arms of the one who had struck me as so handsome were revealing all his grief and terror; those two aged priests, whose cruel eyes must so often have feasted on the vapour from the blood with which they drenched the altars, could not prevent themselves from feeling grief, compassion and terror; they pitied this unfortunate man, suffered and were afraid; that solitary woman leaning against one of the columns, gripped by fear and terror, turned suddenly round; and the other woman with her back to the post fell back, holding one of her hands up to her eyes while her other arm seemed to be pushing this horrifying scene away from her; surprise and terror were visible on the faces of the spectators further from her; but nothing could equal the consternation and grief of the old man with the grey hair: the hair on his brow stood on end, I can see it now, as the light from the fire illuminated him and his arms stretched out above the altar; I can see his eyes, I can see his mouth,

I can see him dart forward, I can hear his cries, they awaken me, the cloth folds and the cavern disappears.

GRIMM. That's Fragonard's painting, that's it, just as I saw it.

DIDEROT. Really?

GRIMM. It's the same temple, the same disposition, the same characters, the same action, the same general effect, the same qualities and the same defects. In the cavern you saw only the semblances of people, and Fragonard too would only have shown you semblances on his canvas. What you had was a beautiful dream and what he painted was a beautiful dream. When you lose sight of your picture for a moment you're always afraid that its canvas will fold up like your screen and those fascinating, sublime phantoms will have vanished like those of the night. If you had seen his picture, you would have been struck by the same magical effect of the light and the way in which the shadows merged with it, and the lugubrious effect this blending had on every part of the composition; you would have experienced the same compassion, the same terror; you would have seen the mass of that light, strong at first, fade with amazing speed and artistry; you would have seen its echoes playing amongst the figures with brilliant effect. The old man whose piercing cries awoke you, he was there in the same place just as you saw him, and the two women and the young child, all dressed, illuminated and afraid as you described. There were the same aged priests, with the ample, picturesque drapery piled high on their heads, the same acolytes with their white, priestly vestments, positioned on his canvas exactly as they were on yours. The one you found so handsome was as handsome in the painting as he was in your dream, with the light coming from behind him, so that all the front of his body was partly or fully shaded, a pictorial effect which is easier to dream than to achieve, and which in no way detracted from his noble air or his facial expression.

DIDEROT. What you say could almost convince me that, although I don't believe in the truth of all this during the day, I'm in contact with it during the night. But that dreadful moment in my dream,

when the sacrificing priest thrusts the dagger into his breast, must be the one that Fragonard chose?

GRIMM. Certainly it is. We just noticed in the picture that the high priest's vestments were a bit too feminine.

DIDEROT. But that's how it was in my dream.

GRIMM. And the young acolytes, noble and charming as they were, were neither one sex nor the other, but like hermaphrodites.

DIDEROT. That's how I dreamt it too.

GRIMM. That the victim lay convincingly as she had fallen, but that her clothes were perhaps a little too tight round her legs.

DIDEROT. I noticed that too in my dream; but I credited her with a sense of modesty, even at such a moment.

GRIMM. That her head, with its pale colouring, weak expression and lack of shading or variation, was more like that of a woman asleep than one who has fainted.

DIDEROT. She had these faults in my dream.

GRIMM. As for the woman with the child on her knees, we thought she was excellently painted and posed, and the stray beam of light which fell on her was completely convincing; the light reflected on the nearer column was absolutely right, and the candelabra beautifully shaped and giving exactly the effect of gold. The figures had to be as boldly coloured as Fragonard's were to stand out against that red carpet bordered with a gold fringe. The old men's heads we thought were brilliantly done with their expressions of surprise and horror; the spirits were suitably furious and ethereal and the dark mist they brought with them was properly scattered and gave the scene an amazing effect of terror; and the shaded areas contrasted powerfully and brilliantly with the dazzling splendour of the lights. And then there was something quite unique. Wherever you looked, you met with an impression of terror: it was present in all the characters: it radiated out from the high priest and spread all around, gathering force with the two spirits, the dark vapour which came with them and the dull glow from the fires. It was impossible to resist such an insistent effect. It was like those popular risings where we're seized by the passions of the crowd before we even

know what it's all about. But apart from the fear that all these beautiful simulacra would vanish at the first sign of the cross, some critics of a purist bent thought they saw something rather theatrical in the whole composition which was not to their taste. Whatever they say, you can be sure you had a beautiful dream and Fragonard painted a beautiful picture. It has all the magic, all the command, all the effects of a fine picture. This artist has a sublime imagination and lacks only the true sense of colour and the technical perfection which time and experience will bring.

GREUZE

Salon of 1761

The *Portrait of Madame Greuze as a Vestal*. That, a Vestal? Greuze, my dear fellow, you're having us on: with her hands crossed over her breast, that long face, the age she is, those big eyes gloomily turned towards the sky, those great folds of drapery carried up over her head, that's a mother of sorrows, and a mean and rather cross-faced one at that. This piece would do credit to Coypel, but it does none to you.[1]

There's much variety in the actions, faces and characters of all these little rascals, some of whom are distracting that poor *Chestnut Vendor* while the others rob her.

That *Shepherd* holding a thistle in his hand and trying to find out if his shepherdess loves him doesn't count for much. From the elegance of the clothes and the brightness of the colour, you might almost take it for a Boucher. And if you didn't know what the subject was, you'd never guess.

The *Paralytic* being helped by his children, or the drawing which the painter has called *The Fruits of a Good Upbringing*, is a painting of manners. It's proof that this genre can provide compositions capable of doing honour to the talent and feeling of the artist. The old man is in his chair; his feet rest on a stool. His head and those of his son and his wife are things of rare beauty. Greuze has much

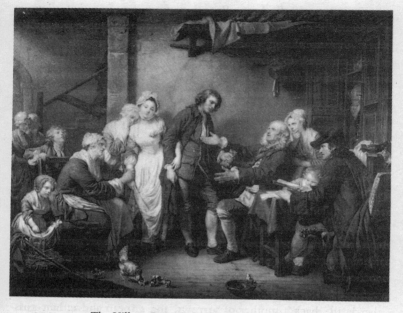

GREUZE The Village Betrothal (L'Accordée de Village) *Louvre*

intelligence and taste. When he's working, he concentrates totally; he's deeply affected by what he's doing: in company he brings with him the character of the subject he's painting in his studio, sad or cheerful, frivolous or serious, sociable or reserved, according to whatever busied his brush and his imagination in the morning.

I've seen it at last, this painting by our friend Greuze; but not without an effort: it's still drawing the crowds. It's *A Father who Has just Paid his Daughter's Dowry*.[2] It's a very touching subject and you feel a tender emotion stealing over you as you look at it. Its composition struck me as very beautiful: this is the event as it must have happened. There are twelve figures, each of them in their place and doing what they should. How well they're linked together! How well they undulate and form a pyramid! I'm not

bothered about these conventions, but when they come together in a painting by chance without the painter having thought to employ them, without making any sacrifices for them, I do find them pleasing.

To the right of the viewer is a notary sitting at a small table, his back turned to the observer. On the table, the marriage contract and other papers. On the notary's lap, the youngest of the children of the family. Then, following the composition from right to left, an older daughter standing up, leaning on the back of her father's chair. The father is sitting in the one armchair in the house. In front of him, his future son-in-law, standing, holding in his left hand the bag with the dowry. The bride, also standing, with one arm loosely passed under her fiancé's, the other arm held by the mother, who is sitting below her. Between the mother and the betrothed, a younger sister standing, leaning on the betrothed, with one arm round her shoulders. Behind this group a young child standing on tiptoe to see what's going on. Below the mother, in the foreground, a seated girl with little pieces of cut-up bread in her apron. Right over on the left in the background and far from the scene, two servant-girls standing and looking on. On the right, a very neat larder, with the things one usually has in it, forming part of the background. In the middle, an old arquebus on its hook; then a wooden staircase leading upstairs. In the foreground, on the floor, in the space left empty by the figures near the mother's feet, a chicken leading her chicks, to which the little girl is throwing bread; an earthenware pan full of water with a chick on its rim, holding its beak up to let the water it has drunk go down into its craw. Such is the general arrangement. Now for the detail.

The notary is dressed in black, with coloured breeches and stockings, a cloak and a band, and wearing his hat. He certainly has the wily, argumentative air appropriate to a peasant of his profession; it's a fine figure. He's listening to what the father is saying to his future son-in-law. The father is the only one speaking. The others are listening in silence.

The child on the notary's knees is excellent in the rightness of his

actions and his colouring. Without paying attention to what's going on, he's looking at the papers with their scribbled notes and running his little hands over them.

You can see that the elder sister, standing and leaning on the back of her father's chair, is full of grief and jealousy that her younger sister has been preferred to her. Her head is leaning on one of her hands, and she's looking at the couple with eyes full of curiosity, sorrow and anger. The father is an old man of sixty, with grey hair, and a kerchief knotted round his neck; he has a pleasingly good-natured demeanour. His arms stretched out towards his future son-in-law, he's speaking to him with a heartfelt warmth which is delightful. He seems to be saying to him: 'Jeannette is gentle and good; she will make you happy; take care to make her happy . . .' or something about the importance of his duties as a husband . . . What he's saying is certainly touching and honest. One of his hands, of which the back is visible, is tanned and brown; the other, of which you see the inside, is white; that is in the nature of things.

The bridegroom has a thoroughly pleasant face. He's tanned, but you can see he has a white skin. He's leaning a little towards his father-in-law; he's paying attention to what he's saying and appears to be impressed by it. He's beautifully done, and excellently dressed, without stepping out of his class. I would say the same for all the other characters.

The painter has given the bride a charming face, seemly and reserved; she's wonderfully dressed. That apron in white cloth couldn't be better. There's a little refinement in the trimmings, but this is a betrothal day. You would need to see how exactly right the folds are in all the clothes of this figure and the others. This charming girl is not standing up straight; there's a slight, gentle curve in her whole figure and all her limbs which makes her full of grace and truth. She is really pretty, very pretty indeed. A finely shaped bosom which you don't see at all; but I bet there's nothing there to support it and that it holds up all by itself. Had she been paying more attention to her fiancé, she would have been less decorous; and with more attention to her mother or father she would

have seemed false. She has her arm half under that of her future husband and her fingertips are resting gently on his hand; that's the only mark of tenderness she shows him, perhaps without being aware of it herself; it's a delicate touch on the part of the painter.

The mother is a good peasant woman, nearly sixty but in good health. She too is generously and beautifully dressed. With one hand she's holding the upper part of her daughter's arm; with the other she's holding it above the wrist. She's seated, looking up at her daughter; she's certainly quite sorry to see her go, but it's a good match. Jean is a good lad, honest and hardworking; she doesn't doubt that her daughter will be happy with him. Cheerfulness and tenderness are mingled in the face of this good mother.

As for this younger sister standing beside the bride, embracing her and weeping on her breast, she's a thoroughly interesting character. She's genuinely upset at being separated from her sister, and she's crying; but this incident does not cast a gloom over the composition; on the contrary, it makes it more touching. A lot of taste, good taste, went into thinking of this episode.

The two children, one of whom, sitting beside its mother, is amusing itself throwing bread to the chicken and its little family, while the other is standing on tiptoe and craning forward to see, are charming, but especially the latter.

The two servant-girls, standing at the back of the room, nonchalantly leaning against each other, seem to be saying, both by their attitudes and their faces: 'When will it be our turn?'

And this chicken who's brought its chicks into the midst of the scene, who has five or six little ones, just as the mother at whose feet she's looking for sustenance has six or seven children, and that little girl who's throwing them bread and feeding them; it must be said that all this fits in delightfully with the scene, the place and the characters. It's a really ingenious touch of poetry.

It's mainly the father who draws one's attention, then the fiancé, then the betrothed, the mother, the younger or the elder sister, depending on the character of the person looking at the picture,

then the notary, the other children, the servants and the background. A definite proof of good composition.

Teniers perhaps paints manners more accurately.[3] It would be easier to find the actual scenes and people he painted, but there's more elegance, more grace and a pleasanter effect in Greuze. His peasants are neither coarse like those of our good Fleming, nor unreal like those of Boucher. I think Teniers' colour is far superior to Greuze's. I also think he's more inventive: and he's a great landscape painter, a great painter of trees, forests, water, mountains, cottages and animals.

Greuze can be criticized for repeating the same face in three different paintings. The head of the *Father who Has just Paid his Daughter's Dowry* and that of the *Father Reading the Scriptures to his Children* and I think too that of the *Paralytic*. Or at least they're three brothers with a strong family likeness.

Another defect. That elder sister, is she a sister or a servant? If she's a servant she shouldn't be leaning on the back of her master's chair, and I don't know why she should be so envious of her mistress's good fortune; and if she belongs to the family, why this mean look, why this neglected appearance? Whether she's happy or unhappy, she should have been dressed in the proper way for her sister's betrothal. I can see people are being misled and that most of those who look at the picture take her for a servant, and that the others are perplexed. I'm not sure whether this elder sister's face isn't also that of the *Laundrywoman*.

A very intelligent woman pointed out that this painting contains two types of people. She maintains that the father, the bridegroom and the notary are definitely peasants, country people, but that the mother and all the others are from the Paris markets. The mother is a big fruit- or fish-seller and the daughter is a pretty flowergirl. This is at the very least a perceptive observation. Go and look, my friend, to see whether it's right.

But it would be better to ignore these trifles and go into ecstasies over a piece which offers all manner of beautiful things. It's definitely the best thing that Greuze has done. This piece will do him

credit, both as a painter learned in his art, and as a man of intelligence and taste. His composition is full of intelligence and delicacy. His choice of subjects is proof of his sensibility and moral standards.

Salon of 1765

Perhaps I'm a bit long-winded; but if you only knew how much I'm enjoying boring you! like all the other bores in the world. But then I have described a hundred and ten paintings and passed judgement on thirty-one painters.

This is your painter and mine; the first of our countrymen to think of bringing morality into art, and to link a series of events which would be easy to turn into a novel. He's a bit vain, this painter of ours, but it's the vanity of a child, the intoxication of talent. Take away this naivety which makes him say of his own work: Just look at that, isn't it beautiful? . . . and you'll take away his inspiration, you'll put out his fire, and his genius will die. I'm very much afraid that when he does become modest he'll have good reason to be. Our good qualities, or at least some of them, are closely linked to our defects. Most honest women are bad-tempered. Great artists are a bit crack-brained; almost all dissolute women are generous; devout women, good women even, are not averse to backbiting. I hate all those mean actions which only reveal a contemptible character, but I've no hatred for great crimes, firstly because they make fine paintings and fine tragedies; and then, because great, sublime actions and great crimes are marked by the same strength of purpose. If a man were not capable of setting fire to a city, another man would not be capable of leaping down a precipice to save it. If the soul of Caesar had not been possible, nor would that of Cato. A man can be born a citizen of Tenara, or of heaven; he's Castor and Pollux, a hero, a rogue, Marcus Aurelius, Borgia, *diversis studiis ovo prognatus eodem.*[4]

We have three painters who are clever, productive, and studious observers of nature, never starting or finishing anything without constant reference to their model; they are Lagrenée, Greuze and

Vernet. The second takes his talent everywhere, to popular gatherings, churches, markets, fashionable avenues, houses and the street; he's endlessly collecting actions, passions, characteristics, expressions. Chardin and he speak well of their own talents, Chardin with calm and good judgement, Greuze with warmth and enthusiasm. La Tour, in a small gathering, is worth hearing too.

There are a lot of pieces by Greuze, a few indifferent ones, several good ones and many which are excellent. Let's have a look at them.

The Girl Weeping for her Dead Bird[5]

What a pretty elegy and a pretty poem! What a fine idyll Gessner would make of it![6] It would serve as the illustration to a piece by that poet. It's a delightful painting, the most pleasing and perhaps the most interesting in the Salon. We see her full-face, her head is leaning on her left hand. The dead bird is on the upper edge of the cage, its head hanging down, its wings splayed out, its claws in the air. How naturally posed she is! What a lovely face! and elegant hair! What expression there is in her face! Her grief is profound, she is completely absorbed in her misfortune. What a pretty catafalque that cage makes! How graceful is the green garland twined round it! And oh! that lovely hand! that lovely hand! that lovely arm! Look how true the detail is in those fingers, and those dimples, and that softness, and the touch of red with which the pressure of the head has coloured the tips of those delicate fingers, and the charm of it all. You could go up to that hand and kiss it, if you didn't respect the child and her grief. Everything about her is enchanting, even her dress. The way that neckerchief is placed! it's so supple and light! When you see this piece, you say: Delightful! If you stop and go back to it, you cry: Delightful! delightful! Before long you find you're talking to this child and consoling her. So much so that this is what I remember saying to her at various times.

But, little one, your grief is very profound, and very thoughtful! Why this dreamy, melancholy air? What, all this for a bird? You're not crying, but you're distressed, and there's a thought behind your distress. Come, child, open your heart to me, tell me what it is, is it

the death of this bird that makes you so sad and withdrawn? . . .
You lower your eyes and don't answer me. Your tears are ready to
flow. I'm not a father, I'm not indiscreet or severe. Well then, I
understand, he loved you, he'd been swearing it and swearing it for
such a long time! He was suffering so much, and how can you see
someone you love suffering? . . . Come now, let me go on: why are
you closing my mouth with your hand? That morning, alas, your
mother was out; he came, you were alone; he was so handsome, so
passionate, so tender, so charming, there was such love in his eyes,
such truth in his expression! He said things which went straight to
your heart! And as he said them he was at your knees; that's easy to
understand; he was holding one of your hands, now and then you
could feel the warmth of a few tears falling from his eyes and
running down your arms. And your mother still didn't come back;
it's not your fault, it's your mother's fault . . . But now you've
started crying! what I'm saying isn't meant to make you cry. Why
cry? He made you a promise, he won't go back on anything he
promised. When someone's had the good luck to meet a charming
girl like you, he tries to win her and please her for life . . . What
about my bird? . . . You're smiling . . . (Oh, my friend, how lovely
she was! if you could have seen her smiling and weeping!) I went
on: Well, what about your bird? When you forget yourself, do you
remember your bird? When it was nearly time for your mother to
come back, the one you love went away. He was happy, contented
and walking on air! How hard it was for him to drag himself away
from you! . . . What a look you're giving me! You see, I know it
already. How many times he got up and sat down again! how
many times he said goodbye without going! how many times he
went out and came back! I've just seen him with his father, there's a
charming gaiety about him, a gaiety they all have and they can't do
anything about it . . . What about my mother? . . . Your mother,
she came back almost as soon as he'd gone, she found you in the
dreamy state you were in just now; that's the way it always is.
Your mother spoke to you and you didn't hear what she said; she
told you to do one thing and you did another. A few tears welled

up and either you held them back or you turned away and wiped them furtively. Your constant absentmindedness annoyed your mother, she scolded you, and this was when you cried freely and felt relieved. Shall I go on? I'm afraid what I'm going to say might renew your suffering. You want me to? Well then, your good mother was sorry she'd made you unhappy, she came close to you, she took your hands, she kissed your forehead and your cheeks, and that only made you cry more. Your head leaned towards her, and your face, which was beginning to colour, there, just as it's colouring now, buried itself in her breast. What gentle things that mother said to you, and how those gentle things hurt! And all the time your canary was singing, trying to attract you, calling to you, flapping his wings, complaining that you'd forgotten him, but it was no good, you didn't see him, you didn't hear him, you had other things to think about; his water and his seed weren't renewed and this morning the bird was no more . . . You're still looking at me; is there still something I have to say? Ah, I understand, the bird was a present from him. Well, he'll find another one that's just as nice . . . There's still something; you're staring at me and you're upset; what is it then? Speak to me, I can't work out what you want . . . And what if the death of this bird was an omen . . . what would I do? what would become of me? what if he didn't care about me? . . . What nonsense! Don't be afraid, it won't happen, it can't happen . . . – But, my friend, aren't you laughing at the thought of a staid personage wasting his time consoling a child in a picture for the loss of her bird, or the loss of whatever you like? But then look how beautiful she is! how engaging! I don't like to be the cause of suffering, but all the same, I wouldn't mind too much being the cause of her troubles.

The subject of this little poem is so subtle that many people didn't understand it; they thought it was only her canary the girl was weeping for. Greuze painted the same subject once before.[7] He placed before a broken mirror a tall girl dressed in white satin, sunk in deep melancholy. Don't you think it would be as stupid to attribute the tears of the girl in this Salon to the loss of a bird, as the

melancholy of the girl in the Salon before it to her broken mirror? This girl is weeping for something else, I tell you. In the first place, you heard her, she admits it, and her affliction tells you the rest. That grief! at her age! and for a bird! – How old is she, then? – What shall I answer, and what sort of question is this? Her face is fifteen or sixteen, and her arm and hand eighteen or nineteen. It's a defect of this composition which is all the more noticeable because the head, leaning as it is on the hand, means that one of the parts is wrong for the other. Place the hand differently, and no one will notice that it's a little too strong and well formed. What has happened, my friend, is that the head has been taken from one model and the hand from another. Apart from that, that hand is very real, very beautiful, and very expertly coloured and drawn. If you're prepared to overlook the slight blemish of a rather purplish colour tone, it's a very beautiful thing. The head is well lit, the colour is the most pleasing one can imagine for a blonde; perhaps one could ask for her features to be a little more prominent. The striped neckerchief is broad, light, beautifully transparent, and all of it done with strong brush-strokes which don't detract from the delicate effect of the detail. This painter may have done as well, but not better.

This piece is oval, two feet high, and belongs to Monsieur de Lalive de la Briche.

The Spoilt Child[8]
A painting two feet six inches high by two feet wide.

Here we have a mother sitting beside a table and looking on indulgently as her son feeds his soup to a dog. The child is giving the soup to the dog in a spoon. That is the basic subject. There are additional features, such as, on the right, a pitcher and an earthen-ware vessel in which some washing is soaking; above, a sort of cupboard; from the side of the cupboard hangs a string of onions; above that, a cage is fixed to the side of the cupboard, and there are two or three poles propped against the wall. From left to right, starting from the cupboard, runs a kind of sideboard on which the

artist has set an earthenware pot, a glass half-full of wine, a piece of clothing hanging over the edge; and behind the child, a chair with a straw seat and a bowl. All of which means that his little laundry girl of four years ago has got married and he plans to tell us what's happened to her.[9]

The subject of this picture is not obvious. The idea behind it does not stand out clearly enough; it's either the spoilt child or the spoilt dog. It glitters all over with little spangles of light which hurt your eyes. The mother's face is charmingly coloured; but her headdress is not properly fixed on her head, so that her face doesn't stand out clearly. Her clothes are heavy, especially the undergarments. The child's head is a model of beauty, by which I mean painter's beauty; he's a fine painter's child, but not the sort a mother would want. That head is most delicately painted; the hair much finer than he usually does it; but that dog there, that's a real dog! The mother's breast is opaque, lacking any transparency, and even a little red. And there are too many accessories, too much clutter. They've made the composition heavy and confused. The mother, the child, the dog and a few pots and pans would have been more effective. There would have been points of rest where there are none.

Head of a Girl[10]

Yes, of a girl standing at a street corner, head in the air, reading the posters while she waits for a customer. She is in profile. You can certainly call this a strongly coloured piece. The planes stand out so well that you'd almost think she was sculpted. She demolishes fifty paintings around her; there's a really wicked little trollop for you. Look how the Introductor of Ambassadors,[11] right beside her, has grown pale, cold, flat and pasty, and the damage she's done at long range to Roslin and all his miserable family! I've never seen such devastation.

Girl Holding a Small Wooden Capuchin Friar[12]

What truth! what variety of tone! And those red blotches! who hasn't seen them on children's faces when they're feeling cold or

suffering from toothache? and those tearful eyes, and those numb, frozen little hands, and those plaits of blonde hair scattered across her forehead: they're so real and wavy you want to tuck them under her bonnet. A headscarf in coarse, serviceable material, with the creases they tend to get. A neckerchief of good, coarse cloth round her neck, arranged as they usually are. A little Capuchin, standing up really straight, really wooden, with really stiff clothes. Monsieur Drouais, come here, do you see this child? it's flesh; and the Capuchin is plaster. As far as truth and boldness of colour go, it's a little Rubens.

Portrait of Madame Greuze

Here, my friend, is an example of how much ambiguity there can be in the best painting. You see this fine fishwife with her well-rounded body, her head thrown back, her pale colour, her headdress all adrift and untidy, her expression of mingled pain and pleasure, all betraying an excitement which it's sweeter to experience than it's proper to portray; well, that's the sketch, the study for *The Beloved Mother*. How does it come about that a person's nature can be respectable at one time and not at another? Do we need additional features and circumstances so that we can judge correctly of people's faces? Are they not clear without this support? There must be something in it. The half-open mouth, the swimming eyes, the head and body thrown back, the swelling throat, the voluptuous mingling of pain and pleasure make all the respectable women here lower their eyes and blush. Right beside it there's the same posture, the same eyes, the same throat, the same mingling of passions, and not one of them pays any attention to it. But if the women go quickly past this piece, the men spend a long time over it, the connoisseurs, I mean, and also those who use the pretext of being connoisseurs to enjoy a particularly voluptuous scene, and those who, like me, do it for both reasons. On the forehead, from the forehead down to the cheeks, and from the cheeks to the throat, there are some wonderful variations in tone; it teaches you to look at nature and reminds you of what it's like. The details of that

swelling throat need to be seen and not spoken about; it's perfectly beautiful, true and skilful. Never can the presence of two contradictory emotions have been so clearly indicated. This *tour de force* was not even surpassed by Rubens at the Luxembourg gallery when the painter showed in the queen's face the pleasure of having given birth to a son and the traces of the painful experience which preceded it.[13]

Portrait of Monsieur Watelet[14]

It's colourless; it looks as though the paint has lost its shine, it's gloomy. It's the man himself; turn the picture to the wall.

Another Portrait of Madame Greuze

This painter certainly loves his wife, and quite rightly; I loved her myself, when I was young and she was called Mademoiselle Babuty. She worked in a little bookshop on the Quai des Augustins; she was all dolled up, her skin was white and she was straight as a lily, red as a rose. I used to go in in that lively, enthusiastic, crazy way I had, and I'd say: Please, Mademoiselle, may I have the *Tales of La Fontaine* and a *Petronius*. — Here they are, Sir. Are there any other books you require? — Well, forgive me, Mademoiselle, but ... — Tell me then. — *The Nun in a Shift*. — Come now, Sir! Do you think we stock dirty books like that? Who do you think reads them? — Oh, it's a dirty book; really, Mademoiselle, I'd no idea ... And then when I went in another day she would smile and so would I.

There was a portrait of *Madame Greuze with Child* in the last Salon; her interesting state drew your attention, and then the beautiful colouring and the truth of the details bowled you over. This one is not as beautiful, but the whole effect is graceful, the pose is good, the posture is a sensuous one, there's an enchanting delicacy of tone in the two hands, but the left hand is poorly conceived, and it even has a broken finger, which offends the eye. The dog being stroked with the more beautiful hand is a spaniel with a long black coat, and a muzzle and paws speckled with tan. His eyes are full of life; if you look at him for a while, you'll hear him bark. The

stiffened lace headdress makes you want to ask who made it; I can say the same for the rest of her clothes. You can see that the head gave the painter and the model a lot of trouble, and that's a defect in itself. The colour tones in the forehead are too yellow; we know that women who have had children are often left with these marks, but if one wants to imitate nature to the extent of portraying them, they must be softened; this is a case where you have to beautify nature a little, since it's possible to do it without losing the resemblance. But since facial blemishes offer difficulties which give artists a chance to show off their talent, they rarely refuse it. These colours also have a reddish glint which is true to life, but unpleasant to look at. Her lips are straight; that pinched look round the mouth gives her a rather prim appearance; it looks very mannered. If you find this mannered look in the figure, so much the worse for the figure, the painter and the painting. Is this woman perhaps trying to provoke her spaniel against someone? That would make the prim, provocative look less false, but it would still offend. But the shape of the mouth, the eyes and all the other details are delightful; endless subtleties in the colouring; the neck holds the head up beautifully, it's beautifully drawn and coloured, and joins on to the shoulders just as it should. But that bosom, I can't bear to look at it, and yet at fifty I'm still not averse to bosoms. The painter has made his figure lean forward, as though to say to the spectator: Look at my wife's bosom. I'm looking, Monsieur Greuze, and your wife's bosom is flabby and yellow; if it's really like that, so much the worse for you, her and the picture. One day Monsieur de la Martelière was coming down from his apartment; on the stairs he passed a young fellow going up to his wife's apartment. Madame de la Martelière had the loveliest face in the world, and Monsieur de la Martelière, as he watched the young suitor going up to see his wife, muttered to himself: Oh yes, but wait till he sees her legs ... Madame Greuze also has a very lovely face, and there's no reason why Monsieur Greuze shouldn't mutter to himself one day: Oh yes, but wait till he sees her bosom ... It won't happen, because his wife is respectable.[15] The yellow colour and the flabbiness of this bosom

are Madame's, but the lack of transparency and the matt effect are Monsieur's.

Portrait of Monsieur Wille, Engraver[16]

A very fine portrait. That's Wille's hard, abrupt look, his stiff bearing, his small, wild, fiery eye, his blotchy cheeks. How well the hair is done! What fine draughtsmanship! What confident brush-work! What truth and variety in the tones! And the way the velvet, the jabot and the ruffles are executed! I should like to see this picture next to a Rubens, a Rembrandt or a Van Dyck; I should like to get an idea of what our painter has to lose or gain by the comparison. When you've seen this Wille you turn your back on the portraits of the others, even those by Greuze.

The Beloved Mother
Sketch.

Sketches generally have an energy that the painting does not; this is the moment when the artist is full of fervour, pure inspiration, without any of the careful detail born of reflection, it's the painter's soul spread freely over the canvas. The poet's pen, the skilful draughtsman's pencil seem to move freely and effortlessly across the paper. A rapid thought finds expression in a single stroke. Now the more expression in the arts is ill-defined, the more the imagination is at ease. In a piece of vocal music, you're forced to hear what it expresses. I can make a well-constructed symphony say almost anything I like, and as I'm better than anyone at being touched by the movements of my own heart, it's not often that the interpretation I make of the sounds, based on my mood at the time, whether serious, tender or cheerful, doesn't move me more than another which I was less free to choose. Roughly the same thing applies to the sketch and the painting: in the painting I see something clearly stated; in a sketch what a lot of things I can imagine which are barely hinted at!

The composition of The Beloved Mother is so natural, so simple,

that those who don't give much reflection to the matter can be led to believe that they might have thought it up themselves and that it didn't require a great mental effort. All I would say to these people is: Yes, I do think you would have gathered all those children round the mother and made them show their affection to her; but would you have made one of them cry because he's upset at not being favoured over the others, and would you have chosen that moment to introduce that man, so cheerful, so pleased to be the husband of that woman and so proud of himself at being the father of so many children? Would you have made him say: I did all that . . . And the grandmother, would you have thought of putting her there? Are you quite sure?

Let us set the scene. It takes place in the country. In a low-ceilinged room, going from right to left, we see a bed; in front of the bed, a cat on a stool, then the beloved mother reclining on her *chaise-longue* with her children spread all over her, six of them at least. The smallest is in her arms; a second is hanging on one side, and a third on the other; a fourth has climbed on to the back of the chair and is kissing her forehead; a fifth is nibbling at her cheeks; a sixth is standing with his head in her lap and is not at all pleased with his role. The face of the children's mother is a picture of joy and tenderness, together with some of the discomfort which comes from the movement and weight of all those children overwhelming her with violent expressions of love which would soon become a burden to her if they went on very long. This sensation, not far from pain, mingled with the tenderness and joy, and with the reclining, weary posture and the half-open mouth, makes the head, seen separately from the rest of the composition, so remarkable in its effect. In the front of the picture, around this charming group, a child on the floor with a little wagon. Towards the back of the room, her back against a chimneypiece furnished with a mirror, the grandmother sitting in an armchair and very much the grandmother in face and dress, roaring with laughter at the scene before her. To the left, nearer to us, a dog barking with pleasure and joining in the fun. To the far left, almost as far from the grandmother as she is

from the beloved mother, the husband returning from the hunt; as he comes in he stretches out his arms, leans back a little and laughs. He's a big, healthy young lad and beneath his contentment you can detect his vanity at having produced this fine bunch of brats. Beside the father, his dog; behind him, right at the left-hand edge of the canvas, a clothes basket; and on the doorstep, a bit of a departing servant-girl.

This is a work of talent and high moral tone; it preaches in favour of big families and very movingly portrays the happiness and inestimable value of domestic harmony. It says to every man of good heart and good sense: look after your family, give your wife children, give her as many as you can, give them only to her, and be sure you'll be happy in your home.

The Ungrateful Son[17]
Another sketch.

I don't know how I'm going to manage this one, any more than the next. My friend, this man Greuze will be the ruin of you.

Imagine a room into which light hardly ever penetrates except when the door is open, or, when it's shut, by a square-shaped opening above it. Cast your eyes round this gloomy room and you will see nothing but poverty, except that on the right, in a corner, there is a bed which doesn't seem too awful, and it's carefully made. In the foreground, on the same side, a big black-leather carver chair which must be comfortable to sit in. Place the father of the ungrateful son in it. Next to the door put a low cupboard, and right next to the decrepit old man a little table on which some soup has just been served.

Despite the help the eldest son of the family might have been to his old father, his mother and his brothers, he has volunteered; but he is not going to leave without getting what he can out of these wretched people. He has come with an old soldier. He has asked for what he wants. The father is indignant; he is not sparing of harsh words for this inhuman child who knows neither father, mother nor duty and returns insults for their reproaches. We see him in the

centre of the picture; he looks violent, insolent and hot-tempered; his right arm is raised towards his father over the head of one of his sisters; he is drawn up to his full height, making a threatening gesture with his hand; he is wearing a hat, and his gesture and his face are equally insolent. The good old man, who has always loved his children but never allowed any of them to disobey him, tries to get up, but one of his daughters, on her knees before him, is holding him back by the skirt of his coat. The young ruffian is surrounded by his elder sister, his mother and one of his little brothers; his mother is gripping him round the body and the brute is trying to shake her off and pushing her away with his foot; the mother looks overwhelmed, grief-stricken. The elder sister has also stepped between her brother and her father; the mother and the sister seem by their attitudes to be trying to distance them from each other; the sister has seized her brother by his coat and is saying, judging from the way she is pulling him: You wretch! What are you doing? You reject your mother! You threaten your father! Get down on your knees and ask forgiveness . . . Meanwhile the little brother is crying; with one hand raised to his eyes and the other hanging on to his brother's right arm, he is struggling to pull him out of the house. Behind the old man's chair, the youngest of them all looks stunned and frightened. At the other extremity of the scene, towards the door, the old soldier who has enrolled the ungrateful son and come with him to his parents' house is going away, his back turned to what is happening, his sword under his arm and his head bowed. I was forgetting that in the midst of this tumult, a dog in the foreground is making it worse with its barking.

Everything in this sketch is well observed, well arranged, well characterized and clear, both the pain and even the weakness of the mother for a child she has spoilt, and the violent feelings of the old man, and the various actions of the sisters and the small children, and the insolent behaviour of the ungrateful son, and the discretion of the old soldier who can't help himself from shrugging his shoulders at what is going on; and the barking dog is one of those extra features which Greuze has a special gift for.

But this very fine sketch is not, in my opinion, as good as the one which follows.

The Son Punished[18]
Sketch.

He has been to war and now he returns, and at what moment? At the very moment when his father has died. The house is very much changed; once it was the home of poverty, now it is the home of grief and wretchedness. There is a miserable bed without a mattress. On this bed the old man lies dead; the light from a window illuminates only his face, the rest is in shadow. At his feet, on a stool, we see the consecrated candle burning and the holy water stoup. The elder daughter, sitting in the old leather carver chair, is reclining in an attitude of despair, one hand on her forehead, the other still holding the crucifix which she has given her father to kiss. One of her children has timidly hidden his head in her bosom; the other, arms outstretched, fingers splayed, seems to be getting his first notions of death. The younger sister, standing between the window and the bed, cannot convince herself that she no longer has a father; she is bent over him, she seems to be seeking a last glimmer of life in his eyes, she lifts one of his arms, and her half-open lips cry: Father, can't you hear me any more? The poor mother is standing near the door, her back to the wall, grief-stricken, and her knees are giving way beneath her.

Such is the spectacle which awaits the ungrateful son. He comes forward, reaches the doorway. He has lost the leg with which he pushed his mother away, and the arm with which he threatened his father is now useless.

He comes in. His mother receives him; she says nothing, but her arms stretched out towards the body say to him: There, look, do you see? That is what you have done to him! . . . The ungrateful son appears dismayed, his head falls forward, and he strikes his forehead with his hand.

What a lesson for fathers and children!

And that is not all. This man thinks as carefully about the incidentals as he does about the central subject.

From the book lying on the table in front of the elder daughter, I surmise that this poor unhappy woman has been given the painful task of reading the prayer for the dying. That bottle beside the book looks as if it contains the remains of some medicine.

And the warming-pan on the floor had been brought to warm the dying man's icy feet.

And there's the same dog, uncertain whether to recognize this cripple as the son of the house or to take him for a beggar.

I don't know what effect this short, simple description of the sketch for a painting will have on others; but for my part I must confess that I couldn't make it without feeling some emotion.

It's beautiful, very beautiful, sublime, everything. But as it is written that man will never make anything perfect, I don't think the mother's action fits the occasion; I feel that, in order to hide her eyes from the sight of her son and the corpse of her husband, she should have covered her eyes with one hand and shown the ungrateful son the body of his father with the other. We should still have seen all the violence of her grief on the rest of her face, and the figure would have been even more simple and moving. And then the detail is wrong, only in one small respect, it's true, but Greuze is a perfectionist: the great round stoup with the holy water sprinkler is the one the Church will place at the foot of the bier; what they put at the feet of the dying in cottages is a pot of water with a branch blessed on Palm Sunday.

Apart from that, these two pieces are, in my opinion, masterpieces of composition; there are no contrived or extravagant attitudes, nothing but the actions appropriate to the painting; and in the second one in particular, an overall effect of violence throughout the painting. For all that, public taste is so dreadful, so mean, that perhaps these two sketches will never be painted,[19] and if they are painted, Boucher will have sold fifty of his indecent, commonplace marionettes before ever Greuze sells his two sublime paintings. And, my friend, I know what I'm talking about, because isn't his *Paralytic*,

or the picture of the reward of good education, still in his studio? Yet it's a masterpiece. They heard about it at court, sent for it and it was much admired, but they didn't take it, and it cost the artist near enough twenty *écus* for the inestimable good fortune ... But I'll shut up, I'm losing my temper, and I feel like doing something dangerous.

Talking of Greuze's type of painting, will you allow me to ask you a few questions? The first is: What is true poetry? The second is: Is there any poetry in these last two sketches by Greuze? The third: What difference do you see between this poetry and that of the *Sketch for Artemisia's Tomb*,[20] and which do you prefer? The fourth: Of two domes, one of which you take to be a painted dome, and the other a real dome, although it's painted, which is the more beautiful? The fifth: Of two letters, say from a mother to her daughter, one of them full of grand and beautiful passages of eloquence and emotion over which you're constantly exclaiming in admiration, but which don't fool anyone, and the other simple, natural, so simple and natural that everyone is taken in and takes it for a letter which a mother has really written to her daughter, which is preferable and, for that matter, which is more difficult to do? You can well imagine that I'm not going to embark on these questions; it's neither your plan nor mine for me to write one book inside another.

The Nursemaids[21]
Another Sketch.

Chardin has placed it underneath Roslin's *The Family*; he might as well have written under one of the paintings: *Model of Discord*, and under the other: *Model of Harmony*.

Going from right to left, three casks standing in a row; a table; on this table a dish, a skillet, a kettle and other kitchen utensils. In the foreground, a child leading a dog on a string; with her back to this child, a peasant woman with a little girl asleep on her lap. Further back, a fairly tall child holding a bird – you can see a drum

at his feet and the bird's cage fixed to the wall; then another woman sitting in a group with three children; behind her, a cradle; at the foot of the cradle, a kitten; on the floor, a box, a pillow, a bundle of sticks and various pieces of equipment for cottages and nursemaids.

Ostade would not disown this piece.[22] It's impossible to paint more vigorously; the effect is completely lifelike. You don't look to see where the light is coming from. The groups are charming. The arrangement is beautifully thought out and not in the least contrived. You feel you're in a cottage, nothing jars, neither in the subject nor the artistry. Some people want there to be more light on the cradle; all I want is the painting . . .

Ah! what a relief! That's Greuze finished with. I enjoy all the work he gives me, but he does give me a lot.

HALLÉ

Salon of 1765

The Emperor Trajan, Leaving for an Urgent Military Expedition, Gets Down from his Horse to Listen to a Poor Woman's Grievance
Large painting intended for Choisy.[1]

Trajan occupies the centre foreground of the picture. He is listening to a woman kneeling at some distance from him between two children. Beside the emperor, in the middle distance, a soldier is holding the bridle of his rearing horse; this horse is certainly not the one for which Father Canaye asked and of which he said: *Qualem me decet esse mansuetum.*[2] Behind the supplicant, another woman is standing. To the right, in the background, what seem to be a few soldiers.

Monsieur Hallé, your Trajan, based on an antique model, is dull, lacking in any nobility, expression or character; he seems to be saying to this woman: My good woman, I see that you're tired; I'd be happy to lend you my horse, but he's as skittish as the devil . . . This horse is in fact the only character worthy of note in the whole

scene; he's a poetic horse, grey and misty, like the ones children see in the clouds; the spots with which the painter has chosen to speckle his breast are a very good imitation of fleecy clouds. Trajan's legs are wooden, as stiff as if his clothes were lined with sheet-metal or tinplate. The cloak he's been given is a heavy blanket in poorly dyed crimson wool. As for the woman, whose facial expression should have created all the emotional effect of the scene, and who draws our attention with her coarse blue garment, well, we only see her from behind; I said the woman, but perhaps it's a young man; I can only go by the hair and the guidebook, there's nothing here to define the sex. Yet a woman is no more a man from behind than from the front; the nape of the neck is different, and so are the shoulders, the back, the thighs, the lower legs and the feet; and that big yellow rug which I can see hanging from her belt like an apron, tucked under her knees and then reappearing behind her, I suppose she's brought it so as not to spoil her nice blue dress; that bulky piece of material was never part of her clothes when she was standing up. And then the hands are not properly finished, nor the arms or the hair, she's a victim of *plica polonica*.[3] That material over her forearm looks like furrowed Saint-Leu stone.[4] The whole of Trajan's side is without colour; the sky is so bright that it reduces the group to a half-tone and destroys its effect. But you really need to see the arm and hand of this emperor, the arm for its stiffness, the hand and the thumb for the faulty draughtsmanship. History painters regard these little details as trivialities, they go for the big effects; this kind of strict imitation of nature, holding them up at every step, would extinguish their ardour and stifle their genius: is that not so, Monsieur Hallé? It wasn't exactly what Paul Veronese thought: he took trouble over his flesh, his feet and his hands; but the futility of it has been recognized, and it's no longer the practice to paint them, though it's still the practice to have them. Do you know what that child in the foreground looks like? a bunch of big wens; except that on his leg, which twists like a snake, they're a little more swollen than on his arms. That pot, that copper household utensil which the other child is leaning on, is such a strange

colour that I had to be told what it was. The officers accompanying
the emperor are as pitiful as he is. Those scrappy figures scattered
round about, would you say they're meant to indicate the presence
of an army? This painting is incoherent in its composition, it's a
nothing, nothing in its colour which is made of faded herbal juices,
or its expression, or its characterization, or its draughtsmanship; it's
a great gloomy lifeless enamel.

But this was a very difficult subject. You're wrong, Monsieur
Hallé, and I'll tell you how another painter could have made
something of it. He would have had Trajan stop in the centre of his
canvas. The chief officers of his army would have stood around
him; each one would have registered on his face his reaction to the
supplicant's words. Look at the way Poussin's Esther appears before
Ahasuerus.[5] And what was to prevent your woman, overcome as
she was with her suffering, being similarly accompanied and sup-
ported by women of her own kind? You want her to be alone on
her knees? All right, but for goodness' sake don't show her to me
from behind: backs aren't very expressive, whatever Madame Geof-
frin may say.[6] Let all her suffering be seen in her face; let her be
beautiful, with the nobility of her class; let her movements be
strong and moving. You didn't know what to do with her two
children; go and study *The Family of Darius*[7] and there you'll learn
how the minor figures can be made to contribute to the interest of
the principal ones. Why not indicate the presence of the army by
having a crowd of heads clustered round the emperor? Some of
these figures cut off by the frame would have led me to imagine as
many more as I wanted. And why is the scene round the woman
left empty of witnesses or spectators? Was there no one, relations,
friends, neighbours, not men, women or children, who might have
been curious to know the outcome of her action? There, I think, is
something to enrich your composition with, but as it is, everything
is sterile, insipid and bleak.

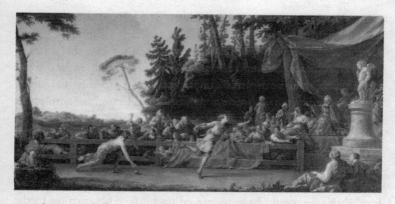

HALLÉ The Race between Hippomenes and Atalanta (La Course d'Hippomène et d'Atalante) *Louvre*

The Race between Hippomenes and Atalanta[8]
A painting twenty-two feet wide by eighteen feet high.

This is a large and quite beautiful composition. Monsieur Hallé, I congratulate you, neither I nor anybody else expected it. It's a painting, you've done a painting. Imagine a large, spacious, fresh landscape, fresh as a morning in spring: hillocks, decked with fresh growth, and set out on different planes, give space and depth to the scene; at the foot of these hillocks a plain; part of this plain separated from the rest by a long wooden fence. It is the space in front of this fence and in the front of the picture which provides the site for the race. At the right-hand end of this space, you see some fresh green trees, mingling their branches and shades to form a natural arbour. Set up a platform under these trees, place on this platform the fathers, mothers, brothers and sisters and the judges of the contest, protect their heads either from the dampness of the trees or the heat of the day with a large awning hung from the branches. In front of the platform, inside the area of the race, a statue of Love on its pedestal; this will be the finishing-point. A tall tree which chance has placed at the other end of the space will mark the starting-point for the contestants. Beyond the fence distribute spectators of all ages

and both sexes, each interested in the activities in their own way, and you will have Monsieur Hallé's composition before your eyes.

Hippomenes and Atalanta are alone inside the fence. The race is well under way. Atalanta hastens to pick up a golden apple. Hippomenes is already holding one which he is about to drop; he has only a few paces to go to reach the finish.

There is certainly plenty of variety in the attitudes and expressions both of the judges and the spectators. Amongst the characters under the awning one notices especially an old man sitting there, whose joy leaves one in no doubt that he is Hippomenes' father. Those heads appearing along the far side of the fence are very pleasing. I have a high, very high opinion of this painting. When I'm told that it's intended for a tapestry, I can no longer see anything wrong with it. The Hippomenes is as nimble as it's possible to be. He runs with infinite gracefulness; he's raised up on tiptoe, with one arm thrust forward, the other stretched out behind him; there is elegance in his figure, his attitude, his whole person; there is the certainty of triumph, and joy in his eyes. It may be that this race is too contrived, more like an operatic dance than a contest; it may be that when it's a matter of winning or losing the person one loves, one runs differently, with the body thrown forward, all one's action directed towards the finish; it may be that one doesn't go up on tiptoe, or think about positioning one's limbs, displaying a fine leg and fine arms, or dropping an apple from one's fingertips as if one were scattering flowers. But perhaps this criticism, powerful as it would be if the race were just beginning, can be answered when the race is ending. Atalanta is still a long way from the finish, Hippomenes is almost there, victory can no longer escape him, he doesn't even bother to run, he's showing off, prancing about, congratulating himself. He's like our actors when they've performed some energetic dance, they amuse themselves by throwing off a few more steps as they go into the wings. It's as if they were saying to the spectators: I'm not tired; if I have to do it again, I'm quite ready; you may think I've put a lot into it, but I haven't at all. This sort of showing off is quite natural, and I don't see any difficulty in

supposing it to be the case with Hallé's Hippomenes. That's how I understand it, so I've no more argument with him. But I shall find it harder to make my peace with his Atalanta. I don't like her long, lean, sinewy arm; it's not the right sort of arm for a woman, it's a young man's. I don't know whether this figure is at rest or running along; she's looking at the spectators ranged along the barrier, she's bent over, and if she were thinking of halting their gaze with the power of her own and furtively picking up the apple that's near her hand, that's exactly how she would do it.

LAGRENÉE

Salon of 1765

Magnae spes altera Romae[1]

This man is a real painter. The progress he has made is amazing. Draughtsmanship, colour, flesh tints, expression, the most beautiful draperies, the finest types of face, everything is there except inspiration. What a great painter he'll be if the spirit visits him! His compositions are simple, his movements are lifelike, his colouring firm and beautiful; he always works from nature. There are some paintings of his where the most severe of critics wouldn't find anything to object to. His little virgins are like Guido Reni's. The longer you look at his *Justice and Mercy* or his *Kindness and Generosity*, the more pleased you are with them. I remember that I once tore the brushes from his hand; but then who wouldn't have forbidden Racine to write poetry if his early verses were anything to go by? Lagrenée has a very simple explanation for the progress of his talent: he says he uses the money he's earned from doing bad things to do good ones.

Justice and Mercy[2]
An oval picture, overdoor for the Choisy gallery.

On the left, Justice, seated on the ground, in profile, her left arm

placed on the shoulder of Mercy, her sword held loosely in her right hand. On the right, Mercy, kneeling before her, bent forward over her knee. Behind Mercy, a little child lying on its back, subduing a roaring lion. Around Justice, her scales and other attributes.

What a lovely picture! Praise the colouring, the distinctive features, the postures, the draperies and all the details. The hands, the feet, everything is beautifully finished. What a face that Mercy has! Where did he find a face like that? It's the true face of kindness; and she's kind in her character, her attitude, her drapery, her expression, her back, her shoulders, everything. I've heard it said that Justice should be a little more dignified. You've seen her; don't you think she should be left as she is? If I dared say a word in the painter's ear, I'd advise him to remove that piece of drapery spread out behind her, which spoils the effect, and put anything he likes in its place; to change that gaudy blue border which adorns Mercy; to have another go at that child, who's too red and insensitively coloured; to get rid of half the folds in the rumpled drapery he's lying on, and to give a more lively treatment to the lion's mane. But if you were to leave the work as it is, write *Guido Reni* underneath and take it to Italy; only its freshness would give you away.

Kindness and Generosity[3]

This artist excels above all in easel paintings. This one is the matching piece to the preceding one and loses nothing in the comparison. Kindness is seated, I think; she is seen in full face. She is squeezing her left breast with her right hand and sending a jet of milk into the mouth of a child standing in front of her. Generosity, leaning against Kindness, stretched out on the ground, is scattering gold coins with her right hand, while her left is resting on a huge conch from which riches flow in all their symbolic forms. You should see how this figure is positioned, the effect of the two arms, how her head is set well back into the canvas and the rest of the figure comes forward, how every part is at its proper distance, how the arm scattering the gold stands out from the body and comes out of the canvas; and all the bold picturesque features in the whole

figure. The conch is a most beautiful shape and very finely worked. This piece provides an example both of fine drapery and of ordinary drapery. The blue drapery covering the knees of Kindness is broad enough, but a little harsh, lifeless and stiff; on the other hand, that covering the same parts of Generosity, just as broad as the other, is still soft and flowing. Kindness is modestly draped, as is proper; Generosity is richly apparelled, as she must be. The child beside this last figure is badly done: the arm he is stretching out is stiff, without any natural detail, reddish in tone. For all that, this piece is enchanting and most effective; one cannot imagine more beautifully conceived heads, and then the hands, the feet, the flesh, the life. Steal this pair of pictures from the king, because kings are fair game to steal from, and be sure you'll have the best things in the Salon.

Mary Magdalene[4]

She is facing us. Her eyes are turned towards heaven, tears flow down her cheeks, she weeps not just with her eyes, but with her mouth and every part of her face. Her arms are folded over her breast; her long hair winds down over it; only her arms and part of her shoulders are naked. As, in her grief, her arms tighten across her breast and her hands on her arms, the ends of her fingers press gently into the flesh. The expression of her repentance is utterly gentle and true. It is not possible to imagine hands, arms and shoulders more beautiful than this. The slight impressions made in her flesh by her fingertips are rendered with infinite delicacy. This painting is a little gem, but this little gem is not without its flaws. The painter has encircled her head with a dreadful glowing halo which destroys all the effect; and then, to tell the truth, I'm not wildly happy with the drapery.

Behind the holy penitent who, as Panurge says,[5] is well worth the compliment of a sin or two, there is a block of stone, and on this stone the vase of perfumes, the saint's attribute. If the woman who anointed the feet of Christ at thirty-three and wiped them with her hair was as beautiful as this one and Christ's flesh was not roused, he was not a man, and this phenomenon can be used as an argument against all those of the Socinians.[6]

LOUTHERBOURG

Salon of 1765

Here is this young artist who, with his lifelike animals, beautiful sites, rustic scenes and cool mountains, has started out in the style of Berghem, and has presumed, with his bold brush, his understanding of natural and artificial light and other painterly qualities, to compete with the fearsome Vernet.

Take heart, young man; you have come further than anyone has a right to at your age. You won't know poverty, because you work fast and your compositions are well thought of. You have a charming wife, which should keep you in order. Never leave your studio unless it's to study nature. Live in the fields with her; go and see the sun rise and set, the red clouds colouring the sky. Walk in the meadows amongst the cattle; see the drops of dew shining on the grass; see the mists forming in the evening, spreading over the plain and gradually concealing the mountain tops. Get out of bed early in the morning, even if you have got a lovely young wife beside you; get there before the sun returns; see its darkened disc, with the edges of its orb invisible and all its numerous rays lost, scattered and swallowed up in the immense, deep mist which is only faintly tinged with a reddish glow; already that nebulous mass is beginning to collapse under its own weight; condensing on to the earth, it will dampen it, then soak it through, and the softened turf will stick to your feet. Turn your eyes towards the summits of the mountains; now they are beginning to pierce through the ocean of mist. Hurry, climb quickly up some high hill and from there contemplate the surface of that ocean as it gently undulates over the surface of the ground and, as it subsides, reveals the tips of the church spires, the treetops, the roofs of the houses, towns, villages, whole forests, the complete natural scene illuminated by the light of the sun. This star has scarcely embarked upon its journey, your charming wife has not yet opened her eyes; soon one of her arms will reach out to seek you at her side: hurry back, conjugal love

beckons you. The spectacle of living nature awaits you. Take up the brush that you've just dipped in the light, the waters, the clouds; the varied scenes which fill your head are asking only to be released and fix themselves to the canvas. While you're busy in the heat of the day painting the freshness of the morning hours, the sky is preparing new phenomena for you. The light is fading, the clouds are shifting, separating, coming together, and the storm is building up; go and see the storm gather, break and subside, and let me go to the Salon in two years' time and see the trees it has destroyed, the torrents it has swollen, the whole spectacle of its ravages, and let my friend and me, supporting each other as we gaze at your work, be frightened by it still.

Meet of the Prince de Condé's Hunt in that Part of the Forest of Chantilly Called the Rendez-vous de la Table

There are quite a lot of compositions by Loutherbourg, because this man is a prolific artist; some of them are excellent and all have some merit. The one I shall deal with first is the least good, and it's a work done to order: the setting and the subject were given and the painter's muse was imprisoned.

Anyone unfamiliar with the tedious effect of symmetry only has to look at this picture. Draw a vertical line down the middle of the canvas, fold the canvas along this line and you'll find that one half of the enclosed space containing the 'rendez-vous' folds exactly on to the other half. At the entrance to the enclosure, one section of fence closes exactly on to another section of fence, and as you move forward into the picture, you'll see huntsmen and dogs meeting huntsmen and dogs, and then one piece of forest meeting a similar piece of forest. The avenue running through these two wooded areas and the table set in the middle are also cut in two, so that half the table and half the avenue close on to their other halves. Now take a pair of scissors and cut the picture along the vertical line and you'll have two half-pictures which exactly mirror each other.

But, Monsieur Loutherbourg, was it not possible to break this symmetry? Did this avenue have to go right up the middle of your

canvas? Would the subject have been any less a meet if it had been opened up from one side? Can't this site in the Forest of Chantilly be approached and viewed from a hundred angles and still be the same? Why choose the very centre? And that's not all: your huntsmen and your amazons are stiff, like puppets. Take it all to the Foire Saint-Ovide,[1] it'll sell well, because there's no doubt these dolls are a lot better than the ones they sell there – not all of them though, because there are some that children would take for cardboard cutouts. Your trees are poorly painted and in a green that you've never set eyes on. As for the dogs, they're all very good; and so is the terrace forming the enclosure which runs from the edge of your picture into the background, the only thing you were able to decide for yourself; I can see your hand in that, I can tell by its look of reality, the accidental effects of light, its warm colouring and the splendid shading. It's good, very good.

My friend, if you think for a moment about symmetry, you'll realize that it's only suitable for large architectural masses, and only architectural, not natural masses, like mountains; because architecture works according to rules and symmetry is appropriate to that; symmetry is an aid to concentration and has a magnifying effect. Nature has made animals symmetrical, with a face where one side is like the other, two eyes, a nose in the middle, two ears, a mouth, two cheeks, two arms, two breasts, two legs, two feet. Cut the animal with a vertical line through the middle of the nose and one of the halves will be exactly like the other. Hence the activity, movement and contrast when these alter the position of their limbs; hence the profile is more pleasing than the full face, because there is order and variety without symmetry, and the three-quarter view with its various angles is even preferable to the profile, because there we have order, variety and a symmetry which is both indicated and concealed. In painting, if you embellish your background with an architectural feature, you place it to the side to conceal the symmetry which would offend the eye, or if you show it from the front, you call up a few clouds or plant a few trees to break it up. We don't want to know everything at the same time; women are

well aware of this: they grant and they deny, they reveal and conceal. We want the pleasure to last, so there must be a gradual process. The pyramid is more beautiful than the cone, which is simple but without variety. An equestrian statue is more pleasing than one of a man standing, a broken straight line more than a straight line, a circular line more than a broken straight line, an oval more than a circle, a serpentine line more than an oval. After variety, what we find most striking is mass. So groups are more interesting than single figures, large areas of light are beautiful, all objects are beautiful when their larger aspects are shown. Large masses are striking in nature and in art; we are struck by the enormous mass of the Alps and the Pyrenees, the vast extent of the ocean, the dark reaches of the forests, the breadth of the façade of the Louvre, even though it is ugly, the great structure of the towers of Notre-Dame, despite the enormous number of small points of rest which break up the height and help the eye to measure it, the pyramids of Egypt, the elephant, the whale, the great robes of the magistrates and their voluminous folds, and the lion's mane, long, thick, bristling and fearsome. It is this idea of mass, taken secretly from nature, with its accompanying ideas of permanence, greatness, power and solidity which has given rise to the simple, broad, sweeping style, even where the smallest items are concerned, because even a fichu can be done in this way. It is when an artist lacks this notion that his taste becomes trivial in its form, trivial and fussy in its drapery, trivial in its characteristics, trivial in every aspect of composition. Give me, or give such artists, the Cordilleras, the Pyrenees, the Alps, and we shall both succeed, they with their stupidity, I with my artifice, in destroying their greatness and majesty: we shall need only to cover them with little round lawns and little bare patches so that they look as though they're covered all over with a huge patchwork quilt. The smaller the patches and the bigger the quilt, the more disagreeable the view, the more ridiculous the contrast between the great and the small, because the ridiculous often arises from the proximity and opposition of qualities. A solemn-looking animal makes you laugh because it is an

animal and is putting on an air of dignity. The donkey and the owl are ridiculous because they are stupid and look as though they are meditating. Do you want the monkey, capable of a hundred different contortions, to look ridiculous instead of just funny? Give him a hat. Do you want him to look more ridiculous? Put a full-bottomed wig under the hat.[2] That's why President de Brosses,[3] whom I respect in his ordinary clothes, makes me curl up with laughter in his lawyer's robes. How can you keep a straight face when you see this cheerful little face with its mocking, satyr-like expression eclipsed beneath a huge forest of hair, and this forest tumbling down to right and left and taking over three-quarters of the rest of his tiny figure? But let us get back to Loutherbourg.

Morning, after Rain
Storm Blowing Up at Sunset
Matching pieces, four feet wide by three feet high.

In the centre of the canvas, an old castle. At the foot of the castle, cattle going into the fields. Further back, a herdsman on horseback, leading them. On the left, rocks, and a path between them. How well this path is illuminated! On the right, a distant view with a little landscape.

That's beautiful; the light is good and the whole effect is good, but difficult to appreciate if you haven't lived in the country. You need to have seen the misty, greyish sky in the morning, that gloominess in the atmosphere which heralds more bad weather for the rest of the day; you need to remember that kind of washed-out, melancholy look that the fields have after the night's rain, which puts the traveller in a bad mood when he gets up at daybreak and goes, still in his nightshirt and nightcap, to open the shutters at the window of the inn and sees the weather, and the promise the sky holds for the day to come.

Anyone who has not seen the sky darkening as a storm approaches, the cattle coming back from the fields, the clouds gathering, a weak, reddish light over the housetops; who has not seen the

peasant shutting himself up in his cottage or heard the shutters of the houses slamming on all sides, and who has not felt the terror, the silence and the solitude of that moment as they suddenly descend on a village, will not understand Loutherbourg's *Storm*.

In the first of these two pictures I like the fresh atmosphere and the setting; in the second I like the old castle and that dark doorway which gives entry to it. The clouds which herald the storm are heavy, thick and too much like a cloud of dust or smoke. – All right. The reddish vapour . . . – That vapour is crudely painted. – All right again, as long as you weren't talking about the vapour over the mill on the left; that's a sublime imitation of nature; the longer I look at it, the less I know what the limits of art are. When a man has done that, I can't imagine that anything is impossible any more.

A Caravan[4]

At the top centre of the canvas, on a mule, is a woman holding a child to which she is giving the breast. This woman and the mule are placed partly above another mule laden with clothes, baggage and household utensils, and above the man leading them and the dog following him, and partly above another mule similarly laden with baggage and goods; and this dog and the leader and the two mules above a flock of sheep, all of which form a beautiful pyramid of objects piled one on top of another, in between bare rocks to the left and mountains covered with greenery to the right.

This is what happens when the exaggerated and ill-conceived affectation of the pyramid structure is not accompanied by an understanding of planes. Now here there is no understanding or distinction of planes; all these objects really look as though they are sitting one on top of another, with the sheep at the base; on this base of sheep the two mules, the drover and his dog; on this dog and the mules and the drover, the woman's mule; and on that the woman and her child, forming the summit.

Monsieur Loutherbourg, when they say that to please the eye a

composition needs to form a pyramid, they don't mean two straight lines running up to a point and forming the summit of an isosceles or scalene triangle; they mean a serpentine line running through different objects whose curves, having just touched the tip of the highest object in the composition, then descend by more curves to touch the tips of the other objects; and even then this rule has as many exceptions to it as there are different scenes in nature.

Apart from that, the colouring in this *Caravan* is strong and well built-up and the figures are very picturesquely arranged. It's a pity it's a shambles with a pointed top because this shambles will never get itself out of the mountains where the painter has ventured: it will just stay where it is.

Several landscape paintings

Loutherbourg's landscapes do not have the delicacy of tone of Vernet's, but they have a very definite effect. He lays his paint on thickly and it's true his shades are sometimes a little crude and dark.

Monsieur Francisque,[5] since you claim to be a landscape artist, come here, look closely, see how exactly right these rocks on the left are! how transparent that running water is! Look at the way that rock is extended; and there, more to the right, look carefully at that tower with its little arched bridge behind it and learn the way to place, raise and illuminate a stone structure when you need one in a picture. Don't disdain to look for a moment at the shrubs and wild plants growing from the gaps in the rocks on which the tower is built, because they're as they should be. That dark, narrow doorway cut into the rock is quite effective, wouldn't you say? And those peasants and soldiers you'll notice in the distance if you look towards the right: they're well drawn, and they're full of life. And that sky? that's effective. Monsieur Francisque, you're unmoved by it all. Ah! you think you're as good as Loutherbourg, and my lecture has been a waste of time. All right then, Monsieur Francisque, go on thinking you're good, and being the only one to think it.

Loutherbourg's best piece is his *Night*. I've compared it to Vernet's, and there's no point in going over it again. Those who don't

think much of the animals are forgetting that these are just nags, miserable beasts of burden.

But I must say something about the two little *Landscapes* no bigger than your hand which you'll have seen above the ticket window as you go into the exhibition rooms. They're mellow, warm and delightful. One is *Daybreak in Spring*: from the left-hand side of a hut you see a flock of sheep going to pasture. There's some countryside on the right-hand side. The other is *Sunset in Autumn, between Two Mountains*. On the right, there are just some dark mountains; on the left, the mountains are lit up; between them, a glowing sky; in the foreground, a raised piece of ground on to which a shepherd, standing at the bottom, is driving his animals. They're two fine pieces, but the second especially is the more exciting and full of life. This man doesn't feel his way, his strokes are bold and free. I'll leave these landscapes for you to think everything good you want to about them.

If you remember this Salon, you'll want to know the reason why I haven't mentioned the one where you see some cattle being led by a herdsman to a stream in the foreground whose babbling waters are flowing over some yellowish stones;[6] and the one where, between some tall, steep mountains on the right and some other mountains with a stretch of forest on the left, the artist has scattered some sheep and shown a peasant woman milking a cow in the foreground; the reason, my friend, is simply that I should go on repeating the same praises.

Salon of 1767

A Seascape

On the right you see a long stretch of ruined wall and above it, well over on this same side, a sort of vaulted structure. At the foot of this building, rock masses. Over to the left-hand side, above the wall, and set back a little, a fairly high section of a gothic tower with its supporting buttress. In the front, towards the top of the building, a narrow passage with a balustrade leading from this ruined building

to a sort of lighthouse. This passage is built over the top of an archway from which you go down to the sea by a long flight of steps. At the foot of the lighthouse, on the same plane, to the left, a vessel on its side, ready to be refitted or caulked. Further to the left, another vessel. The whole space between the building on the right and the other side of the canvas is sea, except that in the left foreground there is a spit of land on which sailors are drinking, smoking and taking their ease.

This is a very fine painting, of great vigour. The building on the right is varied in style, well conceived, and striking in its effect. The figures on the spit of land are well drawn and imaginatively coloured. If you were to see this piece by itself, you couldn't help exclaiming: 'That's really beautiful!' but unfortunately you compare it with a Vernet, which makes the sky look heavy, brings out the awkwardness and contrivance in the building, makes the water look unnatural and makes the least expert of viewers aware of the difference between a figure done with grace, ease, lightness, talent and a gentle touch, and a figure which is well drawn and well coloured, but nothing more; the difference between a brush which is vigorous, but harsh and severe, and the harmony of nature; between an original work and a good imitation; between Virgil and Lucan. The Loutherbourg is a finished work and a well-finished one. The Vernet is a creation.

A Storm[7]

On the left you see a great rock. On a long outcrop rising steeply out of the water, a man, on his knees, is bending forward and holding a rope out for a drowning victim. All that is well conceived. On a projection from the foot of the rock another man has his back turned to the water and is covering his face with his hands so as not to see the horrors of the storm; that too is good. In the foreground, on the same side, a drowned child, stretched out on the shore, and the mother grieving for her child. Monsieur Loutherbourg, that's a better idea, but it's not your own, you've taken this incident from Vernet. In the same place, more to the right, a husband is supporting

his naked, dying wife with his hands under her arms. That's not yours either, Monsieur Loutherbourg, it's another incident borrowed from Vernet. All the rest is a stormy sea, and rough, foaming water. Above the water a dark sky is turning to rain.

A crude, harsh painting, having neither merit nor power, made up of ideas taken from a number of others. Plagiarism. These waters of Loutherbourg's are either false or else Vernet's. This sky of Loutherbourg's is either solid and heavy or else the same skies by Vernet are too light, liquid and volatile. Monsieur Loutherbourg, go and look at the sea. You've been inside stables, that's obvious, but you've never seen any storms.

Another Storm

On the right, formidable rocks jutting out into the sea and arching over its surface. On these rocks, more in the foreground, are other rocks, smaller, but jutting further out into the sea. In a sort of strait, or bay, formed by the latter, a raging sea smashes on to them. On a slope, in the half-light, a man is sitting, supporting the head of a drowned woman whom another man, on the lower slope, is holding by her feet. At the extreme end of one of these arched rocks in the background, the one furthest out into the sea, a spectator, arms outstretched, frightened, stupefied, is looking at the sea at a point where very likely some poor people have been battered and drowned. Round about these precipitous, jagged, uneven masses, both in the foreground and in the distance, violent, foaming waves. In the background, on the left, a vessel buffeted by the storm. The whole of this dark scene gets its light from only one point in the sky, on the left, where the clouds are thinner.

The water is crudely done. As for the clouds, Vernet would have been able to make them just as dense, without making them dull, heavy, motionless and solid. If Loutherbourg's sky, water and clouds are crudely contrasted, it is a result of the vigour he affects, and the problem of achieving harmony, when some of the colours have been overdone.

Waterfall

On the right, a mass of rocks. Between these rocks, a waterfall. Mountains in the background. To the left, beyond the waterfall, on an elevated stretch of land, animals and a herdsman, a cow lying down, another cow going down to the water, a third standing still, while the herdsman, seen from behind, is resting his arms on it. Right over to the left, the herdsman's dog, then trees and landscape.

The trees are heavy, the sky is poor, as usual; it's a poor landscape. This artist generally has a livelier brush. But what, you'll say, is lively painting? It consists in preserving on the canvas, in the objects you are imitating, the colours they have in nature, in all their power, all their truth and all their outward features. If you exaggerate, your work will be striking, but crude and harsh. If you understate, your work will perhaps be soft, smooth and harmonious, but weak. In either case, judged by the most rigorous standards, it will be false.

Another landscape

I see mountains to my right, and further into the background, on the same side, the spire of a village church; in the foreground, moving to the left, a peasant sitting on a rock and his dog standing up on its hind legs with its front paws on his knees; lower down and further to the left, a milkmaid giving some milk from her bowl to a shepherd's dog. When a milkmaid gives some of her milk to the dog to drink, I can't imagine what she can refuse the shepherd. Around the shepherd, in the foreground, sheep lying down or grazing. Further to the left, and a little further back, oxen and cows; then a pond. On my extreme left, in the foreground, a cottage, a little house and a small shed beyond which trees and rocks complete this rural scene, the centre of which is occupied by mountains stretching into the distance, these mountains giving space and depth to the scene. The reddish glow which illuminates it is certainly an evening light; and there is some ingenuity in the way this picture is conceived.

Another landscape

There's a painting by Vernet which seems to have been specially made to be compared with this one and bring out the merits of each artist. I should like these comparisons to be possible more often. What advances we could make in our knowledge of painting! In Italy, several composers write songs to the same words. In Greece, several dramatists would treat the same subject. If the same kind of contest were set up for painters, how exciting it would be to go to the Salon! How we should argue with one another! And as each person struggled to justify his preference, what sureness of judgement we should acquire! And as well as that, wouldn't the fear of coming second encourage rivalry between the artists and make them try a little harder?

A number of private individuals, anxious that artistic activity should be kept alive amongst us, had a project for a subscription, a lottery. The price of the tickets was to be used to give work to the painters of our Academy. The paintings would have been exhibited and appraised. If there had been less money than was needed, the ticket price would have been raised. If the proceeds from the lottery had exceeded the value of the paintings, the surplus would have been carried over to the next lottery. For the first prize one would have been allowed into the exhibition first to choose the painting one liked best. There was thus no judge other than the winner. So much the worse for him, and so much the better for the person who had the choice after him, if he ignored the judgement of the artists and the public and relied on his own taste. This project did not come into being because it was fraught with various problems which would disappear if my simple method were adopted.

On the right of the scene is the summit of an old castle, with rocks beneath. Three arches have been built between these rocks. Alongside them runs a torrent, whose waters, hemmed in by another mass of rocks more in the foreground, come down and break on a great lump of rough stone, bounce off and cover it with their foam before running off in small cascades down the sides of this obstacle. The torrent, the waters and the mass of rock are a very

fine sight, and a very picturesque one. Beyond this poetic site, the waters spread out to form a pond. Beyond the arches, a little further back and over to the left, we discern the summit of another rock covered with shrubs and wild plants. At the foot of this rock, a traveller is leading a horse loaded with baggage; he seems to be intending to climb up towards the arches by a path cut into the rock along the bank of the torrent. Between him and his horse is a goat. Beneath this traveller, nearer to us and slightly to the left, we see a peasant woman mounted on a donkey. A baby donkey is following its mother. Right in the foreground, on the edge of the pond formed by the waters from the torrent, on a plane corresponding to the space which separates the traveller leading his horse from the peasant woman astride her she-ass, is a shepherd leading his animals to the pond. The scene is closed on the left by a tall mass of rocks covered with shrubs, and it gets its depth from the tops of the hazy mountains placed in the distance, which can be seen between the rocks on the left and the building on the right.

Even if Vernet were not far superior to Loutherbourg in respect of his facility, his effects and every aspect of his technique, his compositions would still be much more interesting than those of his rival. All the latter can put in his pictures is herdsmen and animals. What do we see in them? Herdsmen and animals; and more herdsmen and animals. The other painter distributes people and incidents of every kind, and these people and incidents, although authentic, do not belong to the everyday life of the countryside. Yet Vernet, ingenious and prolific as he is, is still far behind Poussin in respect of imagination. I'll say nothing of his *Arcadia*, nor its sublime inscription: *Et in Arcadia ego*, 'I too have lived in delightful Arcadia'. But this is what he has produced in another landscape which is perhaps more sublime, and less well known. This man can also, when it suits him, create an atmosphere of fear and terror in the midst of a pastoral scene.[8] The background of the painting consists of a noble, majestic, sweeping landscape. It contains nothing but rocks and trees, but they are impressive. Your eye travels across a multitude of different planes from the point nearest you to the

most distant scene. On one of the furthest planes, far in the distance, is a group of travellers resting and talking, some seated, others standing, all of them completely at ease. On another plane, more in the foreground and occupying the centre of the canvas, is a woman doing her washing in a river; she is listening. On a third plane, more to the left and right in the foreground, a man is crouching; but he is beginning to get up and look uneasily and questioningly towards the left foreground of the scene; he has heard something. Well over to the right, in the foreground, a man is standing, seized with terror and about to take flight; he has seen something. But what has frightened him like this? What has he seen? He has seen, right across in the left foreground, a woman stretched out on the ground, in the coils of a huge snake which is devouring her and dragging her down into the water, which has already covered her arms, her head and her hair. From the peaceful travellers in the background to this final scene of terror, what an enormous distance there is, and over this distance, what a series of different emotions, leading to you, the last object and the final point of the composition! What a beautiful overall conception! One single idea has given rise to this painting. Unless I'm totally mistaken, this landscape is the matching piece to the *Arcadia*; and under the latter one might inscribe *Fear* and under the former *Pity*.

Such are the scenes you should be able to imagine if you want to be a landscape painter. With the help of these fictions a rural scene can become as interesting as a historical event, and even more so. You see the delights of nature together with the sweetest and most terrible things that can happen in life. It's not enough to show here a man passing by, there a herdsman driving his beasts, elsewhere a traveller resting, in another place a fisherman with his line in his hand and his eyes fixed on the water. What does all that mean? What feelings can it arouse in me? What imagination or poetry is there in it? It does not take any wit to invent these features, and their only merit lies in being well or badly placed, and well or badly painted. Before you set out to practise any kind of painting, you must first have read, meditated and thought hard; you must

first have tried your hand at history painting, which leads to everything else. All the incidents in Poussin's landscape are linked by a common idea, even though they are isolated, distributed over different planes and separated by large intervals. The ones who are the most exposed to the danger are those who are furthest from it. They suspect nothing; they are perfectly at ease, happy, and talking about their journey. Alas! among them there is perhaps a husband impatiently awaited by his wife, who will never see him again; an only son whom his mother has not seen for a very long time and for whose return she sighs in vain; a father longing to return to the bosom of his family; and the terrible monster lying in wait in that perilous place, whose delights invited them to rest there, will perhaps bring all those hopes to nothing. One is tempted, looking at this scene, to cry out to that man getting up in alarm: 'Flee!'; to that woman doing her washing: 'Leave your washing and flee!'; to the travellers resting there: 'What are you doing there? Flee!' Do country-dwellers, in the midst of their proper pursuits, not have their troubles, their pleasures, their passions: love, jealousy, ambition? their afflictions: the hail which destroys their harvests and brings desolation to them; the taxes which take away their household goods to be sold; the corvée which commandeers their beasts and removes them; poverty, and the law which takes them off to prison? Do they not have our vices and our virtues? If to a sublime technique our Flemish artist had joined a sublime imagination, we should raise altars to him.

A Painting of Animals

On the right we see part of a rock with trees growing on it and a shepherd sitting at its foot. Smiling, he holds out a piece of his bread to a white cow coming towards him; beneath it the artist has placed a red cow, lying down. This cow is in the foreground, screening the hoofs of the white cow. All around these two cows are sheep, ewes, rams, billy-goats and nanny-goats. There is a vista of countryside in the background. Well over to the left of the picture, a donkey emerges from behind another rock feature towards

some thistles scattered round this mass which closes off the scene on the left-hand side.

A fine, a very fine painting, coloured with great vigour and discernment. The animals are true to life, generously painted and lit. As for the shepherd and the whole of the right-hand side of the picture, it perhaps looks too shaded because of the position in which it's hung. The sky is one of the worst and heaviest this artist has ever done. It's a great lump of lapis-lazuli which you'd need a stonemason's chisel to cut through. You can sit on it. It's quite solid. A falling body will never get through anything as thick as this. No bird exists which would not die of suffocation in it. It shows no sign of moving or going away. It presses with all its weight on those poor beasts. Vernet has made us fussy about skies. His are so light, so airy, so vaporous, so liquid. If Loutherbourg knew that secret, what an effect it would have on the rest of his composition. His objects would stand out, come out of the picture towards you, and it would be a scene from real life. So, young artist, study the skies. You want powerful effects, well and good, but try not to be ponderous. Here, for example, you've avoided one of these defects without falling into the other; and old Berghem⁹ would have been pleased with your animals.

HUBERT ROBERT

Salon of 1767

Robert is a young artist who is exhibiting for the first time. He has returned from Italy, bringing back an ease of execution and a talent for colour. He has exhibited a large number of pieces, amongst which some are excellent, some indifferent, and hardly one bad.

Ruin of a Triumphal Arch, and Other Monuments
The effect of these compositions, whether good or bad, is to leave you in a state of sweet melancholy. We fix our gaze upon the remains of a triumphal arch, a portico, a pyramid, a temple, a

palace, and we come back to ourselves. We anticipate the ravages of time and in our imagination we scatter across the earth the very buildings we inhabit. Immediately, solitude and silence prevail around us. We alone survive from a nation that is no more; and that is the first line of the poetics of ruins.

On the right is a tall narrow building, in the body of which a niche, occupied by a statue, has been made. On either side of the niche there remains one column without a capital. To the left, in the foreground, a soldier is lying face down on some stone slabs, with the soles of his feet towards the building on the right, his head pointing to the left, from where another soldier is moving towards him with a woman carrying a small child in her arms. Beyond, in the background, water is visible; beyond the water, and to the left, between some trees and a stretch of landscape, the summit of a ruined dome; further away, on the same side, an archway crumbling with age; near this archway, a column on its pedestal; around this column, shapeless masses of stone; beneath the archway, a stairway leading to the bank of a lake; beyond, a view into distant countryside; at the foot of the archway, a figure; in the foreground, on the edge of the water, another figure. I'm not going into detail about these figures, which are so roughly done that you can't tell whether they're men or women, still less what they're doing. But this is not the way to liven up ruins. Monsieur Robert, take more care with your figures. Do fewer of them, and do them better. Above all, study the true nature of this kind of figure, for they have one of their own. A figure in a ruin is not the same as a figure in another setting.

A Tall Gallery Lit from its Far End

O what beautiful, what sublime ruins! What firmness and at the same time what lightness, sureness and ease in the brush-strokes! What an effect! What grandeur! What nobility! Someone tell me who these ruins belong to so that I can steal them: it's the only way to get things when you're poor. Alas, they may give so little happiness to the stupid rich man who owns them, and they would

give so much to me! Idle owner! Blind husband! What harm do I
do to you when I take possession of delights which you ignore or
neglect! With what amazement, what astonishment I look upon this
shattered vault and the masses raised above this vault! And the
peoples who built this monument, where are they? What has
become of them? Into what vast, dark and silent depths will my eye
be drawn? How unbelievably distant is the area of sky which I see
at that opening! What an amazing gradation in the light! How it
fades as it comes down along the columns from this vault! How
those shadows are confined by the light from the entrance and the
far end! You never tire of looking at it. When you gaze at
something in admiration, time comes to a stop. How short a time I
have lived! How brief my youth has been!

It's a tall vaulted gallery, embellished inside with a colonnade
running along the left- and right-hand sides. About half-way down
into the gallery, the vault has collapsed to reveal the remains of an
edifice built on top of it. This huge long structure is also lit from
the opening at its far end. To the left, outside the building, is a
fountain; above this fountain, a seated antique statue; above the
pedestal of this statue, a basin mounted on solid rock; around this
basin, in the space in front of the gallery, in between the columns, a
crowd of small figures, small groups, a variety of little scenes.
They're drawing water, resting, walking about or talking. That's a
lot of noise and movement. I'll tell you what I think about that
later, Monsieur Robert, in just a minute. You're a clever man.
You'll excel, you do excel in your genre. But study Vernet. Learn
from him how to draw, to paint, to make your figures interesting.
And since you've committed yourself to painting ruins, you should
know that this genre has its own poetics. Which you know abso-
lutely nothing about. Try to discover it. You have the skill, but you
lack the ideas. Can't you see that there are too many figures here
and that three-quarters of them should be removed? The ones you
need to keep are those who add to the effect of solitude and silence.
Just one man wandering amid this darkness, arms folded across his
breast, head bowed, would have affected me more. The darkness

alone, the majesty of the building, the grandeur of the structure, the extent and quietness of the scene, the subdued echoes from all this space would have made me tremble. I could not have prevented myself from going and dreaming beneath this vault, sitting amongst its columns, walking into your picture. But there are too many people in the way, so I stop, look, admire and pass on. Monsieur Robert, you don't know yet why ruins give so much pleasure, quite apart from the variety of features they offer to the eye, and I'll tell you now the ideas that come to me.

There is grandeur in the thoughts that ruins awaken in me. All things vanish, die and pass away. Only the world remains. Only time persists. How ancient this world is! I walk between two eternities. Wherever I cast my eyes, the objects around me herald the end of things and resign me to the end that awaits me. What is my fleeting existence compared with this rock as it sinks down, this valley hollowing out its path, this forest about to fall, these unsteady masses hanging above my head. I see the marble of tombs crumbling to dust; and I don't want to die! I want to preserve a feeble tissue of flesh and nerves in the face of a universal law which works its will on bronze! Nations are swept along one after another in a torrent which carries them down into a common grave, and I, I alone aspire to stop at the edge and cleave through the waves which flow beside me!

If the site of a ruin is dangerous, I tremble. If I can be sure of secrecy and safety, I'm freer, more alone, more myself, closer to myself. There I call my friend to me. There I long for the woman I love. There we shall enjoy our own company, freely, without anyone to observe us, intrude upon us or envy us. There I can delve into my heart. There I can probe her heart, and be troubled or reassured. Between this place and the inhabitants of cities, the dwellings of tumult, the abode of self-interest, passion, vice, crime, prejudice and error, there is a great gulf.

If my soul is prey to tender feelings, I shall abandon myself freely to them. If my heart is calm, I shall savour all the sweetness of its peace.

In this remote, solitary, spacious refuge, I hear nothing; I have cut myself off from all life's worries. No one troubles me or listens to me. I can talk to myself out loud, give way to grief and shed tears without restraint.

Beneath its dark archways, modesty would have less hold over an honest woman and a tender, timid lover would be more forceful and courageous in his resolve. Without realizing it, we love everything that favours our inclinations, flatters our desires and excuses our weaknesses.

'I will leave this deep cavern and leave behind the troubling memory of that moment,' says a woman, and then adds: 'If I have been deceived and sad memories lead me back there, I shall abandon myself to all my grief. The solitude will echo with my laments. I shall rend the silence and the darkness with my cries, and when my heart is sated with bitterness I shall dry my tears with my hands, return to the company of men and they will never suspect that I wept.'

If ever I were to lose you, idol of my heart; if sudden death or an unexpected misfortune separated you from me, this is where I should want your ashes to be laid and where I should come to commune with your shade.

If absence keeps us apart, I shall come here to seek the same ecstasy which so completely and delightfully held sway over our senses; my heart will once again beat faster and I shall rediscover that voluptuous abandon. You will be there, until the moment when the sweet languor, the sweet lassitude of pleasure is past. Then I shall rise again and come back, but I shall not come back without stopping, turning my head and gazing at the place where I was happy with you and without you. Without you! No, I am wrong, you were still there; and when I return, people will see the joy I feel, but they will not guess its cause. What are you doing now? Where are you? Is there no cavern, no forest, no remote, secret place where you can turn your steps and likewise rid yourself of sadness?

O voice of censure, dwelling in the depths of my heart, you have followed me even here! I sought to escape from your reproaches, and

in this very place I hear you more clearly. Let us flee from here. Is it the abode of innocence, or that of remorse? It is one and the other, depending on one's state of mind. The wicked man shuns solitude; the just man seeks it out. He is so much at ease with himself!

The creations of artists are seen very differently by the man who knows passion and the man who does not. They say nothing to the latter. What do they not say to me? The one will not enter that cavern which I was seeking; he will keep away from this forest where I love to lose myself. What would he do there? He would be bored.

If I have anything more to say about the poetry of ruins, Robert will remind me.

The work in question here is the finest of those he has exhibited. The air is tangible, the light is heavy with the vapour of chilly places and the motes which the darkness allows us to see. And then the brushwork is so soft, so gentle, so assured! It's a wonderful effect effortlessly produced. You don't think about the art in it. You admire it, with the same admiration you have for nature.

An Exceedingly Small Ruin

To the right, the sloping roof of a shed built against a wall. Beneath this straw-covered shed, barrels, some apparently full and lying on their sides, others empty and standing upright. Above the roof, what remains of the wall breaking up and covered with parasitic plants. On the extreme left, at the top of this wall, a piece of balustrade with crumbling pilasters. On this section of balustrade, a pot of flowers. Adjoining this structure, an opening or kind of doorway, the latticed door of which, made of lengths of wood, is half open and coming forward to form a right angle with the side of the structure on which it hangs. Beyond this door, another structure, made of stone, in ruins. Behind it, a third structure. In the background, a stairway leading to a vast stretch of water which can be seen through the opening between the two buildings. To the left, a fourth stone structure facing the one on the right and at right angles to those in the background. On the front of this last building,

the poorly-made figure of a saint in its niche. Below the niche, the spout of a fountain which empties into a trough. On the wooden steps going down to the river, a woman with her pitcher. By the trough, a woman doing her washing. The upper part of the building on the left is also breaking up and covered with parasitic plants. The artist has also adorned it at the top with another pot of flowers. Above this pot he has made an opening for a window and stuck into the wall on either side of this window some poles on which he has put some sheets out to dry. Right over on the left, the door of a house; inside the house, leaning with her arms on the lower part of the door, a woman looking out at what's going on in the street.

A very good little picture; but an example of the difficulty of describing, and understanding a description. The more one goes into detail, the more the picture one presents to the minds of others differs from what is on the canvas. In the first place, the space our imagination allots to an object is proportionate to the number of elements in it. There's an infallible way of making the person listening to you take a greenfly for an elephant; all you have to do is describe in extreme detail the anatomy of this living atom. A regular and very natural habit, especially amongst intelligent people, is to try to clarify their ideas; the result is that they exaggerate, and the dot in their minds is slightly bigger than the dot described, for otherwise they would no more be able to see it inside themselves than they do outside. Detail in a description produces roughly the same effect as trituration. A body fills ten or a hundred times less space or volume in a mass than in molecules.[1] Monsieur de Réaumur[2] didn't suspect this, but get someone to read you a few pages of his *Treatise on Insects* and you'll discover the same absurd effect as in my descriptions. In the preceding one, there's no one who wouldn't allow several square feet for a ruin no bigger than your hand. I think I've already drawn from this an experiment which would determine the relative size of images in the heads of two artists at different times. It would consist in making them do a clear, distinct drawing, as small as they could, of an object which allows of detailed description. I think that the eye and the imagination

have about the same field of vision, or perhaps, on the other hand, the field of the imagination is in inverse proportion to that of the eye. However that may be, it is impossible that people with long or short sight, who see so differently in reality, should see the same thing in their heads. Poets, prophets and long-sighted people tend to see flies like elephants; philosophers and short-sighted people tend to reduce elephants to the size of flies. Poetry and philosophy are the two ends of the telescope.

THE LATE CARLE VAN LOO

Salon of 1765

Augustus Ordering the Doors of the Temple of Janus to be Closed

A picture nine feet high by eight feet four inches wide. It is intended for the Choisy gallery.[1]

On the right of the observer, the temple of Janus placed in such a way that the doors can be seen. Beyond the doors, against the front of the temple, the statue of Janus on a pedestal. This side of the doors, a tripod with its lid on the ground. A priest dressed in white, holding a great iron ring with both hands, closes the doors, which are covered with iron plates at the top, the bottom, and in the middle. Beside this priest, in the background, two more priests, dressed like the first. Opposite the priest closing the doors, a child carrying an urn and watching the ceremony. In the middle of the scene, in the foreground, Augustus, standing by himself in military uniform, silent, an olive branch in his hand. At the feet of Augustus, at the same level, a child with one knee on the ground and on the other a basket from which he is throwing flowers. Behind the emperor, a young priest whose head is almost all that is visible. On the left, some distance away, a mixed band of people and soldiers. On the same side, right at the edge of the canvas and in the foreground, a senator seen from behind, holding a scroll. That is what Van Loo is pleased to call a public celebration.

It seems to me that, since the temple is not just an accessory, a background decoration, more of it should have been shown, instead of the poor, mean structure we do see. Those iron plates covering the doors are broad and effective. As for Janus, he looks like two ugly Egyptian faces joined together. Why stick the saint of the day against a wall like that? That priest closing the doors is closing them brilliantly; his movement, drapery and character are all beautiful. I can say the same for his neighbours; the heads are very fine, painted in a grand, simple, truthful manner, the brush-strokes are strong and vigorous. If there is another artist capable of doing as much, I should like to know who it is. The little boy carrying the urn is clumsy and perhaps altogether superfluous. The other one scattering flowers is charming, well conceived and supremely well composed; he is scattering his flowers gracefully, too gracefully perhaps, almost like Aurora shaking them from her fingertips. But your Augustus, Monsieur Van Loo, is pitiful. Wasn't there a pupil in your studio with the courage to tell you he was stiff, common-looking and short, that he was made up like an actress, and that the red drapery you've adorned him with offended the eye and clashed with the rest of the picture? That? an emperor? With that long palm frond he's hugging against his left shoulder he looks like someone from the brotherhood of Jerusalem coming back after a procession. And that priest I can see behind him, what is he trying to do with that box and those silly, awkward movements? That senator entangled with his gown and his piece of paper, with his back to me, is a space-filler whose top half looks thin and scrawny because his gown is so wide at the bottom. And what does the whole thing signify? Where is the interest? Where is the subject?

To close the temple of Janus means to announce peace throughout the Empire, a period of rejoicing, a festival, and wherever I look on the canvas I don't see the slightest trace of joy. This picture is cold, it's insipid; all is gloom and silence, and mortal sadness: it's a Vestal's funeral.

If I had had this subject to do, I should have shown more of the temple. My Janus would have been tall and handsome. I should

have placed a tripod at the door of the temple; young children with their heads decked with flowers would have been burning perfumes there. There one would have seen a high priest, venerable in countenance, garments and character; behind this priest I should have assembled a few others. Priests have always been jealous observers of sovereigns: these would have been trying to discover what they had to fear or to hope for from their new master, and I should have made them observe him closely. Augustus, accompanied by Agrippa and Maecenas, would be giving the order for the temple to be closed, and that would be the gesture he was making. The priests, with their hands on the iron ring, would be ready to obey. I should have gathered a tumultuous crowd of people which the soldiers would have great difficulty in holding back. More than anything, I should want my scene to be well lit; nothing contributes to gaiety like the daylight on a fine day. The procession for St Sulpicius would not have come out if the weather were as dark and misty as that.

Yet if this composition had caught fire when the artist was not there and had only spared the group of priests and a few heads here and there, we should all have exclaimed at the sight of those precious remains! What a pity!

The Graces[2]

A picture seven feet six inches high by six feet two inches wide.

Because these figures are holding each other, the painter believed they formed a group. The eldest of the three sisters occupies the central position, her right arm is placed round the back of the one on the left and her left arm is wound round the right arm of the one on the right. She is facing us. The scene, if such it is, is in a landscape. You can see a cloud coming down from the sky, going behind the figures and spreading out over the ground. The Grace on the left, with three-quarters of her face and back visible, has her left arm on the shoulder of the one in the middle and holds a flask in her right hand; she is the youngest. The second, with two thirds

of her back visible and her head in profile, has a rose in her left hand. The oldest one has been given a myrtle branch which she holds in her right hand. The site is strewn with a few flowers.

It is hard to imagine a more lifeless composition, and Graces more insipid, more ponderous, and less pleasing. They possess neither life, nor movement, nor character. What are they doing there? I'll be blessed if they know anything about it. They're simply exhibiting themselves. This was not the way the poet saw them.[3] It was springtime, and a lovely moonlit night; the mountains were covered in fresh greenness, the streams were murmuring and you could hear and see their silvery waters bubbling up; the brilliant light of the moon shimmered on their surface. The scene was lonely and quiet, and on the soft grass of the meadow, with a forest nearby, they were singing and dancing. I can see them, and hear them too. How sweet their singing! How lovely they are! How firm their flesh! The gentle light of the moon gives an even softer quality to the whiteness of their skin. How smooth and airy their movements! And there is old Pan playing the flute. The two young fauns at his side have pricked up their pointed ears; their burning eyes wander over the most secret delights of the young dancers; what they see does not prevent them regretting what is concealed by the different movements of the dance. The wood nymphs have drawn near, the water nymphs have pushed their heads through the reeds; soon they will be joining in the games of the charming sisters.

Junctaeque nymphis Gratiae decentes
Alterno terram quatiunt pede . . .[4]

But let us return to the Graces of Van Loo, which don't bear comparison with the ones I'm leaving. The one in the middle is stiff, as though she had been posed by Marcel.[5] Her head is too big and she has a job to hold it up. And those little strips of drapery which have been stuck to the buttocks of one of them and the upper thighs of the other, what's keeping them there? Nothing more than the artist's bad taste and the people's low morals. They don't realize that it's the sight of a half-dressed woman, not a naked

one, which is indecent. An indecent woman would have a cornet[6] on her head, stockings on her legs and slippers on her feet. That reminds me of the way Madame Hocquet[7] turned the usually modest Venus into the most unseemly creature possible. One day she took it into her head that the goddess could not conceal herself very well with her lower hand, so what did she do? She put a plaster cloth between this hand and the corresponding part of the statue, which promptly made it look like a woman drying herself. Do you imagine, my friend, that Apelles[8] would have taken it into his head to put a piece of drapery the size of a hand on the bodies of the three Graces? Alas, since the time when they emerged naked from the head of the ancient poet and came to Apelles, if any painter has seen them, I swear it was not Van Loo.

Van Loo's Graces are tall and thin, especially in their upper parts. That cloud coming down on the right and spreading out at their feet doesn't make any sense. For soft, gentle persons such as these, the brush-strokes are too firm and vigorous; and then all around them there's a fanciful green colour which darkens and obscures them. There is nothing here to strike or involve us; it was drawn and painted straight on to the canvas. It's a vastly inferior composition to the one he exhibited in the previous Salon and then destroyed. Of course the Graces, being sisters, must have a family resemblance, but do they have to have the same head?

For all that, the worst of these three figures is better than the preciousness, affectation and red bottoms of Boucher. At least this is flesh, fine flesh even, with an austere character which is less offensive than licentiousness and low morals. If there is a manner here, it's the grand manner.

The Chastity of Susanna[9]
A picture seven feet six inches high by six feet two inches wide.

We see Susanna seated, in the centre of the canvas; she has just emerged from her bath. Placed between the two old men, she is leaning towards the one on the left and reveals to the gaze of the

one on the right her beautiful arm, her beautiful shoulders, her hips, one of her thighs, the whole of her head, three-quarters of her charms. Her head is thrown back; her eyes, turned towards heaven, appeal for help; her left arm holds the draperies covering the top of her thighs; her right hand is pushing away the left arm of the old man on that side of her. What a beautiful figure! The attitude is a fine one; the distress and suffering are powerfully expressed; it is drawn in the grand manner; there is real flesh, the finest colouring, and the truth of nature is everywhere visible on the neck, the breast and the knees; the legs, thighs, these flowing limbs could not be better positioned; its grace does not detract from its nobility, and there is variety without any extravagance of contrast. That part of the figure in half-tone is most beautifully executed. The white drapery spread across the thighs is admirably reflected on the flesh, it's a mass of brightness which leaves the effect intact: a difficult illusion to achieve, which bears witness both to the skill of the master and to the vigour of his colouring.

The old man on the left is seen in profile. His left leg is bent, and his right knee seems to be pressing the underside of Susanna's thigh. His left hand is tugging at the drapery covering her thighs, while his right hand invites Susanna to yield. This old man might almost be Henri IV. The type of face is well chosen, but there should have been more movement, more action, more desire, more expression. The figure is heavy and lifeless; all one sees is a large, stiff, uniform garment, with no folds and with no suggestion of a body underneath: it's a sack with a head and two arms sticking out. Drapery should certainly be amply provided, but not in this way.

The other old man is standing and almost full face. With his left hand he has pulled away all the coverings which concealed Susanna on his side; he is still holding them. His right hand and his arm are stretched out in front of the woman in a threatening gesture; the expression on his face is similar. This man is even more lifeless than the other one: cover up the rest of the canvas and this figure will represent nothing more than a Pharisee asking Jesus Christ a difficult question.

If there had been more warmth, more violence, more passion in the old men, it would have given far more interest to this lovely, innocent woman, delivered up to the mercy of two old rogues; she herself would have been more terrified, more expressive, because one thing leads to another. Passions on the canvas go together or clash just as colours do. There is in any work taken as a whole a unity of emotion as well as of colour. If the old men had been more insistent, the painter would have felt that the woman should be more frightened, and very soon her eyes would have sent a very different plea to heaven.

On the right is a building in greyish stone; it appears to be a water-tank, a bath-house; on the front of it is a channel with a miserable little stream of water spurting out of it which is in very bad taste and also breaks the silence. If the old men had been completely carried away with passion and Susanna had been equally terrified, perhaps the sound of a mass of water gushing out violently would have provided a very convincing accompaniment.

For all these faults, this composition by Van Loo remains a fine piece of work. De Troy has painted the same subject.[10] There is hardly a painter of antiquity whose imagination has not been struck by it, and whose brush has not been put to work on it, and I would wager that Van Loo's painting could hold its own with everything that has been done. They say that Susanna is academized; might it be that her action is a little studied, that her movements are a little too rhythmic for a violent situation? Or is it rather that a model happens sometimes to be so well posed that this standard position, even though recognized as such, can be successfully transferred to the canvas? If the old men could be more violent in their movements, then perhaps Susanna's could be more natural and true to life. But I am happy with it as it is, and if I had the misfortune to dwell in a palace, this piece might well come out of the artist's studio and into my gallery.

An Italian painter has made a very ingenious composition out of this subject. He has put both the elders on the same side. Susanna has moved all her clothing to this same side, so that to hide herself

from the gaze of the old men she is completely exposed to the eyes of the viewer. This is a very bold composition and no one is offended by it; the intention is clear and this is its justification, and the viewer does not get disturbed by the subject-matter.[11]

Since seeing this *Susanna* by Van Loo I can no longer bear to look at the one belonging to our friend Baron d'Holbach; yet it is by Bourdon.[12]

LOUIS-MICHEL VAN LOO

Salon of 1767

Monsieur Diderot[1]

I like Michel myself, but I like the truth even more. It's quite like me, and he can say to anyone who doesn't recognize it, like the gardener in the comic opera: 'That's because he's never seen me without my wig.' It's very much alive; that's his gentleness, and his liveliness; but too young, the head too small, pretty like a woman, ogling, smiling, simpering, mincing, pouting; nothing of the sober colouring of the *Cardinal de Choiseul;*[2] and the clothes are enough to ruin the poor man of letters if the poll tax collector were to put a tax on dressing-gowns. The writing-desk, the books, the accessories are as good as they could be when you've seen the brilliant colours and you want it all to be in keeping. A sparkling look from close up, vigorous from further away, especially the flesh tints. The hands are well shaped, but the left hand is not properly drawn. You see him full face: his head is bare; the tuft of grey hair and the simpering expression make him look like an ageing coquette who's still trying to be lovable; the pose is that of a secretary of state and not a philosopher. The portrait got off to a bad start and that influenced all the rest. It was that crazy Madame Van Loo coming in and chatting with him that made him look like that and spoilt everything. If she had sat down at her harpsichord and played a prelude or sung

Non ha ragione, ingrato
Un core abbandonato

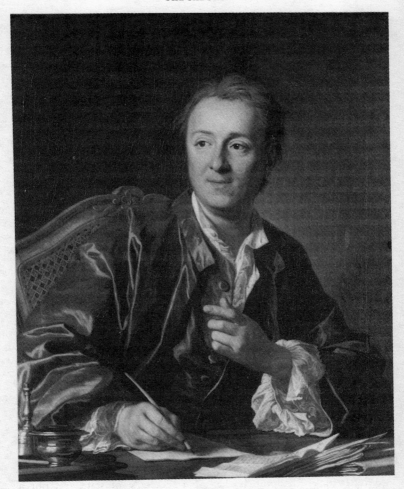

MICHEL VAN LOO Monsieur Diderot *Louvre*

or something else in the same vein, the impressionable philosopher would have assumed a totally different character, and the portrait would have benefited. Or better still, he should have been left alone to his musings. Then his mouth would have been half-open, his absent gaze would have looked into the distance, the workings of

his busy mind would have been visible on his face; and Michel would have done a fine painting.

My pretty philosopher, you will forever be a precious souvenir of the friendship of an artist, an excellent artist and an even more excellent man. But what will my grandchildren say when they come to compare my gloomy works with this grinning, dainty, effeminate old flirt? Children, I give you notice that this isn't me. In one day I would have a hundred different faces, depending on what affected me. I was serene, dreamy, tender, passionate, enthusiastic; but I was never like the man you see here. I had a broad forehead, very lively eyes, quite large features, a head exactly in the mould of an ancient orator, a good nature which was very close to the stupidity and rustic simplicity of olden times. If it weren't for the exaggeration of all the features in the engraving which was done after Greuze's pencil sketch, I would come over far better. I have a mask which deceives the artist: either because there are too many things mixed together in it, or because my mental reactions follow each other very quickly and all show on my face, the painter's eye never sees me the same from one moment to the next and his task becomes much more difficult than he thought it was. The only person who ever did a good portrait of me was a poor devil called Garand who caught my likeness in the way a fool sometimes makes a witty remark. Anyone who sees my portrait by Garand sees me. *Ecco il vero Polichinello.*[3] Monsieur Grimm had an engraving done of it, but he doesn't show it to anybody. He's still waiting for an inscription, which he won't get until I've produced something to make me immortal. – And when will that be? – When? Tomorrow, perhaps. Who knows what I'm capable of? I don't feel I've used up the half of my powers yet. Until now I've just been trifling the time away. I was forgetting, amongst the good portraits of me, the bust by Mademoiselle Collot, especially the last one, which belongs to my friend Grimm. It's good, very good; it's taken the place in his house of another, done by her teacher Falconet, which was not good. When Falconet saw the bust by his pupil, he took a hammer and smashed his own in front of her. That was a brave and honest

thing to do. As it fell to pieces beneath the artist's blows, this bust revealed two fine ears which had been preserved whole under an awful wig in which Madame Geoffrin had dolled me up afterwards. Monsieur Grimm could never bring himself to forgive Madame Geoffrin for that wig. Now, thank God, they are reconciled; and Falconet, this artist who had so little care for his future reputation, this man who so resolutely disdained immortality, who was so *disrespectful* of posterity, was relieved of the necessity of delivering a bad bust to him. I will say of this bust, though, that you could see the signs of a secret anxiety which was troubling me when the artist did it. How is it that an artist can miss the obvious features of a face that's in front of him, and can transfer to the canvas or the clay the secret feelings, the impressions hidden in the depths of a heart he does not know? La Tour had done a portrait of a friend. They told this friend that he'd been given a brown complexion which he didn't have. The work was taken back to the studio and a day fixed for retouching it. The friend arrived at the time arranged. The artist took up his pencils. He started work and ruined everything. 'I've ruined everything,' he cried, 'you look like a man who's fighting off sleep'; and that was in fact what his model was doing, having spent the night with a sick relative.

VERNET

Salon of 1763

Why can I not, for a brief moment, bring back the painters of Greece and those of Rome, both ancient and modern, and hear what they would have to say of Vernet's works! It is almost impossible to talk about them; they must be seen.

What an enormous variety of scenes and figures! What water! What skies! What truth! What magic! What an effect!

If he lights a fire, it will be just where its brilliance seems as if it should extinguish the rest of the composition. The smoke rises

thickly, thins out gradually and disappears in the atmosphere immense distances away.

If he mirrors objects on the glassy surface of the sea, he can extend their colour down to the greatest depths without it losing its natural colour or its transparency.

If he casts light on it, he can make it penetrate through and through; you see it quivering and trembling on its surface.

If he puts men into action, you see their actions.

If he scatters clouds in the air, how lightly they are suspended in it! How they move at the bidding of the winds! What space lies between them and the firmament!

If he raises a mist, the light weakens, and in its turn the vaporous mass is imbued and coloured with it. The light darkens and the vapour grows luminous.

If he raises a tempest, you hear the winds whistling and the waves roaring; you see them beating against the rocks and whitening them with their foam. The sailors are shouting; the sides of the vessels burst open; some leap into the water, others, dying, are stretched out on the shore. Here, onlookers are raising their hands to heaven; there, a mother hugs her child to her breast; others risk death to save their friends or family; a husband clasps his half-unconscious wife in his arms; a mother weeps for her drowned child while the wind makes her clothes cling to her body and reveals its shape to you; some of the cargo floats on the water and passengers are dragged down into the depths.

Vernet is the man who can gather storms, release the cataracts of the skies and flood the earth; and he it is who can, when he pleases, scatter the tempest and restore the sea to calm and the heavens to serenity. Then all nature, emerging as it were from chaos, lights up enchantingly and takes on all her magic again.

How serene his days are! How tranquil his nights! How translucent his waters! He it is who creates the silence, the freshness and the shade in the forests. He it is who is not afraid to set the sun or the moon in his firmament. He has stolen nature's secret from her: all that she makes he can make again.

For how could his compositions not fill us with amazement? He embraces infinite space; the whole extent of the sky with the most elavated landscape, the surface of the sea, a multitude of men working for the happiness of society, immense buildings stretching out as far as the eye can see.

A Moonlit Night[1]

The painting they call his *Moonlight* is an effort of pure artistry. It's everywhere night and everywhere day; here the night star gives light and colour; there it is firelight; elsewhere it is the mingled effect of the two. He has painted the visible, palpable darkness of Milton. And I say nothing of the way he has made this ray of light quiver and play over the trembling surface of the water; that is an effect that struck everyone.

View of the Port of Rochefort Seen from the Colonial Warehouse[2]

His *Port of Rochefort* is very fine; it attracts the attention of artists because of the ungrateful nature of the subject.

View of the Port of La Rochelle Seen from the Petite Rive[3]

The *Port of La Rochelle* is infinitely more exciting. That's what you call a sky; that is what transparent waters are, and all those groups are so many authentic scenes, typical of the locality; the figures are drawn with the greatest accuracy. How bold and light the brush-strokes are! Who understands aerial perspective better than this man?[4]

Look at the *Port of La Rochelle* through a glass which takes in the main area of the picture and cuts out the border, and, at once forgetting that you're examining part of a painting, you'll exclaim, as if you were standing on top of a mountain, like an observer of nature itself: 'Oh! what a beautiful view!'

And then the fertility of this artist's genius and his speed of execution are unimaginable. You would not have been surprised to hear that he'd spent two years painting just one of these pieces, and there are twenty with the same power. It's the whole universe exhibited in all kinds of aspects, at every time of day, in every light.

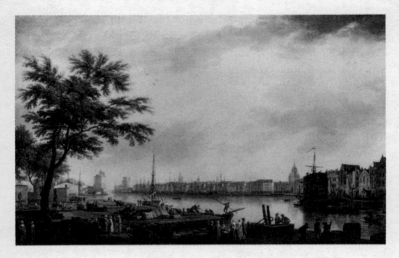

VERNET View of the Port of La Rochelle, seen from the Petite Rive (Vue du Port de La Rochelle, prise de la Petite Rive) *Musée de la Marine, Paris*

I don't look all the time, sometimes I listen. I heard someone who was looking at one of these pictures saying to his neighbour: 'I think there's even more interest in Claude Lorrain . . .' and the other replying: 'Agreed, but there's less truth in him.'

I don't think this was the right answer. There's an equal amount of truth in each of the artists, but Claude chose more unusual moments and more extraordinary phenomena.

Ah, you say, so you prefer Claude to Vernet? because you don't take up a pen or a brush to write or paint commonplaces.

That I admit, but remember that Vernet's great compositions are not freely invented, they're done to order; he has to render a particular site just as it is, and remember that even in these pieces Vernet undoubtedly has a different approach, a different talent from Claude in the incredible number of activities, objects and particular scenes he offers. One is a landscape artist, the other a history painter of the first rank in every aspect of painting.

The Shepherdess of the Alps[5]

A subject taken from Monsieur Marmontel's *Moral Tales*

Madame Geoffrin, a woman well known in Paris,[6] has had this one done. I can find nothing marvellous in either the tale or the painting. The painter's two figures are neither arresting nor interesting. A lot of fuss is made about the landscape: they say it possesses all the horror of the Alps seen from a distance. That may be, but the whole thing is absurd, because for the figures, and for me sitting next to them, they're only a short distance away; we're close up to the mountain which is behind us, and this mountain is painted as a nearby mountain should be; we're only separated from the Alps by a narrow gorge. Why then are these Alps shapeless, without distinct features, greenish and hazy? To make up for the ungrateful nature of his subject, the artist has put all his effort into a large tree which fills the whole of the left-hand side of his composition; that's not at all what's required! The point is, you should never give orders to an artist, and if you want a beautiful picture by him, you should say: 'Paint me a picture and choose whatever subject suits you . . .' And even then it would be safer and quicker to get one that's already done.

But one poor painting in the middle of so many masterpieces cannot harm an artist's reputation, and France can take as much pride in her Vernet as Greece in her Apelles and Zeuxis and Italy in her Raphaels, Correggios and Carracci. He really is an amazing painter.

Salon of 1765

A view of the port of Dieppe. The four times of day. Two views of the environs of Nogent-sur-Seine. A shipwreck; a landscape; another shipwreck. A seascape at sunset. Seven small landscapes; two more seascapes; a storm, and several other pictures with the same number. Twenty-five pictures, my friend, twenty-five pictures! And what

pictures! For speed he compares with the Creator, and for truth with nature. There's hardly a single one of these compositions on which another painter, without wasting his time, wouldn't have spent the two years which Vernet spent doing them all. What unbelievable effects of light! Those lovely skies! And the water! What excellent composition! What extraordinary variety in the scenes! Here, a child saved from the wreck is being carried on his father's shoulders; there, a woman lying dead on the shore, and her husband grieving for her. The sea roars, the winds whistle, the thunder rumbles, the wan, mournful glow of lightning pierces the clouds, illuminating or obscuring the scene. You can hear the noise as the sides of a vessel burst open, its masts leaning over, its sails rent apart. There are some on the decks with their arms raised upwards, others have hurled themselves into the water and are dashed by the waves against nearby rocks where their blood mingles with the white foam. I can see some on the surface of the water, some about to disappear beneath the waves, some struggling to reach the shore where their bodies will be smashed. The same diversity of character, action and expression prevails amongst the spectators; some are shuddering and turning away, others are giving help, others look on motionless; there are some who have lit a fire under a rock; they are trying to revive a dying woman and I hope they succeed.

Turn now to another sea and you will see calm water with all its enchantment; the quiet, even, smiling waters stretch out, gradually losing their transparency and gaining brightness on their surface as they stretch away from the shore to where the horizon meets the sky; the vessels lie motionless, the sailors and passengers are amusing themselves in whatever way they can to calm their impatience. If it is morning, what delicate vapours rise up! How these vapours, scattered over the natural objects, have freshened them and brought them to life! If it is evening, what a golden light there is on the mountain tops! What gradations of light tint the skies! How the clouds progress, shift and set down on the water the varied effects of their colours! Go into the country, look up to the vault of the skies, take careful note of the phenomena you see at that moment

and you'll swear that a piece of that great shining canvas, lit by the sun, has been cut out and transferred to the artist's easel. Or clench your fist and make a tunnel which only allows you to see a small area of the great canvas, and you'll swear that it's a Vernet painting which has been taken off its easel and carried up to the sky.

Although he is the most prolific of all our painters, none gives me less work to do. It is impossible to convey what his paintings are like, you have to see them. His nights are as moving as his mornings are beautiful; his ports are as beautiful as his imaginary pieces are exciting. And the miracle is the same, whether his captive brush submits to a scene which is given, or whether his unshackled muse is free and left to its own devices. He is beyond comprehension, whether he employs the light of the sun or the moon, natural or artificial light, to illuminate his paintings; always full of harmony, strength and wisdom, like those great poets, those rare men in whom judgement is in such perfect balance with inspiration that they are never intemperate and never cold. His structures, his fine buildings, clothes, actions, men, animals, all are true to life. Close up, his paintings are striking, from a distance they are even more striking.

Chardin and Vernet, my friend, are two great magicians. You could say of Vernet that he starts by creating the setting and that he has a stock of men, women and children with which he peoples his canvas as one peoples a colony; then he gives them whatever weather, sky, season, happiness or unhappiness he fancies. He's like Lucian's Zeus, who, weary of hearing the plaintive cries of mankind, rises from his table and says: Hail in Thrace . . . and in no time the trees are stripped bare, the harvests flattened and the thatch torn off the roofs and scattered; plague in Asia . . . and doors are slammed shut, streets deserted, men fleeing; here, a volcano . . . and the earth shakes underfoot, buildings topple over, animals take fright and townspeople flee to the countryside; a war there . . . and nations take up arms and slaughter one another; in that place a famine . . . and the old ploughman dies of hunger on his doorstep. Jupiter calls

that ruling the world, and he's wrong; Vernet calls it painting pictures, and he's right.[7]

View of Dieppe Harbour[8]

A great composition of huge proportions. A light, silvery sky. A fine group of buildings. A picturesque, appealing view: a multitude of figures busy fishing, making preparations, selling fish, working, repairing their nets and doing similar things; natural, lifelike activities; figures done with bold, striking brush-strokes; but, since nothing must be left unsaid, neither as bold nor as striking as usual.

The Four Times of Day[9]

A most beautiful combination of light effects. If I look over all these pieces and only stop at the special skill, the particular quality which marks them out, what is the result? In the end you realize that this artist has all the skills and all the qualities.

Two Views of the Environs of Nogent-sur-Seine[10]

Here is an excellent lesson for Le Prince, whose compositions are shown with those of Vernet. He won't lose what he's got and he'll realize what he's missing: Le Prince's figures are lively, delicate and natural, but at the same time they're weak, bloodless and lacking in effect. The other's colouring is consistent, his touch always confident and harmonious, and he overshadows his neighbour. Vernet's distant views are vaporous, his skies are insubstantial; one can't say the same for Le Prince. Yet he's not without merit, and if his paintings are moved away from Vernet's they acquire strength and beauty, because the other outshines and stifles him. This cruel juxtaposition is another piece of mischief on the part of Chardin, who is responsible for hanging the pictures.

Two companion pieces, a Shipwreck and a Landscape[11]

The landscape is charming, but the shipwreck is something else altogether; it's the figures one needs to concentrate on. There's a fearsome wind and the men can hardly stand up. Look at that

drowned woman who has just been pulled out of the water, and brace yourself if you can against the grief of the husband.

Another Moonlit Shipwreck

Look carefully at those men warming the unconscious woman at the fire they have lit beneath a rock; surely you've seen one of the most interesting groups it's possible to imagine. And look how this moving scene is illuminated! How the vault is lit up by the reddish glow of the fire! And the contrast between the pale, wan light of the moon and the strong, red, sad and gloomy light of the burning fire! No painter has the right to put such discordant phenomena side by side and achieve a harmonious effect. How is it possible not to get a jarring effect where the two different kinds of light meet, mingle and create this particular splendour?

A Seascape at Sunset

If you have seen the sea at five o'clock on an autumn evening you know this painting.

Seven small Landscapes

If I knew one of these to be below standard I would tell you. The weakest one is beautiful, and I mean beautiful for any other artist, because there are one or two which are unworthy of this artist, and Chardin has hidden them. As for the others, think as well of them as you like.

Young Loutherbourg has also exhibited a nocturnal scene which you could have compared with Vernet's if the *tapissier* had so wished, but he has placed one of these compositions at one end of the Salon and its counterpart at the other end: he was afraid that one might destroy the effect of the other. There is, I think, more vigour on one side and more harmony and smoothness on the other. As for the interest, shepherds mingling with their animals and keeping warm under a rock cannot be compared with a dying woman being brought back to life. And I don't think that the landscape which occupies the rest of Loutherbourg's canvas can

stand comparison with the seascape which occupies the rest of Vernet's. Vernet's light is infinitely more authentic and his colours more accurate. To sum up: Loutherbourg would be proud of Vernet's painting; Vernet would not be ashamed of Loutherbourg's.

One of the Four Seasons pieces, the one where you see in the background on the right-hand side a water mill, running water round the mill, women doing their washing at the waterside, struck me especially for its colour, its freshness, the variety of objects, the beauty of the setting and the natural life in it.[12]

The remaining landscapes lead one to say: *Aliquando bonus dormitat Homerus.*[13]

My friend, there will be some repetitions in this Vernet article of what I wrote about him two years ago, but since the artist is revealing the same genius and the same talent to me, I must necessarily resort to the same praise. I stick to my opinion: Vernet is the equal of Claude Lorrain in the art of raising vapours on the canvas, and he's infinitely superior to him in inventing scenes, drawing figures, varying his incidents and all that. The first is purely and simply a good landscape artist, the other is a history painter. In my view, Claude chooses natural phenomena which are rarer and therefore perhaps more exciting; Vernet's atmospheres are more everyday, and therefore closer to one's experience.

Salon of 1767

I wrote this artist's name at the top of my page and I was about to talk to you about his works when I went away to a country area near the sea which is famous for its beauty spots. There, some would be wasting the best hours of the day, the best days, their money and their good spirits round a green baize cloth, while others, guns on their shoulders, tired themselves out following their dogs across the countryside. Some disappeared into the furthest reaches of a park, where, fortunately for the companions of their

errant ways, the trees are most discreet. Other more earnest individuals were still, at seven in the evening, making the dining-room ring out with their tumultuous shouting about the latest ideas of the economists, the usefulness or uselessness of philosophy, religion, morals, actors, actresses, the government, the pros and cons of the two styles of music,[14] the fine arts, letters and other weighty questions, whose answers they always sought at the bottoms of bottles; then, hoarse of voice and unsteady of gait, they took refuge in their rooms, whose doors they were hard put to find, and sank into an armchair to recover from the passion and energy they had expended as they wore out their lungs, stomachs and intellects in the interests of establishing the best possible order in every branch of administration. Meanwhile I, accompanied by the tutor of the children of the house, his two pupils, my stick and my notebooks, went off to see the most beautiful spots in the world. It's my intention to describe them to you, and I hope these pictures will be as good as many others you may see. My walking companion had an expert knowledge of the topography of the area, knew the best times to look at each rustic scene, which place you had to see in the morning, which one was more engaging and delightful at dawn or at sunset, and the refuge where we could find freshness and shade at the hottest time of day. He was the cicerone of the locality. He did the honours of it for the benefit of newcomers, and no one knew better the best angle of approach for a stunning first view of a site. So we set off.

[*The two companions, Diderot and the abbé, go from one spot to the next, each of which corresponds to one of the Vernet landscapes in the exhibition. Of the seven pictures viewed, or 'sites' visited, some are now lost, some survive only in engravings, and only two are known to be extant, both in private collections. As they walk through the various landscapes, some of them examples of the picturesque or the sublime, they discuss questions of aesthetics, morals and philosophy. The extracts which follow concern the fourth and seventh paintings.*]

Fourth Site
[*Having covered three sites on their first day's walk, the two friends have spent the night back at the château. The following morning, Diderot is meditating upon the superiority of the simple country life.*]

That was the point I had reached in my daydream, as I lounged idly in an armchair, letting my thoughts wander where they would. It is a delightful state, in which the soul is naturally good, the mind effortlessly just and scrupulous, and ideas and feelings seem to come into being of their own accord, as though springing up from fertile soil. My gaze was fixed on a beautiful landscape, and I said: The abbé is right, our artists understand nothing, because their finest works have never made me experience the ecstasy I'm feeling now, the pleasure of being truly myself, the pleasure of recognizing my true goodness, the pleasure of looking at myself and taking pleasure in myself, and the even sweeter pleasure of forgetting myself. Where am I at this moment? What are my surroundings? I don't know, I have no idea. What do I lack? Nothing. What do I desire? Nothing. If there is a God, this is what he is like. He exists in enjoyment of himself. A distant sound – it was a washerwoman beating the clothes – suddenly reached my ear: farewell to my divine existence. But if it is pleasant to live as God lives, it is sometimes also pleasant to live as men do. If only she could come now and appear before me; if only I could see her round eyes as she gently puts her hand on my brow and smiles at me . . . how good that group of strong leafy trees looks over there on the right! And that spit of land jutting out in front of those trees and sloping gently down towards the water's surface is truly picturesque. How lovely that water is as it refreshes that little peninsula, and bathes its banks. Come, Vernet my friend, take up your pencils and hasten to enrich your portfolio with that group of women. One of them is leaning over the water and rinsing her washing. Another is crouching down and wringing it out. A third, standing up, has filled her basket and put it on her head. Don't forget that young man with

his back to you, quite near them, who's leaning forward, busy with the same work. Hurry, because in a minute these figures may take up a different position which might be less interesting. The more faithful your copy is, the finer your picture will be. But I'm wrong. You will bring a lighter touch to these women. Your brush-strokes will not be so heavy. You will lighten the dry, yellowish colour of that terrace. But the fisherman over on the left, who has just cast his net where the water stretches out to its widest extent, you will leave him as he is. You won't think of anything better than that. Look at his attitude. How right it is! And put his dog beside him. What a host of interesting details for your talent to collect! And then that piece of rock right over on the left, near the rock in the background, those buildings and hamlets, and, in between this structure and the landspit where the washerwomen are, those calm, tranquil waters whose surface stretches out into the distance.

If, on a plane corresponding to those busy women, but at some considerable distance, you include in one of your compositions, as nature suggests here, some misty mountains, of which all I can see are the summits, the horizon of your canvas can be pushed back as far as you like. But how will you go about rendering, not the shapes of these different objects, nor even their true colours, but the magical harmony which links them together . . . Why am I alone here? Why is there no one to share the charm and beauty of this spot? I feel that if she were there, lightly clothed, and I were holding her hand as her feeling of wonder accompanied mine, I should admire it all much more. I was calling you, calling my friend, when the dear abbé came in. His children were at their studies, and he had come to talk to me. A keen emotion, even after it has passed, leaves traces on the face which are not difficult to recognize. The abbé was not mistaken. He guessed something of what had been going on behind mine. — I've come at a bad time, he said. — No, abbé. — Another sort of company might be more welcome at the moment. — That might be so. — I'll go, then. — No, stay. — He stayed . . . He invited me to prolong my visit and promised as many more walks as I had enjoyed the day before, as many more

pictures such as the one I had before my eyes as I would grant him days.

It was nine o'clock in the morning, and everybody around us was still sleeping. Of all the many agreeable men and charming women who had gathered here, who had all escaped from the city, as they said, to enjoy the pleasures and happiness of the countryside, not one had left their bed to breathe the early freshness of the air, hear the first song of the birds, feel the charm of nature revived by the vapours of the night, take in the first scent of the flowers, shrubs and trees. They seemed to have come to inhabit the fields only to seek a more certain and uninterrupted pursuit of the tedium of the city. If the abbé's company was not quite what I would have chosen, I enjoyed myself more with him than I should have done by myself. A pleasure which is for me alone has little effect on me and is very short-lived. It is for myself and my friends that I read, reflect, write, meditate, listen, look and feel. In their absence my devotion refers everything to them. I think constantly of their happiness. If I am struck by a fine phrase, they will know about it. If I come across a stroke of wit, I promise myself I will tell them about it. If I have some delightful scene before my eyes, I automatically start to imagine how I shall describe it to them. I have devoted the use of all my senses and faculties to them, and that is perhaps why everything gets a little exaggerated and embellished in what I think and say. They sometimes reproach me for it: how ungrateful they are!

The abbé was sitting next to me and going into ecstasies, as usual, about the delights of nature. He had repeated the word 'beautiful' a hundred times, and it struck me that this common term of praise was applied to a whole variety of different objects. Abbé, I said, you call that steep rock beautiful; you call the lofty forest above it beautiful; that torrent whitening the bank with its foam and disturbing the pebbles, you call that beautiful. As far as I can see, you apply the word to humans, animals, plants, stones, fish, birds and metals. But you'll grant me that there's no physical property which all these things have in common. Why then this universal tribute? – I

don't know, and you've led me to think about it for the first time.
– It's very simple. The general nature of your praise, my dear abbé,
comes from a few common ideas or sensations which are aroused in
your mind by completely different physical properties. – I under-
stand, it's admiration. – Add to that, pleasure. If you consider the
matter closely, you'll find that objects which arouse amazement or
admiration without giving pleasure are not beautiful; and that those
which give pleasure without arousing surprise or admiration are not
beautiful either. The spectacle of Paris burning would fill you with
horror. Some time later, you would enjoy walking among its ashes.
You would suffer violently to see your beloved dying; some time
later, a feeling of melancholy would lead you to her grave, and you
would sit down beside it. There are simple sensations and compound
sensations, which is why the only beautiful things are those we can
see or hear. If you remove from a sound any concomitant moral
notion you will take away its beauty. If you stop an image going
beyond the surface of the eye, so that the impression does not pass
to the mind or the heart, there will be nothing beautiful about it.
And there is another distinction, the object in nature and the same
object in art or imitation. A terrible fire, in the midst of which
men, women, children, fathers, mothers, brothers, sisters, friends,
strangers, fellow-citizens, everything, perish, fills you with dismay;
you flee, you turn your eyes away, you shut your ears to the cries
of distress. As an onlooker, in despair at having survived so many
loved ones, you will risk your life. You will try to save them, or
seek to share their fate in the flames. But if the events of this
tragedy are shown to you on a canvas, your eyes will linger on
them with delight. You will say with Aeneas: *En Priamus; sunt hic
etiam sua praemia laudi*.[15] – And I shall shed tears. – I don't doubt it.
– But since I experience pleasure, what am I doing weeping? And if
I am weeping, how is it that I'm experiencing pleasure? – Is it
possible, abbé, that you have never known those tears? that you
have never had a feeling of vanity when your strength subsides?
Have you never stopped to look at the woman who had just made
the greatest sacrifice for you that an honest woman can make? Have

you never . . . – Excuse me, I . . . I have had that experience, but I've never known the reason for it, and I should like you to tell me.

What a question to ask me, dear abbé. We should still be talking tomorrow, and while we would be spending your time pleasantly enough, your disciples would be wasting theirs. – Just one word. – I can't. Go back to your proses and unseens. – One word. – No, no, not one syllable. But take my notebook, look at the back of the first page, and perhaps you'll find a few lines which will set your thoughts on the right track. The abbé took the notebook, and while I was dressing, he read.

La Rochefoucauld said that *in the worst misfortunes of those who are dearest to us, there is always something which is not entirely displeasing.* – Is that it? the abbé said. – Yes. – But that hasn't got much to do with it. – Carry on reading . . . And he continued.

Might there not be something in this notion which is both true and less distressing for the human race? It is a fine and lovely thing to have compassion for the unfortunate. It is a fine and lovely thing to sacrifice oneself for them. It is to their misfortune that we owe our flattering knowledge of the power of our own soul. We are not as frank with ourselves as a certain surgeon who said to his friend *I wish you had a broken leg: then you would see what I can do.* But ridiculous as this wish may seem, it lies hidden at the bottom of every heart. It is natural. It is universal. Who would not wish to see his mistress surrounded by flames, if he could be sure of plunging in like Alcibiades and carrying her out in his arms? On the stage we would rather see a good man suffering than a wicked man punished. Virtue put to the test makes a fine spectacle. We are happy to see the most terrible efforts being employed against it. We readily associate ourselves in our imagination with the persecuted hero. The man who is most in love with the violence of tyranny will abandon the tyrant and be overjoyed to see him fall, stabbed to death, in the wings. What a credit it is to the human race that the heart should make this impartial judgement in favour of innocence. One thing alone can draw us towards a wicked man, and that is the grandeur of his vision, the breadth of his genius, the danger of his undertaking.

So if we forget his wickedness in order to share his fate, if we conspire against Venice with the Count of Bedmar,[16] it is virtue with another face which wins our assent ... Dear abbé, observe in passing how dangerous an eloquent historian can be, and now read on ... We go to the theatre to seek a self-esteem which we do not deserve, to get a good opinion of ourselves, to share in the glory of great actions which we shall never perform, the empty shadows of the famous people exhibited before us. There, quick to embrace virtue in danger and press it to our hearts, we are sure of triumphing with it, or of abandoning it while there is still time. We follow it to the foot of the scaffold, but no further, and no one has placed his head on the block, beside the Earl of Essex.[17] Thus the pit is full, but the places of real suffering are empty. If we really had to suffer the fate of those we see on the stage, the boxes would be empty. The poet, the painter, the sculptor and the actor are charlatans who sell us a cheap version of old Horace's steadfastness and Cato's patriotism: they are the most seductive of flatterers.

The abbé had reached that point when one of his pupils came in, full of glee, with his exercise book in his hand. The abbé, who preferred talking to me to doing his duty, for duty is one of the most unpleasant things in this world, it's being nice to one's wife and paying one's debts, sent the child away and asked if he could read the next paragraph. – Read it, abbé, and the abbé read.

An imitator of nature will always direct his work to some important purpose. I don't say that this is a matter of method, plan or reflection, but of instinct, personal inclination, natural sensibility and a superior and noble discernment. When Voltaire was shown *Denys le Tyran*, the first and last tragedy by Marmontel,[18] the old poet said: 'He'll never achieve anything, he hasn't got the secret.' – Genius, perhaps? – Yes, abbé, genius, and also the right choice of subjects, the man of nature opposed to civilized man, man under the sway of despotism, man bowed down beneath the yoke of tyranny, fathers, mothers, husbands and wives, the most sacred, the gentlest, the most violent, the most universal bonds, the evils of society, the ineluctable law of destiny, the consequences of the great

passions: it is hard to be moved by a danger which one may never have experienced. The less distance there is between a character and myself, the more quickly I am attracted, the more strongly I am involved. It has been said: *Si vis me flere, dolendum est primum ipse tibi.*[19] But you will weep alone, and I shall not be tempted to mingle one tear with yours, if I cannot put myself in your place. I must be clinging to the end of the rope which keeps you hanging in space, or else I shall not tremble. – Ah, now I understand. – What, abbé? – I play two roles; there are two of me; I am Le Couvreur[20] and I remain myself. It is I Le Couvreur who tremble and suffer, and it is I, just I, who enjoy it. – Very good, abbé; and there lies the limit for the imitator of nature. If I forget myself too much, and for too long, the fear is too great. If I don't forget myself at all, if I remain completely myself, it is too weak. It is this exact balance which causes delightful tears to flow.

[*At the end of the sixth site; Diderot comes out into the open and admits that the walks with the abbé have been invented, a daydream induced by the realism of Vernet's landscapes. The seventh and final discussion is therefore about a painting, and is addressed to Grimm.*]

So I'm not talking to the abbé any more, but to you. The moon, just above the horizon and half-hidden behind thick, dark clouds and a very stormy, dark sky, occupies the centre of the painting and casts its pale, feeble light over the curtain of cloud which conceals it and the surface of the sea on which it shines. There is a building on the right, and near it, in the foreground, the remains of some piles. A little more to the left and further back, a small boat at whose prow a sailor is holding up a lighted torch. This boat is moving towards the piles. Still further back, almost in the open sea, a vessel in full sail heading towards the building; then a stretch of dark, endless sea. Right over on the left, some steep rocks. At the foot of these rocks, a solid mass of stone, a sort of esplanade from the side or front of which you can go down to the sea by a long series of steps. This esplanade is closed off on the left by the rocks and on the right by a wall which forms the back of a fountain whose jets point

towards the sea. In the space enclosed by this wall, on the left, beside the rocks, stands a tent: in front of it, a barrel on which two sailors, one sitting on the front, the other leaning with his elbows on the back, are looking at a fire burning on the ground in the middle of the esplanade. Over this fire is a cooking-pot, hanging by iron chains from a sort of tripod. In front of this pot crouch a sailor, seen from behind, and a woman, on his left, in profile. Two figures are leaning with their backs against the vertical wall which forms the back of the fountain, a man and a woman, both charming in their gracefulness, natural demeanour and relaxed poses. A husband, perhaps, and his young wife, or two lovers, or a brother and sister. That represents more or less the whole of this wonderful composition. But what meaning can these cold, inert phrases of mine have, these lines without warmth or life, lines which I have simply set down one after another? Nothing, nothing at all. It must be seen. And then I forgot that on the steps of the esplanade there are traders, sailors busy rolling or carrying things, active or at rest, and, right over on the left, on the lower steps, some fishermen working at their nets.

I don't know what I most want to praise in this piece. Is it the reflection of the moon on the rippling waters, or the dark heavy clouds and the way they move, or the vessel sailing along in front of the moon, reflecting it and drawing it to itself from its immense remoteness, or the reflection in the water of the little torch that sailor is holding at the prow of his boat, or the two figures leaning against the fountain, or the fire whose reddish glow spreads over all the objects around it, without destroying the general harmony, or the whole effect of the darkness, or that fine mass of light shining on the parts of the rock that jut out and mingling its vapour with the clouds where it meets them?

They say that this is Vernet's finest painting, and that's because it's always the latest work of this master that is called the finest. But I say once again, it must be seen. The effect of these two kinds of light, these places, these clouds, these shadows which cover everything and allow us to see everything, the horror and the truth of this august scene can only be deeply felt, but not described.

The amazing thing is that the artist can recall these effects a hundred miles away from nature, that his only model is what is in his imagination and that he paints with unbelievable speed. For he says: Let there be light, and there is light, let night follow day, and day follow darkness, and it is night, and it is day. For his imagination, as accurate as it is fertile, supplies all these truths, so that the person who observed them coolly and calmly from the shore is filled with amazement when he sees them on the canvas. His compositions proclaim the grandeur, might and majesty of nature more powerfully than nature herself. It is written, *Coeli enarrant gloriam Dei*,[21] but these are Vernet's skies, and this is Vernet's glory. What does he do that is not marked by excellence? Human figures of every age, every condition, every nation, trees, animals, landscapes, seascapes, vistas, every kind of poetry, eternal mountains, calm, restless or rushing waters, torrents, calm seas, raging seas, sites of infinite variety, Greek, Roman or Gothic buildings, civil, military, ancient or modern architecture, ruins, palaces, cottages, all kinds of structures, rigging, tackle, vessels, skies, distant prospects, tranquil scenes, calm or stormy weather, skies for different seasons, light at different times of day, tempests, shipwrecks, tragic situations, victims and touching scenes of every kind, day, night, natural or artificial light and the isolated and mingled effects of that light. There is not one of these fortuitous scenes which would not in itself make a valuable painting. Ignore the whole right-hand side of his *Moonlight Scene*; cover it so that you see only the rocks and the esplanade on the left and you will have a fine painting. Take out the part of the sea and sky where the light from the moon falls on the water and you will have a fine painting. Concentrate your gaze on the rock on the left and you will have seen a thing of beauty. Confine yourself to the esplanade and what is happening there; look only at the steps and the various activities going on there and your judgement will be satisfied. Just cut out that fountain with the two figures leaning on it, and you'll carry a prize away with you. But if each separate part has this effect on you, think of the effect of the whole, the value of the complete work.

This is truly the painting by Vernet which I should like to possess. A father with children and moderate wealth would make a wise investment if he bought it. He would have the enjoyment of it for his lifetime, and in twenty or thirty years he would still have invested his money at a good rate of interest. For when death has broken this artist's palette, who will pick up the pieces? Who will restore them to our descendants? Who will pay for his work?

But how, you ask, can poets, orators, painters and sculptors be so inconsistent, so different from themselves? It can be the work of a moment, your physical or mental state, a minor disagreement at home, making love to your wife in the morning before going to the studio and losing a few drops of fluid which contained all your ardour, passion and genius, a child saying or doing something stupid, a friend making a tactless remark, a mistress giving too fond a reception to someone else who's not interested anyway; what do I know? A bed too cold or too warm, a blanket falling off in the night, a pillow awkwardly placed, half a glass of wine too much, a stomach upset, hair untidy under your nightcap, and you can say goodbye to inspiration. Chance plays its part in chess and every other game of skill. And why not? That sublime notion which suddenly comes to you: where was it a moment before? What made it come or not come? What I do know is that it's so closely bound up with the appointed life of the poet and the artist that it could not come earlier or later, and that it's absurd to imagine that it might have been exactly the same in another being, in another life, in another order of things.

This man Vernet, the awesome Vernet, combines the greatest modesty with the greatest talent. He said to me one day: If you ask me if I do skies like such-and-such a master, I shall answer no, or figures like some other painter, and I shall answer no. Trees and landscape like so-and-so, the same answer. Mists, waters, vapours like someone else, the same answer again. I'm inferior to them in this one aspect, but I surpass them in all the others. And that is true.

Goodnight, my friend. That's quite enough about Vernet. Tomor-

row morning, if I remember anything I've left out which is worth telling you, you'll hear about it.

[*Diderot does in fact remember two shipwreck scenes which he describes as though they took place in his dreams. There follows a discussion on the interaction of mind and body which parallels the theories he advances in* D'Alembert's Dream. *The passage which follows, concluding the section on Vernet in the 1767 Salon, presents Diderot's ideas on the sublime and owes much to Edmund Burke's* Philosophical Enquiry into the Origin of our Ideas of the Sublime and Beautiful.]

But I see you're frowning. What is it now? What do you want from me? . . . I know. You don't let me get away with anything. I'd promised the abbé a few rambling thoughts on the ideas we associate with shadows and darkness. All right, we'll get this sorted out and let that be the end of it.

Anything which astonishes the mind, anything which inspires a feeling of terror, is conducive to the sublime. A vast plain is not as disturbing as the ocean; nor is a calm sea as disturbing as a rough sea.

Darkness adds to terror. Scenes of darkness are rare in tragic compositions. Technical difficulties make them even rarer in painting, where they are also hard to achieve and can be truly judged only by masters of the art. Go to the Academy and propose this simple enough subject. Ask someone to show you Love flying over the globe at night, waving his torch and sending down to earth, through the cloud which carries him, a shower of fire mixed with arrows.

Night hides the shapes of things and adds horror to their sounds; even the sound of a leaf in the depths of a forest sets the imagination working, the imagination has a powerful effect on our bodies, and everything is magnified. A cautious man will be on his guard. A coward will stop, tremble and run away. A brave man will reach for his sword.

Temples are dark places. Tyrants are rarely seen. Not seeing them, we judge them by their atrocities to be greater than they are.

The sanctuary of both civilized man and savage man is full of darkness. Of the art of making an impression on oneself it can rightly be said: *aliquid latet arcana non enarrabile fibra*.[22] Priests, set up your altars and build your temples in the depths of the forests. Let the cries of your victims pierce the darkness. Let your mysterious, theurgic, blood-drenched rites be lit only by the sombre glow of torches. Bright light serves well to convince people; it is useless for moving them. Bright light, however it is understood, detracts from enthusiasm. Poets, speak endlessly of eternity, the infinite, immensity, time, space, divinity, tombs, ancestral spirits, the torments of hell, dark skies, deep seas, dark forests, thunder, lightning piercing the clouds. Be mysterious. Loud noises heard in the distance, waterfalls heard but not seen, silence, solitude, wild places, ruins, caverns, the slow, regular beating of muffled drums, the hesitant chiming of a bell, the cries of nocturnal birds, or of fierce beasts on a winter night, especially if they are mingled with the murmuring of the wind, the moaning of a woman in labour, any cry which stops and then resumes even more loudly before it finally fades away: there is in all these things something terrible, mighty and mysterious.

It is these associated impressions, necessarily linked to night and darkness, which finally bring terror to the heart of a girl making her way to an assignment in a dark wood. Her heart is beating fast. She stops. Fear is now added to the passion she already feels. She is overcome. Her knees give way beneath her. She is only too happy to reach her lover and be embraced and supported in his arms, and her first words are: Is it you?

I believe that black people are less beautiful to black people themselves than white people are to both blacks and whites. It is not within our power to separate ideas which nature associates. I will change my mind if I am told that black people are more moved by darkness than by the brightness of a fine day.

Ideas of power also have sublimity. But power which threatens is more moving than power which protects. A bull is more beautiful than an ox; a bull without its horns, bellowing, than a bull walking

and grazing; a horse running freely with its mane flowing in the wind than a horse carrying its rider; a wild ass than a donkey; a tyrant than a king; a crime even than virtue; cruel gods than good gods; and all this was well known to the sacred lawmakers.

Springtime is not suitable for an august spectacle. Magnificence is beautiful only when disorder is present. Make a pile of all your precious vases. Cover these piled up, overturned vases with materials equally precious. An artist will see only a fine group, fine shapes in all that. A philosopher will discover a deeper principle. What powerful man who owns these things would leave them to the mercy of anyone who comes along?

The pure, abstract dimensions of matter are not without some expressive power. The perpendicular line, an image of stability, a measure of depth, is more striking than an oblique line.

Farewell, my friend. Farewell and goodnight. Think carefully about it before you go to sleep or when you wake up, and you'll agree that the treatise on the beautiful is yet to be written, despite all I have said in the preceding Salons, and all I shall say in this one.

VIEN

Salon of 1767

St Denis Preaching the Faith in France[1]

A picture twenty-one feet three inches high by twelve feet four inches wide, for one of the chapels of the Church of Saint Roch.

Public opinion has been divided between this painting by Vien and Doyen's *Miracle des Ardents*, and there's no doubt they are two fine pictures, two great creations. I shall here describe the first. The description of the other will be found in its proper place.

On the right is a piece of architecture, the façade of an ancient temple with its raised platform in front. At the top of a few steps leading to this platform we see the apostle of the Gauls preaching. Standing behind him, some of his disciples or proselytes. At his feet,

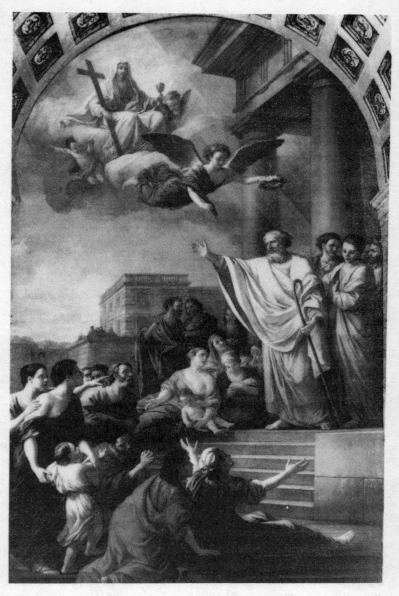

VIEN St Denis Preaching the Faith in France (Saint Denis prêchant la
foi en France) *Church of Saint Roch, Paris*

going from the apostle's right towards the left-hand side of the picture, a little further back, sitting, kneeling, crouching, four women, one of whom is weeping, the second listening, the third meditating, the fourth looking at him with an expression of joy. This last is holding a child which she encircles with her right arm. Behind these women, right in the background, stand three old men, two of whom are conversing and apparently unable to agree. Continuing in the same direction, a crowd of listeners, men, women, children, sitting, standing, bowing down, crouching, kneeling, showing all the different shades of meaning of the same expression, from hesitant uncertainty to admiring conviction; from deep concentration to troubled amazement; from grave emotion to anguished repentance.

To get some idea of this crowd occupying the left-hand side of the painting, imagine, seen from behind, crouching on the bottom steps, a woman lost in admiration, with her arms outstretched towards the saint. Behind her, on a lower step, a little beyond her, a man kneeling, listening, bending forward and showing assent with his head, arms, shoulders and back. Right over to the left, two tall women, standing. The one in front is paying close attention; the other is linked to her by her right arm, which is resting on the first one's shoulder. She is looking at something, pointing at one of her brothers, it would seem, amongst the group of disciples or proselytes standing behind the saint. On a plane between them and the two figures occupying the foreground, who are seen from behind, the head and shoulders of an old man, amazed, bowing down in wonder. The rest of this person's body is hidden by a child, seen from behind, who belongs to one of the two tall women. Behind these women, the rest of the assembled people, whose heads alone are visible. In the centre of the picture, in the distant background, a stone structure, very high, with various people, men and women, leaning on the parapet and watching what is going on in the foreground. In the sky above, seated on clouds, the figure of Religion, a veil drawn over her face, holding a chalice. Beneath her, with outstretched wings, a great angel descending with a crown which he is about to place on Denis's head.

Here then is the path followed by this picture: Religion, the angel, the saint, the women at his feet, the people assembled in the background, those on the left and also in the background, the two tall women standing up, the old man bowing down at their feet, and the two figures, one a man, the other a woman, seen from behind and placed right in the foreground, a path descending gently and moving in broad curves from Religion down to the background of the composition on the left where it turns back on itself to form, in a broad circle round the saint, a kind of enclosure which is broken by the woman placed in the foreground, who, with her arms stretched out towards the saint, reveals the whole inner space of the scene; a connecting line which runs clearly, precisely and easily through the main elements in the composition, missing only the buildings in the background on the right and the indiscreet old men who are interrupting the saint as they talk to each other and have a private argument.

Let us go over this composition again. The apostle is well posed. His right arm is stretched out, his head straining forward a little. He is speaking. This head is firm, calm, simple, noble, gentle, somewhat rustic in character and truly apostolic. So much for the expression. As for the execution, it is well painted, with the colour well applied. The beard is broad and cleverly painted. The drapery, or the great white alb, which falls in straight, parallel folds, is very fine. If it suggests the body underneath less than one would like, it's because one garment is placed over another. The whole figure draws all the strength and brilliance of the light, and is the first thing to attract our attention. The general tone is perhaps a little grey, and too even.

The young man behind the saint, in the foreground, is well drawn and well painted. It's like a Raphael figure in its wonderful purity, its nobility and the divine nature of the head. It's very strongly coloured. People say that the drapery is a bit heavy. That may well be. The other acolytes stand up well beside him, both in shape and colour.

The women crouching at the feet of the saint are pale and stand

out too sharply. The child one of them is holding with her arm is like wax.

Those two people conversing in the background are grimily coloured, meanly characterized and poorly draped, but they go quite well together.

There's something awkward about the heads of the women standing on the left who form a group. Their clothes flutter beautifully over the surface of their bodies.

The woman sitting on the steps, with her arms stretched out towards the saint, is strongly coloured; the brush-strokes are very fine and the energy of her gesture establishes a good distance between her and the saint.

The figure of a man kneeling behind this woman is just as beautiful and just as vigorously done, with the result that it's brought well into the foreground.

They say these last figures are too small for the saint, and even more so for the ones standing beside them. That may be so.

They say the right arm of the woman with outstretched arms is too short and that you're not aware of any foreshortening. That too may be so.

As for the background, it's perfectly in keeping with the rest of the picture, a thing which is neither common nor easy to achieve.

This composition truly forms a contrast with Doyen's. All the qualities that one artist lacks, the other has; there prevails in this picture the most beautiful harmony of colour, and a peace and silence which cast a spell upon one. There is here all the magic of an art without contrivance, affectation or effort. One cannot deny Vien this praise, but if you then turn to look at the Doyen and see how dark and dynamic, full of fire and warmth it is, you have to admit that in *St Denis Preaching* the whole effect is produced by a superior technique applied to weakness, a weakness which Doyen's strength makes obvious, but a harmonious weakness which in its turn brings out all the discordance in his rival. Each of these great duellists makes a successful thrust at the other. The two compositions are to each other as the characters of the two men. Vien has a free,

sober style, like Domenichino. Fine heads, accurate draughtsman-
ship, beautiful feet, well-placed draperies, simple, natural expres-
sions; nothing tortured or affected either in the details or in the
disposition. There is a beautiful calm in all this. The longer you
look at him, the more pleasure you get. There is something in him
of both Domenichino and Le Sueur.[2] The group of women on the
left is very fine. All the faces seem to have been modelled on the
first of these masters; and the finely coloured group of young men
on the right is in the style of Le Sueur. Vien holds your attention
and leaves you ample time to study him. Doyen, more exciting to
the eye, seems to be telling it to hurry up in case the impression
made by one object should destroy the effect of another, so that the
spell would have evaporated before you could take in the whole
composition.

Vien possesses all the features which belong to a great craftsman.
Nothing is neglected. And there is substance there. He provides a
rich subject of study for young people. If I were a teacher, I would
say to them: Go along to Saint Roch and look at *St Denis Preaching*.
Absorb it fully, but then go quickly over to the *Miracle des Ardents*;
it's a sublimely inspired work which you're not yet up to imitating.
Vien has done nothing better, except perhaps for his presentation
piece.[3] Vien, like Terence, *liquidus puroque fluit simillimus amni*;[4]
Doyen, like Lucilius, *dum flueret lutulentus erat quod tollere velles*.[5] Or,
if you prefer, it's like Lucretius and Virgil. Yet it must be said that
for all the effect of his harmony, Vien is monotonous: there's no
variety in his flesh tints, and the flesh of his men and women is
almost the same. Moreover, with the greatest possible understanding
of his art, he lacks imagination, inspiration, poetry, movement,
incident and interest. This is no popular gathering, it's a family, one
family. This is not a nation to which a new religion is being
brought, it's a nation already converted. Was this a country then in
which there were no judges, priests or educated citizens? What is
there to see but women and children, and more women and
children? It's like Saint Roch on a Sunday. Sober judges, if they
had been there, would have listened and weighed up what was

conducive or contrary to public order in the new doctrine. I see them standing there, listening carefully, eyebrows lowered, heads and chins resting on their hands. Priests, had there been any, furious at seeing their gods threatened, would have been biting their lips with rage. Educated citizens like you and me, had there been any, would have been shaking their heads in contempt, and exchanging over the heads of the assembled people comments which would have been just as banal as any you or I might make.

But don't you think that, with a little invention, it would not have been possible to fill this scene with the highest degree of movement, and the most violent and varied incidents? – When someone is preaching? – When someone is preaching. – Without making it unrealistic? – Without making it unrealistic. Simply choose a different moment and take St Denis's speech in its closing moments, when he has infected the whole populace with his fanaticism and inspired them with the greatest contempt for their gods. You'll see the saint full of ardour and fire, carried away with his enthusiasm, inciting his listeners to smash their idols and overturn their altars. You'll see the people being swept along by the flow of his eloquence and induced to tie ropes round the necks of their divinities and drag them down from their pedestals. You'll see the wreckage, and from the midst of this wreckage, the priests in their fury hurling threats, shouting out, attacking, defending themselves, pushing back the crowd. You'll see the judges vainly intervening, their persons insulted and their authority disregarded. You'll see all the madness of the new superstition mingled with that of the old. You'll see women restraining their husbands as they rush forward to kill the apostle. You'll see neophytes, proud in their suffering, being taken to prison by the judges' attendants. You'll see other women embracing the feet of the saint, surrounding him and defending him with their bodies, for in such circumstances women know a different kind of violence from men. St Jerome used to say to the disciples of his own time: 'Appeal to women if you wish your doctrine to prosper. *Cito imbibunt, quia ignarae; facile spargunt, quia leves; diu retinent, quia obstinaces.*'[6]

Such is the scene I should have depicted, had I been a poet, and painted, had I been an artist.

Vien draws well and paints well, but he does not think or feel. Doyen would be his pupil in art, but he would be Doyen's pupil in poetry. Given patience and time, the painter of the *Ardents* may acquire what he lacks, an understanding of perspective, the art of distinguishing planes and a knowledge of the true effects of light and shade, for there are a hundred decorative painters for every painter of feeling. But what the painter of St Denis does not know can never be learnt. If he is weak in invention, he will remain so. If he lacks imagination, he will never have it. Without the fire in his belly, he will be cold all his life. *Laeva in parte mamillae nil salit Arcadico juveni*, nothing beats in the young Arcadian's breast.[7] But let us justify our epigraph, *sine ira et studio*,[8] and at the same time give full credit to some other aspects of his composition.

One can't imagine anything more beautiful than the angel darting down from the feet of Religion to crown the head of the saint. He has an incredible lightness, grace and elegance, his wings are spread out, he's flying, he doesn't weigh an ounce, and although there's no cloud there to hold him up, I'm not afraid he'll fall. He's beautifully spread out. I can see a large space before and behind him. He's crossing the empty air. I can measure him from his toes to the hand in which he's holding the crown. My eye can move all round him. He imparts great depth to the scene. He enables me to distinguish three principal planes which are very clearly marked, that of Religion, which he projects a long way into the background, the one he occupies himself, and that of the preacher, which he projects forward. He has a fine head too. He's well draped. His limbs have a fine rhythm to them, and his action and movement are wonderful. Less attention has been paid to the painting of Religion than to him or the figures lower down, and this shading off is so right that one doesn't notice it.

All the same, Religion is not ethereal enough. The colour is a little too solid. Apart from that, it's well drawn and even better

clothed; there's nothing vague about the draperies; they're perfectly right. You can see where they come from and where they go.

The saint is very tall, and would look even taller if his head were not so powerful. Generally, large heads make figures look shorter. And because he's dressed in a loose alb which doesn't touch his body, its long, straight folds add to his size.

Doyen's and Vien's paintings are both exhibited. Vien's comes over better. Doyen's looks a bit dark, and I see there's a scaffold put up in front which tells me he's touching it up.

My friend, when you have any paintings to judge, go and see them at the end of the day. It's a very critical time. If there are any gaps, the faintness of the light will show them up. If there are too many bright patches, they will look even brighter. If the harmony is complete, it will remain so.

People say, as I do, that the whole of Vien's composition is cold, and so it is. But those who make this criticism of the artist are certainly unaware of the reason why. I say to them that without changing anything in the painting, anything at all apart from one thing which has nothing to do with the disposition, or the incidents, or the position and characters of the figures, or the colouring or the light and shade, I should bring them round to a position where they asked for even more calm and tranquillity. In respect of what follows, I appeal to those who have a profound understanding of the theory and practice of art.

I maintain that, other things being equal, the more tall and dignified the characters in a composition, the more exaggerated in scale, powerful in their proportions and beyond the average offered by nature, the less movement there needs to be. This law can be observed on a moral and a physical level. It is the law of mass in physics. It is the law of characters in the moral world. The greater a mass, the more subject it is to inertia. In the most fearsome scenes, if the spectators are venerable people, if on their wrinkled brows and bald heads I see the signs of age and experience, if the bodies and faces of the women are sober and generously proportioned, I should be amazed to see much movement in them. Expressions of any

kind, passions and movements diminish in proportion as features are exaggerated. That is why Raphael is accused of being cold when he is truly sublime, when, genius that he is, he adjusts expressions, movement, passions and actions to the type of person he has chosen to create. Keep the characters of the figures in his painting of the Demoniac[9] as they are and then introduce more movement, and see if the picture isn't spoilt. Similarly, introduce into Vien's painting, without changing anything else, the features and proportions of Raphael, and tell me if you don't find too much movement in it. I would therefore lay down the following principle for an artist. If your characters are very large, your scene will be almost motionless. If they are too small, your scene will be full of turmoil and agitation. But there is a middle path between coldness and extravagance, and it is where, in relation to the action represented, the choice of characters is most advantageously combined with the degree of movement. Whatever type of character is preferred, movement increases in inverse proportion to age, from the child to the old man. Whatever the size and proportion of the figures, movement remains in the same inverse proportion.

These are the basic rules of composition. Ignorance of these rules is responsible for the diversity of judgements made of Raphael. Those who accuse him of being cold are asking of his great mind what is suitable only for the small minds which they have. They don't belong in his world. They are Athenians in Sparta.

The Spartans were probably no differently built from other Greeks. Yet there is no one who does not imagine, from their calm, firm, stolid, sober, cool and composed characters, that they are much taller.

[*There follows a longish discussion in which Diderot brings forward various aesthetic and historical arguments to support his case. Returning then to the fact that Doyen's painting was generally preferred because of the movement and activity in it, he attributes this to the superficiality of public taste. He concludes his discussion of the Vien painting with another aspect of composition which came up in one of his discussions with Prince Galitzin,*

a cultivated francophile, and the man who acted for the Empress Catherine II in the purchase of Diderot's library.]

In one of our nocturnal conversations, the contrast between these two works gave Prince Galitzin and myself the opportunity to discuss a number of questions concerning art, one of which had to do with groups and masses.

I observed first of all that these two terms, grouping and massing, were constantly confused, when, in my opinion, there was a difference between them.

However inanimate objects are arranged, I should never say that they're grouped, but I should say that they're massed.

However animate objects are combined with inanimate objects, I should not say that they're grouped, but massed.

However animate objects are placed one beside the other, I should only say they are grouped if they are linked together by some common function.

Take as an example Poussin's painting of the Israelites gathering manna in the desert. Those three figures you see on the left, one gathering manna, the second doing the same, and the third standing up and tasting it: each differently occupied and separate from the others, they have only local proximity and don't, in my opinion, form a group. But that young woman sitting on the ground giving her breast to her old mother and using one hand to comfort her child as he stands in front of her crying at being deprived of the nourishment that nature intended for him and that a filial love stronger than mother love is denying him, forms a group with her son and her mother, because there is a common activity which links this figure with the other two, and them with her.

A group always forms a mass; but a mass does not always form a group.

In the same painting, that Israelite gathering manna with one hand and pushing away another who is trying to get some from the same heap forms a group with him.

I noticed that in Doyen's composition, in which there were only

fourteen principal figures, there were three groups, and that in Vien's, in which there were thirty-three and perhaps more, they were all distributed in masses and that there was no group in the proper sense of the word; that in Poussin's painting there were over a hundred figures and barely four groups, each one containing only two or three figures; and that in *The Judgement of Solomon* by the same artist, everything was in masses, and that apart from the soldier who is holding the child and threatening him with his sword, there was no group.

I observed that on the Sablons plain, when there's a military review, and curiosity brings about fifty thousand Parisians out to watch, the number of masses would be infinite in comparison with the groups; that it would be the same at church on Easter Day; in an avenue on a fine summer evening; at the theatre on a first night; in the streets on a day of public celebration; even at the Opéra ball, on the Monday before Lent; and that to make groups form in these big gatherings you would have to imagine them being threatened by some unexpected incident. If, for example, the auditorium catches fire in the middle of a performance, everyone thinking about their own safety or sacrificing it for the sake of someone else, all these figures who a moment before were quietly and separately concentrating on the play will leap into action, falling over one another, while women faint in the arms of their lovers or husbands, daughters rush to help their mothers or are helped by their fathers, others leap from the boxes into the pit where arms are held out to receive them, men will be killed, suffocated, trodden underfoot and there will be an infinite number of incidents and different groups.

Other things being equal, it is movement and tumult which creates groups.

Other things being equal, movement comes less readily to characters who are larger than life than to weak, ordinary ones.

Other things being equal, there will be less movement and fewer groups in compositions in which characters are larger than life.

I concluded from this that the true imitator of nature, the wise artist, was economical with groups, and that one who, without

regard for the moment or the subject, or the proportions or nature of that subject, tried to put as many as he could into his picture, was like a student of rhetoric who couches the whole of his speech in apostrophes and rhetorical figures; that the true art of grouping represented perfection in painting and that a mania for grouping represented decadence in painting, belonging not to the time of true eloquence but to that of declamation, which always follows it; that in the beginnings of art the group must have been a rare thing in compositions, and that I was inclined to think that sculptors, who are almost obliged to make groups, had first given the idea to painters.

If my ideas are right, you will strengthen them with reasons which have not occurred to me, so that they will cease to be conjectural and become evident and proven. If they are wrong, you will demolish them. Whether they are true or false, the reader will always gain something from them.

Introductory Note

ISOLATED THOUGHTS ON PAINTING

The *Pensées détachées sur la peinture*, of which a small selection is offered here, are themselves incomplete, being intended for a more ambitious work which was, so far as we know, never embarked upon. They owe their existence to two events. The first was Diderot's journey to Russia of 1773–4. The version on which this translation is based is in fact the one in the Hermitage collection. His journey took him through Holland and Germany, where he was able to visit a number of galleries and broaden his experience of painting, particularly that of the Dutch school. Then, after his return to France, there was the discovery of Hagedorn's *Betrachtungen über die Malerei* (*Reflections on Painting*), on the translation of which he himself probably collaborated. Hagedorn was much indebted to a Dutch work on painting by Gerard de Lairesse, translated into German in 1728 but not known in a French translation until 1787. It is in a sense disappointing that Diderot's 'thoughts' are thus doubly derivative, the more so because his own work to a large extent adopts the order of Hagedorn's and also contains many of his observations, for the most part unacknowledged. But then one's enthusiasm is rarely aroused by the works one discovers unless they reflect and develop ideas one already has. This is clearly what happened in Diderot's case. Leaving aside the more technical aspects of painting, which have been omitted from this selection, much of what Hagedorn wrote must have echoed Diderot's own preoccupations.

In some ways the *Isolated Thoughts* read like a distillation of the ideas he expresses in passing in the *Salons*. There are the attempts to pin down the elusive elements which define taste; the emphasis on the moral function of art, together with the distinction between the moral and technical aspects of the practice and judgement of painting; reflections on the nature of illusion; the primacy of the

imitation of nature over respect for convention and tradition; the importance of natural values such as grace, simplicity and naivety; and some memorable lines on the sublime. In amongst these observations are items reminiscent of the maxims which were then a popular literary form, comments on contemporary life, and the occasional remark which reminds us how much Diderot belongs to a past age, such as his amazement that Rubens could have taken his models from the people around him instead of looking to the classical past.

ISOLATED THOUGHTS ON PAINTING

On Taste

The feeling for beauty is the result of a long series of observations; and when have these observations been made? All the time, at every moment. These observations relieve us of the necessity for analysis. Taste has made its judgement long before it knows the motive for it. Sometimes it seeks it without finding it, but it still goes on trying.

★

Ordinary nature was the first model for art. When a less ordinary kind of nature was successfully imitated, it became clear that there were advantages in making a choice, and the most rigorous choice made it necessary to beautify or gather into one object the beauties which, in nature, are dispersed among a large number of objects. But how is unity imposed on so many parts borrowed from different models? That was the work of time.

★

Everyone says that taste comes before all the rules, but few know the reason. Taste, good taste, is as old as the world, man and virtue; passing ages have only served to perfect it.

★

I believe we have more ideas than we have words. How many things are felt without being named! Of these things there are numberless examples in ethics and in poetry and in the arts. I confess I have never been able to say what I have felt about

329

Terence's *Andria* and the *Venus dei Medici*. That is perhaps why these works are always new for me. One can hardly remember anything without the help of words, and words are hardly ever enough to convey exactly what one feels.

★

Nothing is easier than to tell the man who feels deeply and speaks badly from the man who speaks well and feels nothing. The first is sometimes to be found in the street, the second often at court.

On Criticism

There are few, very few men who take genuine pleasure in the success of someone who is following the same career; it's one of the rarest phenomena in nature.

★

The poet said: *Trahit sua quemque voluptas.*[1]

If the observation of nature is not the dominant preoccupation of the man of letters or the artist, don't expect anything worthwhile from him; and if you see it in him in his earliest youth, you should still suspend your judgement. The Muses are women and do not always grant their favours to those who most insistently press for them. How many unhappy lovers they have made, and how many more they will go on to make! And even the happy lover still has to choose his moment.

★

What a stupid occupation, to spend all one's time stopping us enjoying things, or else making us blush for what we have enjoyed! . . . That is what the critic does.

On Composition and the Choice of Subjects

The harmony of the finest painting is only a pale imitation of the harmony of nature. The most difficult thing in art is to make up for this weakness.

★

If anyone commissions a painting, the more details he gives about the subject, the more certain he is of getting a bad picture. He doesn't know how limited the talent is of even the most brilliant artist.

★

The head of a man on the body of a horse we find pleasing; the head of a horse on the body of a man we find displeasing. Creating monsters is the business of taste. I may rush into the arms of a siren; but if the part which is woman were fish, and that which is fish were woman, I should turn my eyes away.

★

Why would the Hippogryph, which I like so much in the poem,[2] not please me on a canvas? I'll give a reason, which may or may not be a good one. The image, in my imagination, is only a fleeting shadow. The canvas fixes the object under my gaze and forces me to recognize its deformity. Between these two imitations there is the difference between *it may be* and *it is*.

★

If all the paintings of martyrs which our great masters have painted

so sublimely were to come down to a distant posterity, what would they take us for? Wild beasts or cannibals.

<div align="center">★</div>

In every imitation of nature there is the technical aspect and the moral aspect. Judging the moral aspect is a matter for all men of taste; the technical aspect is only for artists.

<div align="center">★</div>

Drawing, and perhaps bas-relief, enjoy certain kinds of freedom which are denied to painting. The strength of the colour brings out the falsity, the ugliness or the distasteful aspect of the object.

<div align="center">★</div>

I am not an ascetic monk, but I confess I would happily sacrifice the pleasure of seeing beautiful nudes if I could hasten the time when painting and sculpture, more deeply imbued with decency and morality, decided to cooperate with the other fine arts in inspiring virtue and improving morals. I feel I have seen enough breasts and buttocks; these objects get in the way of the higher feelings by having a disturbing effect on the senses.

<div align="center">★</div>

A licentious painting or sculpture is perhaps more dangerous than a bad book. The first of these imitations is closer to the thing itself. Tell me, men of letters and artists, answer me: if an innocent girl had been led away from the path of virtue by one of your works, would you not be mortified? And would her father forgive you? Would her mother not die of grief? What have these honest parents done to you, that you should trifle with the virtue of their children and their own happiness?

<div align="center">★</div>

Enthusiasm is not absent from genre painting, because there are two kinds of enthusiasm; the enthusiasm of the heart and that of the craft. If one is lacking, the basic concept will lack warmth, if the other, there will be weakness in the execution; the union of the two is what makes a work sublime. The great landscape painter has his own enthusiasm; it is a kind of sacred horror. His caverns are dark and deep, his jagged rocks threaten the sky above them, his torrents come crashing down, shattering from afar the august silence of his forests. Man passes here through the habitations of demons and gods. Here it is that the lover entices his beloved, where his sighs are heard by her alone. Here it is that the philosopher, seated or walking with measured tread, communes with his thoughts. If I stop to gaze upon this mysterious imitation of nature, I shudder.

★

If the painter of ruins does not turn my mind to the vicissitudes of life and the vanity of the works of man, he has produced nothing but a shapeless pile of stones. Did you hear that, Monsieur de Machy?[3]

★

I have remarked that there is only one moment for the artist to choose, but this moment may carry traces of the moment which preceded it and signs of the one which will follow. Iphigeneia is not yet being sacrificed, but I see the executioner's assistant approaching with the bowl which is to receive her blood, and this accessory makes me tremble.

★

Why is art so much at ease with mythical subjects, despite their unreality? For the same reason that theatrical performances are more at ease with artificial light than daylight. Art and this light are a

beginning of magic and illusion. I should be inclined to think that nocturnal scenes would be more effective on the canvas than daylight scenes, if they were as easy to imitate. Go to Saint-Nicolas-des-Champs and see Jouvenet bringing Lazarus back from the dead by torchlight.[4] Go to the Chartreux and see St Bruno dying in artificial light.[5] I admit there is a secret link between death and the night, which moves us without our realizing it. The resurrection is all the more wonderful and the death all the more melancholy.

★

This question of contrast between figures, so stupidly recommended and even more stupidly compared with that between dramatic figures, understood as it is by writers and perhaps by artists, would give their compositions an unbearable effect of contrivance. Go to the Chartreux and look at forty monks drawn up in two parallel lines. They're all doing the same thing, not one of them resembles another: one has his head thrown back and his eyes closed, another bows his head and buries it in his hood, and the same goes for the rest of their bodies. I know of no other contrast than that.

Is it really necessary for one to speak while another is silent, for one to shout while another speaks, for one to stand up straight while another leans forward, for one to be sad while another is cheerful, for one to behave badly while another behaves well? That would be too absurd.

Contrast is a matter of convention, you say. I don't think so for a moment. If the action requires that two figures should be leaning forward, let them both lean forward; and if you copy them from nature, don't be afraid that they'll look the same.

Contrast is not a matter of chance any more than it is of convention. There is a necessity, which one cannot escape without being false, according to which two figures, whether they differ in age, sex or character, will do the same thing differently.

★

An artist will avoid parallel lines, triangles, squares and anything which approximates to a geometrical figure, because, when objects are arranged by chance, there is only one case in a thousand where the arrangement hits upon these figures. As for acute angles they are to be avoided because their shapes are so awkward and uninteresting.

★

One should not imagine that inanimate objects have no individual characteristics. Metals and stones have them. Amongst the trees, who has not observed the suppleness of the willow, the distinctive shape of the poplar, the rigidity of the fir, the majesty of the oak? Amongst the flowers, the coquettishness of the rose, the modesty of the buttercup, the pride of the lily, the humility of the violet and the nonchalance of the poppy?

★

When describing a painting, I first of all say what the subject is, then I go on to the main character and from there to the secondary figures in the same group; then to the groups linked with the first, allowing myself to be led by the connections between them; then to expressions, characteristics, draperies, colouring, the distribution of light and shade, the additional features and finally the impression given by the whole. If I follow a different order, then my description is badly done, or else the painting is badly composed.

★

Lairesse[6] claims that it is permissible for an artist to introduce the observer into the scene of his painting. I don't think so at all; and there are so few exceptions to this that I would happily make a general rule of the opposite. It seems as much in bad taste to me as the performance of an actor addressing himself directly to the pit. The canvas embraces the whole space, and there is nobody outside

it. When Susanna reveals herself naked to my gaze, at the same time placing all her clothing between herself and the eyes of the elders, Susanna is chaste and so is the painter; neither of them knew that I was there.

★

What do we see in this painting of Eudamidas?[7] The dying man on the bed; beside him, the doctor feeling his pulse; the notary taking down his last will; at the foot of the bed, Eudamidas' wife, seated, with her back turned towards her husband, her daughter lying on the floor between her mother's knees with her head resting on her lap. There are no multitudes of people. Large numbers and crowds are suggestive of disorder. And what additional features are there here? Nothing but the main figure's sword and shield hanging on the wall in the background. Large numbers of such decorative elements are suggestive of lack of invention. They are called space-fillers in painting and padding in poetry.

★

I was looking at the waterfall at Saint-Cloud and thinking: What an enormous expense to make something pretty, when it would have cost half as much to make something beautiful! What are all these little jets of water, all these tiny waterfalls running down one step after another, compared with a great mass of water gushing out of an opening in a rock or a dark cavern, crashing down, being broken in its fall by huge rough stones, whitening them with its foam, making high, broad waves as it flows along; the rustic rock masses at the top, carpeted with moss and covered, like the sides, with trees and bushes arrayed with all the horror of wild nature? Put an artist in front of that waterfall and what will he do? Nothing. Show him this one and he will immediately take out his pencil.

This example is not the only one where, to ascertain whether a work of art is in good or bad or trivial taste, all one needs to do is

to make it a subject of imitation for the painter. If it is beautiful on the canvas, you can say that it is beautiful in itself.

★

The poet says: 'There is no monster so hateful that, imitated by art, it cannot please the eye.'[8]

I make an exception for the heads of our young women, adorned as they are at the moment.

★

If a woman is pursued by a ravisher and her right arm is raised and stretched forward, the shoulder on that side will certainly be higher than the other. It is precisely for this reason that, if her fear causes her to turn her head to see if the man pursuing her is near her or far away, she will look over her left shoulder.

On the Antique

Rubens had infinite respect for the Ancients, whom he never imitated. How is it that such a great master could confine himself to the coarse figures of his own country? It's incomprehensible.

★

You see these fine antique statues, but you have never heard the master; you have never seen him with his chisel in his hand; the spirit of the school is lost for you; you cannot see the history, in bronze or marble, of the steady progress of the art from its crude beginnings to its final perfection. You are to these masterpieces what the scientist is to the phenomena of nature.

★

Antoine Coypel' was certainly a clever man when he said to artists: 'Let us, if possible, make the figures in our paintings the living models of antique statues rather than that these statues should be the originals of the figures we paint.' One could give the same advice to men of letters.

On Grace, Negligence[10] and Simplicity

Grace hardly ever belongs to any but delicate and weak characters. Omphale has grace, Hercules has not. The rose, the carnation and the calix of the tulip have grace; the old oak, whose top is lost in the clouds, has none; perhaps its branches or leaves do.

★

Negligence in a composition is like a young woman in her morning *déshabillé*; in a minute, fully dressed, she will have spoilt everything.

★

Beautiful landscapes teach us to know nature better, just as a skilled portraitist teaches us to know our friend's face better.

★

Why do we never see negligence in nature? Because, whatever object she presents to our gaze, at whatever distance it is placed, from whatever angle it is seen, it is as it must be, the result of causes whose effects it has experienced.

On the Naive and on Flattery

To say what I feel, I must make up a word, or at least I must extend

the meaning of an existing word: *naive*. In addition to the simplicity which it expresses, one must add innocence, truth and the pristine quality of a childhood which still knows no constraint. Thus defined, the naive will be an essential feature of every artistic creation; the naive will be discernible at every point of a Raphael canvas; the naive will be very close to the sublime; the naive will be found in everything of great beauty, in an attitude, in a movement, in a drapery, in an expression. It is the thing itself, the pure object, without the slightest alteration. Art no longer has a place in it.

<center>★</center>

All that is true is not naive, but all that is naive is true, with an exciting, original and rare truth. Nearly all Poussin's figures are naive, that is, purely and perfectly what they have to be. Nearly all Raphael's old men, women, children and angels are naive. That is to say they possess a certain natural originality, a grace with which they are born, which is not given to them by instruction.

<center>★</center>

Manner is to the fine arts what hypocrisy is to morals. Boucher is the biggest hypocrite I know. There is not one of his figures to whom one could not say: 'You want to be lifelike, but you're not.' Naivety belongs to every condition: one can be a hero naively, a scoundrel naively, pious naively, handsome naively, an orator naively, a philosopher naively. Without naivety there is no true beauty. One is a tree, a flower, a plant, an animal naively. I would almost go so far as to say that water is naively water, for otherwise it would aspire to be polished steel or crystal. Naivety is the strong resemblance of the imitation to the thing itself, accompanied by a great facility in execution: it is water taken from the stream and thrown on to the canvas.

<center>339</center>

I have been too hard on Boucher; I take it back. I think I have seen some children by him who are really naively children.

★

Painting has its own form of flattery: it attracts at first sight, but one soon tires of it.

★

I spoke of flattery in relation to style. There is also flattery on a moral level; its resource is allegory. An allegory is done in praise of a person about whom one has nothing particular to say. It is a kind of lie which is saved from contempt by its obscurity.

On Beauty

As soon as an artist thinks of money, he loses his sense of beauty.

★

Everything that has been said about elliptical, circular, serpentine and undulating lines is absurd. Every part of the body has its line of beauty, and the line of the eye is not the line of the knee.

And even if the undulating line were the line of beauty of the human body, which should be preferred among a thousand lines which undulate?

★

They tell you: 'Let your outlines be clear'; and then they add: 'Be hazy in your outlines.' Is there a contradiction there? No, but it can only be reconciled in the picture itself.

340

★

The Italians call this hazy effect *sfumato*; and it seemed to me that with *sfumato* the eye moved around the part which was drawn, and that art indicated what one is obliged to conceal, but so effectively that, without seeing it, one thought one could see the outline beyond. If I'm wrong in this definition of a technical matter, I hope that artists will remember that I'm a man of letters and not a painter. I've said what I have seen: that the outlines seemed to be submerged in a light haze.

★

Verisimilitude consists in a greater or lesser degree of possibility. Possibility consists in ordinary circumstances.

★

The art lies in mingling ordinary circumstances with the most fantastic elements, and fantastic elements with the most ordinary things.

NOTES ON THE PAINTERS

BAUDOUIN, Pierre-Antoine (1723–1769). A pupil of Boucher, whose youngest daughter, Marie-Emilie, he married in 1758. Accepted into the Academy in 1763 with *Phryne and Areopagus* (Louvre). Widely criticized for his *risqué* paintings and correspondingly popular with the public.

BOUCHER, François (1703–1770). Showed early promise as a painter of historical and religious subjects. Awarded the Prix de Rome in 1724; spent four years in Rome with Carle Van Loo. Received into the Academy in 1734 with *Rinaldo and Armida*. His activities diversified into book illustration, decoration of interiors, ceramics and furniture, and tapestry design. In 1765 he became Director of the Academy and First Painter to the King. By this time his reputation, established on the basis of his elegant, erotic, rococo treatments of mythological themes, was suffering from a shift in public taste towards more serious subjects.

CASANOVA, François (1727–1802). A London-born Italian. Travelled widely; settled in Paris in the late 1750s. Accepted into the Academy in 1763, after which he exhibited regularly at the Salon. Specialized in military and battle scenes.

CHARDIN, Jean-Baptiste-Siméon (1699–1779). Accepted into the Academy in 1728 as a 'painter of fruit and animals'. Did not begin to exhibit there until 1738, with still lifes and genre scenes, to which he would confine himself throughout his career. Treasurer of the Academy from 1755 until 1774 and also *tapissier* of the Salon, having responsibility for hanging the pictures accepted for exhibition.

DESHAYS, Jean-Baptiste-Henri (1729–1765). Awarded the Prix de Rome in 1751; entered the Academy in 1759 as a history painter. Exhibited at only four Salons (1759–1765) before his early death.

DOYEN, Gabriel-François (1726–1806). Awarded the Prix de Rome in 1746; entered the Academy in 1759 as a history painter. After a distinguished career in France he spent his last years in St Petersburg in the employ of Catherine II and Paul I.

FRAGONARD, Jean-Honoré (1732–1806). Pupil of Boucher. Awarded the Prix de Rome in 1752. Returned to France in 1761. Appointed Painter to the King for *Coresus and Callirhoe* in 1765. Never entered the Academy, but was immensely successful as a painter of romantic landscapes, portraits and erotic scenes until the Revolution, when his popularity waned.

GREUZE, Jean-Baptiste (1725–1805). Spent most of his life in Paris apart from a brief and unproductive stay in Italy from 1756 until 1759. Exhibited at the Salon 1755–1769, where he first achieved fame with *A Father Reading the Scriptures to his Children*, but broke with the Academy when he was refused recognition as a history painter for his *Severus and Caracalla*. By this time his popularity as a portraitist and genre painter was well enough established for him to exhibit in his own studio. In the later years of the century his popularity waned as the Neo-Classical style took hold.

LAGRENÉE, Louis-Jean-François (1725–1805). Pupil of Carle Van Loo. Awarded the Prix de Rome in 1749. Accepted into the Academy as a history painter in 1755. First Painter at the court of Catherine II in 1761. Director of the Rome School in 1781. Regarded as a forerunner of Neo-Classicism.

LOUTHERBOURG, Jacques-Philippe de (1740–1812). Pupil of Carle Van Loo and associate of Casanova. Received into the Academy in 1767 and exhibited at the Salon from 1763 until 1779. In 1771 he settled in London, where he painted picturesque and sublime landscapes and also invented the Eidophusikon, a sort of peep-show providing views of London together with atmospheric and sound effects.

ROBERT, Hubert (1733–1808). Settled in Paris after spending eleven years in Italy. Admitted to the Academy in 1766. Highly popular as a painter of ruins (an aspect of the reviving interest in antiquity), he also painted scenes of contemporary Paris and Versailles.

VAN LOO, Charles-André, known as Carle (1705–1765). Already in Italy when he won the Prix de Rome in 1724, he remained there until 1734. Received into the Academy as a history painter in 1735. Painter to the King in 1762. A distinguished and influential history painter.

VAN LOO, Louis-Michel (1707–1771). Nephew of the above. Awarded the Prix de Rome in 1725. Admitted to the Academy on his return from Italy in 1733. Portrait painter to the Spanish court until 1752, when he returned to France. Exhibited at the Salon from 1753 until 1769.

VERNET, Claude-Joseph (1714–1789). Spent the first part of his career in Italy as a landscape and marine painter. Admitted to the Academy in 1753 as a marine painter and exhibited at the Salon until 1789. Commissioned to do a series of paintings on the *Ports of France*. Those he completed are in the Louvre.

VIEN, Comte Joseph-Marie (1716–1809). Pupil of Natoire. Awarded the Prix de Rome in 1743. Received into the Academy in 1754. After a period concentrating on religious paintings, he turned to-wards Neo-Classicism. Had a distinguished career and became First Painter to the King in 1789.

NOTES

INTRODUCTION

1. Norman Bryson, *Word and Image, French Painting of the Ancien Régime* (Cambridge University Press, 1981).
2. p. 167.

CONVERSATIONS ON THE NATURAL SON

1. This is a reference to Corneille's *Cinna*.
2. The first allusion to the distinction which Diderot makes, both here and in the *Paradox*, between an informal 'salon' or drawing-room performance and the conventions of a theatre performance.
3. Davus was the name of the slave in Terence's *Andria* and was also used for a slave in Horace's *Satires*. Diderot generalizes it to designate slave and servant parts in classical drama.
4. Act V of Lillo's *The London Merchant*, when Barnwell and Millwood meet for the last time, at the foot of the gallows (see also note 15 below). Philoctetes is the eponymous hero of Sophocles' tragedy.
5. Constance.
6. Rosalie.
7. 'What a spectacle my respect for philosophy denied me!' An anecdote Diderot found in Lucian's *On the Dance*.
8. From Racine's *Phèdre*, IV, 6.
9. Actors, all of whom, with the exception of Quinault and his sister, were before Diderot's time.
10. Diderot adds a note here describing Lampedusa as a desert island between the Tunisian coast and Malta. He may have known that a few French subjects colonized it around 1760.
11. An allusion to an incident in 1756, when an English fleet attacked some French ships without declaring war. In Diderot's play, Dorval's father is taken prisoner during this engagement.

12. The theatre opened in 1756 with a performance of *Britannicus*, with Clairon (see note 21 below) as Agrippine.

13. *Sylvie*, a *tragédie bourgeoise*, by Paul Landois (1741).

14. In Voltaire's *Prodigal Son* (1736).

15. *The London Merchant, or The History of George Barnwell*, by George Lillo (1731), and *The Gamester*, by Edward Moore (1753).

16. See note 4 above.

17. Horace, *Ars Poetica*, verse 97.

18. An imperfect quotation by Diderot from Vitruvius's *On Architecture*, here corrected after Didot's edition. 'Just as wind instruments achieve the perfection of strings with the help of strips of copper and horn amplifiers, so the Ancients developed the means of amplifying the voice in the theatre with the help of the laws of harmony.'

19. Horace, *Ars Poetica*, verse 82.

20. The three theatres then open in Paris were the Opéra, the Théâtre Français (or Comédie-Française) and Les Italiens.

21. Claire Legris de Latude, known as La Clairon (1723–1803), one of the finest actresses of the period. The *dramatis personae* of *The Natural Son* is headed: 'Here are the names of the real characters in the play with those of the actors who might replace them', and she is indicated as the actress who might play Constance.

22. Horace, *Ars Poetica*, verse 310. 'Socrates' works can show you the essence of it.'

23. ibid., verse 447: 'He will leave out unnecessary ornaments.'

24. The play is *Hecyra*. The Davus (see note 3 above) is the slave Parmenon.

25. A reference to the closing scenes of Molière's *Le Bourgeois Gentilhomme*.

26. As in *Venice Preserv'd, or a Plot Discovered*, by Thomas Otway (1682). Diderot refers to this in a note and adds: 'Shakespeare's Hamlet and most plays in the English theatre'. Otway's play was performed in translation at the Comédie-Française in 1746.

27. A burlesque entertainment performed by *bateleurs* (jugglers, puppeteers, etc.) in front of a theatre to attract custom.

28. Horace, *Satires*, I, 2.

29. From La Noue's tragedy *Mahomet II*, V, 4.

30. Racine, *Iphigénie*, V, 6.

31. Racine, *Phèdre*, V, 6.
32. Charles Racot de Grandval, the principal tragic actor of Diderot's time until he was eclipsed by Le Kain.
33. Quinault, Lulli's librettist, considered in the same breath as Scarron, comic writer and author of *Le Roman comique* (1651-7), and d'Assoucy, author of *Ovide en belle humeur* (1650).
34. Men getting smaller: Marivaux's *The Isle of Reason or The Little Men* (1727). Angélique is in Quinault's *Roland* (1685).
35. *Iliad*, V, verse 335 *et seq.*
36. Racine, *Iphigénie*, I, 5.
37. Achilles killed Thersites, but Achilles is vulnerable too, in his heel.
38. 2 Kings, 3.15.
39. *Le Devin du village* (*The Village Soothsayer*) is by Jean-Jacques Rousseau. The author of the ballet has not been identified.
40. A troupe of child actors, touring mainly in Germany and Italy.
41. Racine, *Iphigénie*, V, 4.
42. Marie-Françoise Marchand, known as Dumesnil, played in the Comédie-Française between 1735 and 1775.
43. Racine, *Iphigénie*, IV, ⁴.
44. Voltaire, *Le Siècle de Louis XIV*, from Ch. 32, 'On the Fine Arts'.
45. Diderot's second play, *Le Père de famille*, which must already have been in preparation when the *Conversations* were written.
46. Louis-Philippe d'Orléans (1725-1785). He had had a theatre built on his estate at Bagnolet, east of Paris, for himself and his friends to act in. He was one of the first people in France to have his children vaccinated against smallpox.
47. The last volume to be published before the *Encyclopedia* was banned by the Parlement and put on the papal index. The remaining volumes had to wait until 1765, when they were all published together.

IN PRAISE OF RICHARDSON

1. Essayists and maxim-writers of the sixteenth and seventeenth centuries.
2. Tomlinson is Lovelace's accomplice in his efforts to overcome Clarissa Harlowe's resistance.
3. The abbé Prévost produced translations, much adapted to French

taste, of *Pamela* (1742), *Clarissa* (1751) and *Sir Charles Grandison* (1753).

4. Mme Le Gendre, younger sister of Diderot's close friend and correspondent Sophie Volland, who broke off a correspondence with a man friend.

5. From one of Diderot's letters to Sophie Volland, we know that it was in fact Diderot himself who, on collecting the extracts, went off into a corner and wept.

6. Diderot actually wrote 'L'Ours blanc', 'The White Bear'.

7. Clementine says no such thing. Diderot's imagination has run away with him.

THE PARADOX OF THE ACTOR

1. From Molière's *Tartuffe*. The hypocrite Tartuffe is making advances to Elmire, the wife of his host.

2. The Carrefour de Bussy was the site of the Comédie-Française until 1770. Garrick was, with Lacy, the manager of Drury Lane until 1776.

3. Claire Legris de Latude, known as La Clairon (1723–1803). She played the principal roles in classical tragedy for a quarter of a century.

4. François Duquesnoy (1594–1643), a Belgian sculptor.

5. Marie-Françoise Marchand (1711–1803), the rival of Clairon (see note 3 above) in tragic roles.

6. The Second Speaker has expressed one of Diderot's central ideas, upon which his monist materialism was based.

7. From Voltaire's *Zaïre*, IV, 2, and Racine's *Iphigénie*, II, 2.

8. Apart from the substitution of 'Henri' for 'Agamemnon', these lines are from Racine's *Iphigénie*. Diderot took the idea from Grimm's *Correspondance littéraire*.

9. No connection is implied with the 'picturesque' style in art. Diderot actually used the word 'romanesque'.

10. Henri Louis Cain (1729–1778), tragic actor.

11. Michel Boyron (1653–1729), actor, author of comedies and friend of Molière. Gaussin: Jeanne Catherine Gaussin.

12. François Molé (1734–1802) only succeeded in Paris in 1761, after years touring the provinces.

13. Until 1759 there had been benches on the stage, often occupied by unruly young nobles. The reform is also attributed to pressure exerted by Le Kain (see note 10 above).

14. Pierre-Claude Nivelle de la Chaussée (1692–1754), the most notable writer of *drames bourgeois*.

15. An anecdote found in the *Correspondance littéraire*. 'Hamlet' should of course be 'Macbeth'.

16. The work is the first version of *Est-il bon, est-il méchant?* (*Is he good, is he bad?*).

17. *The Unwitting Philosopher*, the best-known play of Michel Jean Sedaine (1719–1797), was first performed in December 1766.

18. Jacques Necker (1732–1804), a banker who became finance minister in 1777.

19. Jean-François Marmontel (1723–1799), tragedian, but better known for his tales and novels. He was a contributor to the *Encyclopedia*.

20. *Inès de Castro*, by La Motte, was first performed in 1723. Duclos: Anne-Marie Châteauneuf, born *c*.1664.

21. In Voltaire's *Sémiramis*. Voltaire himself praised Le Kain's performance.

22. The reference is to Molière's *Tartuffe*. Tartuffe was originally a character in the *commedia dell'arte*, but the word has since come to be used generally for a hypocrite.

23. The first two had recently been involved in a scandalous bankruptcy case; the third was a tax farmer.

24. A Molière comedy, usually translated as *The Bluestockings*.

25. Louis Jean François Lagrenée (1725–1805), a painter of allegorical and historical subjects.

26. *The Holy Family*.

27. Jean-Baptiste Antoine Suard (1732–1817), writer, journalist and, from 1774, censor for plays.

28. In 1741. The play is by Destouches.

29. In the Preface to the 1767 *Salon* (not included in this volume).

30. By Nivelle de la Chaussée (1735); see note 14 above.

31. Montmesnil, the actor son of the novelist Alain René Lesage.

32. 'if you had heard the beast roaring'.

33. Corneille, *Cinna*. I, 3.
34. A tragedy by Du Belloy (1727–1775), first performed in 1777.
35. Epicurus.
36. These two actresses made their débuts in 1731 and 1730 respectively, when Diderot was still a student.
37. 'Tearful comedy', a pejorative but widely accepted term for an emotional type of bourgeois drama practised in particular by Nivelle de la Chaussée (see note 14 above).
38. When Diderot's *Père de famille* was published in 1758, the minister Choiseul encouraged two writers, Fréron and Palissot, and a lawyer, Moreau, to run it down.
39. A paraphrase from Sophocles' *Philoctetes*, very much adapted to *drame bourgeois* style.
40. Horace, *Odes*, III, 5.
41. Pierre Rémond de Sainte-Albine wrote in favour of sensibility in *Le Comédien* (*The Actor*) in 1747. Riccoboni put the opposite view in *L'Art du théâtre* in 1752.
42. Joseph Caillot (1732–1816), a popular actor in the Comédie italienne.
43. *Le Déserteur*, by Sedaine, probably seen by Princess Galitzin in 1770.
44. *Aeneas and Dido*, by Lefranc de Pompignan. Mlle Raucourt appeared in it in 1772.
45. Jean-Baptiste Pigalle (1714–1785), sculptor. He worked on the maréchal de Saxe's tomb between 1753 and 1776. He also did a bust of Diderot.
46. Horace, *Ars Poetica*, verse 127: 'Let the character remain as he was at the beginning and let him be consistent with himself.'
47. By Voltaire.
48. See note 31 above.
49. The reference is to a tailor's dummy.
50. In Rameau's opera *Castor et Pollux*.
51. In fact in the number for 6–9 November 1773, and the speech was made at Covent Garden on 30 October 1773.
52. In Rome, criminals sentenced to death were thrown off the Tarpeian rock, near the Capitoline Hill.

THE SALONS

INTRODUCTION TO THE SALON OF 1765

1. Horace, *Ars Poetica*, I, verses 143–4: 'He thinks not to send smoke after lightning, but to create light out of smoke.'
2. Joseph-François Parrocel (1704–1781), a lesser-known member of the distinguished family of painters.
3. François Le Moyne (1688–1737) worked in a variety of styles and decorated the Salon d'Hercule at the Palace of Versailles.
4. Horace. *Ars Poetica*, I, verses 372–3: 'Poor poets are not spared by the gods, or men, or the columns where they recite their verses.'
5. Malherbe, *Consolation à Monsieur du Périer*: 'And the guard who watches over the gates of the Louvre does not defend our kings from it.'
6. The implication is that one resorts to theory and method when inspiration fails. François Morellet (1727–1819) was a contributor to the *Encyclopedia* and also wrote on literature and philosophy.
7. The burden is the *Encyclopedia*.
8. Van Loo and Deshays: see the section 'Notes on the Painters'. The comte de Caylus was *amateur honoraire* at the Academy from 1731 and exercised considerable influence over the development of art. Diderot, probably unfairly, thought he was too enthusiastic about the cultivation of classical values.

BAUDOUIN

1. Schiff Collection.
2. Phillips Family Collection.
3. Perhaps the familiar name for a particular order, but I can find no reference for it.
4. Part of the red-light district, between the Palais Royal and the Seine.
5. The location of the painting is unknown, but it is well known through engravings.
6. Not dead, but absent from the exhibition, having been refused

entry because he had not yet presented his *morceau de réception* for membership of the Academy.

7. Pietro Bacci, known as l'Aretino (1492–1556), satirist, well known for his pornographic writings.

8. Gleichen, a Danish diplomat, and Galiani, at the Sicilian Embassy, were both amateur archaeologists.

9. Left in French, not to avoid giving offence, but because it defies effective translation. Literally 'Venus with the beautiful buttocks', but any English translation is either clinical or invites ribaldry, which the French does not, though the statue itself obviously did.

10. Henri de La Tour d'Auvergne, vicomte de Turenne, maréchal de France, Louis XIV's greatest general. Nicolas Catinat (1637–1712), another great general.

11. Baudouin married Marie-Emilie, the younger daughter of François Boucher, in 1758.

12. Another painting known only through numerous engravings, which testify to Baudouin's popularity.

BOUCHER

1. Mme Favart, an actress. *Rose et Colas*, by Sedaine, performed in 1764. Deschamps, an actress at the Opéra.

2. Horace, *Ars Poetica*, I, verses 7–8: 'like the dreams of a sick man, creating meaningless forms where neither feet nor head [could form a proper body]'.

3. Petrarch, *Canzoniere*, sonnet CCXLIX: 'and laughter and song and gentle human talk'.

4. By no means a sinecure, this post enabled its holder to exercise an influence over the choice of artists and subjects to benefit from royal patronage.

5. Private collection, New York.

6. Lagrenée's *Justice and Mercy*.

7. Private collection, New York.

8. 'Angelica promises her heart, Medoro is its conqueror.'

9. One of La Fontaine's *Contes*.

CHARDIN

1. *Bocal d'olives* (*Jar of Olives*), Louvre.
2. *The Skate* (1728), Louvre.
3. Jean-Baptiste Pierre (1713–1789), first painter to the duc d'Orléans.
4. A contest in which Zeuxis's painting of grapes, which was shown first, was so realistic that the birds flew down and tried to peck at them. Zeuxis then challenged Apelles to draw aside the curtain from his own painting, but the curtain was the painting.
5. Diderot describes Challe's *Hector Reproaching Paris for his Cowardice*, in the same Salon, as 'one of the stupidest things ever done in paint', but reproaches Chardin for cruelly hanging it next to two Vernets and five Chardins.
6. Louvre.
7. Louvre.
8. A particularly fine Indian cloth.
9. Museum of Fine Arts, Springfield, Massachusetts.
10. Musée d'Angers.
11. Chrysler Museum, Norfolk, Virginia.
12. Daniel Webb, *An Inquiry into the Beauty of Painting*, 1760. Translated into French in 1764.
13. In 1734 and 1748.
14. Jahan-Marcille Collection.
15. Rothschild Collection.
16. *La Pourvoyeuse*, actually exhibited in 1739.

DESHAYS

1. Church of Saint-Symphorien, Montreuil, near Versailles.
2. Equestrian statue of Louis XIV by Girardon, no longer there.
3. Church of Saint-Louis de Versailles.
4. *Mémoires du comte de Comminges* (1735).
5. Horace, *Epistles*, II, 2: 'He will give the impression of play as he torments himself.'
6. See note 3 to Chardin, above.
7. In 1751. The Prix de Rome, or Grand Prix, enabled a young artist to spend about three years at the Académie de France in Rome.

DOYEN

1. Lucretius, *De Rerum Natura*, III, verses 53–4: 'Minds are more actively turned to religion in times of adversity.'
2. Church of Saint Roch, Paris. The painting is usually referred to by its French title, and also as *L'Epidémie des Ardents*. It is best translated, or rather explained, as 'St Genevieve interceding for the plague-stricken'.
3. 'After this, therefore because of this.'
4. Just as Diderot finds it difficult to understand the structure of the building, I have found it difficult to understand his description of it. An examination of the painting will reveal the problem.
5. 'looking for a hopeful sign'.
6. One of Diderot's slips. The hand actually belongs to the victim.
7. Pierre Mignard (1612–1695), best known as a portraitist.
8. Virgil, *Aeneid*, VI, verse 743: 'Everyone is influenced by the spirits of his predecessors.'
9. A probable reference to Domenichino's *Sybil*.
10. *The Plague of Asdod*, Louvre.
11. Terence: 'By understanding too much they end up understanding nothing.'
12. From the *Iliad*, XI, verses 391–5, and verses 452–4 (for the crows).
13. Timanthe, *The Sacrifice of Iphigeneia*.
14. *Ligne de liaison*, Diderot's version of the 'serpentine line', best known from Hogarth's *Analysis of Beauty*, with which Diderot was familiar.

FRAGONARD

1. Louvre.
2. What follows as a result of this fiction is a presentation of the picture as a play, which enables Diderot to give the historical background to the event portrayed.
3. The idea comes from Book VII of Plato's *Republic*.
4. These are the maenads or Bacchantes.

GREUZE

1. Charles-Antoine Coypel (1694–1752), one of a family of painters. He painted in a variety of styles and was Director of the Academy.

2. Louvre. Better known as *L'Accordée de village* in French and as *The Village Betrothal* in English.

3. David Teniers (1610–1690), Flemish painter of realistic genre scenes and landscapes. Diderot frequently expresses admiration for his work.

4. Tenara was at the entrance to Hades. The quotation is adapted from Horace, *Satires*, II, verses 26–8: 'Born of the same egg, but with different passions'.

5. National Gallery of Scotland, Edinburgh.

6. Salomon Gessner (1730–1788). His *Idylls*, full of enthusiasm for the innocent, rustic life, were translated from the German by Diderot and Huber.

7. *The Broken Mirror*, Salon of 1763; Wallace Collection.

8. Hermitage Museum.

9. *A Young Laundry Girl*, Salon of 1761.

10. Perhaps *Head of a Woman* in the Metropolitan Museum of Art, New York.

11. A pastel portrait of M. de Lalive de Jully, who occupied this position, which was rather like that of Master of Ceremonies.

12. National Gallery of Ireland, Dublin.

13. Rubens, *The Birth of Louis XIII*, from the series *The Life of Marie de Medici*; Louvre.

14. Louvre.

15. Diderot is being kind. See Anita Brookner's *Greuze*, p. 61.

16. Musée Jacquemart-André, Paris.

17. Musée Wicar, Lille.

18. Musée Wicar, Lille.

19. They were painted, and are in the Louvre.

20. Deshays' *Artemisia at the Tomb of Mausolus*.

21. Nelson Gallery, Atkins Museum, Kansas City.

22. The genre painter, A. van Ostade.

HALLÉ

1. Musée des Beaux-Arts, Palais Longchamp, Marseille.
2. 'Just as I should be, gentle and peaceable.'
3. A disease common in Poland.
4. No commentator has any information on Saint-Leu stone.
5. Poussin's *Esther Fainting before Ahasuerus*.
6. Geoffrin held one of the better-known salons, which Diderot frequented. Apparently she had herself painted from behind to prove her point.
7. Le Brun, *The Family of Darius*, Château de Versailles, in the series *The Battles of Alexander*.
8. Louvre.

LAGRENÉE

1. Virgil, *Aeneid*, XII, verse 168: 'The other hope of mighty Rome'.
2. Château de Fontainebleau.
3. Château de Fontainebleau.
4. Private collection, Paris.
5. Rabelais, *Gargantua and Pantagruel*, Book V, Ch. 7.
6. The Socinians denied the divinity of Christ.

LOUTHERBOURG

1. A fair held annually in the Place Vendôme from 1764 to 1771. Children's toys could be bought there.
2. Ideas based on Hogarth's *Analysis of Beauty*.
3. Charles de Brosses (1709–1777), first President of the Parlement of Bordeaux.
4. Musée des Beaux-Arts, Marseilles.
5. Joseph-François Millet, of whom little is known. His pictures in the Salon were treated dismissively by Diderot.
6. Probably *Landscape with Figures*; Dulwich Picture Gallery.
7. Possibly the *Shipwreck* in the Stockholm Museum.
8. Poussin's *Landscape with Serpent*, Musée de Dijon.

9. Claes Pieter Berghem (1620–1683), a Dutch landscape painter who influenced several eighteenth-century French painters.

HUBERT ROBERT

1. Diderot's molecules of course bear no relation to molecules as we know them.
2. René Antoine Ferchault de Réaumur (1683–1757). As well as inventing the alcohol thermometer, he made a study of invertebrates.

CARLE VAN LOO

1. Musée de Picardie, Amiens. Unfinished and completed by his nephew, Louis-Michel Van Loo.
2. Château de Chenonceaux.
3. Horace, *Odes*, I, IV, to L. Sestius. What follows is freely paraphrased from it.
4. 'The seemly Graces together with the nymphs beat the ground with alternate feet.'
5. Marcel, a dancing-master to the king.
6. A kind of headdress worn by women *en déshabillé*.
7. Marie Hocquet, a painter not well enough known to figure in the usual reference books.
8. Apelles, reputed to be the greatest of the Greek painters. Active in the late fourth century B.C., and court painter to Alexander and Philip of Macedon. Frequently mentioned by Diderot.
9. Hermitage Museum, St Petersburg.
10. Jean-François de Troy's *Susanna and the Elders*; Musée de Rouen.
11. J. Cesari, *Susanna in the Bath*.
12. Sébastien Bourdon, *Chaste Susanna*.

VAN LOO, LOUIS-MICHEL

1. Louvre. Despite Diderot's reservations, this is the portrait usually used when a picture of Diderot is required.
2. By Van Loo. Exhibited in the same Salon and now in the Musée de Coutances.

3. From a story about a Venetian monk who tried to distract the crowds from a kind of Punch and Judy show by holding up the crucifix and saying 'Here is the true Punch.'

VERNET

1. One of a set of four seascapes commissioned by the Dauphin for his library at Versailles. Now in the Musée de Versailles.

2. Louvre.

3. Musée de la Marine, Paris.

4. Whereas linear perspective is a matter of geometry, aerial perspective concerns light and colour.

5. Musée d'Avignon.

6. This must be written with tongue in cheek. Mme Geoffrin had a European reputation for her salon and her readiness to entertain notable foreign personalities. She also supported the *Encyclopedia*.

7. This is a loose paraphrase of Lucian's *Icaromenippus*.

8. Musée de la Marine, Paris.

9. Louvre.

10. One is lost; the other is in the Staatliche Museum Preussischer Kulturbesitz, Gemäldegalerie, Berlin.

11. The *Shipwreck* is thought to be the painting in the Hermitage Museum called *Tempête*. The other is lost.

12. There was no series called *The Four Seasons* in the 1765 Salon. This painting has been identified as *Midday* from *The Four Times of Day*.

13. Horace, *Ars Poetica*, verse 358: 'Sometimes even good Homer nods.'

14. A reference to the rivalry between the French and Italian styles which had led to the 'Querelle des Bouffons'. It is one of the subjects discussed in *Rameau's Nephew*.

15. Virgil, *Aeneid*, I, verse 462: 'What, do I see Priam? Virtue finds its reward here then.'

16. Bedmar was the Spanish Ambassador to Venice in the seventeenth century and plotted to deliver the city to the Spanish. The events were narrated by Saint-Réal and dramatized by Thomas Otway in *Venice Preserv'd*.

17. Diderot is probably referring to Thomas Corneille's play *Le Comte d'Essex* rather than to the original conspiracy.
18. Diderot is making a point. Marmontel wrote several other tragedies.
19. Horace, *Ars Poetica*, verses 102-3: 'If you want me to weep, you must first suffer yourself.'
20. Adrienne Lecouvreur (1693-1730), a tragic actress. This theme is developed fully in *The Paradox of the Actor*.
21. Psalm 19: 'The heavens declare the glory of God.'
22. Persius, *Satires*: 'something lying in the secret, inexpressible parts of us'.

VIEN

1. Church of Saint Roch, Paris.
2. Eustache Le Sueur (1617-1655), best known for his series *The Life of St Bruno*.
3. The painting submitted for acceptance into the Academy.
4. Horace, *Epistles*, II, 2, verse 120: 'flowing pure and smooth like a great river'.
5. Horace, *Satires*, I, 4, verse 11. The verse should begin 'Cum . . .'; 'He flowed like a muddy stream from which there were things you would like to pick out.' My thanks to Emyr Tudwal Jones, who drew my attention to the Budé edition (translation by François Villeneuve) for the most likely rendering of this obscure line.
6. 'They absorb quickly, because they are ignorant; they spread the news easily, because they are empty-headed; they remember for a long time, because they are stubborn.'
7. Juvenal, *Satires*, VII, verses 159-60: 'Nothing has entered the heart of this Arcadian youth.'
8. Tacitus, *Annals*, I, 1: 'without anger or favour'.
9. Raphael's *Morte de Anania*.

ISOLATED THOUGHTS ON PAINTING

1. Virgil, *Bucolics*, II, 65: 'Everyone is betrayed by his own passion.'
2. From Greek mythology: a monster with a griffon's head, wings

and claws, and a horse's body. The griffon is itself a hybrid creature with a head like an eagle's and a lion's body.

3. Pierre-Antoine de Machy (1723–1807). As well as ruins, he painted a series of scenes of Paris.

4. *Jesus Bringing Lazarus back from the Dead*; Jean Jouvenet (1644–1717). Now in the Louvre.

5. One of the series from *The Life of St Bruno*, commissioned by the Carthusians in 1645. The painting referred to is now in the Louvre.

6. Gérard de Lairesse, *Le Grand Livre des peintres*, much borrowed from by Hagedorn in its German translation of 1728.

7. *The Testament of Eudamidas*, by Poussin, much admired and discussed in the eighteenth century. Now in the Moltke Gallery, Copenhagen.

8. From Boileau's *Art poétique*.

9. Director of the Academy of Painting and Sculpture. He published a set of lectures in 1721 criticizing the exaggerated respect for the antique.

10. Diderot's terms *négligence* and *négligé*, both of which I have represented, rather than translated, by 'negligence', are, like 'grace' and 'simplicity', concepts opposed to convention and academicism, and imply 'unaffectedness', 'heedlessness', and one would like to say 'naturalness', were it not that, as Diderot says, negligence is not found in nature.

FURTHER READING

BROOKNER, ANITA. *Greuze. The Rise and Fall of an Eighteenth-Century Phenomenon* (Elek, 1972). An interesting and informative attempt to understand one of the strangest aspects of eighteenth-century sensibility.

BRYSON, NORMAN. *Word and Image. French Painting of the Ancien Régime* (Cambridge University Press, 1981). Two excellent chapters on Diderot and one on Greuze.

CHARLTON, D.G. *New Images of the Natural in France* (Cambridge University Press, 1984). A wide-ranging discussion of the natural in art, literature and social life.

CONISBEE, PHILIP. *Painting in Eighteenth-Century France* (Phaidon, 1981). A good general survey with a particularly useful opening chapter on the artist's world.

CROCKER, LESTER. *Diderot's Chaotic Order. Approach to Synthesis* (Princeton University Press, 1974).

CROW, THOMAS E. *Painters and Public Life in Eighteenth-Century Paris* (Yale University Press, 1985). An excellent study of the role of painters and painting in society. Much information on the Salons.

FRANCE, PETER, *Diderot* (Past Masters series, Oxford University Press, 1983). A good general study of his life and works.

FRIED, MICHAEL. *Absorption and Theatricality. Painting and Beholder in the Age of Diderot* (University of California Press, 1980). An influential study of this all-important aspect of Diderot's aesthetics.

HOBSON, MARIAN. *The Object of Art. The Theory of Illusion in Eighteenth-Century France* (Cambridge University Press, 1982). A wide-ranging and scholarly study of this complex subject.

SENNETT, RICHARD. *The Fall of Public Man* (Cambridge University Press, 1977). A discussion of the dual nature of eighteenth-century society. Includes a stimulating analysis of *The Paradox of the Actor*.

TAYLOR. S.S.B. (ed.). *The Theatre of the French and German Enlightenment* (Scottish Academic Press, 1979). Contains a very sensible article by the editor on Diderot's plays and ideas on drama.

WILSON, ARTHUR. *Diderot* (Oxford University Press, 1972). The standard biography in English.

READ MORE IN PENGUIN

In every corner of the world, on every subject under the sun, Penguin represents quality and variety – the very best in publishing today.

For complete information about books available from Penguin – including Puffins, Penguin Classics and Arkana – and how to order them, write to us at the appropriate address below. Please note that for copyright reasons the selection of books varies from country to country.

In the United Kingdom: Please write to *Dept. JC, Penguin Books Ltd, FREEPOST, West Drayton, Middlesex UB7 0BR*

If you have any difficulty in obtaining a title, please send your order with the correct money, plus ten per cent for postage and packaging, to *PO Box No. 11, West Drayton, Middlesex UB7 0BR*

In the United States: Please write to *Penguin USA Inc., 375 Hudson Street, New York, NY 10014*

In Canada: Please write to *Penguin Books Canada Ltd, 10 Alcorn Avenue, Suite 300, Toronto, Ontario M4V 3B2*

In Australia: Please write to *Penguin Books Australia Ltd, 487 Maroondah Highway, Ringwood, Victoria 3134*

In New Zealand: Please write to *Penguin Books (NZ) Ltd, 182–190 Wairau Road, Private Bag, Takapuna, Auckland 9*

In India: Please write to *Penguin Books India Pvt Ltd, 706 Eros Apartments, 56 Nehru Place, New Delhi 110 019*

In the Netherlands: Please write to *Penguin Books Netherlands B.V., Keizersgracht 231 NL–1016 DV Amsterdam*

In Germany: Please write to *Penguin Books Deutschland GmbH, Friedrichstrasse 10–12, W–6000 Frankfurt/Main 1*

In Spain: Please write to *Penguin Books S. A., C. San Bernardo 117–6° E–28015 Madrid*

In Italy: Please write to *Penguin Italia s.r.l., Via Felice Casati 20, I–20124 Milano*

In France: Please write to *Penguin France S. A., 17 rue Lejeune, F–31000 Toulouse*

In Japan: Please write to *Penguin Books Japan, Ishikiribashi Building, 2–5–4, Suido, Bunkyo-ku, Tokyo 112*

In Greece: Please write to *Penguin Hellas Ltd, Dimocritou 3, GR–106 71 Athens*

In South Africa: Please write to *Longman Penguin Southern Africa (Pty) Ltd, Private Bag X08, Bertsham 2013*

A CHOICE OF CLASSICS

Matthew Arnold	**Selected Prose**
Jane Austen	**Emma**
	Lady Susan/ The Watsons/ Sanditon
	Mansfield Park
	Northanger Abbey
	Persuasion
	Pride and Prejudice
	Sense and Sensibility
Anne Brontë	**Agnes Grey**
	The Tenant of Wildfell Hall
Charlotte Brontë	**Jane Eyre**
	Shirley
	Villette
Emily Brontë	**Wuthering Heights**
Samuel Butler	**Erewhon**
	The Way of All Flesh
Thomas Carlyle	**Selected Writings**
Arthur Hugh Clough	**Selected Poems**
Wilkie Collins	**The Moonstone**
	The Woman in White
Charles Darwin	**The Origin of Species**
	The Voyage of the Beagle
Benjamin Disraeli	**Sybil**
George Eliot	**Adam Bede**
	Daniel Deronda
	Felix Holt
	Middlemarch
	The Mill on the Floss
	Romola
	Scenes of Clerical Life
	Silas Marner
Elizabeth Gaskell	**Cranford** and **Cousin Phillis**
	The Life of Charlotte Brontë
	Mary Barton
	North and South
	Wives and Daughters

READ MORE IN PENGUIN

A CHOICE OF CLASSICS

Thomas Macaulay	**The History of England**
Henry Mayhew	**London Labour and the London Poor**
John Stuart Mill	**The Autobiography**
	On Liberty
William Morris	**News from Nowhere** and **Selected Writings and Designs**
Robert Owen	**A New View of Society and Other Writings**
Walter Pater	**Marius the Epicurean**
John Ruskin	**'Unto This Last' and Other Writings**
Walter Scott	**Ivanhoe**
Robert Louis Stevenson	**Dr Jekyll and Mr Hyde and Other Stories**
William Makepeace Thackeray	**The History of Henry Esmond**
	The History of Pendennis
	Vanity Fair
Anthony Trollope	**Barchester Towers**
	Can You Forgive Her?
	The Eustace Diamonds
	Framley Parsonage
	The Last Chronicle of Barset
	Phineas Finn
	The Small House at Allington
	The Warden
Mary Wollstonecraft	**A Vindication of the Rights of Woman**
Dorothy and William Wordsworth	**Home at Grasmere**

READ MORE IN PENGUIN

A CHOICE OF CLASSICS